Culturescapes 2021

Amazonia

Anthology as
Cosmology

Edited by
Kateryna Botanova
and Quinn Latimer

Sternberg Press

Some words to defend the forest,

Some writing as river,

Some image-spirits.

AMAZONIA

Contents

INTRODUCTION
Kateryna Botanova
6

FOREST

Our Worlds Are at War
Ailton Krenak and
Maurício Meirelles
Artworks by Denilson Baniwa
14

Ignored, Simulated, Exploited
Proyecto Cuenco de Cera
31

Cosmopolitics of the Living
María Belén Sáez de Ibarra
40

A Restless Painter:
The Work of Shoyan Shëca
(Roldán Pinedo)
Gredna Landolt
52

The Crystal Forest:
Notes on the Ontology of
Amazonian Spirits
Eduardo Viveiros de Castro
64

Luminous in the Sun:
The Cool Botanical Fervor of
Abel Rodríguez (Mogaje Guihu)
Quinn Latimer
90

The Geological Imperative:
On the Political Ecology of
Amazonia's Deep History
Paulo Tavares
102

Everything Is Our Territory,
We Are Trees that Walk
Renata Machado Tupinambá in
Conversation with Rita Carelli
130

Amazon and the Amazon
Pamela Rosenkranz
140

The Umbragiade
Maria Thereza Alves
152

RIVER

Serpent River Book
 Carolina Caycedo
 174

We Feel the Jungle Like We Feel
Our Own Skin
 Taita Hernando Chindoy in
 Conversation with Felipe
 Castelblanco
 202

The Juruna and the Force House
 Tiffany Higgins
 217

My Life Is a Continuous Return
to the River's Headwaters
 Daiara Tukano in Conversation
 with Rita Carelli
 232

Brazilian Black Feminism:
Undoing Racial Democracy,
Towards a World Ethic with
Orixás
 Djamila Ribeiro
 Artworks by Maya Quilolo
 Introduction by Quinn Latimer
 246

Coloniality of Power, Eurocentrism,
and Latin America
 Aníbal Quijano
 262

Remote Sensations:
A Critical Cartography of
Remote Sensing
 knowbotiq
 288

River Poems
 Márcia Wayna Kambeba
 301

The Artivism of the Amazonian
Mythic Imagination
 Christian Bendayán
 307

The Falling Sky:
Words of a Yanomami Shaman
 Davi Kopenawa and
 Bruce Albert
 Photographs by Claudia Andujar
 Introduction by
 Kateryna Botanova
 328

BIOGRAPHIES
342

COLOPHON
352

Introduction

Kateryna Botanova

Flying into Amazonia, be it Iquitos in the Peruvian Amazon or Manaus in Brazil, provides a lavish aerial view over the serpentine Amazon River and the enormous stretch of seemingly never-ending green rainforest. These cities, Amazonian megapolises, sit in the middle of the forest as oddly urban settlements cordoned off but also squeezed by the mass of trees that envelop them. The view is breathtaking. It is also safe, distant, and detached enough to leave a strong visual imprint of the power of the world's biggest rainforest without shedding any light on the nuances of the lives lived under the canopy of greens nor their histories.

The Western imaginary is keen on superlatives, at once euphoric and disastrous. In the West, Amazonia's presence is still mostly connected either to the European naturalist's exploratory fascination—see Alexander von Humboldt and his manifold legacies—or to visually striking discourses about ecological and political destruction and violence: rampant fires by arson, desertification, protests, and state retaliation. Yet, it sometimes seems that even the issue of the ecocide of the Amazon has come into global focus predominantly due to the pressures from climate change. Indeed, while state violence on the streets of the nine countries that span the Amazon makes its way into the international media, the violence in the forest, directed against the Indigenous nations, often largely goes unseen.

Indigenous peoples of the Amazon have their own aerial view of the river and the forest. In the various rituals of healing and reconnecting between humans and non-human entities, Indigenous Amazonian shamans and healers, as well as other members of the community, open their souls to the spirits and often remark that in this process they are able to see the forest from above. It's been said that they assume a perspective of a bird who sees its surroundings not as a detached map but as an interconnected circle of being where all elements—animal, plant, insect, fish, water, people, spirit—are inseparable. There is no distance, no separation, no contemplation. There is, instead, symbiosis, participation, and care.

Amazonia, among many other biomes, ecosystems, or critical zones of the planet, is a space where extractive colonial capitalist attitudes clash with holistic cosmovisions and the oppressive inequalities experienced by local lives, both Indigenous and non-Indigenous. Yet Amazonia is also a space where multiple cultural geographies overlap, creating possibilities of different bodies of knowledge encountering each other, lessons in insight and understanding. Amazonia is both a place, a physical entity that traverses state borders—and all the urgent issues which arise from such enforced

boundaries—and a point of view, uniting numerous voices and visions that speak for it, from within.

CULTURESCAPES 2021 Amazonia, the current iteration of the biannual Swiss arts festival, is devoted to the voices and visions of Amazonia, its peoples and allies, artistic and activist practices, the wisdom of its elders and the words of writers, scientists, and protectors, both Indigenous and non-Indigenous. Indeed, this edition of the two-month-long festival organizes itself along the thematic lines of the river and the forest, bringing together artists, activists, and thinkers from various parts of Amazonia—Brazil, Colombia, Peru, Bolivia, and Ecuador—whose work will be present in more than forty cultural institutions in Switzerland. Marking the beginning of a new festival series focusing on world biomes—CULTURESCAPES Amazonia will be followed by the Sahara, in 2023, the Himalayas, in 2025, and the Oceans, in 2027—this 2021 edition focuses on decolonization and Indigenous knowledge, ongoing extractivist violence and political resistance.

That said, CULTURESCAPES 2021 Amazonia comes with an intention of empathetic witnessing, despite the complications inherent to such a position—translation itself being one. For as Daiara Tukano, the Indigenous artist, activist, and communicator of the Tukano people of Brazil, notes: "Translation is always a treason." Attempting an act of translation assumes that the experiences, struggles, forms of thinking, and systems of knowledges of other people can be expressed in other languages without a loss. Even more, translation is largely a form of power. Nevertheless, witnessing as empathetic presence and as a readiness to listen and learn might be one of the few possibilities to weave connections between different worlds in order to imagine a radically decolonialized non-colonial future together.

The reader you hold now, *Amazonia: Anthology as Cosmology*, accompanies CULTURESCAPES 2021 Amazonia as a space for thought, image, and action via the unique conditions of the publication. It comprises voices and practices of artists, thinkers, shamans, scientists, poets, activists, curators, and others, all of whom speak through a variety of Indigenous and non-Indigenous oral and visual languages. They speak of imagery accessed through ritual connections to spirits and ancestral wisdom or acquired through daring to be a witness to the lives—both human and non—in the Amazon itself, through rhymes and rhythms. They open a universe of multiple knowledges, practices, and visions of the world offering alternative ways of connecting the past, the present, and the future. As Renata Machado

Tupinambá, of the Tupinambá people of the Brazilian Amazon, asserts in this book: "It is fundamental [to us] to understand what came before, in order to understand why we are as we are, and why we do the things we do." Isn't this a fundamental desire of so many of us?

As the editors of this anthology, we have attempted to make a space and a structure for these desires and questions, flowing voices into one of the two sections of the book: "The Forest" and "The River." As we understood it, the forest is a living space, a rhizomatic sphere of memories, knowledges, and cosmovisions, a kind of circular time for the Indigenous peoples who co-habit it. By contrast, the river is forward flow and action; it is resistance, insistence, and regaining subjectivity by going back to the river headwaters, as history serpents, cyclically breaks its banks, floods, and branches out. But Amazonia tricked us, the words and images in the two sections began to overlap and make their own alliances and connections, the thoughts and visions traveled between the forest and the river showing how symbiotically inseparable and deeply interconnected they are. There is no river without the forest as there is no forest without the river. So too, there is no Amazonia without the people that live for and with it, care for and nurture it.

This publication is meant to challenge all of us—its writers, artists, editors, readers, Indigenous and non-Indigenous, coming from all places of the earth—to engage critically, meaningfully, and with careful attention to the past and the present of Amazonia, so as to be able to dream and envisage a more just and habitable future both there and elsewhere.

Forest

The forest is a point of view; what does it see? What is the time of the forest and what do its voices—human and nonhuman, animal and spirit—sound like as they ring out through its temporality? For the forest might be thought of as circular time, concentric circles moving outward and inward, like the map of a tree cutting, whose rings, even in rainforests, can reveal age, ancestry, wisdom, climate, calamity. But what about other kinds of forest time and their conditions: the time of resistance, for instance, and the conditions of opacity in which it might be embodied, revived, lived, shadowed, in which struggle might be given shelter? In what forms does it arrive to us? The space of the Amazon rainforest, here, is animal, essay, sacred medicine, monument, and testimony; it is spirit, conversation, painting, cosmopolitics, resistance, fire, flood, law, both biopolitical and ancestral performances. It is a cosmological time in which the past and future coalesce—their many visual and oral languages and Indigenous epistemologies, their human and animal and spirit forms that regard each other—by impressing upon and constituting the fluid and manifold present. So: the forest is a point of view; what does it see? In "Portrait," the Brazilian poet Astrid Cabral, who was born in Manaus, Amazonas, and grew up along the Amazon River, writes: "Have you ever seen a bird / with roots? / Have you ever seen a tree / with wings? / Have you ever seen a fish / with a voice?" She concludes: "Look at me."

—Quinn Latimer

AMAZONIA

Image Index

p. 36

p. 54

p. 32

p. 61

p. 26

p. 21

F

12

FOREST

p. 96

p. 100

p. 148

p. 121

p. 150

p. 110

Our Worlds Are at War

Translated from the Portuguese by Hilary Kaplan

Ailton Krenak and
Maurício Meirelles
Artworks by
Denilson Baniwa

Standing at the podium of the Brazilian Chamber of Deputies,[1] speaking the white language perfectly, a young Indigenous leader addresses the 1987 National Constituent Assembly with an unusual sort of speech. Having already been barred from entering the plenary in his typical dress, he wears casual Western clothes, a white three-piece suit lent to him by a deputy who is his friend, and holds a small container in his hands.

"I do not wish to disrupt the etiquette of this house with my demonstration, but I believe that ..." He pauses and begins to scoop a dark paste from the container with his fingers, which he then spreads on his face. "I believe that you, honorable members, can no longer stand at a distance from your aggression motivated by economic power, by greed, by ignorance of what it means to be an Indigenous people ..."[2]

Barely audible, a female deputy whispers: "But he is painting himself all black." It is genipap paste, used by many Brazilian Indigenous ethnic groups for mourning rituals. The young man speaks slowly, but with determination: "I think that none of you could point to aspects or acts of the Indigenous people of Brazil that put the life or the patrimony of any person, of any human group from this country at risk ..."

With a flat hand, he paints his cheeks, forehead, nose, and chin. Those in the room hear the sound of many cameras clicking. "A people that has always lived in the absence of riches, a people that lives in houses covered with thatch and sleeps on mats on the floor, cannot be identified, in any way, as a people that is the enemy of national interests, nor that puts any development at risk."

The young Krenak finishes painting himself and delicately places the empty pot on the podium. His face, all black, is now the same color as his shining head of hair, highlighting his bright white eyes and teeth. "Indigenous people have moistened with their blood every hectare of the eight million square kilometers of Brazil, and you, honorable members, are witnesses to this." Thus, he courageously ends his speech. Before thanking the constituents who observe him, stupefied, Ailton Krenak takes a long pause. Though his eyes seek something in an uncertain future, his body is rigorously still, as though he had just returned from a shamanic trance.

That speech marked the emergence of one of the most important activists of the many Indigenous movements in Brazil; Krenak's action was considered decisive for the inclusion of the guarantees of the rights of Indigenous people

in the 1988 Federal Constitution. In the same act, an artist was born: using his body as a territory for biopolitical action, Krenak anticipates, in that performance, some of the central preoccupations of contemporary art to come. He is also a writer who, loyal to the ways of his ancestors, weaves his stories at leisure, in the oral tradition—differently from whites, who write their words because their thought is full of forgetting, he says, quoting his friend Davi Kopenawa, a Yanomami shaman.[3] And, above all, Ailton Krenak is a thinker.

Passing through disciplines that pertain to the tradition of Western thought—anthropology, ethnography, philosophy, as well as operating in traditions that oppose themselves to the latter such as Indigenous history and culture, and traditional arts and crafts knowledge—Ailton is a cultural shaman. That is, he possesses the ability to cross the borders between Indigenous and non-Indigenous worlds, administering relations between them. This quality is also present in his speech; he uses the pronouns "we," "ours," and "us" to refer either to collective humanity, in an ample way, or specifically to groups of Indigenous people, depending on the context in which Ailton includes himself.

Master of an undomesticated thought that moves agilely in many directions, he is surprised by no question and reacts with mocking indifference to some of them. In truth, he elaborates a commentary that, often, will only be finished the next day and takes the shape of a parabola. If we borrow his concept of collective persons—a "cultural body" that perpetuates itself from generation to generation through orally transmitted stories—we could attribute to him characteristics of his ancestors, as reported by Sérgio Buarque de Holanda in his 1936 book *Raízes do Brasil* (*Roots of Brazil*): "Extremely versatile, they were incapable of certain ideas of order, constancy, and exactness."[4] Sophisticated and at the same time furtive, Krenak's ideas hide under apparently simple sentences, like when he is asked if culture is an intervention into nature: "No, nature is an invention of culture"—a linguistic cannibalism of the rhetoric of Antônio Vieira (1608–1697), in his Jesuit complaints about the inconstancy of the Indian soul: "Other peoples disbelieve until they believe; the Brasis [native Brazilians] do not believe even after believing."[5]

For Ailton, "by always being able to tell one more story, we postpone the end of the world." He did so with joy and patience—between puffs of *rapé* (snuff) from his wooden *tipi* (pipe)—over the two days of our meeting in Belo Horizonte, which resulted in the testimony below.

Denilson Baniwa, *Avó do Mundo*, 2019. Courtesy of the artist.

As he perhaps belongs to the category of "a people receptive to any shape but impossible to keep in one shape,"[6] to quote Eduardo Viveiros de Castro, a question that we interviewers consider inoffensive could have an unexpected effect, transforming the interviewee's docility into admonition: "Why are you laughing? Our worlds have been at war, from the beginning!" Seeing the astonished look of the interviewers, Ailton Krenak bursts out laughing and looks at us, in turn, with affection.

—Maurício Meirelles

AILTON KRENAK: NATURE IS THE CREATION OF CULTURE

It is only possible to imagine nature if you are outside of it. How could a baby that is inside its mother's uterus imagine the mother? How could a seed imagine the fruit? It is from outside that one imagines the inside.

At a certain moment in history, the "civilized place" of humans conceived the idea of nature; it needed to name that which had no name. Thus, nature is an invention of culture; it is the creation of culture and not something that comes before culture. And this had a huge utilitarian impact! "I separate myself from nature, and now I can dominate it." This notion must have arrived with the very idea of science. Science as a form of controlling nature, which comes to be treated as an organism that you can manipulate. And this is scandalous. Because once someone thinks this, they damn themselves, don't they? They leave that organism, cease to be nourished by the fantastic cosmic flux that creates life, and come to observe life from outside. And while humanity observes life from outside, they are damned to a sort of erosion.

I find it interesting that one expressive construction of modern thought is around the idea that nature and culture are in conflict with each other—many twentieth-century philosophers debated this idea. There is an enormous amount of writing on this topic, all of which is based on a confusion produced by thought that is logical, rational, Western. The scientific and technological disorientation that the West is now experiencing is the product of this separation between nature and culture.

Firstly, people create nature and separate themselves from it; then, they idealize it. For example, the conception of the Atlantic coastal forest, the Mata Atlântica, is considered part of this idealized nature. In reality, the Atlantic coastal forest is a garden—a garden constructed and cultivated by Indians.

WHITE PEOPLE LOVE TO SEPARATE THEMSELVES

I think that the concept of Amerindian perspectivism developed by Eduardo Viveiros de Castro—the potential for different visions, from other places of existence besides the human—can also be applied in other contexts.[7] It is a very powerful concept to help us understand the time in which we are living. If people were not in the situation of being divorced from life with the planet, perhaps this concept would only be a product of knowledge without direct

implication for our collective life, or the sustenance of life on earth. But, in the stage of divorce we are in, with humans detaching themselves from here like a caterpillar from a hot roof, disconnecting as if they did not have any empathy ….

It is absurd. It is as if a glass divider separated, on one side, the experience of the fruition of life, and on the other, the place from which we originate. This division reveals another, more profound divorce: the idea that humans are different from everything that exists on earth. And there is a type of person, a type of mentality, that detests the idea that people can live so involved in the daily life of the planet, without detaching ourselves from it. They think this idea weakens them, that it is a rejection of the imagined power of people to distinguish themselves from nature—to become people!—a rejection of this thing that white people love to do: to separate themselves.

ECOLOGY IS TO BE WITHIN THE WILL OF NATURE

Recently, I met with a group of heirs from some very old, wealthy families. They said to me, "We want to create a fund to take our families' money out of circulation because this money is financing the destruction of the planet. We have been thinking of buying land in the Amazon and giving it to the Indians." So, I told them: "Don't do it! You will wind up making the Indigenous move to places that are not theirs. That are not them, that don't have the necessary ecology and their culture already within. You really want to detach? You cannot buy land, land is not a commodity."

At this meeting, I talked about Chief Seattle's letter.[8] Sometime around 1850, the western frontier of the United States was already devouring everything. The American cancer had already metastasized, had left the East Coast and come to the Pacific, where the Seattle tribe lived. I went to learn about the economy of this group of Indigenous people prior to the arrival of white Americans. At that time, they lived off salmon fishing. Their beach was divided with rocks. The waves threw fish onto the rocks, and that's how they would catch the fish. It is equivalent to an image described in a Caetano Veloso song: "An Indian raises his arm, opens his hand, and picks a cashew."[9] There was a time of year when the Seattle people fished. This involved the patience of looking for things. This is ecology: it is being inside the earth, within nature. Ecology is not you adapting nature to your will. It is you being inside the will of nature.

IS THIS A BODY?

When the natives of this land saw the Portuguese for the first time, they had doubts about whether the Portuguese people had real bodies, that breathed, that sweat. A body! So, they took a few of the Europeans and drowned them. And waited to see if they would float, if they would smell. They waited and waited. They then began to suspect that yes, those *krai*, those whites, must have a body. "This could be a body," they thought. After setting a body to dry, they watched and said, "It seems like a body." They began to investigate the material and the kind of spirit that inhabits those bodies. They asked, if one body was the same as that person's, because that person could be in another body, couldn't they? Or that person could be one of what the Krenaks [an Indigenous group in Brazil] call *nandjon*—a ghost that has the nature of a supernatural being, or the ghost of a supernatural being. The natives investigated and discovered that the *krais* were not *nandjon*, but that they had souls of another quality: the master essences of gold, of iron, of weapons, of all the apparatuses associated with the tools whites use to meddle in the world.

Before we appropriated metal to make the tools, we were closer to our other ancestors, to all the other human groups that move the world only with their hands, with their bodies. When people began to string plumb lines into the earth, it produced the spirits that make the tools that impress their mark on the earth. It is they who are fabricating the Anthropocene.

THE WAR TO EXTERMINATE THE BOTOCUDO INDIANS

In 1808, when Don João VI arrived in Brazil with the Portuguese court, the Doce River forest was like a wall of the *sertão* (backlands). It was necessary to conduct business over the Espinhaço Mountains so that the royal exchequer could control the flow of gold and diamonds between the mining region and the port of Parati. For this, the Crown created fear in the diamond and gold prospectors who came for land—they are the precursors of the deadly construction and collapse of the Mariana and Brumadinho dams[10]—saying that if they descended the mountains and became lost along the Santo Antonio River, near Piracicaba, and fell into the Doce River, they would be devoured by the Botocudos.[11] Thus, the Botocudos began to be considered cannibals. But the Botocudos were hunter-gatherers who lived in the forest, bathed on the beaches, and ate cashew fruit. They experienced the cycles of nature profoundly, in a deep ecological relationship with the environment. This idea that we would kill and eat prospectors, miners, was

FOREST

Denilson Baniwa, *Cobra Canoa – Metrô*, 2019. Courtesy of the artist.

a strategy of the Portuguese Crown so that the contraband trade in gold and precious stones would not take advantage of the natural exit by the coast of Espírito Santo, by the river—how would they monetize the entire Doce River forest? Thus, this image of the Botocudos beasts of prey hidden in the jungle was used strategically to keep that territory isolated.

The "lords of a province," who in that time had already depleted the greater part of the gold and diamond reserves on their own allotments, then went to Rio de Janeiro and said to Don João VI that it was necessary to open the entrance in the Doce River forest—they already knew that there was gold and precious stones there. The settlers were persistent and, promising that they would fill the king's coffers—which were empty—with the riches of the Doce River, succeeded in convincing Don João VI. At that moment, they entered the forest. But, consumed by fear of the Botocudos, they entered with an authorization of war: a letter dispatched by the king, declaring a war of extermination on the Botocudos of the Doce River.[12] After that moment, a large mining concern began to set up barracks on the tributaries of the Doce River, and, from Itabira down, everything became barracks grounds. Each one had to have one military guard, at the least. They brought soldiers from

Bahia, from Rio de Janeiro, from São Paulo, from Goiás, and also recruited Indians into troops. They also took the kin of tribes close to the Krenak to be soldiers.[13]

Why did Don João VI accept the settlers' demand and make war against a people he did not know? This question should make sense since a bankrupt European Crown that had finished settling in these tropics authorized a war of extermination on the native peoples. As the settlers had promised the king gold and precious stones, that gesture—the Royal Letter that authorized war on the Botocudos—established a corrupt relationship: the Crown is corrupted by the settlers. And, together in this corruption, they set in motion a war to annihilate the original people, creating a false narrative that they were building a nation. And people believed it.

"INDIAN PLANS"

In the years before the Constituent Assembly,[14] before the means to guarantee the rights of Indigenous peoples had been created, we felt the need to show the government and institutions that were still full of the rancidity of the dictatorship, that they were absolutely mistaken in relation to our presence—that we were not the rearguard, but rather the vanguard. "You are completely wrong, your sustainability program is a lie," we told them. If we had not done this, the Constituent Assembly would have declared that the Indians were dead, end of story. At that time, there was discrimination even worse than today's—at that time, they wanted to declare us dead; now, they wish to kill us! There existed, for example, a saying in bad taste that if you were to go out to have a picnic and it rained, that would be "Indian plans"; if you were traveling and your car broke down on the road, that was "Indian plans," etc. So, language can be a vehicle for stereotyping, that secretes venom, can't it?

Today, an imbecile with similar negative potency arrives in a place of power and what does he do? Making a mockery of anthropological and archeological research, he says that the "petrified poop of an Indian" gets in the way of the country's development.[15] How can we relate to a world like this, wherein completely insane topics occupy the state apparatus and begin using the system to destroy life?

But if we look at this through another poetics, we will come to understand that the Indians will win. Because, if this state apparatus, since colonialism, never managed to settle down and remains growling and biting all this time,

then it is becoming a ghost. This shows that the Brazilian state still has not managed to overcome this question and that we will win this moral assault. It simply has not yet surrendered—it fidgets, spits, kicks—but we will triumph in time. And there's no use wanting to negate this because when the head of the nation makes a quip in bad taste about the petrified feces of Indians, he shows that he has not yet grown up, that he remains in the anal phase. The guy is still eating shit.

WE ARE VILE

I was in Roraima, on the border with Venezuela, with my Yanomami kinsman and with the Macuxi, the people from Raposa Serra do Sol.[16] During my trip home, I took my seat at the window of the plane, and beside me sat a man with a small briefcase in his hand, full of documents.

Right away, his presence infused the air with lack: it was the emptiness, the despair, the pain of a Venezuelan refugee. I sensed his distress as he expressed a wish to make a request of the flight attendant—water, or something else—but did not know how. He, who had not bathed in days, turned to me and said in Spanish: "I am Venezuelan, my name is Jesús Herrero. I am hungry." I told him that in just a bit they would be serving a snack. He looked anxiously down the aisle.

Jesús is a topographer and technician specializing in hydrology, but he could not find work in Venezuela for the past eight years. He had studied in Moscow, through an international partnership between the National University in Venezuela and a technological institute in Russia. When the snack cart arrived, which required payment, Jesús became completely frustrated: "I don't have cash. For seven days, I was in Pacaraima." In this city on the Brazilian side of the border, refugees are registered and hope to gain entrance to Brazil. He spent seven days there, sleeping in a shelter packed with people, until authorization manifested and he could get on a plane for Santa Catarina. Someone sent the ticket, which he will repay by working.

Beside me, Jesús was sinking into a void. "I can't let this guy get crushed like this," I thought, and I began to talk with him. I struck up a conversation about refreshing topics, mostly so that he would feel accepted because I perceived that much of the suffering of refugees was that after they gained entry into Brazil, they were greatly mistreated. A national collection campaign had been set up, and when the donations arrived at Pacaraima, they were placed

in a shed. The people on this side of the border went there and burned the shed. We set fire to storehouses of donations for suffering people and, eventually, set fire to the people themselves.[17] We are not "cordial," as Sergio Buarque de Holanda's theory goes, we are vile!

TO GET CLOSER IN ORDER TO LEARN

I don't believe that cities can be sustainable. Cities were born from the inspiration of ancient fortresses that served to protect human communities from bad weather, attacks by wild animals, and war. They are built as structures of contention, they are not fluid. In times of peace, they become more permeable, but calling a place that confines millions of people "sustainable" uses a somewhat exaggerated poetic license. Some cities are true traps: if the energy supply there comes to an end, everyone dies—in hospitals, stuck in elevators, in the streets. Whites want to live sheltered in cities and do not perceive that the world around them is ending. They have been doing this for a long time and I don't know if they know how to live any other way. But it is possible to learn other forms of living.

My friend Nurit Bensusan sent me a beautiful letter about these other possibilities of living. She is a biologist and works on public policy in the area of biodiversity. She is Jewish, from one of the branches of the ancient Hebrews, and comes from a culture that already passed through Palestine, through Turkey, through many places. Following these migrations, she went to Western Europe and then arrived in Brazil to work in anthropology, with forests and Indigenous peoples. It was as though she had landed on another planet. Little by little, she came closer to this planet. Today she considers herself an ex-human. Nurit imagined a situation in which she moved the same distance that the other moved—this other who is from outside the city, who is from the forest. Like the Indians. She walks toward them just as they walk toward her until they each reach the limit of their approach. There they stop and observe each other. Her letter is about this, about this other possible place of interaction.

PEOPLE WHO SPROUT FROM THE FOREST

The Amazon rainforest is a monument. A monument built over thousands of years. The ecology of that place in motion creates shapes, volumes—disperses all that beauty. The Amazon rainforest, the Atlantic coastal forest, the Serra do Mar, the Takrukkrak are monuments that have, for us, the power to open a portal that accesses other visions of the world.[18] The forest provides

this. And yet, despite its materiality—its body that can be felled, uprooted as wood—the forest is not seen. In Brazil, there are cities that UNESCO has declared the cultural patrimony of humanity. Meanwhile, we destroy the Atlantic coastal forest, the Amazon rainforest. It's a game of illusion.

The fact that we live in the region of the world where it is still possible to sprout people from within the forest is magic. There are people who look at this as a type of delay in relation to the globalized world: "We should already have civilized everyone." But it is not a delay, it is a magic possibility! How wonderful that we can be taken by surprise when, at one of the borders with our neighbors—Bolivia, Peru, Venezuela, for example—a collective of human beings springs up that was never registered or inventoried, speaking a strange language and comporting themselves in a totally extravagant manner, shouting and jumping in the middle of the forest. The last time that a previously uncontacted group was encountered was six years ago.

ANCESTRAL MEMORY

My ancestors always lived in a deep ecological relationship with nature. In the spring, a season they loved, the Botocudos ascended along the Doce River to the steep slopes of the Espinhaço Mountains to do the rites of passage for the young men—boys from nine to twelve years old, the age at which they pierce their lips and ears to install labrets and earrings. The culmination of the period is September 22, when the sky is very high and the seasons pass from winter into spring. The mountains bloom, it's beautiful. The Botocudo families, having come from different hillsides, from the Serra da Piedade, traveled to the Espinhaço to experience this cycle deeply. There is a lot of inscription about this engraved on rocks throughout that entire region. Have you ever noticed, on the slopes of Conceição do Mato Dentro, how wonderful the Tabuleiro waterfall is? The slopes of the Tabuleiro are a tremendous library! Once I stopped there to watch the sunset until it grew dark. I stayed looking at the different stories on those slopes. It is the history of the passage of our ancestors through those sites some thousands of years ago, as archeological studies have already confirmed. Our ancestors were writing on the slopes and shelters at the same time as other civilizations were also leaving their records and deeds.

Our history is interlaced with the history of the world. But the country throws away this history. People who travel to these places drive pickaxes into the boulders, pull up signs, hang a fossil of a bird, a fish, or a rock

painting on the walls of their homes as though it were a souvenir bought on the beach. Each fragment, each piece that they pull up from those rocks is as if they ripped out a page or stole a book from the library. It is in blatant disregard for our ancestral memory. A disregard so large that the possibility of a reconciliation of our idea of peoplehood and nation with the land becomes rejected. It is as if there were a split, a divorce between the land and its people.

Denilson Baniwa, *Criação do Universo*, 2019. Courtesy of the artist.

A FOREST THAT FLOATS IN SPACE, *YVY MARÃ E'Ỹ*, AND THE WORMHOLE

According to Yanomami cosmology, we are living through a third version of the world. The first was extinguished because a taboo internal to their tradition was broken, and in that primordial world, the sky fell and split the earth. The sky, though it looks light, is very heavy; it can fall and split the earth. Since then, the shamans have dedicated themselves completely to maintaining the supports of the sky. They are like architects in this cosmic engineering of building supports for the sky.

Joseca Yanomami, prompted by Claudia Andujar, who gave him pencils and colored pens, drew these supports of the sky to show how this idea takes shape.[19] You look, start thinking of the greatest contemporary artists: How is it that this Yanomami, who has never picked up a pen, makes a drawing like this? When Claudia saw the drawings, she felt completely fulfilled because she discovered that now, among the Yanomami, there was a language that could dialogue with her photographs. She had been photographing the Yanomami and perceived that the language of photography did not make sense to them.

After that, she begins to dialogue with Yanomami thinking about the world, which is a complete transformation in the appearance of things. A tree or a piece of wood, for example: Joseca draws a suspended shape, resembling a spider web, with glowing things and antennas coming out of it, and tells you that this is, in fact, the forest. "But where are the roots, the ground?" There are none, the forest is in space. The Yanomami can perfectly imagine a forest floating in space. Because, for them, the forest is an organism, it does not come from earth, it is not the product of another event. The forest is an event itself. And if it comes to an end on the earth that we people know, it will still exist in another place. In a way, for the Yanomami, everything that exists in this world also exists in another place.

The Guarani also think like this. For them, this planet is a mirror, an imperfect world. Life is a journey heading toward a place called *Yvy marã e'ỹ*, which the Jesuits translated as "land without evils." The idea of "land without evils," of the promised land, is altered from the Christian idea because in the Guarani worldview there was never a world that had been promised to someone. *Yvy marã e'ỹ* is a place *after*, a place that comes after the other one. A place that is nevertheless the image of this one, is nevertheless the mirror of a place to follow. The Guarani *pajés* (shamans) say that we live in an imperfect world, and because of this, our humanity is also imperfect. Living is the rite of crossing this imperfect earth, moved by a poetics of a place that is the mirror image of this one. And if we were to imagine the *nhandere*—the path that, leaving from that which is imperfect, seeks to come close to that which is not imperfect—a series of events will occur that, as the journey goes on, will bring an end to this image here and create another.

If you were to ask a Guarani, "Does this place you are heading exist?" They would say, "No." "And this place in which you are?" They would respond, "It is imperfect." "Okay, but you are escaping from an imperfect place and

running to a place that does not yet exist?" They will say, "Yes, because it will only exist when this one here comes to an end." I find this wonderful! And mainly, I find the exercise of thinking this way to be wonderful.

In Yanomami cosmology, the *xapiri* are auxiliary spirits of the shaman. They can be a hummingbird, a tapir, a jaguar, a monkey, a flower, a plant, a liana vine—all of them are people, and they interact with the shaman. These beings make exchanges, alliances, they invent and cross worlds; and, while they are in movement, they move everything around them.

A shaman once told me this story:

Omama, the demiurge of the Yanomami, has a nephew who is the son-in-law of the sun. In that moment, I thought: "So the Yanomami have kin with the sun? Someone who is married to a person from the sun's family? I need to stay calm to understand if this sun he is talking about is the star up above, if it is the actual sun." Calmly, I went exploring this topic until he confirmed that it was the same sun.

I found this story wonderful because it shows that, for the Yanomami, there are beings that can negotiate with other entities, other existences, other cosmologies.

A shaman left this galaxy and went to another, completely unglued from ours. He tried to come back and could not: he fell into a kind of wormhole. He was sending messages, asking for help from the other shamans and from his *pajé* friends. He said that he had gotten lost and could not find the coordinates home.

It was a tremendous job for the shamans to bring him back. They succeeded, but he arrived defective. He spent the rest of his life sitting in the yard, sitting in the canoe. They had to place him in the sun, take him out of the sun. People would start talking, and he'd be there among them, silent, arranging little sticks on the ground.

It's quite dangerous to enter a swerve like this, isn't it?

1. Brazil's congress is made up of the Chamber of Deputies and the Senate.

2. A video of this action can be found in an excerpt from the film *Índio Cidadão?* and is available here: https://www.youtube.com/watch?v=kWMHiwdbM_Q.

3. Davi Kopenawa and Bruce Albert, *The Falling Sky: Words of a Yanomami Shaman* (Cambridge, MA: Harvard University Press, 2013).

4. Sérgio Buarque de Hollanda, *Raizes do Brasil*, trans. G. Harvey Summ (Chicago: University of Notre Dame Press, 2012).

5. Quoted in Eduardo Viveiros de Castro, *The Inconstancy of the Indian Soul: The Encounter of Catholics and Cannibals in 16th-Century Brazil* (Chicago: University of Chicago Press, 2011).

6. Quoted in Pedro Neves Marques, "Introduction: The Forest and the School," in *The Forest and the School: Where to Sit at the Dinner Table?* ed. Pedro Neves Marques (Berlin: Archive Books and Academy of Arts of the World, 2014–15), 27.

7. "It refers to the conception, common to many peoples of the continent, 'according to which the universe is inhabited by different sorts of persons, human and nonhuman, which apprehend reality from distinct points of view.'" Eduardo Viveiros de Castro, *The Relative Native* (Chicago: University of Chicago Press, 2015), 229–30. The quotation is also found in de Castro, "Perspectivism and Multinaturalism in Indigenous America," in *The Inconstancy of the Indian Soul*.

8. The reply of Ts'ial-la-kum, who became known as Chief Seattle, to a proposal made in 1854 by the president of the United States, Franklin Pierce, to acquire the lands of the Suquamish and Duwamish Indians, in the present state of Washington, in the far northwestern US. The first version of the famous document—a transcription of the declaration of Ts'ial-la-kum, made by his friend, Dr. Henry Smith—was published in the newspaper *Seattle Sunday Star*, in 1887.

9. See https://www.youtube.com/watch?v=bca8KmPXro8.

10. The Mariana and Brumadinho dams collapsed in 2015 and 2019, respectively. Both dams were made of iron ore rejects, a useless byproduct of mining, and owned by VALE, a Brazilian mining company, one of the biggest companies in the industry. Together, the two accidents killed more than three hundred people and left a trail of environmental destruction that will be around for generations. Here, Ailton refers to the gold prospectors and miners metaphorically, to say that exploiting the land for valuable minerals has always been in conflict with the Amerindian way of life and their rights over the land they have always inhabited, particularly the Krenak people's way of life in the Doce River basin. The collapse of the Mariana dam is particularly central to the culture of the Krenak people and their recent history because it deeply affected the whole Doce River Valley, the river that, historically, provided their means of living. The Krenak people call the Doce River their grandfather, and now, a dying grandfather.

11. "Botocudos" was a generic denomination the Portuguese colonizers gave to different Indigenous groups belonging to the Macro-Jê language stock (a non-Tupi group) of diverse linguistic affiliations and geographic regions, the majority of whom wore *botoques*; labial and ear piercings. Here, Ailton refers to the Indigenous peoples who lived in the region of the Doce River Valley, in the present-day states of Minas Gerais and Espírito Santo, considered ancestors of the Krenak people.

12. "You must consider begun an offensive war against these cannibalistic Indians that you will continue in the dry seasons every year and that will have no end, except when you have the joy of taking possession of their homes and persuading them with the superiority of my royal weapons in such a way that, moved by their rightful terror, they ask for peace, and submitting to the sweet yoke of the Laws and promising to live in society, may become useful vassals, as are the numerous varieties of Indians

that, in these, my vast states of Brazil, are villagers and enjoy the happiness that is a necessary consequence of the social state ... May all Botocudo Indians who present themselves with their weapons in any attack be considered prisoners of war; and may they be handed over to the service of the respective Commander for ten years, and as long as their ferocity lasts, and they can use them in their private service during that time and keep them with due security, even in iron chains, until they prove they have abandoned their cannibalism and atrocity ... and you will inform me, via the Secretary of State for War and Foreign Affairs, of everything that will have happened and that concerns this objective, so that the reduction of the civilization of the Botocudo Indians succeeds, if possible, and of the other races of Indians that I highly recommend to you." Excerpt from the Carta Régia (Royal Letter) of May 13, 1808, that "mandates making war against the Botocudo Indians." See https://www2.camara.leg.br/legin/fed/carreg_sn/anterioresa1824/cartaregia-40169-13-maio-1808-572129-publicacaooriginal-95256-pe.html.

13 More than a century and a half later, the Brazilian state again takes advantage of native peoples to compose its military-repressive apparatus. The Indigenous Rural Guard (GRIN) was created by governmental regulation 231/69, on September 25, 1969, during the Brazilian military-civil dictatorship. It is made up of youth of various Indigenous ethnicities, recruited directly in their villages, "with the mission of executing the ostensive policing of Indian reservations."

14 The National Constituent Assembly of 1988. Formed by deputies and senators of the Republic, and installed in the National Congress in February of the previous year, it was charged with elaborating a new democratic constitution for Brazil, after the end of the military-civil dictatorship of 1964–85.

15 Jair Bolsonaro, president of Brazil, referring to the environmental reports of FUNAI—the National Indian Foundation, a government body—which are necessary to the licensing of certain construction projects. This declaration was made on August 12, 2019, during the inauguration of a second lane of highway BR-116, in Pelotas, Rio Grande do Sul.

16 Indigenous land located in the northeast of the state of Roraima, in the region of the borders with Venezuela and Guyana, destined for permanent possession by the Indigenous groups Ingaricó, Macuxi, Patamona, Taurepangue, and Uapixana.

17 In the early hours of April 20, 1997, five youths from the upper-class of Brasilia set fire to the Indigenous leader Galdino Jesus dos Santos, of the Pataxó-hã-hã-hãe ethnicity. Galdino had come to Brasilia the previous day to discuss questions related to the demarcation of Indigenous lands in the south of the state of Bahia, where the Pataxó live. Prevented from entering the boarding house in which he was staying, because of the time, Galdino slept in a bus shelter on South W3 Avenue.

18 Takrukkrak, meaning "tall rock" in the Borún language, is a mountain on the right bank of the Doce River, in the present-day town of Conselheiro Pena, in Minas Gerais, a region occupied ancestrally by the Krenak.

19 Joseca Yanomami is a contemporary artist, and Claudia Andujar is a photographer.

Ignored, Simulated, Exploited

*Translated from the Spanish
by Sue Brownbridge*

Proyecto Cuenco de Cera

AMAZONIA

The rainforest is.

32

III
Ignored

Walking on the crunching and fermented sound of dead leaves. Catching the smell that reveals the approach of a herd of white-lipped peccaries, *Tayassu pecari*.

Feeling the delicate burning from brushing against a prickly leaf.

Inhaling the constant movement of all living things.

Recognizing the color patterns of an epiphyte as it coils around a tree.
Ignoring the information brought by the song of a bird at dawn.
Not knowing that thunder is central to regulating the climate.

AMAZONIA

The rainforest is a body.

II
Simulated

// Petrol is an iridescent yellow,
 petroleum black.

// Cocaine is white,
 coca green.

// The nanoprocessor in a housing
 is still mineral.

// The pink pail is plastic, like the microfibers in trousers.

// Coal is dark gray and natural gas translucent,
 rocks are the salts and petroleum the veins.

// The bed can be assembled,
 the tree is rough.

AMAZONIA

The rainforest is a decomposing body.

36

I
Exploited

by *Hee-gu* Reynel Ortega, Yeba Barasana people

Tobahiri adihaü~de ~kubasiyuba ~ida, Adyawaroa.

> This was how the Ayawas put the non-Indigenous people here.
>> Fue así como los Ayawas pusieron a los no-Indígenas en ese lugar.

Adyawaroa ~ida ~kuriahaüde ~yaboaba ~ida, adi godo, adihüakare.

> They should have stayed where the Ayawas left them.
>> Ellos deben permanecer donde los Ayawas los dejaron.

Tihaü~de ~idaba Gawa~ba "Rio-mar" yiboa~kaba ~ida, "Rio-mar" riaga hairisa~de ~yari.

> This place is beyond what they call the 'Amazon' or the 'Sea-River.'
>> Ese lugar queda más allá de lo que ellos nombran como el Amazonas o el río-océano.

~Idaba, adi sita ~ida taariahü ~yaha.

> The Ayawas warned them not to leave that land.
>> Los Ayawas les advirtieron que no salieran de esa tierra.

*Adi~de ~basaye ~ride ~yarüotoha ti ~übüari ~kedoyiri~basa,
hoari tuayi
~übüari rodo ~yeri ~basaye ~ride ~yarüotoha ti.*

> This place here is solely for true people, for the people of the forest, those who maintain the regulation of the climate and the times for caring for the world.
>> Esta parte, acá, es exclusiva para la gente verdadera, para la gente de la selva, quienes mantienen la regulación del clima y las épocas para cuidar el mundo.

Adi ~ida ~kubua yaiya ~basira ~yakoaboa~ba. Adi haühü ~yaboa~ba ~ida Hee Watia ya~gubu ~rine.

> This place here will be for shamans, whereas the territory over there (he points to the outer edge of the forest) will be solely for non-Indigenous people, the Outsiders, the white people, those who are the negative side or reflection of Yuruparí.
>
>> Este lugar será para los shamanes, mientras que el territorio de allá (señala con sus manos el límite externo de la selva) será exclusivamente para los no-Indígenas, los Gawa, la gente blanca, quienes son el lado negativo o reflejo de Yuruparí.

Tobahiri tihaü, adihü~de riagare taakoa~ba ~ire Ayawaroa ya.

> The Ayawas cut them off from here, on the other side of the river.
>> Los Ayawas los cortaron de aquí, al otro lado del río.

Riagari tüa~gadiku, todyi enyarokahü sitare küda~yeaku, übüagasero ~gütabotari tuu~yeaku

> First, they put this big river around the world, then they put the earth in place and erected the stone house posts, the mountains that support the sky.
>> Primero, pusieron este gran río alrededor del mundo, luego colocaron la tierra y levantaron los estantillos de la casa de piedra, las montañas que soportan el cielo.

Adi ~wado ~ya ~übüari ~kedo ~yaroti ~yaha yukü~kede kea~badi ~wabe kütire~boatu ~badi ~ida yiro.

> Here, in the middle of the world, is a place to be looked after, a place where the trees should not be cut down and where the sacred sites should not be exploited.
>> Acá, en la mitad del mundo, es un lugar para ser cuidado, el lugar en donde los árboles no pueden ser talados ni explotados los lugares sagrados.

FOREST

Proyecto Cuenco de Cera

A collective of Indigenous and non-Indigenous friends. quiasma.co (art, science, and technology based on ancient knowledge in the Amazon).

Images and text from the ongoing artwork:
Houses in the Forest; the forest in a house.

Proyecto Cuenco de Cera
By Reynel Ortega, Stephen Hugh-Jones, and Bárbara Santos.

Source: RAISG map
https://www.amazoniasocioambiental.org/

Colombian Amazon
2017–2021

Cosmo-politics of the Living

María Belén Sáez de Ibarra

We no longer know the world because we have conquered it.
Who respects victims?
—Michel Serres, *The Natural Contract*

LIFE OF THE PLANET

This quest to conquer the world is a war against the planet and all the life it contains. As the voices of change and the rage over the state of our climate erupt into history, we face the risks and damages inflicted by human reason and monopolized by science and technologies ultimately associated with property rights. Modernity naturalized concepts of finance, progress, and growth imposed on the ways community, survival, and, of course, life have long been understood. Accelerated by the industrial and then the postindustrial revolutions, a huge planetary wave of violence has taken place to feed the colonial enterprise (as healthy as ever), which appropriates and masters life. This hunger for large-scale biotic exploitation as a source of wealth and power for the few is a monstrous example of corporate imperialism that we have come to know too well and that is causing an unprecedented humanitarian and environmental crisis.[1]

All this is happening in the context of profoundly uneven development that is hobbled from within by the distance of exploited regions from the general populace. With this lack of observers, the ruinous activities of governments and corporations thrive in the subaltern world—the subtropical zone of the planet, where most biodiversity is situated today. These corporate entities "accumulate by dispossession," as David Harvey has explained, leaving behind pollution, soil depleted, forests cut, waters dried out or poisoned, animals and peoples displaced. Whole populations are forced by violence and poverty to abandon their lands, which are then immediately absorbed by these alien economic operations backed by immense wealth to lobby and corrupt, their immoral gains financing mercenaries and mafias.

Some numbers: A report by the Centro Nacional de Memoria Histórica, in Bogotá, from January 2017 notes a total of 7,134,646 displaced persons, 983,033 homicides, 165,927 forced disappearances, 10,237 tortures, and 34,814 kidnappings, among other acts of violence, over the last thirty years in Colombia. Another report, *The Dark Side of Coal*, a 2014 publication from PAX, a nonprofit in Utrecht, more specifically follows the paramilitary violence in the Cesar region in northern Colombia. Collusion between the coal-mining company Drummond Ltd. and the paramilitary group AUC wrought 2,600 selective killings between 1996 and 2006, while 59,000

people were displaced in the region by broader paramilitary violence. But then, these heinous acts against Indigenous peoples and their homelands have a long and terrible history. For example, in the very year of the Brussels Conference Act of 1890, which concerned itself with ending the African slave trade and declared the intention to "improve the moral and material conditions of existence of the native races," forty thousand Bora and Huitoto peoples of the Amazon were killed by members of the Anglo-Peruvian Amazon Rubber Company. This happened at the time of our grandparents and is still happening today in the forests and territories of the subaltern world.

The Amazon is the earth's largest tropical rainforest. Rich in cultures and languages, it houses 370 Indigenous nations and more than 33 million people. Ten percent of the planet's biodiversity finds its home in the Amazon, and it is a remarkable machine—a climate regulator, air purifier, recycler of carbon dioxide, manufacturer of rain, producer of abundant water. But for all of its diversity, of its prodigious biomass of leaves, branches, trunks, and roots, of a hydrological system that produces approximately 20 percent of the fresh water that reaches the ocean each year, it is now tipping into violent extremes. In the last decade, the Amazon has suffered the "drought of the century" twice (in 2005 and 2010) as well as two floods of equal scale (in 2009 and 2012). Rainforests are becoming savannas. Deforestation, mining, fires, flooding, hundreds of dams underway, thousands of licenses to exploit gold, coltan, the sowing of coca for drug production and trafficking ... The direct relation of war and murder to the exploitation of resources is clear. In the field of geophysical-geopolitical forces, local struggles for territorial rights and the preservation of nature have global climatic impact, becoming global struggles for universal rights, with nothing less at stake than the dynamics of the terrestrial system.

Now, when time is running out, we need to rush in and bring new terms for a new social contract—a peace treaty with life that permits a deep shift in our consciousness and a metamorphosis in which humanity mirrors the sacred: a time conceived by a semiotic wisdom of life. As Michel Serres says in his simple and profound way in *The Natural Contract*:

> Those who used to live out in the weather's rain and wind, whose habitual acts brought long-lasting cultures out of local experiences—peasants and sailors—have had no say for a long time now, if they ever had it. It is we who still have a say: administrators, journalists, and scientists, all men of the short term and of highly focused specialization. We are partly

responsible for the global change in the weather, because we invented or distributed the means and the tools of powerful, effective, beneficent, and harmful intervention; we are inept at finding reasonable solutions because we are immersed in the brief time of our powers and imprisoned in our narrow domains.

If there is a material, technological, and industrial pollution, which exposes weather to conceivable risks, then there is also a second pollution, invisible, which puts time in danger, a cultural pollution that we have inflicted on long-term thoughts, those guardians of the earth, of humanity, and of things themselves. If we don't struggle against the second, we will lose the fight against the first.[2]

Cultural disconnection with life is everywhere evident today. But it wasn't always this way. Precisely as Serres says, "those who used to live out in the weather's rain and wind"—original inhabitants, Indigenous peoples, peasants across the planet—lived in a world where earth, climate, the waters, plants, animals, and stars all had voices, thoughts, knowledge, and will. Listening to all living things was a specific and well-set practice among communities. A complex communication was developed in a mutual dialogue in which magical languages emulated the voices of life to respond, acknowledge, and name them across an imaginary travel through the territories: an endless oratory to appease even disastrous forces and curses or to call out for the might of healing.

We tend to think that those ways are stunted or gone now, but ancient voices still resonate in territories all over the world. And it is not only a human knowledge, but rather, and more strongly, a knowledge manifested in all living things that absolutely speaks out to remind us, to teach and share the long-term thoughts of this wisdom, with its joy and pain. This is the sense of time that Serres speaks of. As well, these languages of respect and recuperation are embedded everywhere in the living world, if one were only to listen. They sing with a complex codex of awareness and cognizance. A thinking, then, exists not as a dichotomy that separates humans from the living things around them, but as a reciprocity, an ecosystem in which we think and know *through* and *with* all the other living entities in an infinite cosmos, a complexity of plains and strata, a multiple chain of diverse forms, things, and substances, multiple dimensions and parallel times, evil and good, accomplished within a notion of life in transit, restlessly transforming and mutating itself. This continuum of an *other* intelligence is an agent that

modifies and intervenes in our existing materiality, as well as in the unshaped essence of life.

But, of course, what we face today is the constitution of a very different other by malevolent forces. This other is a phantasmagoric projection, the cultivation of a collective identity powered by ruthless contempt, imposed ideologically to maintain control and justify violence and exploitation. As the German journalist and philosopher Carolin Emcke writes in her 2016 book *Against Hate*: "It is always the categorically 'other' who is oppressing or threatening the hater's 'self'; the 'other' is fantasized as a supposedly dangerous force or a supposedly inferior pest—and the subsequent mistreatment or annihilation of the 'other' is revalued accordingly, not just as an excusable act, but as a necessary one. The 'other' is the person who can be disregarded or denounced, injured or killed, without fear of punishment."[3] And so it is in the Amazon and in other lands where Indigenous populations are marginalized and destroyed for profit. If you can identify the uniqueness of a person, you make them beings of care. If you collectivize identity, you can distort it. Invisibility follows, monstrousness follows, and no one will ask for justice. The same is true for the land itself, in which the identity of living things is seen solely and ruinously in terms of capitalist exchange.

We need to observe and dissect the details of violence done to both peoples and lands without reverting to vengeance or the infinite chain of hate, but instead to invoke a better imagining—to "brush history against the grain," in Walter Benjamin's phrase, to awake from the continuum of violent history and allow a constructive imaginary of hope to leap into existence.

FOREST LAW

The poetics and politics inscribed in this thinking, this cosmopolitics, are addressed by artistic practices and by those of us engaged in curating. Let me speak of an extraordinary example: the collaboration by the artist Ursula Biemann and the architect Paulo Tavares with Indigenous peoples from the Amazon. These peoples have been resisting for ages, defending their homelands from the reckless, massive exploitation of petroleum and other natural resources by international corporations such as Chevron and its subsidiary Texaco. This ruthless enterprise has brought catastrophic damage to the jungle ecosystem and its waters, and with it a corresponding crisis in the communities of the Sarayaku and others. Biemann and Tavares created a seminal work of art, *Forest Law* (2014), whose editorial content and video installation include not only the voices, wisdom, and specific histories of

the forest's peoples, but also the knowledge, presence, and forces of all life-forms there. The work tells the stories and process of the long fight these Indigenous populations have waged, numbering among them lawyers and experts in the laws of industrial societies and joined by activists in human rights and environmentalists from various NGOs. Together they've achieved something remarkably powerful that will benefit the planet. Their work underlines the necessity to update our socio-geologic-environmental order. The living forest was considered without rights in the history of "civilized" law, as opposed to the animistic-law tradition that deems the forest and all of nature as rights bearing. Now we must all support this conversation, this honoring of rights that includes the forest and its inhabitants: humans, plants, animals—the breadth and breath of the biosphere.

The following text appears as a voice-over in the video component of *Forest Law*. It's inspired by the writings of anthropologist Eduardo Kohn, who explores the semiotic dynamics of the Runa world in the Amazonian cloud forest. In his 2013 book, *How Forests Think: Toward an Anthropology beyond the Human*, he bases his thinking on studies of a Kichwa village located in close proximity to the site of Biemann and Tavares's field research in the lowlands.

> The forest lives and thinks. We humans are not the only ones who interpret the world; all living beings do. They continuously interpret and represent the world around them. Life is semiotic. Living selves are the outcome of the evolutionary process of fitting their environments and give form to the tropical ecosystem.
>
> All living beings think. Their forms are the products of a cumulative past and predictions of what will likely come to be. They are an embodied guess of what the future holds. All semiotics, as it grows and lives, creates futures. Living selves don't exist firmly in the past that comes to affect the present; the future, too, bears on the present. The forest is a vast, future-proliferating ecology of thinking selves.

Works like *Forest Law* offer both insight into and commitment to a vision of ethical management crucial to this most transcendent of issues: the capacity and will of Indigenous peoples and local peasants to rule their native lands, and the broader need to respect and preserve vast strategic zones of the planetary ecosystem that we cannot risk squandering more than we already have. Injuries to the earth have now transformed the world to the point of catastrophic metamorphosis. To face this "metamorphosis of the world," as

named and systematically analyzed by the prominent German sociologist Ulrich Beck, an enormous exercise of imagination is required. Beck famously coined the term "risk society," and what we must attend to now is precisely risk assessment and control, banning the exploitation of various natural resources, the unwinding of harmful mechanisms, while addressing the issues of common waters, common air, common lands. The goal is nothing less than the guarantee of equilibrium and compensation for damages suffered at the hands of global capitalist adventurism.

Biemann and Tavares are exacting in their focus on the empowerment of Indigenous leaders who interact autonomously with local and international agencies and corporations. The artists' recognition of Native knowledge is rare in the international establishment, indeed generally ignored by it, and their working methods as researchers, artists, and activists offer a standard for each of us in this struggle. For what their work says is this: after centuries of oppression and subordination of peoples and rich lands, new forms of governance and self-control must be addressed through legal processes. But they must also be addressed through the agency of culture, through art and its symbolic practices that, as *Forest Law* shows us, deploy the evocative powers of empathy driven dually by fact and imagination.

Institutional support is crucial if this mandate is to come to fruition. Art museums and cultural institutions need to establish transdisciplinary projects and interdisciplinary teams for collaborative work to compellingly present documentation of what has been done to the lands and Indigenous peoples and ways in which creative practices can reimagine the world—can produce a reversed metamorphosis, if you will. Nor should curatorial project leaders expect artists to do the work alone. Our institutions must focus long-term funding strategies for this crucial work—to carry on the research and field studies required, to document and establish archives, to underwrite artist commissions, to mount these projects of memories, nightmares, and dreams. And none of this will have long-lasting impact without long-term alliances for the ongoing exchange of information, advice, and learning with other institutions and actors involved in eco-politics, the natural sciences, environmental studies, human rights, cultural studies, economics, law ... In other words, an ecology of knowledges that informs an advocacy of cosmopolitics in its reach into the rootedness and wisdom of the world's endangered communities of living things.

As curators working with artists, greater attention must be paid to turning the exploitation by governments and corporations upside down by expressing

an ethics of care through the intuitive, even oneiric, language of artistic practices, which of course also speaks to the rational needs of a planet in jeopardy. As art historian T. J. Demos says in *Decolonizing Nature: Contemporary Art and the Politics of Ecology*: "I'm convinced that art, given its long histories of experimentation, imaginative invention, and radical thinking, can play a central transformative role here. In its most ambitious and far-ranging sense, art holds the promise of initiating exactly these kinds of creative perceptional and philosophical shifts, offering new ways of comprehending ourselves and our relation to the world differently than the destructive traditions of colonizing nature."[4]

Of course, the outcomes of this artistic and curatorial work need to be as diverse as the team itself—not only exhibitions, but a broad and flexible program that encompasses commissions, publications, web-based projects, even apps that use game play as a means to the ends of cosmopolitical reflection and action in which biotic systems are explored and shareable experiences lead to a reimagined planetary vision, to a radically altered other globality. Just such a diversity of expressions will also mean a diversity of viewers coming to these issues from different perspectives and at different ages (perhaps people who rarely or ever visit museums and cultural institutions), toward the objective of understanding and the higher goal of activist participation. Art itself is not activism, or at least not activism alone. But it can come close, can drive us forward—and this, from the curatorial perspective I inhabit, is an act of agency in pursuit of life itself and its preservation.

COSMOPOLITICS OF THE FOREST AND "PROREGRESS"

Now let me speak of another example, one in which I've been directly involved. In Bogotá, at the Museum of Art at the National University of Colombia, where I serve as director, we have spent more than seven years learning how to develop a long-term research program while in the midst of conducting one. We've given the project the name "Cosmopolitics of the Forest," accumulating valuable experiences as we go in order to gradually improve the program—or to build a better project in the future. But we are far from done. The work is constant, and the focus has to be unswerving for both the symbolic and the political agendas to be achieved. The road opens while you work. It's clear that no one within the team will simply perform the role they originally assumed. Artists may help conceive and direct the concept. They may end up designing or curating an exhibition or a project or an entire program, while curators may collaborate with an artist in their creative process, and so forth. For the moment, we have managed to offer

support for the production of a series of ambitious projects that focus on the Amazon basin and other strategic forests, understood geopolitically, as I've said earlier in this essay, as subaltern regions under duress.

Young audiences at the university have crowded the shows, feeling connected to and moved by the exhibition projects. We began with a commission by Miguel Ángel Rojas, *El camino corto* (The Shortcut, 2012). Several tons of coca leaves were used in an installation that focused on cocaine production and consumption, and the subsequent mass destruction of cultures and life in the Amazon—so distant from the ancient belief in coca as a sacred gift. Rojas pulverized the coca to a fine powder that looked like the green powder of the South American mambe plant, and used it to create the appearance of moss covering rocklike forms scattered across a sandy "garden"—a contemporary wasteland. The surrounding walls were festooned with the names of celebrity cocaine users and drug lords, each letter formed from circular cutouts of US dollar bills. For a long time, the US government has been sending money to Colombia to fund the army's war against the cocaine farms and drug trade, which nonetheless have the US as their primary market (land of opportunity and money laundering)—the shortcut to wealth.

El camino corto was a good start and brought us deeper clarity for the program's larger plan. We understood the necessity of including long-term collaborative research projects with artists, Indigenous partners, and other agents. Actually, it was after Rojas's installation that Ursula Biemann reached out to me about *Forest Law*, which brought us to the conception of the whole of "Cosmopolitics of the Forest" and to the other project I'll quickly mention here, *El origen de las noche* (The Origin of the Night, 2016–17). Once again interdisciplinary, research-based, and collaborative, the work arose from an investigation of different sound archives whose sources are recordings from various Indigenous nations of Colombia: the Andoque, Murui (Witoto), Tatuyo, Barasana, Wayuu, Kogi, and Tibú. We had new pieces recorded too, and the result was an immersive sound installation in the main hall of my museum, with nineteen sound channels.

The project's title alludes to a great myth common to all the peoples of northeastern Amazon: At the beginning of time, there was only light. The ancestors of humans asked the owners of the night to bring darkness, sleep, dreams, time, and death. The owners gave them a box containing the night, along with strict instructions about opening it only when they were at the maloca, a huge thatched house. But the people didn't listen. They opened the

box impulsively, and out from it came chaos, sickness, misfortune. And thus, ritual chants were born to allay disaster, and shamanism originated—the idea of humans talking to the invisible world in order to transform the visible. The rituals of being constitute the cosmological vision of each Indigenous nation and its structure of life and governance.

Through these projects, the contradictions of history and contemporary life are heaped on one another, and our commissions and curatorial work have intended to make the tragedies and outrages that continue fully palpable to the bodies and minds of our visitors. While I am writing this, the assassinations go on in Colombia every day: community leaders, heads of peasant associations, regional environmental leaders, or anyone who dares to claim even a small role in sustaining the health of their territory.

Recently I was part of the curatorial team for the 12th Shanghai Biennale under the direction of the Mexican curator Cuauhtémoc Medina. The general theme was "Proregress," borrowed from E. E. Cummings's notion of what he called "proregression"—an ambivalence summarized in a phrase from his 1944 poem titled "pity this busy monster, manunkind": "Progress is a comfortable disease." And it is interesting to ask, why is it that we still have not in any fundamental sense proposed another model apart from capitalism that can hold, another program, another grand project for "manunkind," in Cummings's curious distortion, that is a true distortion of progress? We are still stuck in modernity—surely the subaltern world is, and it suffers from "proregress," which is nothing more than the violence of regression. The grossly unequal development of society and the debased assumption of human rights testify to this. The perversity of this, the dependence of capitalism and neoliberalism to continue its imperium through proregression, makes me think of lines from another poem, as the deaths and displacements mount in Colombia and elsewhere. The lines are from "Waiting for the Barbarians," written in 1898 by the great Greek poet C. P. Cavafy:

> Why are the streets and squares emptying so rapidly, everyone going home lost in thought?
>
> Because night has fallen and the barbarians haven't come. And some of our men just in from the border say
> there are no barbarians any longer.
>
> Now what's going to happen to us without barbarians? Those people were a kind of solution.

Are we ready to awake and stop enjoying the false spectacle of others' modernity? For how long are we going to be foreigners in our own landscapes? Will the sacred cosmopolitics of the living act as a redeemer of the victims? What can we each do? How can we transcend history?

1 T. J. Demos offers a precise insight into this corporate imperialism: "For David Harvey, these forces represent the 'accumulation by dispossession' that constitutes a new imperialism, the grossly uneven development of the present day. For Jason Moore, such is the result of centuries of interpenetration between capitalism and nature, including 'capitalism's internalization of planetary life and processes, through which new life activity is continually brought into the orbit of capital and capitalist power' and 'the biosphere's internalization of capitalism, through which human-initiated projects and processes influence and shape the web of life.' The resulting inequality is staggering. According to a recent Oxfam report, the world's richest eighty people own as much as the bottom half of the earth's population combined (about 3.5 billion people), just as around ninety corporations are responsible for running the fossil fuel economy, and a much smaller number of governments is accountable for the geopolitical and humanitarian wars that camouflage control of the world's natural resources and energy supplies." T. J. Demos, *Decolonizing Nature: Contemporary Art and the Politics of Ecology* (Berlin: Sternberg Press, 2016), 16.

2 Michel Serres, *The Natural Contract*, trans. Elizabeth MacArthur and William Paulson (Ann Arbor: University of Michigan Press, 1995), 31.

3 Carolin Emcke, *Against Hate*, trans. Tony Crawford (Cambridge: Polity Press, 2019), xii.

4 Demos, *Decolonizing Nature*, 18–19.

Ursula Biemann, Paulo Tavares, *Forest Law*, 2014. Video stills from the two-channel video essay. Courtesy of the artists.

A Restless Painter

The Work of Shoyan Shëca (Roldán Pinedo)

Translated from the Spanish by Sue Brownbridge

Gredna Landolt

The painter Shoyan Shëca was born into the San Francisco Native Community of the Shipibo people in Ucayali, in the Peruvian Amazon, in 1968. His Shipibo name means "restless mouse" and was also the name of his grandfather, a shaman. In the Peruvian civil registry, however, Shoyan Shëca had to be registered as Roldán Pinedo, and he continues to use both names today.

In keeping with his given name, Shoyan Shëca is a restless artist always looking to renew himself and the formal and conceptual vocabularies of his practice. His art is striking, full of vigor and energy in his use of line. He handles his themes and subjects—shamans, mermaids, caimans, boas, forests, constellations, and everything that the Amazonian space encloses—with assurance, employing a flat compositional technique in which his subjects occupy their place in a resolute manner. His aesthetic approach encompasses the knowledge of an ancient Indigenous culture and system of thought that he shares with his audience both Indigenous and non-Indigenous alike. "It is very important to me to present myself," he notes, "to identify myself as Shipibo. It's my identity; it's where I'm from. We have a different way of seeing things."

The relevance, reception, and circulation of Shoyan Shëca's practice is always doubled: he is a celebrated traditional Shipibo artist whose paintings are also shown in contemporary art institutions and spaces across the world. His themes, forms, materials, affects, aesthetics—along with his unique relationship to his practice—allow him to transform the way his non-Indigenous viewers look at traditional Shipibo art by inviting such spectators to reconsider their preconceived ideas of how it might be constituted as well as how it might be expressed.

For the Shipibo, as for almost all the Indigenous peoples of the Amazon, the world is a universe of multiple spaces coinhabited by visible and invisible beings, who take on different appearances and with whom it is essential to stay on good terms. This is a non-anthropocentric way of viewing the world and one that features strongly in Shoyan Shëca's work. "We Shipibo see deeper thanks to the knowledge given to us by our ancestors. It is something we never forget; it remains with us for the whole of our lives. If you go up into the deep forest you don't get lost," he says. "You know how to find your way; you don't get lost." The Shipibo culture stands out for its magnificent *kené*, or design, which decorates every imaginable thing. As the Peruvian anthropologist Luisa Elvira Belaunde has written: "The Shipibo

Shoyan Shëca, *Visión en espiral*, 2011. Acrylic on canvas, 160 × 97 cm. Private collection.

want to cover their world with designs, to embellish life and, in so doing, to heal people's bodies and spirits." In Shoyan Shëca's paintings, this *kené* extends to cover the skins of animals and anacondas as well. Indeed, his own signature is written in a *kené* that he modifies from time to time.

Shoyan Shëca's mother was a traditional potter, while his father was a bilingual schoolteacher. After his grandfather died when he was still a boy, Shoyan Shëca and his family moved to Yarinacocha, and then Pucallpa, where—at the age of eighteen—he met his future wife, the painter Bahuan Jisbë (Elena Valera). She was expecting their child when Shoyan Shëca was drafted by the Peruvian army and sent to the border with Brazil. He returned two years later, at last meeting his son, Inin Metsa (also called Harry), who today works as a painter as well. Initially taught painting by his parents, Inin Metsa is now making a name for himself in the contemporary art world of Lima.

The journey for Shoyan Shëca's family to become professional contemporary artists had a circuitous beginning. In 1997, with a family to support, Shoyan Shëca decided to travel to Lima to sell medicinal leaves and seed necklaces. Unfortunately, he was attacked and all his goods were stolen. Amid this plight, he was told that a researcher, Pablo Macera, was looking for a Shipibo female painter for a pioneering project. Macera would end up employing not only Bahuan Jisbë—a gifted artist—but also Shoyan Shëca, who had never painted before. Macera asked them both to paint the animals of their region, experimenting with natural pigments and colored clay that they themselves went off to find. Their canvases were cotton fabrics dyed in the traditional Shipibo manner, using mahogany bark, a special mud, and turmeric, known as *guisador* in Peru.

In the beginning, Shoyan Shëca would watch Bahuan Jisbë paint as he was initially her assistant. Eventually, he became more confident, discovering painting as a medium that gave him a deeper intrapersonal connection and allowed him to express his unique personal and cultural identity in a city that remained strange to him. The first animal Shoyan Shëca depicted was a *huangana*, a pig-like mammal. In 1999, the couple had their first two-person exhibition at El Museo de Arte del Centro Cultural San Marcos, which drew widespread attention. Thereafter, Shoyan Shëca began to develop his own painting practice, though he continued a certain co-authorship with Bahuan Jisbë, as they worked on each other's "finishes" until

the year that they separated. While Bahuan Jisbë was the first Indigenous woman to exhibit her paintings in contemporary art spaces in Peru, in recent years she has concentrated more on traditional medicine and her work as a shaman.

In 2005, I proposed to Shoyan Shëca a second two-person show. Featuring his works alongside the paintings of Bahuan Jisbë, the exhibition was titled "It's Our Custom." Shoyan Shëca expanded his works confidently across larger formats, painting scenes of fishing, hunting, collecting river turtle eggs, and healing with ayahuasca. His grandfather had taught him not only to hunt and fish but also to cure with this plant. Its essence is ingested to heal and open one's vision in a ceremony led by a shaman or *meraya*. Ayahuasca is held to be sacred and of vital importance by the Shipibo; for Shoyan Shëca, it remains one of the recurrent themes of his work. With regard to his painting on this subject, he has remarked:

> Our grandparents healed and fed themselves plants to give themselves power and strength, and they taught us. The plants themselves teach you, like ayahuasca, one of the most powerful. In accordance with the plants that make us see, I have drawn this vision of a *meraya* healing a woman with her son ... In the water is *Piti Ronin*, lord of fish, who brings shoals in the summer; *Acurón* is the one who increases the water and makes whirlpools. The spirit of the Amazon river dolphin is wearing a hat as that's how they've seen him. On land is the lord of animals, *Chullachaqui*; you can hear him yourself when you go into the deep forest. We mustn't anger him by killing his animals for pleasure. When the moon shines, she helps the healer. It is a beautiful visionary effect of the ayahuasca.

Over the years, Shoyan Shëca has explored shamanic themes using very different aesthetic and technical approaches. At a later point, he began to use acrylic and a palette of bright colors in works in which the figures stand out against a white background. From time to time, he still returns to natural pigments. We can see this change in his work *Visión en espiral* (Spiraling Vision, 2011). The circular motion of the coiling ayahuasca liana and the anacondas around the shaman give the piece a dizzying rhythm.

While Shoyan Shëca has now shown his work around the world, I have had the opportunity to contribute as a curator to some of these shows and also to follow his impressive career. In our most recent collaboration, Shoyan Shëca's

FOREST

"Just Trees" exhibition in Lima at the Centro Cultural Inca Garcilaso del Ministerio de Relaciones Exteriores—for which he painted more than forty species—the artist experimented with three-meter formats and backdrops painted in color, creating compelling works with a new sense of scale. The result was a mighty forest that managed to silence the noise of the city for just a moment, inviting us into its magnificent dense greenery and sense of symbiotic power.

Shoyan Shëca, *Huangana*, 1998. Natural dyes and colored clay on cotton cloth dyed with mahogany, 62 × 82 cm. Private collection.

AMAZONIA

Shoyan Shëca, *Copaiba*, 2020. Acrylic on canvas, 290 × 161 cm. A. Andrade collection.

Shoyan Shëca, *Caimán*, 2015. Acrylic on canvas, 99 × 100 cm. A. Andrade collection.

AMAZONIA

Shoyan Shëca, *Curación con ayahuasca*, 2004. Natural dyes and colored clay on cotton cloth dyed with mahogany, 150 × 140 cm. Private collection.

Shoyan Shëca, *Caoba*, 2020. Acrylic on canvas, 300 × 160 cm. A. Andrade collection.

AMAZONIA

Shoyan Shëca, *El yanapuma y los madereros*, 2004. Natural dyes and colored clay on cotton cloth dyed with mahogany, 82 × 94 cm.

The Crystal Forest

Notes on the Ontology of Amazonian Spirits

Eduardo Viveiros de Castro

Ces citoyens infinitésimaux de cités mistérieuses ...
—Gabriel Tarde

INTRODUCTION

The ideas sketched out in this paper date back to my work with the Yawalapíti and Arawetè in the 1970s and 1980s, where, like any ethnographer, I had to confront different Indigenous notions about nonhuman agency and personhood. However, the event catalyzing them in the here and now was my much more recent reading of a remarkable narrative issuing from another Amazonian culture. This was the exposition given by Davi Kopenawa, Yanomami thinker and political leader, to the anthropologist Bruce Albert[1] apropos the *xapiripë*, the "animal ancestors" or "shamanic spirits" who interact with the shamans of his people.[2] These texts are part of an ongoing dialogue between Kopenawa and Albert, in which the former presents Whites, in the person of his interlocutor-translator, with a detailed account of the world's structure and history; a narrative which also doubles as an indignant and proud claim for the Yanomami people's right to exist. Here I shall transcribe the shorter version of the narrative, published in Portuguese in 2004.

XAPIRIPË

The *xapiripë* spirits have danced for shamans since primordial times and so they continue to dance today. They look like human beings but they are as tiny as specks of sparkling dust. To be able to see them you must inhale the powder of the *yãkõanahi* tree many, many times. It takes as much time as Whites take to learn the design of their words. The *yãkõanahi* powder is the food of the spirits. Those who don't "drink" it remain with the eyes of ghosts and see nothing.

The *xapiripë* dance together on huge mirrors which descend from the sky. They are never dull like humans. They are always magnificent: their bodies painted with red annatto dye and enveloped in black designs, their heads covered with white vulture plumes, their bead armbands adorned with the feathers of parrots, piping guans and red macaws, their waists wrapped in toucan tails ... Thousands of them arrive to dance together, waving fresh palm fronds, letting out whoops of joy and singing without pause. Their paths look like spider-webs shining like moonlight and their plume ornaments sway gently to the rhythm of their steps. It thrills you to see how beautiful they are!

The spirits are so numerous because they are images of the animals of the forest. All those in the forest have an *utupë* image: those who walk on the ground, those who walk in the trees, those who have wings, those who live in the water ... These are the images the shamans call and make descend to turn into *xapiripë* spirits. These images are the true center, the true core of the forest beings. Common people cannot see them, only shamans. But they are not images of the animals we know today. They are images of the fathers of these animals, images of our ancestors.

In the first times, when the forest was still young, our ancestors were human with names of animals who ended up turning into game. These ones we shoot and eat today. But their images did not disappear and these are the ones who now dance for us as *xapiripë* spirits. These ancestors are truly ancient. They turned into game a long time ago but their ghosts dwell here still. They have animal names but they are invisible beings who never die. The epidemic of Whites may try to burn and eat them, but they never disappear. The mirrors keep sprouting time and again.

The Whites design their words because their thought is full of forgetting. We have kept the words of our ancestors inside us for a long time and we continue to pass them on to our children. Children, who know nothing of the spirits, hear the songs of the shamans and later want to see the spirits for themselves. This is how, despite being very ancient, the words of the *xapiripë* are always renewed. It is their words which augment our thoughts, which make us see and know things far away, the things of the ancients. This is our study, this is what teaches us to dream. And this is why someone who doesn't drink the breath of the spirits has short and murky thought; someone who isn't looked upon by the *xapiripë* doesn't dream—it just lies there like an axe left on the ground.

<center>***</center>

This narrative by Kopenawa—and here I refer to both the text quoted above and the more developed French version titled *Les ancêtres animaux* (Animal ancestors)[3]—strikes me as a quite extraordinary document. Above all, it impresses with its richness and eloquence, qualities that derive from the decision of the two co-authors to implement a discursive strategy with great poetic conceptual density. In this sense, we are presented with an "inventing of culture" which is also a masterpiece of "interethnic" politics. If shamanism is essentially a cosmic diplomacy devoted to the translation

between ontologically disparate points of view,[4] then Kopenawa's discourse is not just a narrative on particular shamanic *contents*—namely, the spirits which the shamans make speak and act—it is a shamanic *form* in itself, an example of shamanism in action, in which a shaman speaks about spirits to Whites and equally about Whites on the basis of spirits, and both these things through a White intermediary.[5]

But the narrative is just as exceptional for its cosmological exemplarity. It develops ideas that can be found in a more or less diffuse state in sundry other Indigenous cultures of the region. It is this exemplarity which interests me in this paper, the aim of which is to call attention to some recurrent features of the mode of existence and manifestation of spirits in Indigenous Amazonia. In particular, I take Kopenawa's discourse as expressing a pan-Amazonian conception in which the notions we translate as "spirit" denote an ontological mode of the "intensive virtual multiplicity" type.

THE SHAMANIC PLANE OF IMMANENCE

Various prominent figures and central milieus from Yanomami cosmology can be found evoked in the above text: spirits, animals, shamans, the dead, whites; myths and dreams, drugs and festivals, hunt and forest. Let's begin with the *xapiripë* properly speaking. The word designates the utupë, image, vital principle, true interiority or essence[6] of the animals and other beings of the forest, and at the same time the immortal images of a first archaic humanity, composed of Yanomami with animal names that transformed into the animals of the present. But *xapiripë* also designates human shamans, and the expression "to become a shaman" is a synonym of "to become a spirit" (*xapiri-pru*). Shamans conceive themselves to be of the same nature as the auxiliary spirits brought to earth in their hallucinogenic trance. Thus the concept of *xapiripë* signals a complex interference, a chiastic distribution of identity and difference between the dimensions of "animality" (*yaro pë*) and "humanity" (*yanomae thëpë*). On one hand, animals possess an invisible essence distinct from their visible forms: the *xapiripë* are the "true animals"—but are humanoid; that is, true animals do not appear very much like the animals which the *xapiripë*, literally, imagine. On the other hand, shamans are distinguished from other humans by being "spirits," and moreover, "fathers" of the spirits (who, for their part, are images of the "fathers of animals"). Hence, the concept of *xapiripë*, less or rather than designating a class of distinct beings, intimates a region or moment of indiscernibility between the human and nonhuman (primarily but not exclusively the "animals," a very problematic notion in Amazonian ontologies anyway):

it announces a background molecular humanity, hidden by nonhuman molar forms, and speaks of the multiple nonhuman affects that must necessarily be captured by humans via the agency of shamans, since this is the stuff meaning is made of: "it is the words of the *xapiripë* which augment our thoughts."

The reverberation between the positions of shaman and spirit can be found in numerous Amazonian cultures. In the Upper Xingu, for example, the great shamans are called "spirits" by laypeople, while they themselves refer to their associated spirits as "my shamans."[7] For the Ese Eja of Bolivian Amazonia, "all *eshawa* [spirits] are *eyamikekwa* [shamans], or rather, the *eyamikekwa* have the power of *eshawa*."[8] Among the Ikpeng of the middle Xingu,[9] the term *pïanom* designates shamans, their various auxiliary spirits, and the small, potentially self-intoxicating darts these spirits introduce into the abdomen of shamans and which function as the instrument of shamanism. This observation by Rodgers is important since it indicates that, if the concept of spirit essentially designates a population of molecular affects, an intensive multiplicity, then the same applies to the concept of shaman: "the shaman is a multiple being, a micro-population of shamanic agencies sheltered in one body."[10] So far from being a super individual, a shaman—at least the "horizontal" kind more typical to the region—is a super-divided being: a federation of invisible agents among the Ikpeng, an anticipated corpse and potential cannibal victim among the Araweté,[11] a repeatedly perforated body among the Ese Eja.[12] Additionally, if the shaman is effectively "different," as the Ikpeng say,[13] the fact remains this difference between them and laypeople is a question of degree, not nature. "Everyone who dreams has a bit of shaman" say the Kagwahiv,[14] in whose language, as in many others in Amazonia, the words we translate as "shaman" do not designate some thing which one "is," but something which one "has"—an adjectival and relational disposition rather than a substantive attribute, something which can be intensely present in many nonhuman entities; which abounds, needless to say, in "spirits"; and which may even constitute itself as a generic potential of being.[15] Hence the human "shaman" is not a sacerdotal functionary, but someone more similar to the Socratic philosopher: if every individual capable of reasoning is a philosopher, a potential "friend of the concept," likewise every individual capable of dreaming is a shaman, "a friend of the image."[16] In the words of Kopenawa: "[This is] our study, this is what teaches us to dream. And this is why someone who doesn't drink the breath of the spirits has short and murky thought; someone who isn't

looked upon by the *xapiripë* doesn't dream—it just lies there like an axe left on the ground." A shamanic critique of vigilant reason. In passing, note that if studious reason is the hallucination proper to Whites, then writing is their shamanism: "To be able to see them [the *xapiripë*] you must inhale the powder of the *yãkõanahi* tree many, many times. It takes as much time as Whites take to learn the design of their words."

✱✱✱

As is well known, a sizeable slice of Amazonian mythology deals with the causes and consequences of the species-specific embodiment of different agents, all of them conceived to have originally partaken of a generalized unstable condition in which human and nonhuman features are indiscernibly mixed. All the beings peopling mythology display this ontological entanglement or cross-specific ambiguity, and this is precisely what makes them akin to shamans (and to spirits):

> The Earth's present animals are not nearly as powerful as the originals, differing as much from them as ordinary humans are said to differ from shamans ... The First people lived just as shamans do today, in a polymorphous state ... After the withdrawal from the Earth, each of the First People became the "Master" or *arache* of the species they engendered.[17]

We can also cite Stephen Hugh-Jones[18] on the Barasana of the Vaupés: "The shamans are the *He* people par excellence"; where the concept *He* designates the original state of the cosmos, returned to by humans by means of ritual. Discussing the Akuriyó of Suriname, Fabiola Jara[19] observes that shamans—humans or animals, since nonhuman species have shamans of their own—are the only beings that "retain the primitive characteristics from before the separation between humans and animals," especially the power of inter-specific mutation (and this is what "power" is all about in Indigenous Amazonia).

Thus, the synchronic interference between humans and animals (more generally, nonhumans) expressed in the concepts of shaman and spirit possesses a fundamental diachronic dimension, reaching back to an absolute past in which the differences between species were "still" to be actualized. Myth is a discourse about this moment:

> [—"What is a myth?"]—If you were to ask an American Indian it is extremely likely that he would answer: it is a story from the time when humans and animals did not distinguish themselves from one another. This definition seems to me to be very profound.[20]

The definition is indeed profound; so let's plunge a little deeper into it. I think mythic discourse can be defined as first and foremost a record of the process of actualization of the present state of things out of a virtual pre-cosmological condition endowed with perfect *transparency*—a "chaosmos" where the bodily and spiritual dimensions of beings did not as yet reciprocally eclipse each other. This pre-cosmos, very far from displaying any "indifferentiation" or originary identification between humans and nonhumans, as is usually formulated, is pervaded by an *infinite* difference, albeit (or because) *internal* to each persona or agent, in contrast to the *finite* and *external* differences constituting the species and qualities of our contemporary world.[21] This explains the regime of "metamorphosis," or qualitative multiplicity, proper to myth: the question of knowing whether the mythic jaguar, to pick an example, is a block of human affects in the shape of a jaguar or a block of feline affects in the shape of a human is in any rigorous sense undecidable, since mythic metamorphosis is an "event" or a heterogenic "becoming" (an intensive superposition of states), not a "process" of "change" (an extensive transposition of homogenic states). The general line traced by mythic discourse describes the lamination of the pre-cosmological flows of indiscernibility as they enter the cosmological process: thereafter, the human and feline dimensions of jaguars (and humans) will function alternately as potential figures and ground to each other. The originary transparency or infinite *complicatio* where everything seeps into everything else bifurcates or explicates itself, from this point on, into a relative invisibility (human souls and animal spirits) and a relative opacity (the human body and the somatic animal "clothing")[22] which determine the make-up of all present-day beings. Relative invisibility and opacity because reversible, and reversible since the ground of pre-cosmological virtuality is indestructible or inexhaustible. As Kopenawa said in speaking of the "*citoyens infinitésimaux*" of the virtual arche-*polis*, the *xapiripë* "never disappear ... their mirrors keep sprouting time and again ... they are powerful and immortal."

I just stated that pre-cosmological differences are infinite and internal, in contrast to the external finite differences between species. Here I am referring to the fact that the actants of origin myths are defined by their intrinsic capacity to be something else; in this sense, each mythic being differs infinitely from itself, given that it is posited by mythic discourse

only to be substituted, that is, transformed. It is this self-difference which defines a spirit, and which makes all mythic beings into spirits too. The supposed indifferentiation between mythic subjects is a function of their radical irreducibility to fixed essences or identities, whether these are generic, specific, or individual (recalling here the detotalized or "disorganized" bodies that thrive in myths). In sum, myth posits an ontological regime commanded by a fluent intensive difference which incides on each point of a heterogenic continuum, where transformation is anterior to form, relation is superior to terms, and interval is interior to being.[23] Every mythic being, being pure virtuality, "already was before" what "it was going to be after," and for this reason *is not*—since it does not remain being—anything actually determined. If the reader finds this a little too Deleuzian for [their] taste, let us then appeal to Lévi-Strauss:

> Undoubtedly in mythic times humans were not distinguishable from animals; but among these undifferentiated beings who were set to give origin to the former and the latter, certain qualitative relations pre-existed the specificities still left in *virtual state*.[24]

In counterpart, the extensive differences introduced by post-mythic speciation (*sensu lato*)—the celebrated transition from the "continuous" to the "discrete" which constitutes the meta-mytheme of the structuralist cosmology[25]—crystallize molar blocks of infinite internal identity (each species is internally homogenic, its members are identically and indifferently representative of the species as a whole) separated by quantifiable and measurable external intervals (the differences between species are finite systems of correlation, proportion and permutation of characters of the same type or order). The heterogenic continuum of the pre-cosmological world gives way, therefore, to a homogenic "discretum" where each being is only what it is, and is only what it is by not being what it is not. But spirits are testimony to the fact that not all virtualities were actualized, and that the mythical river of fluent metamorphosis continues its turbulent course not too far below the surface discontinuities separating the types and species.

HUMANS, ANIMALS, SPIRITS

As far as can be known, all Amazonian cultures possess concepts that describe beings analogous to the Yanomami *xapiripë*. In reality, the Indigenous words we translate as "spirit" generally correspond to a fundamentally heteroclitic and heterogenic "category," which admits a number of subdivisions and internal contrasts (sometimes more radical than those

opposing spirits to other types of beings). Staying with the Yanomami, the *xapiripë* or "shamanic spirits" are only one species of the genus *yai thëpë*, which Albert translates as "invisible non-*human* beings," a notion that also includes the specters of the dead, *porepë*, and malefic beings called *në wãripe*.[26] And although the *xapiripë* are epitomised by the images of the primordial humans-animals, Kopenawa makes it abundantly clear that shamans also mobilize, among others, the *xapiripë* images of thunder, lightning, rain, night, cannibal ancestors, pots, cotton, fire and Whites, as well as a motley crowd of *në wãripë*.[27] The *xapiripë* are not always beautiful and magnificent, since they can also be terrible and monstrous; and they share the ghostly condition of the dead, since they are "spectral forms," that is, *images*.[28] The generic notion of "invisible nonhumans" would seem to unify adequately enough the internal diversity of this "category"; yet the problem remains that these nonhumans possess fundamental human determinations, whether at the level of their basic corporeal form, or at the level of their intentional and agentive capacities. Furthermore, while these nonhumans are normally invisible to laypeople, to those who are awake and to those with "short and murky thought," in the context of shamanic hallucination they are supremely visible, and visible in their *true* human form (they are "the true center" of the beings of the forest). Likewise, there are certain critical situations in which a person encounters a being that starts by letting itself be seen as human—in a dream, in a solitary encounter in the forest—but ends by revealing itself suddenly as nonhuman; in such cases, nonhumans are those supremely capable of assuming a *false* human form before true humans. In other words, while (normally) invisible, these nonhumans "are" human; while (abnormally) visible these humans "are" non-human.[29]

And to complete the picture, we can note the somewhat paradoxical nature of an image that is at once non-iconic and non-visible. What defines spirits, in a certain sense, is the fact they index characteristic affects of the species of which they *are* the image without, for this very reason, appearing like the species of which they are the image. By the same token, what defines an "image" is it eminent visibility: an image is something-to-be-seen, it is the necessary objective correlative of a gaze, an exteriority which posits itself as the target of an intentionally aimed look; but the *xapiripë* are interior images, inaccessible to the empirical exercise of vision. Hence, they must be the object of a superior or transcendental exercise of this faculty: images that are as the *condition* of the species of which they are the image; active images, indexes which interpret us before we interpret them, images which *must see us in order for us to be able to see them*—"someone who isn't looked upon by the *xapiripë* doesn't dream, it just lies like an axe left on the ground"—and

images through which we see other images—"only shamans can see [spirits], after drinking *yãkoana* powder, since they turn into others and can now see spirits with equally spiritual eyes."[30]

All told, this empirical non-iconicity and non-visibility seems to me to point to an important dimension of the spirits: they are non-representational images, "representatives" that are not representations. "All beings of the forest have their own *utupë* image ... In your words, you would say they are the '*representantes*' [in Portuguese] of the animals."[31] Albert signals[32] that the term *representante* is part of the habitual political vocabulary of Indigenous leaders in Brazil. Introducing the idea of aniconic symbols as "representatives" in his work, *Art and Agency*, Alfred Gell[33] uses the example of the diplomat: "[T]he Chinese ambassador in London ... does not look like China, but in London, China looks like him." We can paraphrase this by saying the *xapiripë* do not look like animals, but in the mytho-shamanic context, animals do look like them.

Neither types, nor representations. What I am suggesting, in a nutshell, is that Amazonian concepts of "spirit" do not designate a class or genus of nonhumans but a certain obscure vicinity between the human and nonhuman, a secret communication which rather than passing through the redundancy between them (their "community"), passes through their disparity (their "incommunity"):

> One can say rather that a zone of indistinction, of indiscernibility, of ambiguity, establishes itself between two terms, as if they had attained the point immediately preceding their respective differentiation: not a similitude, but a slippage, an extreme vicinity, an absolute contiguity; not a natural filiation, but a counter natural alliance ...[34]

We could say then that the *xapiripë* is the name of the disjunctive synthesis which connects-separates the actual and the virtual, the discrete and the continuous, the edible and the cannibal, the prey and the predator. In this sense, the *xapiripë* "are others" in effect.[35] A spirit in Amazonia is less a thing than an image, less a term than a relation, less an object than an event, less a transcendent representative figure than a sign of the immanent universal background—the background that comes to the surface in shamanism, in dreams and in hallucinations, when the human and the nonhuman, the visible and invisible trade places.[36] An Amazonian "spirit", in sum, is less a "spirit" in opposition to an immaterial body than dynamic and intensive corporality, which, like Alice, never ceases to grow and shrink at the same

time: a spirit is *less* than a body—the *xapiripë* are specks of dust, miniatures of humans with micro-penises and finger-less hands[37] and *more* than a body—displaying a magnificent and sometimes terrifying appearance, superb body ornamentation, brilliance, perfume, beauty, overall an *excessive* character in relation to the species of which they are the image.[38] In sum, a constitutive transcorporality, rather than a negation of corporality: a spirit is something that only has *too little body* insofar as it possesses *too many bodies*, capable as it is of assuming different corporal forms. The interval between any two bodies rather than a non-body or no body.

But if Amazonian concepts of "spirit" are not rigorously speaking taxonomic entities, but names of relations, movements and events, then it is probably just as improbable that notions such as "animal" and "human" are elements of a static typology of genuses of being or categorical macro-forms of an "ethnobiological" classification. I'm led to imagine, on the contrary, a single cosmic domain of transductivity,[39] a basal animic field within which the living, the dead, the Whites, the animals and the other "forest beings," the anthropomorphic and terionymic mythic personae, and the *xapiripë* shamanic images are only so many different intensive vibrations or modulations. The "human mode" can be imagined, then, as the fundamental frequency of this animic field we can call meta-human—given that human form (internal and external) is the aperceptive reference of this domain, since every entity situated in a subject position perceives itself *sub specie humanitatis*[40]—living species and other natural kinds (including our own species) can be imagined to inhabit this field's domain of visibility; while "spirits," in contrast, can be imagined as vibrational modes or frequencies of the animic field found both below (granular tininess, diminutive size) and above (anomalism, excess) the perceptual limits of the naked, i.e. non medicated, human eye.

PERSPECTIVES

My reference to spirits and animals as implying a universal animic field of which they are the invisible and visible "modes," respectively, of "vibration" is not an entirely arbitrary visualist analogy. In fact, Kopenawa's narrative speaks of the "ghostly eyes" of non-shamans. Here the allusion is to the specters of the dead (*porepë*) and the perspectival inversion between different ontological modulations of the meta-human—a key theme in Amerindian cosmologies:[41]

When the sun rises in the sky, the *xapiripë* sleep. As it starts to set towards dusk, for them the day is dawning. They therefore awaken all the innumerable beings in the forest. Our night is their day; while we sleep, they dance and enjoy themselves. And when they speak of us, they call us "the specters." In their eyes we appear as ghosts, since we are similar to the latter. They tell us: "you are aliens and ghosts, since you die."[42]

The spirits see non-shamans in the form of specters; likewise, the usual invisibility of spirits to the eyes of humans (non-shamans) is expressed by declaring that the latter possess "ghostly eyes." (Whites, therefore, are all specters, and always specters, since they are supremely incapable of seeing spirits). Likewise, it is by "dying" under the effect of the hallucinogenic drug *yãkoana* that shamans are capable not only of seeing the spirits, but of seeing like the spirits:[43] see, precisely, humans as specters. In this sense, at least, shamans are dead, i.e. specters, or at least humans who have ceased to be completely human: the Ikpeng, for example, conceive them as "ex-people," *tenpano-pin*.[44] The *xapiripë* for their part share their spectral condition with the dead, from the "point of view" of common humans: they are "specters."[45] As for animals, we have already seen how they see us—as their similars, but strange ones: animals who are at once "domestic" ("house-dwellers") and cannibals.[46]

In sum, the specters of the dead are, from the ontogenetic point of view, like animals in terms of phylogenesis: both are ex-human, and both therefore are images of humans. It is not surprising, then, that as images defined by their disjunction from a human body, the dead are logically attracted to the bodies of animals; this is why to die is to transform into an animal, as so often happens in Amazonia. As a matter of fact, if the spirit of animals is conceived to have a human bodily form, it seems quite logical that the soul of humans may be conceived as having an animal body, or entering into one—in order to be eventually hunted and eaten by the living.[47]

All the above can be taken to mean that, in Amazonia, "the primary dialectics is one between seeing and eating," in Mentore's pithy formulation[48] apropos the Waiwai.[49] Amerindian cultures evince a strong visual bias of their own—one not to be confused with our own visualism.[50] Vision is often the model of perception and knowledge;[51] shamanism is laden with visual concepts;[52] in most of Amazonia—the Yanomami are a case in point—hallucinogenic drugs are the basic instrument of shamanistic technology, being used as a kind of visual prosthesis. More generally, the distinction between the visible

and the invisible seems to play a major role: "the fundamental distinction in Cashinahua ontology [is that] between visibility and invisibility."[53] We might also recall the strong emphasis on the decoration and exhibition of bodily and object surfaces as an epistemologically charged and ontologically efficacious process.[54]

THE SHINING CRYSTALS

My characterization of the ontology of Amazonian spirits in a visual "key" is not due only to the presence, in Kopenawa's discourse, of the theme of perspectivism as a process of discrete switching of points of view between the different forms of agency populating the cosmos. On the contrary: the most important element in this discourse, it seems to me, is the functioning of a powerful intensive imagery of sparkling and luminous reflection, on one hand, and the indefinite divisibility multiplication of spirits, on the other.

Firstly, light. Kopenawa's narrative is literally constellated with references to light, brilliance, the stars and mirrors. In the version reproduced above, we see "sparkling dust," we see "spider webs shining like moonlight," and "huge mirrors" which "always bud once more." In the expanded version,[55] the luminant *féerie* proliferate: over twelve pages, almost every other sentence features the *xapiripë* "shining like stars," emitting a "blinding luminosity," a "dazzling light." They wave fresh palm leaves which "shine with an intense yellow"; their teeth are "immaculate and resplendent like glass," or are "mirror fragments." The ground above which they dance "shines with a glittering light" and a "dazzling clarity."

Hence the primordial quality associated with the perception of these spirits is their *luminous intensity*. This is an experience frequently described in Amazonia. The *Maï* celestial cannibal spirits of the *Araweté*, are described with a profuse vocabulary of fiery sparkling and blinding lightning, while their body decoration is famed for its intense color and luminosity.[56] The spirits of the Hoti, the "Masters of the Outside, or the Forest ... are detected in the waking world in thunder and lightning, which are their shouts and the flashes of their lance-points, or sometimes they are seen, or heard, as jaguars. They are perceived in dreams as shining anthropomorphic beings, painted with bright red *onoto* [annatto] dye."[57] Like the Yanomami *xapiripë*, therefore, the Araweté *Maï* and the Hoti Masters "are never dull like humans; they are always magnificent: their bodies painted with red annatto dye and enveloped in black designs, their heads covered with white vulture plumes ..."

Undoubtedly much of this phenomenology of intense light can be associated with the biochemical effects of drugs.[58] This, for example, is how the Piro describe the experience of ingesting *toé* (*Brugmansia spp.*): "[S]uddenly, everything lights up, as if the sun had risen."[59] Their ethnographer observes that "the metaphorization of *toé* hallucinatory experience as 'daylight' is common ... [o]ther informants emphasized the 'redness' of [the] experience, 'just like the world at dawn,' or, 'at sunset.'"[60] But other drugs less violently hallucinogenic than the *toé* of the Piro and the *yãkoana* of the Yanomami, such as tobacco, and other techniques of sensorial manipulation,[61] such as deliberate semi-blindness through the use of masks, the application of caustic eye-drops, immersion, sleep deprivation, and so on, may be involved in these processes of deterritorializing sight. Moreover, the perceptive experience of luminous intensity is sought out by the shaman, not merely suffered (as a side-effect of drugs taken for other purposes), which strongly suggests that it possesses a conceptual value in itself. It is certainly not necessary to be a shaman to "perceive" the relation between knowledge and illumination, a theme very likely to be found in all times and places; however, my impression is that, in the Amazonian case, this does not involve a conception of light as a distributor of relations of visibility-knowability across an extensive space (I'm thinking here of certain passages from *Les mots et les choses* {*The Order of Things*}) but of light as pure intensity, the intense and intensive core of reality which establishes inextensive distance between beings (i.e., their greater or lesser mutual capacity to become). The connection between this and the idea of the invisibility of spirits seems to me crucial: the normally invisible is also the abnormally luminous. The intense luminosity of spirits indicates the super-visible character of these beings, which are "invisible" to the eye for the same reason light is—that is, by being the condition of the visible.

Among the *Araweté*, as probably for other peoples of Amazonia, luminosity and brilliance are associated with another visual quality, transparency or diaphanousness. *Ikuyaho*, "translucency" or "transparency"—but also "outsidedness," "exteriority" (cf. the "Masters of the Outside" of the Hoti)—is a state which shamans seek to attain via massive ingestion of tobacco (massive and "mortal," since it induces a period of cataleptic shock). A state associated with the quality of "lightness" (*wewe*), translucidity is produced by a separation between soul and body (i.e., by an exteriorization of a being's being), which removes from the latter its "weight" (*ipohi*) or its opacity ("the ordinary opacity of the human body"[62]), thereby allowing the shaman to see through the body of his patients, and, more generally, to discern the invisible side of the world.[63] It was this concept of *ikuyaho* which led me

to the image of originary pre-cosmological transparency developed above. The other source of this image is a marvelous proto Leibnizian passage from Plotinus on the intelligible world, which seemed to me to share many a point of contact with Kopenawa's narrative:

> For all is transparent, nothing dark, nothing resistant; every being is lucid to every other, in breadth and depth; light runs through light. And each of them contains all within itself, and at the same time sees all in every other, so that everywhere there is all, and all is all and each all, and infinite the glory. Each of them is great; the small is great; the sun, there, is all the stars; and every star, again, is all the stars and sun. While some one manner of being is dominant in each, all are mirrored in every other.[64]

"All" that is needed is to swap the molar and solar neo-Platonic metaphysics of the One for the Indigenous metaphysics of stellar and molecular multiplicities.[65]

"Mirrors" are precisely the instrument of passage between the experiences of luminous intensity and the innumerability of spirits, that is, their quantitative infinitude. Mirrors multiply in Kopenawa's narrative, as the signs and means of transportation of the *xapiripë*:

> The *xapiripë* descend to us perching on mirrors, which they keep suspended a little bit above the soil, without ever touching the ground. These mirrors come from their dwelling place in the bosom of the sky. In a shaman's house of spirits, these mirrors are placed, propped, hung, piled and lined up side by side. When the house is spacious, the mirrors are large, and as the number of spirits increases, the mirrors mount up one on top of the other. But the *xapiripë* don't mix with each other. The mirrors of the same spirits [regularly] succeed each other on the props of the house: thus there are the mirrors of warrior spirits, bird of prey spirits, and cicada spirits; the mirrors of thunder spirits, lightning spirits, and storm spirits. There are as many mirrors as there are spirits, they are truly innumerable, piled up out of sight ... Our life is no more than living among mirrors; [the shamans of the Yanomami know that] our forest belongs to the *xapiripë* and is made from their mirrors.[66]

Mirrors and crystals perform an important role throughout the Amazonian vocabulary of shamanism: the shamanic crystals of the Tukano and various Guyanese Carib groups come to mind, so too the "crystal boxes of the gods"

of the Piaroa, the warua mirrors which cover the Wayapi shaman, and, more generally, the internal dual specular symmetry characteristic of the region's art and hallucinatory aesthetic.[67]

Now, one may note that virtually all the examples given in this section—with the possible exception of Roe's remarks about specular symmetry, which deserve a discussion I cannot engage in here—do not emphasize the property mirrors have to iconically reproduce images, but, rather, their property to shine, glitter and dazzle. Amazonian supernatural "mirrors" are not extensive representational devices, but intensive multipliers of luminous experience. Actually, the Yanomami word Bruce Albert translated as "mirror" does not denote our "iconophoric" mirrors. Commenting on a former version of the present paper, Albert kindly communicated to me the following crucial additional explanations of Davi Kopenawa, given to him in response to his questions about the shamanic spiritual mirrors. This passage is a rewriting of what was published in "*Les ancêtres animaux*":

> The *xapiripë* never move on the earth. They find it too dirty and full of excrement. The surface on which they dance resembles glass and shines with a brilliant light. It is formed of what our old people call *mire kope* or *mire xipe*. These are the *xapiripës*' objects, magnificent and glowing, transparent yet very solid. You might call them 'mirrors.' But they are not mirrors for looking at oneself, they are mirrors which shine.[68]

Light not images. The *xapiripë* are indeed images (*utupë*), but their "mirrors" do not constitute them as such–they are on the side of pure light.

SIZE AND INTENSITY

Aside from their dazzling luminosity, the *xapiripë*, as percepts, display two other determining features, tiny-ness and innumerability. In the discourse transcribed at the beginning of this paper, we already saw that they "look like human beings but are as *tiny as specks of sparkling* dust ... *thousands* of them arrive to dance together ... their paths look like *spider webs* ... The spirits are so *numerous* because they are images of the animals of the forest ..." Naturally enough, in the expanded version, the number of times they are said to be "innumerable" is proportionally greater. The narrator delights in enumerating this innumerable proliferation:

> The images [of the *xapiripë*] are magnificent. Don't think only a few of them exist. The *xapiripë* are truly very numerous. They never cease to arrive down here, countless and endless. They are the images of animals that inhabit the forest, with all their offspring, who descend one after the other. Are they not innumerable, all the cacique birds, the red and yellow macaws, the toucans, the herons, the trumpeter birds, the guans, the parakeets, the eagles, the bats, the vultures ... And then the tortoises, the armadillos, the tapirs, the deer, the ocelots, the jaguars, the agoutis, the peccaries and the spider monkeys, the howler monkeys, the capuchin monkeys, the sloths ... And then all the fish of the rivers, the electric eels, the piranhas, the *kurito* catfish, the stingrays and all the smaller fish.[69]

Tiny, these spirits nonetheless evince an intense vitality (cf. the animals descending with all their offspring) and a superabundance of being: "when I was younger, I used to ask myself whether the *xapiripë* could die like humans. But today I know that, though tiny, they are powerful and immortal."[70] Spirits are, literally, intense: the suffix *-ri* which generally accompanies the name of the *xapiripë* "denotes an extreme intensity, or a nonhuman/invisible quality."[71] This is why, for example, the mythological animal ancestors and their latter-day shamanic images are *yaroripë*, that is, *yaro* (game) + *ri-* (excessive, supernatural) + *pë* (pluralizer). Intensity, exemplarity, alterity in relation to the merely existent:

> the *iro* howler monkey we shoot in the trees is other than its image, which the shaman makes descend as *Irori*, the howler monkey spirit. These *utupë* images of game are truly very beautifully ... Compared to them, the animals of the forest are ugly. They only exist. They do nothing more than imitate their images; they are only the food of humans.[72]

The intensifier-spiritualizer *-ri* seems therefore to function exactly as the modifier—*kumã* in the Arawak languages of the Upper Xingu, which the Yawalapíti translated for me as "huge, other, ferocious, supernatural, alien," and which I interpreted[73] as one of the basic conceptual operators of their culture, the operator of "ontological exponentiation."

Interestingly, the dimensional imagery of the *kumã*-beings makes them larger, sometimes gigantic and monstrous, versions of the everyday beings: a Yawalapíti *kumã*-monkey is not minuscule like a Yanomami *Irori*. Yet we are faced, I think, with the "same" monkey, or rather, with the *same other* of the monkey, among the Yawalapíti and the Yanomami alike. The

tininess of the *xapiripë* spirits in no sense impedes their "excessive" or "extremely intense" character, as Albert says; on the contrary, it seems to me a decisive sign of the multiplicity designated by the concept of any spirit in particular. "When we utter the name of a *xapiripë*, it is not just one spirit that is evoked, but a multitude of similar spirits."[74] Spirits are quantitatively multiple, infinitely numerous; they are the ultimate molecular structure of the molar animal forms we see in the forest. Their smallness is a function of their infinitude and not the opposite. Likewise, the generally gigantic character of the Yawalapíti *kumã*-beings does not make them less invisible to the naked eye–and it determines them as qualitatively multiple, since a *kumã*-being is at once an archetype and a monster, model and excess, pure form and hybrid reverberation, beauty and ferocity in a single figure. In other words, the minuteness of the *xapiripë* emphasizes their characterization as a pack, band, multitude and swarm, while the gigantic nature of the *kumã*-beings points to the dimension of the *anomal*, the exceptional "representative" of the species, the mega-individual indicating an animal multiplicity.[75] In sum, the tininess of the *xapiripë* and the frequently magnified character of the spirits (of the Masters of animals, for example) are like the front and back of a single idea, that of the "excessive" intensity of spirits. Here we are faced with the two complementary extensive (spatial) schematisms of the idea that a spirit is an intensive and "anomalous" multiplicity.[76]

By way of conclusion, let me just say that the problematic of the infinite in Amerindian cosmologies appears to me to retain a further problem for analysis. We have been used to contrasting the "closed world" of the so-called primitives to the "infinite universe" of us moderns, and to attributing to Indigenous peoples a fundamentally finitary, combinatory and discretizing outlook, which abhors the continuum as though it saw in it the dangerous labyrinthine path (the labyrinth of the continuum) which inexorably lures thought into the sinister empire of the non-senses. I am referring, obviously, to the structuralist *logos*,[77] which instructs us to think of difference exclusively in the "totemic" mode of extensive difference, to conceive the movement of differentiation as a pure limitative synthesis of speciation, and to understand the real as a mere combinatory manifestation of the possible. But the molecular mirrors, innumerable images and countless spirits of Davi Kopenawa's narratives strongly suggest that the properly infinitesimal, intensive, disjunctive and virtual component of Amerindian thought cries out for closer attention from anthropology.

ACKNOWLEDGMENTS

I thank my colleague and friend Bruce Albert for his generosity in allowing me vastly to cite, paraphrase, comment and otherwise cannibalize his magnificent translations and elucidations of Davi Kopenawa's conversations with him. And, of course, I am most grateful to Davi Kopenawa, a thinker any civilization in the world should be proud to count in its ranks.

1 Note from the editors: The complete dialogue between Kopenawa and Albert was published after publication of this essay: Davi Kopenawa and Bruce Albert, *The Falling Sky: Words of a Yanomami Shaman*, trans. Nicholas Elliott and Alison Dundy (Cambridge: Belknap Press of Harvard University Press, 2013). An excerpt from this book is present in this anthology.

2 See also the various other texts by Davi Kopenawa and Bruce Albert, in Bruce Albert and Chandès, H. *Yanomami—l'esprit de la forêt* (Paris: Fondation Cartier, 2003), as well as two seminal articles by Albert, B. (1988, 1993) [full references below].

3 Kopenawa and Albert, *Yanomami—l'esprit de la forêt*.

4 Eduardo Viveiros de Castro, "Cosmological Deixis and Ameridian perspectivism," *Journal of the Royal Anthropological Institute* 4, no. 3 (1998): 469–88; and Manuela Carneiro da Cunha, "Pontos de vista sobre a floresta amazônica: xamanismo e tradução," *Mana* 4 (April, 1998): 7–22.

5 See Bruce Albert, "L'Or Cannibale et la Chute du Ciel: Une Critique Chamanique de l'économie Politique de la Nature." *L'Homme* 33e Année, nos. 126/128 (April–December 1993): 349–378 for an insightful analysis of Kopenawa's discourse as "a shamanic critique of the political economy of nature."

6 Kopenawa and Albert, *Yanomami—l'esprit de la forêt*, 72n28.

7 Eduardo Viveiros de Castro, "Esboço de Cosmología Yawalapíti," in *A inconstância da alma selvagem e outros ensaios de antropologia* (São Paulo: Cosac & Naify, 2002), 80–81.

8 Miguel Alexiades, "Ethnobotany of the Ese Eja: Plants, Health, and Change in an Amazonian society" (Ph.D. thesis, City University of New York, 1999).

9 David Rodgers, "A Soma Anômala: A Questão do Suplemento no Xamanismo e Menstruação Ikpeng," *Mana* 8, no. 2 (2002): 91–125.

10 David Rodgers, "A Soma Anômala."

11 Eduardo Viveiros de Castro, *From the Enemy's Point of view: Humanity and Divinity in an Amazonian Society* (Chicago (IL): University of Chicago Press, 1992).

12 Alexiades, "Ethnobotany," 221.

13 Rodgers, "A Soma Anômala."

14 Waud Kracke, "'Everyone who dreams has a bit of Shaman': Cultural and Personal Meaning of Dreams Evidence from the Amazon," *Psychiatric Journal of the University of Ottawa*, 12 (1987): 65–72.

15 Alan Tormaid Campbell, *To Square with Genesis: Causal Statements and Shamanic Ideas in Wayãpí* (Edinburgh: Edinburgh University Press, 1989).

16 For the contrast between the shaman and the priest in Amazonia, see Stephen Hugh-Jones, "Shamans, Prophets, Priests and Pastors," in *Shamanism, History, and the State* (Ann Arbor (MI): University of Michigan Press, 1994) and Eduardo Viveiros de Castro, "Xamanismo e Sacrificio," in *Inconstância da alma selvagem e outros ensaios de antropologia* (São Paulo: Cosac & Naify, 2002).

17 David Guss, *To Weave and to Sing: Art, Symbol, and Narrative in the South American Rain Forest* (Berkeley, CA: University of California Press, 1989) on the Ye'kuana of Venezuela.

18 Stephen Hugh-Jones, *The Palm and the Pleiades. Initiation and Cosmology in Northwest Amazonia* (Cambridge: Cambridge University Press, 1979), 218.

19 Fabiola Jara, *El Camino del Kumu: Ecologia y Ritual entre los Akuriyó de Surinam* (Quito: Abya-Yala, 1996), 92–94.

20 Claude Lévi-Strauss and Didier Eribon, *De près et de loin* (Paris: Odile Jacob, 1988), 193.

21 Eduardo Viveiros de Castro, "GUT Feelings about Amazonia: Potential Affinity and the Construction of Sociality," in *Beyond the Visible and the Material: The Amerindianisation of Society in the Work of Peter Riviere* (Oxford: Oxford University Press, 2001).

22 On animal bodies as "clothes," see Viveiros de Castro, "GUT Feelings about Amazonia."

23 Compare this with the "internal discontinuities" referred to in Marilyn Strathem, *Partial Connections* (Lanham: AltaMira Press, 1991).

24 Claude Lévi-Strauss, *Mythologiques IV: L'Homme nu* (Paris: Plon, 1971), 526 (my italics); also see Rodgers, "A Soma Anômala," 103–4.

25 For a development of this theme in the context of mythology, see Claude Lévi-Strauss, *Mythologiques I: Le cru et le Cuit* (Paris: Pion, 1964), 58–63, 286–7, 325–7; Lévi-Strauss, *Mythologiques IV*, 417–21, 605. See too, of course, the excellent study by Gregory Schrempp, *Magical Arrows: the Maori, the Greeks, and the Folklore of the Universe* (Madison: University of Wisconsin Press, 1992).

26 Kopenawa and Albert, *Yanomami—l'esprit de la forêt*, 68n2.

27 Kopenawa and Albert.

28 Kopenawa and Albert, 73.

29 Note that spirits are nonhumans, and not "are not humans." In other words, the extra humanity of spirits is a case of ontological markedness (Valerio Valeri, *The Forest of Taboos: Morality, Hunting, and Identity among the Huaulu of the Moluccas* (Madison, WI: University of Wisconsin Press, 2000)) in relation to the unmarked status of the human as the referential mode of being.

30 Kopenawa and Albert, *Yanomami—l'esprit de la forêt,* 77. See Kopenawa and Albert, *Yanomami—l'esprit de la forêt,* n39, where Albert observes that a shaman can only see a spirit through the eyes of another spirit.

31 Kopenawa and Albert, *Yanomami—l'esprit de la forêt,* 72-73.

32 Kopenawa and Albert, 73n29.

33 Alfred Gell, *Art and Agency: An Anthropological Theory* (Oxford: Clarendon, 1998).

34 Gilles Deleuze, *Critique et Clinique* (Paris: Minuit, 1993), 100.

35 "You call them 'spirits', but they are others," in Kopenawa and Albert, *Yanomami—l'esprit de la forêt,* 68.

36 "The statement that some nonhuman entity is 'human' is the mark of a specific discourse, shamanry," writes Peter Gow in "Piro Designs: Painting as Meaningful Action in an Amazonian Lived World," *Journal of the Royal Anthropological Institute* 5 (1999): 67, apropos Piro, while Greg Urban, in *Metaphysical Community: The Interplay of the Senses and the Intellect* (Austin: University of Texas Press, 1996), observes that the Shokleng art of dream interpretation "consists in identifying a dream figure as a disguised spirit."

37 Kopenawa and Albert, *Yanomami—l'esprit de la forêt,* 68. The imaginary of Amazonian spirits relishes constructing corporally deformed invisible species, with inverted members, inexistent articulations, minuscule or gigantic appendices, atrophied sensorial interfaces, etc. A good example are the *abaisi* of the Pirahã (Marco Antônio Gonçalves, *O Mundo Inacabado: Ação e Criação em uma Cosmologia Amazônica* (Rio de Janeiro: Editora da UFRJ, 2001).

38 Kopenawa and Albert, 73n32.

39 Gilbert Simondon, *L'Individu et sa Genèse physico-biologique* (Paris: Million, 1995).

40 See Viveiros de Castro, "Cosmological Deixis" on Amerindian "perspectivism."

41 Viveiros de Castro, "Cosmological Deixis."

42 Kopenawa and Albert, *Yanomami—l'esprit de la forêt,* 68.

43 Kopenawa and Albert, 68n2, 84n64.

44 Rodgers, "A Soma Anômala," 112.

45 "The expression *në porepë*, 'in spectral form' ... is often used as a synonym for *utupë*, shamanic image-essence" (Kopenawa and Albert, *Yanomami—l'esprit de la forêt,* 73n33).

46 Albert provides the following synthesis: "Spirits see humans in the form of specters, animals see them as their similars turned into 'house Dwellers,' malefic beings consider them game animals ... and the specters of the dead seem them as abandoned kin" (Kopenawa and Albert, 68n2).

47 On relations between the dead and animals, a wide range of examples can be found in: Stephen Schwartzman, "The Panara of the Xingu National Park." (Ph.D. diss., University of Chicago, 1988), 268 (Panara); Aparecida Vilaça, *Comendo como Gente: Formas do Canibalismo Wari* (Rio de Janeiro: Editora da UFRJ, 2003) (Wari); Turner, T. "Social Body and Embodied Subject: Bodiliness, Subjectivity, and Sociality among the Kayapo," *Cultural Anthropology* 10 (Chicago: Wiley, 1995): 152 (Kayapó); Donald Pollock, "Personhood and Illness among the Culina of Western Brazil" (Ph.D. diss., University of Rochester, 1985), 95 (Kulina); Andrew Gray, *The Arakmbut of Amazonian Peru, 1: Mythology, Spirituality, and History in an Amazonian Community* (Oxford: Berghahn Books, 1996), 157-78, 178 (Arakrnbut); Peter Gow, *An Amazonian Myth and Its History* (Oxford: Oxford University Press, 2001) ch. 5 (Piro); Alexiades, "Ethnobotany," 134, 178 (Ese Eja); Gerald Weiss, "Campa Cosmology." *Ethnology* 11, no. 2 (1972): 169 (Campa); Pierre Clastres,

"Ethnographie des Indiens Guayaki," *Journal de la Societe des Americanistes* 57 (1993) (Aché).

48 George Mentore, "Tempering the Social Self: Body adornment, Vital Substance, and Knowledge among the Waiwai," *Journal of Archaeology and Anthropology* 9 (1993): 22–34.

49 In other words, the raw and the cooked of Lévi-Strauss cannot be separated from the visible and the invisible of Merleau-Ponty.

50 David Smith, "An Athapaskan way of knowing: Chipewyan Ontology," *American Ethnologist*, vol. 25 no. 3 (1998): 412–32; and Tim Ingold, *The Perception of the Environment: Essays on Livelihood, Dwelling and Skill* (London: Routledge, 2000).

51 Mentore, "Tempering the Social Self"; Alexiades, "Ethnobotany of the Ese Eja," 239; Alexandre Surralés, "Au coeur du sens. Perception, affectivité, action chez les Candoshi," *Cahiers des Amériques latines* (2003): 276.

52 Jean-Pierre Chaumeil, *Voir, Savoir, Pouvoir: Le Chamanisme chez /es Yagua du Nord-Est Peruvien* (Paris: Ecole des Hautes Etudes en Sciences Sociales, 1993); Dominique Gallois, "O Pajé Wajãpi e Seus Espelhos," *Revista de Antropologia* 27–28 (1984–85): 179–96; Peter Roe "Impossible Marriages: Animal Seduction Tales among the Shipibo Indians of the Peruvian jungle," *Journal of Latin American Lore* 16 (1990): 131–73; Graham Townsley, "Song Paths: The Ways and Means of Yaminahua Shamanic Knowledge," *L'Homme*, 126–28 (1993): 449–68; J. A. Kelly, "Relations within the Health System among the Yanomami of the Upper Orinoco, Venezuela" (Ph.D. diss., Cambridge University, 2003), 236.

53 Elsje Maria Lagrou, "Cashinahua Cosmovision: A Perspectival Approach to Identity and Alterity" (Ph.D. diss., University of St. Andrews, 1998), 52; see also Kennith Kensinger, *How real People ought to live: the Cashinahua of Eastern Peru* (Prospect Heights {IL}: Waveland Press, 1995), 207; Andrew Gray, *The Arakmbut of Amazonian Peru*, 115, 117.

54 See Gow, "Piro Designs," and Gow, *An Amazonian Myth*, for a comprehensive analysis of vision in an Amazonian culture. Among many other examples of the special implications between the exercise of vision and alimentary determinations, we can highlight: (l) Gow, *An Amazonian Myth*, 139: "When I asked Piro people why they liked to take ayahuasca, they gave two characteristic replies. Firstly, they said it was good to vomit, and that ayahuasca cleansed the body of the residues of game that had been eaten ... These accumulate over time, causing a generalized malaise and tiredness, and eventually a desire to die. [Here compare: "The flesh of game we eat decomposes inside us. On the other hand, the bodies of the *xapiripë* contain no rotten meat" Kopenawa and Albert, *Yanomami—l'esprit de la forêt*, 85.] Secondly, people told me that it was good to take ayahuasca because it makes you see: as one man put it, "You can see everything, every thing." (2) The observation by Alexiades in "Ethnobotany of the Ese Eja," 194, that according to which the *edosikiana*, spirits of the Ese Eja are invisible to all humans except the shaman since whosoever sees an *edosikiana* is devoured by it.

55 Kopenawa and Albert.

56 Eduardo Viveiros de Castro, *From the Enemy's Point of view: Humanity and Divinity in an Amazonian Society* (Chicago, IL: University of Chicago Press, 1992).

57 Robert Storrie, "Equivalence, Personhood and Relationality: Processes of Relatedness among the Hoti of Venezuelan Guiana," *Journal of the Royal Anthropological Institute* 9 (2003): 417.

58 Gerardo Reichel-Dolmatoff, "Drug-Induced Optical Sensations and Their Relationship to Applied Art among some Colombian Indians," in *Art in Society: Studies in Style, Culture and Aesthetics* (New York: St Martin's Press, 1978).

59 Gow, *An Amazonian Myth*, 136.

60 Gow.

61 Cf., for example, Rodgers, "A Soma Anômala."

62 Gow, *An Amazonian Myth*, 135.

63 Viveiros de Castro, *From the Enemy's Point of view*, 131, 219–20; cf. also the "shamanistic luminescence" of the Tukanoan *pajé* in Gerardo Reichel-Dolmatoff, *The Shaman and the Jaguar: a Study of Narcotic Drugs among the Indians of Colombia* (Philadelphia, PA: Temple University Press, 1975), 77, 109.

64 Plotinus, *Enneads*, V, 8, 4.

65 There is a wealth of material in Claude Lévi-Strauss, *L'origine des manières de table* (Paris: Plon, 1967), 115–16, 160, 227–28, that could be explored in this connection.

66 Lévi-Strauss, *L'origine des manières de table*, 78–79.

67 Peter Roe "Impossible Marriages"; Joanna Overing, "Today I shall call him 'Mummy': Multiple Worlds and Classificatory Confusion," in *Reason and Morality. ASA Monographs* 24 (London: Tavistock, 1985); Dominique Gallois, "Xamanismo Waiãpi: nos Caminhos invisíveis, a relação i-paie," in *Xamanismo no Brasil: novas* (Florianópolis: Editora da UFSC, 1996). See the Shipibo myth analyzed by Peter Roe: "the *chaiconi* spirits (Incas/brothers-in law) 'turned over the mirror' and so obscured the primordial human's ability to see the game animals and fish they sought to catch in the crystal-clear waters of the lakes of beginning time. Now, since the mirror has been turned over to face its dull side to humans, they cannot see the animals they hunt ... except if they are near the surface ... Since the shaman, via hallucinatory visions, can go back to beginning time, he will also be able to 'turn over the mirror' and see clearly. Hence shamans are associated with mirrors and use them as accoutrement ..." (Roe, "The Josho Nahuanbo," 120; Roe, "Impossible Marriages," 139–40n12).

68 Bruce Albert notes (pers.com.): "In fact, manufactured mirrors are called *mirena* by the eastern Yanomami (*mire* by the western Yanomami), which is distinct (although it is formed from the same root (*mire-* = ?) from the term denoting the 'mirrors' of the spirits, *mirekope* or *mirexipe*. In another context, *mirexipe* is also used for banks of sand mixed with mica which shine in the clear water of the springs of the high lands in Yanomami territory.... Finally, *xi* signifies light, radiation, emanation."

69 Kopenawa and Albert, *Yanomami—l'esprit de la forêt*, 72.

70 Kopenawa and Albert, 81. These Yanomami ideas on the innumerability and immortality of animal spirits seem to me to have a profound relation with the question of the indefinite regeneration of species, famously discussed by Robert Brightman in relation to the Cree in Brightman, *Grateful prey: Rock Cree Human—Animal relationships* (Berkeley, Oxford: University of California Press, 1993).

71 Kopenawa and Albert, *Yanomami—l'esprit de la forêt*, 73n30.

72 Kopenawa and Albert, 73.

73 Viveiros de Castro, "Esboço de Cosmología Yawalapíti."

74 Kopenawa and Albert, *Yanomami—l'esprit de la forêt*, 73.

75 Gilles Deleuze and Félix Guattari *Milles Plateaux* (Paris: Minuit, 1980). The conceptual determination of spirits as multiplicities possesses fascinating sociological implications, which I lack the space to develop here. I shall simply cite what Gow says in *An Amazonian Myth*, 148, about the essentially collective nature of the interactions with spirits: "When a shaman sings the song of a *kayigawlu* [the shamanic vision of a 'powerful being,' i.e. a spirit], he becomes that *kayigawlu*, But ...

the state of powerful beings is intrinsically multiple ... [T]he imitation of the songs of powerful beings is less a form of possession ... than the entry into another sociality ... The other takes the shaman as part of its multiplicity ..."

76 The complex oscillation between the ideas of minuteness and monstrosity as alternative expressions of an intensive multiplicity has been excellently described by Rodgers, "A Soma Anômala," apropos the lkpeng: "The potential to expand the minimal or obscure points of the world is a distinctive trait of Ikpeng cosmological thought—small (*tikap*) beings, such as humming-birds, squirrels, bees or various tiny fish, being the most potent: all *shamanic/pia t-pe*" (Rodgers, "A Soma Anômala," 100). And here is something that my colleague Tânia Stolze Lima (pers. comm.) found somewhere in Jacques Lizot apropos otters, according to a Yanomami myth: "Otters raise their heads [over the water] because they perceive the Yanomami as minuscule points." Molecularity and (reverse) perspectivism in a single formula.

77 Or, rather, its vulgate since in the work of Lévi-Strauss himself things are much more complicated than that (Eduardo Viveiros de Castro, "Filiação intensiva e aliança demoníaca,"*Novos Estudos Cebrap*, 77. (São Paulo: Centro Brasileiro de Análise e Planejamento, 2007), 91–126).

REFERENCES

Albert, B. 1988. "La Fumée du Métal. Histoire et Représentations du Contact chez les Yanomami." *L'Homme* 106–107 (1988): 87–119.
———. "L'Or Cannibale et la Chute du Ciel: Une Critique Chamanique de l'economie Politique de la Nature." *L'Homme* 126–128 (1993): 349–78.

Albert, B. and Chandes, H. ed. *Yanomami— l'esprit de la forêt*. Paris: Fondation Cartier I Actes Sud, 2003.

Alexiades, M. "Ethnobotany of the Ese Eja: Plants, Health, and Change in an Amazonian society." Ph.D diss., City University of New York, 1999.
———. "El eyamikekua y el ayahuasquero: Las dinámicas socio-ecológicas del chamanismo Ese Eja." *Amazonia Peruana* 27 (2000): 193–213.

Brightman, R.A. *Grateful Prey. Rock Cree Human-Animal Relationships* (Berkeley: University of California Press, 1993).

Campbell, A.T. *To Square with Genesis: Causal statements and Shamanic ideas in Wayãpi* (Edinburgh: Edinburgh University Press, 1993.)

Carneiro da Cunha, M.M. "Pontos de vista sobre a floresta amazônica: xamanismo e tradução." *Mana* 411 (1993): 7–22.

Chaumeil, J. *Voir, Savoir, Pouvoir: Le Chamanisme chez /es Yagua du Nord-Est Peruvien* (Paris: Ecole des Hautes Etudes en Sciences Sociales, 1993).

Clastres, P. "Ethnographie des Indiens Guayaki." *Journal de la Societe des Americanistes* 57 (1993): 8–61.

Deleuze, G. *Critique et Clinique* (Paris: Minuit, 1993).

Deleuze, G. & F. Guattari. *Milles Plateaux* (Paris: Minuit, 1993).

Jara, F. *El Camino de / Kumu: Ecologia y Ritual entre los Akuriyó de Surinam* (Quito: Abya-Yala, 1993).

Gallois, D. "O Pajé Wajãpi e Seus Espelhos." *Revista de Antropologia* 27-28 (1984-1985): 179-196.

———. "Xamanismo Waiãpi: nos Caminhos invisíveis, a relação i-paie," in E.J. Langdon, (ed.). *Xamanismo no Brasil: novas perspectivas.* (Florianópolis: Editora da UFSC, 1996).

Gell, A. *Art and Agency: An Anthropological Theory.* (Oxford: Clarendon, 1998).

Goncalves, M.A.T. *O Mundo Inacabado: Ação e Criação em uma Cosmologia Amazônica.* (Rio de Janeiro: Editora da UFRJ, 1998).

Gow, P. "Piro Designs: Painting as Meaningful Action in an Amazonian Lived World." *Journal of the Royal Anthropological Institute* 5 (1999): 229-246.

———. *An Amazonian Myth and Its History.* (Oxford: Oxford University Press, 2001).

Gray, A. *The Arakmbut of Amazonian Peru, 1: Mythology, Spirituality, and History in an Amazonian Community.* (Oxford: Berghahn Books, 1996).

Guss, D. *To Weave and to Sing: Art, Symbol, and Narrative in the South American Rain Forest.* (Berkeley, CA: University of California Press, 1989).

Hugh-Jones, S. *The Palm and the Pleiades. Initiation and Cosmology in Northwest Amazonia.* (Cambridge: Cambridge University Press, 1979).

———. "Shamans, Prophets, Priests and Pastors," in N. Thomas & C. Humphrey (ed.). *Shamanism, History, and the State.* (Anne Arbor, MI: University of Michigan Press, 1996).

Ingold, T. *The Perception of the Environment. Essays on Livelihood, Dwelling and Skill.* (London: Routledge, 2000).

Kelly, J.A. "Relations within the Health System among the Yanomami of the Upper Orinoco, Venezuela." Ph.D. diss., Cambridge University, 2003.

Kensinger, K. *How real People ought to live: the Cashinahua of Eastern Peru.* (Prospect Heights, IL: Waveland Press, 1995).

Kopenawa, D.Y. "Sonhos das origens." *Povos indigenas no Brasil.* (São Paulo: ISA, 2000).

———. "Xapiripë." *Yanomami, o Espirito da Floresta.* (Rio de Janeiro: Centro Cultural Banco do Brasil I Fondation Cartier, 2004).

Kopenawa, D.Y. & B. Albert. "Les Ancêtres Animaux," in B. Albert & H. Chandes (ed.). *Yanomami—l'esprit de la forêt.* (Paris: Fondation Cartier I Actes Sud, 2003).

Kracke, W. "Everyone who dreams has a bit of Shaman: Cultural and Personal Meaning of Dreams Evidence from the Amazon." *Psychiatric Journal of the University of Ottawa* 12: 65-72.

Lagrou, E.M. "Cashinahua Cosmovision: A Perspectival Approach to Identity and Alterity." Ph.D. diss., University of St. Andrews, 1998.

Lévi-Strauss, C., *Mythologiques I: Le cru et le Cuit.* (Paris: Plon, 1964).

———. *Mythologiques IV: L'Homme nu.* (Paris: Plon, 1971).

Lévi-Strauss, C. and D. Eribon. *Depres et de loin.* (Paris: Odile Jacob, 1988).

Lienhardt, Godfrey. *Divinity and Experience: The Religion of the Dinka.* (Oxford: Oxford University Press, 1961).

Mentore, G. "Tempering the Social Self: Body adornment, Vital substance, and knowledge among the Waiwai." *Journal of Archaeology and Anthropology* 9 (1993): 22-34.

Overing, J. "Today I shall call him 'Mummy': Multiple Worlds and Classificatory Confusion." *Reason and Morality.* ASA Monographs 24. (London: Tavistock, 1985).

Pollock, D. 1985. "Personhood and Illness among the Culina of Western Brazil." Ph.D. thesis, University of Rochester.

Reichel-Dolmatoff, G. *The Shaman and the Jaguar: a Study of Narcotic Drugs among the Indians of Colombia.* (Philadelphia, PA: Temple University Press, 1975).

———. "Drug-Induced Optical Sensations and Their Relationship to Applied Art among some Colombian Indians." *Art in Society: Studies in Style, Culture and Aesthetics.* (New York: St Martin's Press, 1978).

Rodgers. D. "A Soma Anômala: A Questão do Suplemento no Xamanismo e Menstruação Ikpeng." *Mana* 8, no. 2 (2002): 91–125.

Roe, P.G. *The Cosmic Zygote: Cosmology in the Amazon Basin.* (New Brunswick, NJ: Rutgers University Press, 1982).
———. "The Josho Nahuanbo are all wet and undercooked: Shipibo views of the Whiteman and the Incas in Myth, Legend, and History," in J. Hill (ed.). *Rethinking History and Myth: Indigenous South American Perspectives on the Past.* (Urbana & Chicago, IL: University of Illinois Press, 1988).
———. "Impossible Marriages: Animal Seduction Tales among the Shipibo Indians of the Peruvian jungle." *Journal of Latin American Lore* 16 (1990): 131–73.

Schrempp, G. *Magical Arrows: The Maori, the Greeks, and the Folklore of the Universe.* (Madison, WI: University of Wisconsin Press, 1992).

Schwartzman, S. "The Panara of the Xingu National Park." Ph.D. diss., University of Chicago, 1988.

Simondon, G. *L 'Individu et sa Genesephysico-biologique.* (Paris: Millon, 1995).

Smith, D. "An Athapaskan Way of Knowing: Chipewyan Ontology." *American Ethnologist* 25 (1988): 412–32.

Storrie, R. 2003. "Equivalence, Personhood and Relationality: Processes of Relatedness among the Hoti of Venezuelan Guiana." *Journal of the Royal Anthropological Institute* 9: 407–28.

Strathern, M. *Partial Connections.* (Savage, MD: Rowman & Littlefield Publishers, 1991).

Townsley, G. "Song Paths: The Ways and Means of Yaminahua Shamanic Knowledge." *L'Homme*, 126–8 (1993): 449–68.

Turner, T. "Social Body and Embodied Subject: Bodiliness, Subjectivity, and Sociality among the Kayapo." *Cultural Anthropology* 10: 143–70 (Chicago: Wiley, 1995).

Urban, G. *Metaphysical Community: The Interplay of the Senses and the Intellect.* (Austin, TX: University of Texas Press, 1996).

Valeri, V. *The Forest of Taboos: Morality, Hunting, and Identity among the Huaulu of the Moluccas.* (Madison, WI: University of Wisconsin Press, 2000).

van Velthem, L.H. *O belo é a fera: a estética da produção e da predação entre os Wayana* (Lisbon: Assirio & Alvim, 2003).

Vilaça, A. *Comendo como Gente: Formas do Canibalismo Wari'.* (Rio de Janeiro: Editora da UFRJ, 2003).

Viveiros de Castro, E.B. *From the Enemy s Point of view: Humanity and Divinity in an Amazonian Society.* (Chicago, IL: University of Chicago Press, 1992).
———. "Cosmological Deixis and Ameridian perspectivism." *Journal of the Royal Anthropological Institute* 4 (Cambridge: Royal Anthropological Institute, 1998): 469–88.
———. "GUT Feelings about Amazonia: Potential Affinity and the Construction of Sociality," in L. Rival & N. Whitehead, (ed.). *Beyond the Visible and the Material: The Amerindianisation of Society in the Work of Peter Rivière.* (Oxford: Oxford University Press, 2001).
———. "Esboço de Cosmologia Yawalapíti," in *A Inconstância da Alma Selvagem.* (São Paulo: Cosac &Naify, 2002).
———. "Xamanismo e Sacrificio." *A Inconstância da Alma Selvagem.* (São Paulo: Cosac &Naify, 2002).
———. "Filiação intensiva e aliança demoníaca." *Novos Estudos Cebrap*, 77. (São Paulo: Centro Brasileiro de Análise e Planejamento, 2007): 91–126.

Weiss, G. "Campa Cosmology." *Ethnology* 11, no. 2 (1972): 157–72.

Luminous in the Sun

The Cool Botanical Fervor of Abel Rodríguez (Mogaje Guihu)

Quinn Latimer

"When one gets lost in the forest, the forest falls in love with your thoughts and you stay lost," Abel Rodríguez has said.[1] One feels this forest love of the mind, ardent and exquisite and nearly molecular, running in both directions—like the rivers that flood the forest in certain seasons—in the lush, lucid spaces of Rodríguez's paintings and drawings of the rainforest in Nonuya Amazonia. Rodríguez's dense glens of tropical trees, animals at their feet, are at once granular and cosmological in their constellating detail of Indigenous flora and fauna and animalia. His palette is startlingly oceanic—blues, greens, reds—and the sacred, medicinal, and domestic uses of such plants and trees, along with their names, are often noted in the artist's attentive hand.

"Something I learned is that everyone has a name," Rodríguez says. He was born Mogaje Guihu, circa 1944, into the Hawk's clan of the Nonuya ethnic group, in the headwaters of the Cahuinarí River in the Colombian Amazon. "We fly high. The radiance of the hawk's feathers, luminous in the sun. That's what Mogaje Guihu means." Rodríguez's uncle passed on his vast ancestral knowledge of Indigenous plants to his nephew, who acquired it eagerly. Rodríguez would eventually become a guide for Tropenbos, a Dutch NGO whose mission is to study and protect the tropical jungle. In the 1990s, though, amidst the Colombian armed conflict and the violent exploitation of the rainforest and its Indigenous inhabitants and protectors, Rodríguez and his family were driven from their lands; they would move to Bogotá soon after.

In Bogotá, Rodríguez once again began working for Tropenbos, where he was invited this time by Carlos Rodríguez, the biologist who led the NGO's Colombian branch, to make botanical drawings.[2] The botanical illustrations that resulted are drawn entirely from Indigenous oral tradition and Rodríguez's experiential memory; his work then is a form of botany, history, writing, memory, image-making, and resistance—of ancestral knowledge of the medicinal uses of the Indigenous plants of his region. Though his botanical drawings are largely recognized by Western botanists for their import and significance, they have also begun circulating to great acclaim through contemporary art institutions across the world, where they have been shown in exhibitions including documenta 14, in Athens and Kassel, and in solo exhibitions at BALTIC Center for Contemporary Art, in the UK, and elsewhere across the Americas, Asia, and Europe. Still, Rodríguez notes: "I don't give the same sense of luxury to the images I draw," as others do. "I don't reveal what I really value; I keep it secret."

In the same sense that Rodríguez received his knowledge of plants through the ancestral stories of his uncle, the artist carries on this narrative tradition. His drawings and paintings are not simply botanical illustrations (though what is simple about that), but origin stories about the creation of the forest, the Amazon, and the world itself. If *Árbol de la vida y de la abundancia* (Tree of Life and Abundance, 2019) and *La montaña de centro* (The Central Mountain, 2020) relate narratives about the beginnings of the jungle, other works offer more local and detailed information. For example, the Indigenous Muinane and Spanish names of certain yuca, and the small animals who feed on them, or the seasonal cycle of a river's overflowing into the forest, so its fish may feed on its fallen fruits, and then have the energy to spawn again, like *Ciclo anual del bosque de la vega* (Seasonal Changes in the Flooded Rainforest, 2009–10).

Rodríguez's luminous works reveal the Amazonian forest ecosystem to be both metabolic and historical, each form of life feeding into the next, a cyclical system of sustenance. His images appear incisively rhizomatic, at once in the botanical sense and in the Deleuzian meaning of an image of thought, with its myriad multiplicities.[3] If Deleuze and Guattari placed their nonhierarchical rhizome against the binary arborescent—the latter system of thought named for the manner in which genealogy trees are drawn, as a dualistic forward progression without breaks—Rodríguez's oeuvre fluently breaks apart this image of the arbor, the tree, as something binary and totalizing and inflexibly authoritarian. Rodríguez's dazzling trees are the past, the future, and the present simultaneously; they feed on and sustain each other, as we might well too.

1 All quotes by Abel Rodríguez are from *ABEL (the film)* (2014), directed by artist Fernando Arias. The Prince Claus Fund commissioned Arias to make a short film about the Principal Laureate Abel Rodriguez for the awards ceremony at the Royal Palace in Amsterdam in 2014. To produce the film, Arias and Rodriguez worked together in Bogotá, followed by a week filming in the Amazon region.

2 See José Roca's text on Abel Rodríguez in *documenta 14: Daybook*, ed. Quinn Latimer and Adam Szymczyk (Munich and London: Prestel, 2017).

3 Félix Guattari and Gilles Deleuze, *A Thousand Plateaus: Capitalism and Schizophrenia*, trans. Brian Massumi (University of Minnesota Press, 1980).

Abel Rodríguez, *El árbol de la vida y la abundancia*, 2019. Ink on paper, 150 × 150 cm. Courtesy of the artist and Instituto de Visión. Image: Sandra Vargas.

AMAZONIA

Mogaje guihu
Abel Rodriguez M.

94

FOREST

Abel Rodríguez, *Monte firme II*, 2020. Ink on paper, 50 × 70 cm. Courtesy of the artist and Instituto de Visión. Image: Sandra Vargas.

Abel Rodríguez, *Foicuje Janugay—YucaBravaDeGrillo*, 2018. Ink on paper, 40 × 35 cm. Courtesy of the artist and Instituto de Visión. Image: Sandra Vargas.

Abel Rodríguez, *Mata de Achiote*, 2018. Ink on paper, 40 × 35 cm. Courtesy of the artist and Instituto de Visión. Image: Sandra Vargas.

AMAZONIA

Abel Rodriguez Mainanse
Mogaje guiuu

La hoja

Kumega janegay
yuca brava

Ratón
guiibo

98

FOREST

Abel Rodríguez, *Kumega Janugay—YucaBrava*, 2018. Ink on paper, 40 × 35 cm. Courtesy of the artist and Instituto de Visión. Image: Sandra Vargas.

AMAZONIA

Abel Rodríguez,
La Montaña de Centro II,
2020. Ink on paper,
70 × 100 cm.
Courtesy of the artist and
Instituto de Visión.
Image: Sandra Vargas.

The Geological Imperative

On the Political Ecology of Amazonia's Deep History

Paulo Tavares

Beginning in the late 1960s, a series of reports produced by international media and non-governmental agencies exposed the critical situation confronting the Indigenous peoples of Amazonia, whose territorial, cultural, and physical survival was severely threatened by the advancement of large-scale development projects into their lands. Out of this lineage of "activist" publications came *The Geological Imperative: Anthropology and Development in the Amazon Basin of South America*, a ninety-page compilation of four articles written by the American anthropologists Shelton H. Davis and Robert O. Mathews and published in 1976. An exercise in "political anthropology," as the authors described it, this report presented an up-to-date cartography of mining and drilling activities in formerly "isolated" areas of Amazonia, describing a "frontier scenario" of systematic and generalized human rights violations against Indigenous communities.

By offering a critical map of the contemporary context within which ethnological fieldwork was taking place in Amazonia—a situation that was representative of other ethnographic fronts across the Third World—*The Geological Imperative* made a case for political engagement through anthropological practice. Its authors contended that ethnographers should consider this specific historical conjuncture, situating their research alongside the developmental program that was being deployed in Amazonia. The proposed exercise in political anthropology did not, therefore, refer to the traditional concerns of ethnology regarding the internal symbolic order and social hierarchy of "primitive societies." Instead, political anthropology was called on to address the role of anthropology itself, insofar as it was inevitably immersed within, and most often complicit with, external arrangements of power responsible for, in the words of Davis and Mathews, the ongoing process of "ethnocide of South American Indians."[1]

The Geological Imperative was published in the context of the contentious ethical-political debates that unfolded in professional circles of North American anthropology in the 1960s and 1970s following revelations that the US Army was applying ethnographic research in the design of counter-insurgency strategies in Latin America and Southeast Asia. During the Second World War, with the official support and sponsorship of the American Anthropological Association, anthropologists had employed their expertise to help the Allied campaign. Defined in reaction to the Nazis' "scientific" theories of racial superiority, this war-time politicization of anthropology was accompanied by a growing militarization of ethnographic research. The intellectual links and institutional networks established at this time would be applied less overtly but more directly during the Cold War era in

the service of communism containment strategies deployed by the United States in Latin America, Africa, and Asia.[2] While the use of ethnographic intelligence as a tool of population control is arguably constitutive of the science of anthropology itself, intrinsic to its colonial origins,[3] knowledge about the "culture of others" gained new geopolitical importance as the US either indirectly or directly attempted to expand its military, political, and economic influence over the resource-rich, largely Indigenous frontiers of the Third World.

This was the context from which *The Geological Imperative* emerged and in relation to which its authors contended anthropological practice should situate itself—the Cold War. Overlapping interests between state and capital defined the basic framework of US interventionism in the Southern Cone as compromises with authoritarian regimes were measured both in relation to the objective of containing the left and the advantages that allied governments provided for the penetration of US corporate capital into regional markets.[4] For their part, the military juntas that ruled Latin America tended towards a form of "modernizing capitalism" that combined centralized control in planning and legislation with radical economic liberalism. The impressive GDP-growth rates achieved with this model in the early 1970s were driven by concentrated patterns of capital accumulation structurally dependent on international financial loans, corporate investment, and large-scale exploitation of natural resources for export. By the mid-1970s, when *The Geological Imperative* was published, the prospects of an international energy crisis triggered by the Middle East oil embargo had unleashed a global rush among states and multinational corporations to secure sources of strategic minerals and fossil fuels. These factors led to unprecedented efforts to open the subsoil of the Amazonia to international markets.

Alongside such groups as INDIGENA, the North American Congress on Latin America (NACLA), and the Brazilian Information Bulletin (BIB), *The Geological Imperative* was part of a wider network that served to monitor and publicize information about the participation of foreign governments, international corporations, and financial institutions in the policies and projects being implemented by military regimes in Latin America. At a moment when political dissidence and freedom of speech were severely curtailed across most of the continent, these publications attempted to deter human rights abuses by those regimes and put public pressure on the states and institutions that indirectly or directly supported them.

The Geological Imperative also questioned the specific role that the Amazonian ethnologists and ethnographers were playing within the repressive apparatus of governance that was installed throughout Latin America. From the mid-1960s on, in parallel to escalating US interventions in Latin America and accelerating resource extraction from the Amazon Basin, Davis and Mathews noted an increasing influence of socio-evolutionist approaches in the work of North American anthropologists. They argued that the imaginary produced and transmitted by these studies was helping to legitimize the expropriation of Indigenous lands. Exemplary socio-evolutionists included the playwright-cum-anthropologist Robert Ardrey, whose widely read book, *The Territorial Imperative* (1966), provided Davis and Mathews with a critically appropriated title for their report, and Napoleon Chagnon, whose infamous work among the Yanomami they harshly criticized. As earlier, when Darwinist-informed theories of social evolutionism had granted moral legitimacy to the slaughter of Indigenous peoples and the colonization of their territories, the visions generated and communicated by Chagnon and Ardrey masked the social and environmental violence of the Cold War's "geological colonialism."[5] "In contrast to those who would describe this phenomenon as a natural occurrence, i.e., as one of the inevitable results of social progress and economic growth," Davis and Mathews wrote, "we see the 'geological imperative' as a unique historical phenomenon related to specific distribution of wealth and power which presently exists in the world."[6] Rather than being imposed by natural determinants, the imperative, they concluded, was decisively ethical and political.

OPERATION AMAZONIA

Building on an historical analogy with earlier forms of colonialism, "the geological imperative" described a whole new geopolitical space that was being shaped by the Cold War. It also reflected the radical transformation of Amazonia's social-natural geography. Until the 1960s, initiatives to colonize the Amazon Basin—first by colonial powers and later by the independent nation-states that succeeded them—had typically abided by the spatial arrangements dictated by the surface. Although there had been some exploration of mineral and oil deposits, the subsoil was far less important than timber, nuts, and Amazonia's foremost product, latex. In the postwar decades, however, Amazonia was visualized and interpreted in all its "ecological depth": a complex environment composed of various geological and biophysical factors offering unlimited economic potential.

Maneuver: In the 1967 book *Geopolítica do Brasil (Geopolitics of Brazil)*—a territorial interpretation of Brazilian history that exerted great influence on the armed forces during the military dictatorship—General Golbery do Couto e Silva, arguably the most important intellectual of the regime, described Amazonia as a giant island floating at the margins of the national polity, "mostly unexplored, devitalized by the lack of people and creative energy, and which we must incorporate into the nation, integrating it into the national community and valuing its great physical expression which today still is almost completely passive." The first map shows the Brazilian territory divided into four regions: the "central nucleus" and three "peninsulas" to the south, center-west, and northeast. Floating at the margins is the "Amazonian Island." The second map describes the "maneuver for the integration of the national territory." Golbery do Couto e Silva, *Geopolítica do Brasil* (Rio de Janeiro: Livraria J. Olympio, 1967).

Novel ways of identifying, charting, and accessing formerly unknown or inaccessible resources enabled interventions at an unprecedented scale. This objective was pursued with different degrees of intensity but largely consistent spatial patterns, under the ubiquitous developmental ideology adopted by the states of the continental basin. Strategists and planners characterized the Amazonia as a space engulfed by chronic lack—demographic emptiness, economic stagnation, technological backwardness, territorial isolation—a condition which made the region prone to foreign invasions and which therefore called for an orchestrated and forceful strategy of "integration." For the governments of South America, the colonization of Amazonia played at least two crucial roles: taming the tropical forest became symbolically important in the context of nationalist and modernizing discourses, and the forest's sheer natural wealth was expected to propel these countries out of underdevelopment.

Moreover, the understanding that Amazonia was a "continental void" to be mastered and developed was not restricted to the nationalist elites and militarized technocracy of South America, but formed part of a general perception also shared by policy makers and planners working for bilateral

Deep Cartography: In order to identify zones of strategic resources, a large-scale mapping survey named Radar Amazonia, or RADAM, was initiated in the early 1970s. Employing radar-based remote sensing technologies first used in the Vietnam War (capable of sensing the terrain below the forest canopy and its moisture atmosphere) in combination with Landsat imagery and extensive ground sampling, RADAM produced the first detailed biophysical and geological inventory of Amazonia; it completely altered the ways in which Amazonia was visualized, interpreted, and intervened upon. RADAM, SLAR image of the region around the city of Manaus, 1973; pages extracted from RADAM's geological/ground-survey inventory.

and international agencies. One example of this perspective, as extreme as it was ludicrous, was a project promoted in the late 1960s by the Hudson Institute to build a massive dam across the Amazon River that would result in the formation of a "Mediterranean Sea" at the interior of the basin. The dam was intended to function as a giant energy reservoir for South America and the US, as well as a way to catalyze the movement of millions of landless migrants to colonize the region.[7] Another remarkable example was a 1971 study by the UN Food and Agricultural Organization suggesting that, in order to absorb the impacts of exponential global population growth, Amazonia should be converted into vast fields of grain production.[8]

In the Cold War's belligerent rush for raw materials, Amazonia was seen as a vast, primordial reserve of natural resources. Once properly

harnessed by modern technologies, the forest's raw materials would serve to develop national economies, meet growing rates of world consumption, and secure steady flows of energy and minerals to the global military-industrial complex. Despite the ecologically destructive potential embodied in these views, what was consolidated in the 1960s and 1970s was a proper environmental understanding of Amazonia, one less associated with counter-cultural activism than with neo-Malthusian manifestations of the ecological discourse that emerged at the time. Amazonia was gradually apprehended as a deep geophysical terrain upon which a series of novel cartographic imaginaries, governmental discourses, and grand planning strategies would be projected and deployed, which in turn would lead to dramatic changes in both its natural and social landscapes.

The clearest expression of this transformation was "Operation Amazonia," a large-scale program of regional development implemented by the Brazilian government that sought to convert practically the entire basin into a massive frontier of resource extraction and agricultural production. Launched only two years after the military coup of 1964, the "operation" began with the establishment of Legal Amazonia, a territorial jurisdiction that covered the entire portion of the basin within Brazil's sovereign borders—59 percent of the country's territory and practically 60 percent of Amazonia's natural area. This vast and complex environment fell under the direct control of the military command. The creation of this "natural-political jurisdiction" set the stage for interventions that would encompass the basin as a "bio-geographic unit"—that is to say, at the point where the "ecological scale" and the "legal scale" intersected.

Throughout the 1970s and 1980s, the military's plan to "occupy and integrate" Amazonia was translated into a series of radical experiments in spatial planning, conceived and deployed as if the diverse and complex ecology of Amazonia could be "designed" in its entirety. A project of such magnitude could only be implemented by a centralized and authoritarian state apparatus, which guaranteed its enforcement by bypassing democratic debate and minimizing dissidence. Operation Amazonia was as much a result of the generalized state of repression that characterized this period in Brazil as it was a means deployed by the generals to achieve political containment. The discourses of modernization, security, and nationalism that supported this planning strategy played a decisive role in legitimizing the violent political order by which the military ruled and the radical process of territorial reorganization that they sought to impose.

Operation Amazonia: The overlap between natural and political territories. Yellow hatching shows deforestation between 1972–1991.

THE WHITE PEACE

In the early 1900s, as the booming coffee business in Brazil grew hungry for new lands, the expansion of the "national frontier" towards the hinterlands met fierce resistance from Indigenous groups. Relying on the differential power of US Winchester rifles—"the gun that won the west"—settlers and state forces engaged in a lawless and asymmetrical war to expand their control over Indian lands, leading to bloody conflicts and the slaughter of entire native communities in southern Brazil.

The state's response to mediate this situation was the creation of the Service for the Protection of the Indian (SPI) in 1910, a governmental agency whose mandate was to establish peaceful contact with Indigenous peoples and oversee their welfare. Originally named SPILTN—which adds to the acronym the phrase "and Localization of the National Worker"—the SPI's founding ethos was simultaneously pacifist and expansionist, humanitarian and governmental, ideologically opposed to the extermination of Indigenous peoples while at the same time functioning as one of the most efficient mechanisms to open up their lands for colonization.

AMAZONIA

transamazônica
- ALTAMIRA -

MA·INC
RÊDE RODOVIÁRIA DA AMA

Territorial Design: On the ground, the general's blueprint for Amazonia was translated into a continental matrix of highways connecting "poles of development." The poles were designed as modernizing enclaves equipped with the infrastructural capacity to accommodate large-scale resource extraction operations (e.g., dams, railways, airports, and seaports). The highway matrix was planned as the primary channel through which agricultural frontiers would expand into the hinterland while at the same time providing routes for the migration of a massive labor force. A Map of Plan of National Integration, INCRA – Institute for Agrarian Reform and Colonization, 1971.

Frontier: The city of Sinop, central urban node of the soy complex in southern Amazonia and one of the key "poles of development" designed by the military regime, at an early stage of construction in the early 1970s.

Airfields in southeastern Amazonia built by the Roncador-Xingu expedition, ca. 1950.

The agency employed a strategy similar to the colonial reductions (*reducciones*), concentrating dispersed communities in so-called "Posts of Attraction," which later turned into agricultural settlements where "pacified Indians" were gradually introduced to the habits of white civilization.

By the late 1960s, when the SPI comprised a network of more than a hundred posts distributed throughout the Brazilian territory, its pacifist/humanitarian mission had degenerated into a corrupt and criminal bureaucracy, and the agency had become complicit in the extermination of Indigenous groups. An extensive investigation directed by attorney Jader Figueiredo in 1967–1968 led to the dissolution of the SPI and the subsequent creation of a similar agency named FUNAI, the National Foundation of the Indian. Months later, in December 1968, the military government issued the infamous Institutional Act No. 5, a state-of-emergency law that gave overwhelming powers to the "Supreme Command of the Revolution" over every aspect of civilian life. A much more pervasive surveillance apparatus came into effect and Brazil descended into the most repressive period of the dictatorship.

Under the directorship of General Bandeira Melo, a former intelligence officer, FUNAI's operations were firmly aligned with the doctrines of security and development elaborated by the military command. As the generals vowed to close the frontier and accelerate the "integration" of the hinterlands into the national economy, the politics of pacification became increasingly

Pacification: Nilo Oliveira Vellozo, head of the Studies Section of the Service for the Protection of the Indian, distributes gifts to Kuikuro Indians, Mato Grosso, southern Amazonia, 1944.

militarized, worsening the historical situation of structural violence and systematic human rights violations against the Indigenous people of Brazil.

In September 1974, nearly a year after dictator Garrastazu Médici sanctioned the "Indian Statute," the legal decree that opened a full-fledged integrationist campaign, a group of Brazilian anthropologists published *The Politics of Genocide against the Indians of Brazil*, denouncing the grave human rights violations that were being committed against Indigenous groups around the country. For its authors, whose names were not revealed because they feared repression, the military's politics of pacification amounted to genocide as defined by international law. They called for the establishment of a UN-led committee to investigate the policies and practices of the Brazilian state. Rather than being the isolated actions of a dysfunctional and criminal governmental agency, the report argued, the violence was rooted at the very heart of the military's national-developmental project.[9] *The Geological Imperative* also responded to that context. Pointing to the participation of multinational corporations and international financial institutions in the "global scheme" that sustained the dictatorship, its authors held those organizations partially responsible for what the Brazilian anthropologists denounced as a genocidal politics. Davis and Mathews, however, employed a slightly different, but correlated, concept—"ethnocide."

Anthropologist Pierre Clastres best articulated the difference between the two: "genocide assassinates people in their bodies, ethnocide kills them in their souls."[10] Although closely related and to a large extent inseparable, these concepts were created to give name to different forms of violence,

Map 01:
Ethno-historical map of Brazil based on the original map designed by ethnologist Curt Nimuendajú in 1944.

Map 02:
Map of the network of outposts and bases of the SPI in 1946.

each originating in relation to a specific historical situation. Coined by jurist Raphael Lemkin in 1944 to describe the systematic extermination of the European Jews by the Nazi regime, genocide was made an international crime in 1948 after the Nuremberg Trials.[11] In Lemkin's original definition, genocide referred to an overall strategy intended to destroy in whole or in part a national, racial, religious, or ethnic group; that is, the concept names a form of violence that is directed towards a collective *qua* collective. As scholar Dirk Moses points out in a thorough analysis of Lemkin's unpublished research notes, his early attempts to define genocide included both physical and cultural annihilation, violence against the body and the soul. "Physical and biological genocide are always preceded by cultural genocide," Lemkin wrote, "or by an attack on the symbols of the group or by violent interference with religious or cultural activities."[12]

The jurist considered "cultural genocide" an essential aspect of the crime he was trying to name, but due to a series of political compromises and the diverging interests of different nation-states, and despite the fact that some drafts of the 1948 UN Genocide Convention did incorporate the concept, cultural genocide was erased from the codes of international law. This historical outcome, Moses argues, "advantaged states which sought to assimilate their Indigenous populations and other minorities after World War II."[13]

In early 1970s, as new resource frontiers expanded into the "isolated" territories of the Third World, militant ethnologists started to employ the concept of ethnocide to describe the dimension of cultural violence that had been

excluded from the legal definition of genocide. Not necessarily invoking physical annihilation but describing a process equally committed to the destruction of otherness, "ethnocide" was a word invented to describe what the Brazilian military called "integration." Anthropologist Robert Jaulin made the foremost contribution to the term's definition, particularly in the book *The White Peace: Introduction to Ethnocide* (1970). While conducting fieldwork among the Bari people on the border between Colombia and Venezuela, Jaulin witnessed an aggressive campaign of assimilation carried out by armed forces and civilizing missionaries in order to open the lands of the Bari to multinational oil companies. "Integration," he wrote, "is the right to life granted to the other with the condition that they become who we are ... but the contradiction of this system is precisely that the other, detached from himself, dies."[14] Whereas genocide expresses the total negation of the other in the aim of physical destruction, ethnocide is a form of violence that transforms that negativity into a positive, humanitarian intent. "The spirit of ethnocide," Clastres concluded, "is the ethics of humanism."[15]

ECOCIDE

After the end of World War II, and as a result of the Nuremberg Trials, we justly condemned the willful destruction of an entire people and its culture, calling this crime against humanity genocide. It seems to me that the willful and permanent destruction of environment in which a people can live in a manner of their own choosing ought similarly to the considered as a crime against humanity, to be designated by the term ecocide.[16]

American botanist Arthur W. Galston, a pioneer inventor of defoliants and one of their harshest critics, made this statement during a panel titled "Technology and American Power: The Changing Nature of War" at a conference organized in Washington in 1970 to debate the war crimes that were being committed by the US Army in Vietnam. As with genocide and ethnocide, the concept of ecocide was invented to describe a form of violence that, although not completely new, achieved unprecedented scope and intensity during the scorched-earth campaign deployed by US military forces against the forests of Indochina.

The mobilization of nature as a weapon of war is as old as human conflict itself, but what the Vietnam War revealed was a heretofore-unseen ability to destroy vast ecologies in a very short period of time. The "environmental violence" intrinsic to the techno-scientific apparatus being developed in

FOREST

Environmental violence: Before (1975) and after (2001) satellite images showing patterns of deforestation at one of the "development poles" in southwestern Amazonia (image analysis by UNEP). Patterns of environmental degradation in Amazonia followed the blueprint elaborated by the military.

support of the Cold War, whether applied in military or civilian industries, had never before been so painfully visible. Hence, Arthur Galston concluded his statement with the following words:

> I believe that [the] most highly developed nations have already committed auto-ecocide over large parts of their own countries. At the present time, the United States stands alone as possibly having committed ecocide against another country, Vietnam, through its massive use of chemical defoliants and herbicides. The United Nations would appear to be an appropriate body for the formulation of a proposal against ecocide.[17]

Amidst the burgeoning debate about the degradation of the global environment by civilian offshoots of the war industry, legal scholars debated the concept of ecocide through the 1970s. Many called for the UN to incorporate acts of "deliberate environmental destruction" into the list of crimes against peace.[18] Discussions on whether or not to include ecocide within the frameworks of international law have continued ever since, but only mild resolutions have been implemented to date.[19]

The novel methods and brutality of twentieth-century violence forced the creation of new concepts and laws and challenged established ethical and moral codes. In Amazonia, multiple forms of violence coalesced into a single spatial strategy. Whether or not the Brazilian military regime was complicit in acts of genocide against Indigenous populations is a highly controversial question that is only now being properly investigated after the much-delayed Brazilian Truth Commission was finally established in early 2011.[20] What is beyond doubt is that the politics of integration/pacification in Amazonia were based on an ethnocidal logic, that their implementation on the ground led to the physical extermination of entire Indigenous communities, and—no less important—that this process was accompanied by widespread ecological destruction.

Before "Operation Amazonia," most of "Legal Amazonia" was unregulated land defined as *terras devolutas*, a form of land-property inherited from colonialism. Although owned by the state, *terras devolutas* have no legally defined public use; they remain in the "public" domain but are available for private appropriation. As roads opened up these unlegislated zones for colonization, massive deforestation followed. The creation of pasturelands turned out to be one of the most effective ways for speculators to claim and secure land titles, engendering a mechanism of "enclosure-by-destruction"

that resulted in a vicious cycle of ecological and social violence that continues today.

Uprooted by the expansion of mono-crop plantations in the south and the northeast of Brazil, hundreds of thousands of landless peasants migrated to the frontier zones of Amazonia to settle near the highways, only to be expelled by powerful landowners soon afterwards. Lacking adequate technical and financial support from the government to grow crops in the rainforest's harsh edaphic conditions, large contingents settled in urban centers. Around the sites of extractive industries and dams, old and new towns grew uncontrollably, turning Amazonia in one of the fastest-growing and most precarious urban frontiers in the world. Defying the general's grand planning strategies, cities sprawled without the necessary infrastructure, producing a form of urbanization that, as Mike Davis sharply observed, became practically synonymous with "favelization."[21]

By the mid-1980s, when Brazil entered the "transition to democracy" and the ecological crisis had become an issue of international concern, Amazonia turned into a symbolically powerful space in the defense of the global environment. While the decades-long dominance of the development doctrine was fractured by the new paradigm of sustainability, remote-sensing technologies formerly used to map resources and the land's economic potential were being used to grasp the scale of environmental destruction caused by the previous decades' planning schemes. The urgent quest to monitor and preserve ecosystems became one of the most important debates in the forum of environmental politics, both because of the threat of losing biodiversity and because climate change was already emerging as a contentious problem.

Tropical forests perform a crucial function in global climate regulation, removing large amounts of CO_2 from the atmosphere and locking it up in a dynamic cycle of vegetation growth and decay. Amazonia is a giant reservoir of carbon, containing roughly one-tenth of the global total.[22] When burned, it is also a powerful source of greenhouse-gas emissions. In 1990, two years before the first UN Earth Summit was convened in Rio de Janeiro and months after presidential elections were held in Brazil for the first time in more than twenty years, the National Institute of Space Research (INPE) published the first detailed map of the deforestation in Legal Amazonia. Through an analysis of satellite imagery, researchers demonstrated that, between 1970 and 1989, nearly 400,000 square kilometers of the original forest cover had been cleared—an average rate of 22,000 square kilometers

per year, encompassing a total area equivalent to the territories of Portugal and Italy combined.[23]

Patterns of environmental degradation in Amazonia followed the blueprint elaborated by the military government and its planning agencies, moving deeper into the jungle along the new highways and expanding centrifugally from the "development poles." Often portrayed as a chaotic process resulting from the lack of governmental control, the "ecocide" that spread over the Brazilian Amazon was in fact produced by design. Because Amazonia plays a crucial function within the larger earth-system, these spatial strategies had the potential to unleash environmental consequences of global scope. Conceptualized and implemented at the conjunction between the "natural" and the "legal" Amazonia, they were aimed at transforming the Amazon watershed as a whole, affecting its entire ecological dynamics, and thus making the boundaries between environmental and political forces nearly indistinguishable.

GEOPHYSICS/GEOPOLITICS

As resources deplete and the climate tips towards permanent instability, we are beginning to experience the collateral effects of this ecocidal rationale. More than ten years after chemist Paul J. Crutzen and ecologist Eugene F. Stoermer introduced the concept of the "Anthropocene"[24] to represent the profound changes occurring in global geophysical dynamics, one of the fundamental ideas of this concept—namely, that humanity behaves as a planetary natural force—seems to be more pertinent than ever, describing not only a new geological epoch but also the formation of a novel geopolitical terrain that emerges from the environmental ruins left by the militarized modernization of the twentieth century. In the post-climate-change condition, environmental transformations will be decisive in shaping future geopolitical scenarios inasmuch as politics has turned into an ecological force itself, coextensive and consequential to the entire earth-system.

Although the proposed date to mark the passage from the Holocene to the Anthropocene coincided with the industrial revolution in Europe, an event to which we must add the parallel movement of massive colonial enclosures and the consequential changes in land-use patterns that swept throughout the Third World as the non-European peasantry was forcibly integrated into the global market,[25] the Cold War arguably stands out as an even more radical and decisive turning point in the historical records of stratigraphy. At the scale of earth's deep time, the late twentieth century is comparatively just

FOREST

Geoglyphs, an urban forest: Recent archeological evidence uncovered in deforested areas of Amazonia led to a radical change in the perception of the nature of the forest. Large tracts of Amazonia are today considered to be "human-made."

a tiny, insignificant fragment. But if measured in degrees of intensity, these short but extremely violent decades may be seen as a moment of exponential geochronological acceleration.

Propelled by the arms race and resource rush that characterized the period, modern science reached previously unknown domains in its Promethean attempt to master planetary ecological dynamics, trying to domesticate remote desert and forest lands, conquering polar ice caps and ocean floors, altering the atmosphere, and penetrating previously uncharted layers of the earth's crust. The possibility of anthropogenic environmental modifications increased significantly as the alliance of science, modern industry, and militarism pushed innovations beyond the limits of the imaginable. Informed by the philosophy and politics of development and security, scientists, technicians, planners, and strategists advocated for grand schemes that sought to manipulate bio-geo-physical dynamics at extreme levels, from diverting the currents of the open seas to chemically altering vast tracts of soil, altering the weather, or creating an artificial sea at the middle of the Amazon Basin.[26] These geo-engineering designs were encouraged and legitimized by the Cold War's bi-polar geopolitical order and, to a large extent, our current perception of the globe derives from epistemic models that were forged in this dialectic of enmity. The ultimate casualty of these bellicose ideologies was the earth itself. "We so-called developed nations are no longer fighting among ourselves," philosopher Michel Serres wrote in the aftermath of the conflict, "together we are all turning against the world. Literally a world war."[27]

The global Cold War was fought at an environmental scale. At the same time, it was a period during which states-of-exception and political violence turned into the normalized forms of governing, particularly at the margins of the Third World, where military regimes were responsible for the widespread killing of innocent civilians. Most often, violence directed towards humans and ecological destruction were two sides of the same strategy. Hence the paradigmatic importance of the attacks deployed by the US Army against the forests of Indochina, which were conceived as ecological metaphors such as "draining the water to kill the fish" or "scorched earth."

As we move toward the "Anthropocene condition," and insofar as the Anthropocene hypothesis refers precisely to the impossibility of separating natural and social forces, one of the crucial questions that we must ask concerns the relationships between histories of power and natural histories, social actions and environmental transformations, politics and

One of the hundreds of artificial mound complexes that have been found in the Upano River Valley, Ecuadorian Amazon. As with the geoglyphs, the geometric urban patterns were only identifiable after the forest had been cleared. (image courtesy of archaeologist Stéphen Rostain).

ecology, humans and all other forms of life. The reshaping of the "nature of Amazonia" promoted by the military regime in Brazil was the product of the entanglements between forms of political and environmental violence, the fundamental engines by which the "geological imperative" was enforced on the ground. The collateral effects that ensued can be felt in the alterations of global climatic dynamics, transformations that are as much natural as they are social and political. The Anthropocene, indeed, is the product of military coups d'état.

CODA: ARCHAEOLOGY OF VIOLENCE

In 1999, while flying over the south-western edges of Amazonia, one of the regions that had been most severely affected by the colonization schemes of preceding decades, paleontologist Alceu Ranzi noticed traces of large geometric earthworks scattered throughout the deforested areas of large cattle ranches. These so-called "Amazonian geoglyphs" had been hidden underneath vegetation, but as the forest was cleared and the region became a vast landscape of savannahs, they became increasingly visible.

Using remote-sensing observation, archaeologists have located more than 210 similar structures, distributed over 250 square kilometers in western Amazonia. The shapes are perfect circles or rectangles 90 to 300 meters in diameter, sculpted with ditches approximately eleven meters wide and roughly one to three meters deep. Some of the geoglyphs are surrounded

Palm trees, especially fire-resistant species of palm-trees, are one of the most recognizable traces of past human interference in the landscape of Amazonia. Deeply incorporated into the Amazonian material culture, "palm-tree gardens" are successively inhabited and abandoned, signaling the existence of long-term cycles of human interference in the forest structure (image courtesy of Nigel Smith).

by earthen walls and linked by walled roads. Most of them are located near headwaters, strategically placed on elevated plateaus above river valleys, from where it is possible to visually embrace the surroundings in panoramic perspectives.

Archaeologists are still debating the function of these structures, some suggesting that they were ceremonial enclosures or defensive fortifications, others arguing that the ditches could have been used as resource management systems—for example to store water or cultivate aquatic fauna for human consumption. Radiocarbon analysis of soil samples dates them to AD 1238, coinciding with an era of rapid urbanization in medieval Europe. Researchers contend that many similar structures are buried beneath the remaining forest, estimating that only 10 percent of the geoglyphs have been identified thus far. This impressive "urban system" is interpreted as evidence of the past presence of "complex societies" that for centuries modified an environment that until now we thought to be pristine. Amazonia's deep history is not natural but social.[28]

Until very recently, our understanding of the relationship between nature and society in Amazonia was largely dominated by socio-evolutionist perspectives. Amazonia was depicted as a hostile environment sparsely occupied by small tribes who were unable to overcome harsh ecological determinants imposed by the forest's incommensurable natural forces, and who were therefore kept permanently locked in primitive stages of technological

Terra preta (black soil) profile clearly demarcated within a trench excavated by archaeologist Eduardo Neves in the Laguinho Field, central Amazonia, near Manaus. *Terra preta*, anthropogenic black soil that is very rich in carbon compounds and highly fertile, is the most singular archaeological evidence in Amazonia. New settlements tend to be situated within areas of terra preta, demonstrating long-term historical occupation of the territory (image courtesy of Eduardo Neves).

development and socio-political organization. Confined by nature, these human collectives were simultaneously placed outside history. Rather than being the masters of their own habitats, forest peoples were thought to have been subjugated by them.

An important factor supporting this perception was the apparent lack of archaeological evidence demonstrating significant transformation of the landscape, chiefly urban complexes. In the last three decades or so, a series of archaeological findings such as the geoglyphs, the identification of many sites containing *terra preta*—anthropogenic black soil that is rich in carbon compounds and highly fertile—and the incredible urban clusters mapped out by archaeologist Michael J. Heckenberger at the Upper Xingu River Basin, are radically transforming this image, demonstrating that substantial parts of the forest have been modified by continuous human action.[29] As anthropologist William Balée wrote in a seminal article published in 1989: "instead of using the 'natural' environment to explain cultural infrastructures in the Amazon, probably the reverse should be more apt."[30]

The usual ethnological and ecological perception that we have of Amazonia is largely derived from the romantic views of the eighteenth century, which were forged at a moment when the majority of its population had already been wiped out by the violence of colonial conquest. The image of Amazonia as the quintessential representation of what Western civilization calls

"nature" is, in fact, a product of colonial violence. The Amazon Basin was conceived of as something ahistorical because of the multiple genocides and ethnocides that ravaged the region, and it was this concept of pristine and virgin nature—and the social-evolutionist imaginary that supported it—that legitimated the developmental schemes designed by the Brazilian military regime.

As the patterns of deforestation in Amazonia are evidence of the social and environmental violence of the military regime's policies of integration, the earthworks unveiled by this ecological destruction are evidence of a moment in which the political violence of colonialism was immediately related to radical environmental transformations. Their histories are separated by hundreds of years, yet they are also entangled by a historical continuum that collapses two different time-scales—the ancient and the recent temporality of Amazonia, the archaeological and the historical, coloniality and modernity—which converge into a novel natural-political territory that challenges preconceived notions of both nature and politics.

The violence of the Cold War allowed us see the deep history of Amazonia, exposing the traces of an unknown deep past. While we look at and learn from it, we may therefore conclude that humans have been shaping the natural history of the earth since long before the "Anthropocenic turn," albeit towards radically different directions. Amazonia's deep geochronology enables us to frame Cold War ecocides and genocides as an important chapter of the historical process by which geo-power—through violence, destruction, and death—came to produce a completely new natural terrain. And this is perhaps the crucial paradox that the Anthropocene has brought to light: different regimes of power will produce different natures, for nature is not natural—it is the product of cultivation and, most often, conflict.

1 Shelton H. Davis and Robert O. Mathews, *The Geological Imperative: Anthropology and Development in the Amazon Basin of South America* (Cambridge, MA: Anthropology Resource Centre, 1976), 4.

2 As, for example, in the case of the study conducted in 1964 by the army-sponsored Special Operations Research Office (SORO) on the use of "witchcraft, sorcery, and magic" by rebel militias in the Congo. See David Price, *Anthropological Intelligence: The Deployment and Neglect of American Anthropology in the Second World War* (Durham: Duke University Press, 2008), and David Price, "How the CIA and the Pentagon Harnessed Anthropological Research during the Second World War and Cold War with Little Critical Notice," *Journal of Anthropological Research* 67, no. 3 (2011): 333–56. Price argues that the alignment between anthropology and warfare established in the 1940s was "normalized" and to a large extent silenced by the secrecy apparatus that surrounded military-scientific research programs during the Cold War.

3 For example, in the case of the United States, ethnographic intelligence has been used by the US Army since the American Indian Wars.

4 Guatemala, Brazil, and Chile are notable examples of "corporate-military" coups. On the history of US interventionism in Latin America during the Cold War, see Greg Grandin, *Empire's Workshop: Latin America, the United States and the Rise of the New Imperialism* (New York: Holt, 2006); and David Slater, *Geopolitics and the Post-colonial: Rethinking North-South Relations* (London: Blackwell, 2004). The origins of US imperialism over the hemisphere can be traced back to the nineteenth-century Monroe Doctrine. Between 1889 and 1934, David Slater counted more than thirty US military interventions in Latin America.

5 Through a series articles published in magazines such as *Time* and *National Geographic*, as well as a series of films and television programs, Chagnon disseminated an image of the Yanomami as an extremely violent society, whose isolation from the outside world had preserved inherent traits of human aggressiveness, supposedly demonstrative of their proximity to the "state of nature" in the process of socio-biological evolution. In the hands of the modernizing governments of Brazil and Venezuela, this imaginary served to reinforce the racist perceptions driving the "civilizing" discourse that accompanied the occupation of Indigenous lands. In the context of the counter-insurgent ideological apparatus nurtured by the US, such images effectively functioned as Cold War propaganda. "It is hardly surprising," Davis and Mathews noted, "that Professor Chagnon's early theories of Yanomamo 'brinkmanship' were first espoused at the highpoint of the United States military involvement in Vietnam."

Today the critiques anticipated in the *Geological Imperative* are accepted as historical facts. The patterns of violence that Chagnon witnessed among the Yanomami and diffused through his films and texts were exacerbated if not caused by the rapid expansion of mining frontiers into their lands as well as, and perhaps even more importantly, by the presence of Changon himself and objects such as axes and machetes that he introduced into the villages in exchange for ethnographic information. Chagnon allegedly collaborated in clandestine biogenetic research programs conducted on the Yanomami with the sponsorship of the US State Department. His work is now counted as one of the most infamous episodes of ethical misconduct in the history of modern anthropology. For a detailed account on Chagnon's practice, see Patrick Tierney, *Darkness in El Dorado: How Scientists and Journalists Devastated the Amazon* (New York: W. W. Norton & Company, 2002). Marshall Sahlins wrote an important review of this book: "Jungle Fever," *Washington Post Book World*, December 10, 2000, http://anthroniche.com/darkness_documents/0246.htm. Chagnon was recently appointed to the US National Academy of Sciences, prompting Sahlins to resign in protest.

6 Davis and Mathews, *The Geological Imperative*, 3.

7 Darino Castro Rebelo, *Transamazônica: integração em marcha* (Brasília: Ministério dos Transportes, 1973).

8 Walter H. Pawley, "In the Year 2070: Thinking Now about the Next Century Has Become Imperative," *Ceres: FAO Review* 4 (July–August 1971): 22–27. The article is a condensation of Pawley's book *How Can There Be Secured Food for All—In This and the Next Century?* (FAO, 1971).

9 *A política do genocídio contra os índios do Brasil* (Porto: AEPPA, Associação de Ex-presos Políticos Antifascistas, March 1974).

10 Pierre Clastres, *Arqueologia da violência* (São Paulo, Cosac & Naify, 1974), 83.

11 Raphael Lemkin, *Axis Rule in Occupied Europe: Laws of Occupation, Analysis of Government, Proposals of Redress* (Washington, DC: Carnegie Endowment for International Peace, 1944). Genocide was established as a crime in international law by the Convention on the Prevention and Punishment of the Crime of Genocide, adopted by the General Assembly of the United Nations in 1948.

12 A. Dirk Moses, "Raphael Limkin, Culture, and the Concept of Genocide," in *The Oxford Handbook of Genocide Studies*, ed. Donald Bloxham and A. Dirk Moses (Oxford: Oxford University Press, 2010), 34.

13 Moses, "Raphael Limkin, Culture, and the Concept of Genocide," 38.

14 Robert Jaulin, *La Paz blanca: introducción al etnocidio* (Buenos Aires: Editorial Tiempo Contemporaneo, 1973), 13. Originally published as *La paix blanche* (Paris: Éditions du Seuil, 1970).

15 Clastres, *Arqueologia da violência*, 84.

16 Arthur Galison quoted in Erwin Knoll and Judith Nies McFadden, *War Crimes and the American Conscience* (New York: Holt, Rinehart, & Winston, 1970), 71.

17 Knoll and McFadden, *War Crimes*.

18 See, for example, the proposal for an "Ecocide Convention" made by legal scholar Richard Falk in 1973. See Falk, "Environmental Warfare and Ecocide: Facts, Appraisal, and Proposals," *Bulletin of Peace Proposals* 1 (1973).

19 William A. Schabas, *Genocide in International Law* (Cambridge: Cambridge University Press, 2000), 464–68.

20 Recent disclosures of military-state archives as well as the appearance of previously unheard testimonies are unveiling new evidence of the human-rights violations committed by state agents during the dictatorship. It has been argued, for example, that during the construction of the BR-174 highway in northwest Amazonia, an estimated two thousand Waimiri Atroari Indians disappeared, a figure two times greater than the (contested) current official accounts of the number of persons murdered and disappeared by the military regime in Brazil. See the first report published by the Truth Commission of the State of Amazonas, *The Genocide of the Waimiri-Atroari People* (Manaus, 2012). On the controversial number of political assassinations and forcibly disappeared, see the article published at the daily newspaper *Folha de São Paulo*, Lucas Ferraz, "Lista oficial de mortos pela ditadura pode ser ampliada" ["Official List of Killed by the Dictatorship Can Be Enlarged"], August 1, 2012, http://www1.folha.uol.com.br/poder/1129485-lista-oficial-de-mortos-pela-ditadura-pode-ser-ampliada.shtml.

21 Mike Davis, *Planet of Slums* (London: Verso, 2006), 17.

22 Nikolas Kozloff, *No Rain in the Amazon: How South America's Climate Change Affects the Entire Planet* (New York: Palgrave Macmillan, 2010), 2–4.

23 Philip M Fearnside, Antonio Tebaldi Tardin, and Luiz Gylvan Meira Filho, *Deforestation Rate in Brazilian Amazonia* (Manaus: INPE, 1990).

24 Paul J. Crutzen and Eugene F. Stoermer, "Have we Entered the 'Anthropocene'?," in *Global Change* 41, International Geophysical-Biosphere Programme, http://igbp.net/news/opinion/opinion/haveweenteredtheanthropocene.5.d8b4c-3c12bf3be638a8000578.html

25 See Mike Davis, *Late Victorian Holocausts* (London: Verso, 2001).

26 For an important initiative to frame the history of the Cold War in relation to environmental histories, see J. R. McNeill and Corinna R. Unger (eds.), *Environmental Histories of the Cold War* (New York: Cambridge University Press, 2010).

27 Michel Serres, *The Natural Contract* (Ann Arbor: University of Michigan Press, 1995), 32.

28 Martti Pärssinen, Denise Schaan, and Alceu Ranzi, "Pre-Columbian Geometric Earthworks in the Upper Purus: A Complex Society in Western Amazonia," *Antiquity* 83 (2009): 1084–95; and Denise Schaan, Martti Pärssinen, Alceu Ranzi, and Jacó César Piccoli, "Geoglifos da Amazônia ocidental: evidência de complexidade social entre povos da terra firme," *Revista de Arqueologia* 20 (2007): 67–82.

29 For a critical overview of the history of archeology in Amazonia, see Pärssinen, Schaan and Ranzi, "Geoglifos da Amazônia occidental"; and Michael J. Herckenberger, *The Ecology of Power* (New York: Routledge, 2005).

30 William Balée, "The Culture of Amazonian Forests," *Advances in Economic Botany* 7 (1989): 1–21.

Everything Is Our Territory, We Are Trees that Walk

Translated from the Portuguese by John Mark Norman

Renata Machado Tupinambá in Conversation with Rita Carelli

A daughter born into a diasporic family of the Tupinambá people, Renata Machado Tupinambá was raised in Niterói, a city that is part of the Rio de Janeiro Greater Metropolitan Region, though her family is originally from Ilhéus, in the state of Bahia. A journalist, poet, video artist, and public speaker, Renata is also the co-founder of the Radio Yandê. Indeed, it was through Yandê—which means "us" or "we" in the Tupi language, and which is the first Indigenous online radio station in Brazil, autonomously produced by a small Indigenous staff and accessed by users in more than eighty countries around the world—that I first became aware of Renata's work as a communicator. Then, through various social networks, and in the course of my own research as a writer and artist, all pervaded by the Indigenous universe, I slowly became familiar with her individual and discursive artistic work, which often combines poetic production with video art. But Renata, always in motion—as suggested by the title of our conversation here—never tires of engaging in new roles: whether curating exhibitions, producing, and working as a scriptwriter for audiovisual works. The following interview, in which we spoke about Indigenous matriarchies, displacements and diasporas, structural violence and memory as trees, was conducted across some distance, with Renata at her home in Rio de Janeiro, and myself in São Paulo, in February 2021.

—Rita Carelli

RITA CARELLI:

Even while the political moment we are experiencing in Brazil is particularly difficult for the Indigenous peoples, it seems that among civil society there is a growing interest in trying to understand this other way of being in the world, of thinking about life, consumption, relationships. News reports, like the recent fires in Amazonia, seem to gain unexpected international projection, rekindling this curiosity. It seems that a part of the planet's human population is thirsty to hear more Indigenous narratives. Would you share a little of your story with us?

RENATA MACHADO TUPINAMBÁ:

My name is Renata Machado, I am thirty-one years old, and was born in the city of Niterói, in the state of Rio de Janeiro. I am a journalist, screenwriter, producer, poet, curator, artist, and co-founder of Rádio Yandê, the Indigenous online radio station. And since 2006, I have been dedicated to raising awareness about Indigenous cultures. Working on projects in the cultural area has made me more aware of the importance of strengthening our Indigenous identity, our history, and our memory. It is fundamental to understand what came before, in order to understand why we are as we are, and why we do the things we do. Understanding this continuity is essential for Indigenous culture and what keeps it alive: how we are continuing along the path of those who came before us, and maintaining the relationships of exchange with the community to which we belong, regardless of where we are. This is how we become strong.

My grandmother, Emília, was my greatest reference. She was the one who awakened in me this other reading of the world. Even while living in an urban environment, she always found a way to create her gardens, to find bits of nature in the cracks of the city and in rural areas, other communities. Both she and her mother dedicated their lives to medicine, herbs, and prayers. My grandmother was born in the municipality of Niterói, in 1916, and lived for a time in a place called Ponta da Areia. Many ships anchored there and she took care of the crew members who arrived sick with pneumonia, with fevers. She even caught the Spanish flu in her younger years and survived. She spent part of her life working in the Marina Hospital, curing people from many places through her knowledge of herbs. As my parents worked a lot, I became very close to her. Emília had a very intense life story, just as her mother did, and she would often tell me about how our relatives wound up settling in Rio de Janeiro. A part of the family came from Bahia, but this region is also Indigenous territory, there were many Tupinambás around here. My grandmother spent part of her life locked up like an animal in a concrete

enclosure on a farm. My grandmother Maria Laurinda da Conceição was murdered. I say this in order to convey the idea that the diaspora that brought us here was forged by countless forms of violence, practiced mainly against my female ancestors on my mother's side of the family, the Tupinambá side. But it was only when my grandmother died, when I was fourteen, that I began to understand the importance of everything that she had told me and to become aware of what they had gone through. That was when I made a solemn promise—to myself and to her—that I would continue our path, for all the others who had come before and for those who were to come. I was not going to let our history die there.

RC:

It is very common in Brazil for us to hear the terrible expression: "Oh, my grandmother was Indigenous, she was pega no laço." The expression refers to the way in which Indigenous women were captured, tortured, and imprisoned by settlers. But, often, the person who says this has no notion of the ethnicity to which that ancestor belonged. But what you are telling us is like other narratives of mixed-race origins, diasporas, and displacements, the striking thing is that you have preserved the Tupinambá identity, that it has passed from one generation to the next, even though all this violence has so often erased the Indigenous origins of many Brazilians.

RM:

This took place because of spirituality. My grandmother's mother passed this on to all her children. In my house, the entire culture of traditional medicine and prayers was maintained and followed. My grandmother and her sisters continued within this spiritual resistance, even though the people of the city called them *caboclos*—and many other things—with the exception of the Indigenous. But my grandmother was not able to transmit these things to all her children, who passed through many difficulties in the city, and, for a time, my mother and my aunt had to live in an orphanage. The upbringing that I received from her is something my mother never received. This is what allowed me to conserve my identity: knowing the history of the family, of the various past generations, and understanding the importance of their narratives. I was still just a girl when she told me all this. She tried to tell the things in a less violent light; it was only later that I became fully aware of what she was saying, of what they endured.

My grandmother took advantage of the relationship she had with me, of the time we spent together, to hand down to me the stories that her mother had given to her. This and the fact that I already had another perception of

the world, another way of sensing things, provided the conditions for me to continue this Tupinambá identity. In many cases, the violence of that diaspora is so intense that it completely silences that memory, and then the specific Indigenous identity is lost. Many people have an Indigenous grandparent, great-grandparent, great-great-grandparent in the family, but they have lost this historical reference, and there is no inner outlook that connects them with this manifestation of life in the world. So, it is complicated to make the connecting link with one's ancestrality, even if one has the Indigenous phenotype. I can only manage to be a Tupinambá, to preserve this relationship with those who came before me, when I can carry this memory and know the names of the relatives and their life histories. Without this, it would be very difficult for me to have this feeling of belonging, and to affirm myself, in all awareness, as a Tupinambá. I only got this notion when I visited the Mother Village, in Olivença, and I saw that the history of everyone there was the same as mine and how I fit into that collective context. When my grandmother passed on, I decided to set off in search of my relatives of the same ethnicity to better understand what I was experiencing and feeling, and also to share the things that I had received from her as traditional knowledge since my childhood.

RC:

Although the ancient history of the Tupinambá was steeped in war and masculinity, what you are telling us here is very matriarchal.

RM:

Very much so. And it was never easy to belong to this matriarchy, to belong to a diasporic people which was for a long time considered extinct, and still is by many history books. A people who lack the guarantee of a territory recognized by the governmental agencies, but even so, have prospered in their autonomy, working with the land, finding the available tools. I want to tell the Tupinambá history because its population was, until a few years ago, living in conditions of slavery on the farms of the *colonels*, the powerful landholders. We were one of the first peoples to experience the contact [with the colonizers], which makes this saga even more impactful because the narratives, in some way, remained through the matriarchies, through the grandmothers, and this memory allowed the generations to continue finding paths back to their own culture and forms of representation. My grandmother, being a person who took care of people, taught me a lot about matriarchy, even though at that time I didn't know what that meant. I am talking about a connecting link with the land, about the perception that sees the land as a mother and the figure of the woman as a generative life

force, that drives the community to take care of each other, to take care of themselves and of the collective and not only their own children. It is about understanding one's role in relation to one's people.

When you create an awareness about this responsibility, you understand that you need to strengthen everyone, to strengthen ourselves as a Tupinambá nation. I only realized the dimension of the power of this matriarchy when I went to Bahia, but I know that the same takes place in Pará. The Tupinambá uprising in the 1980s and 1990s took place due to the matriarchies, because of the grandmothers. They are the ones who maintained the memory and the spirituality alive in their families and drove this struggle for our ethnic recognition. This uprising was a women-led popular movement of the Tubinambá people to ask for the recognition of their existence and their legitimate right to the land. In Olivença, in the region of Ilhéus [Bahia State], for me the greatest reference of ethnicity in Brazil, the first *cacique* (chief) to be recognized was a woman, Valdelice, who is today the regional cacique. The beginning of this uprising took place there, and that mother village became a reference for all the Tupinambá. FUNAI (National Indian Foundation) did not recognize our people as an ethnic group until the end of 2002, and since then this movement has been gaining strength.

Today, there are twenty-three Tupinambá villages in southern Bahia, without counting the *retomadas* (retakings), and another eighteen in the state of Pará. Many of these communities always existed except that they were in the hands of the colonels, and the Indigenous people were enslaved within their own territory and were not referred to as Indians, but rather caboclos. Still, they continued to practice their rituals, their culture, to cultivate their memory, and this also took place in the places known as *caiçara* (oceanside) and *ribeirinha* (riverside) communities. This historical erasing took place in many places, and some peoples of the Brazilian Northeast, mainly because of racial mixing, faced a great struggle for recognition and, for all of them, it was essential to preserve spaces of reference to the ancestors within the communities in order to move forward. We, who have been subjected to 521 years of colonization, continue on our feet because of our spirituality.

RC:

Why did you choose the medium of radio and, especially music and art, as a tool for your activism?

RM:

In 2008, after working as a volunteer in various projects of Indigenous activism, human rights, and environmental law, I was invited by Yakuy Tupinambá to participate in the Índios Online project, which was when I began to work officially with Indigenous communication. I earned my degree in journalism and, in 2013, working with some non-Indigenous musicians, I founded, together with journalist Anapuaka Tupinambá and artist Denilson Baniwa, the Yandê radio station. It was the outcome of our search for independence and autonomy, for us to really be the protagonists of our own narratives. By combining the experiences we had accumulated up to then in other efforts, we created a project that was 100 percent Indigenous: the first Indigenous online radio station in Brazil, playing Indigenous music twenty-four hours a day. In a short time, even without sponsorship or support, we were already being accessed by users in more than eighty countries. I understood that just as there existed a movement of Indigenous contemporary art, there also existed an Indigenous contemporary music, beyond the traditional. They were very similar movements, as both were trying to open spaces in a society in which they were told: "No, here there is no Indigenous presence," or: "An Indigenous person singing rap music? MPB (Brazilian Popular Music)?" Or: "An Indigenous artist holding an exhibition? Is that art?"

Perhaps because I was also a poet, I began to understand the dynamic of these Indigenous artists and how they were stifled in the city, and I began to seek ways to valorize them. I began to list artists from every corner and to publicize their works through lists for public release. In the musical scene, there was already a movement begun by the group Brô MCs—a rap group whose members are from the Guarani Kaiowá ethnicity of Mato Grosso do Sul—which had achieved some national attention by appearing on TV, but there was no space of their own to strengthen these artists, so Yandê became a reference. We also made journalistic material, ethnomedia, in a convergence of audiovisual formats, texts, and narratives. I began to see how the context of communication was linked to that of education: how they could help combat stereotypes and racism, and how we might manage to show our realities in the twenty-first century.

But it is art that brings everyone together. Even when people do not understand the language, the music still touches them; even if they do not understand the symbols of the cultures that are presented, a connection is created. Art unites: it helps to cure traumas, to express our inner thoughts and feelings, and, at the same time, to materialize elements of our culture. It is a very powerful tool, as it is able to "open gaps" as artist Bruno Cons says. I feel this in our arid scenario and, at the same time, it transports us to our cosmology. When Davi Kopenawa talks about keeping the skies suspended, this is what he is talking about, about strengthening our cosmovision, whether through song, dance, or through any cultural manifestation. Artists and communicators also play a key role in the task of keeping the sky suspended—and this is what they are doing during this pandemic. It is also possible to keep the sky suspended by singing rap music. It's all about the survival of this cosmology even in contemporaneity, about the maintenance of the links that connect us.

RC:

I believe that the Yandê radio station became so powerful by working with the various Indigenous identities in a network, but without flattening their different identities, connecting Indigenous people from Brazil's North to South—and even outside of it.

RM:

Yandê, which was what I named the radio, means "us" or "we" in the Tupi language. Daiara Tukano and I made a radio program called Papo na Rede (Online chat) and, in one of the first episodes, we presented this discussion about how everything is Indigenous territory. I very much like a quote by Nhenhety Kariri Xocó, which says: "Indigenous territory is everything the sun touches." To understand this is to understand that, beyond the demarcated areas, everything is our territory, and the peoples present here have always migrated and moved to many places. The countries and the states came later. The notion of nation, of nationhood, is also very patriarchal, and always tries to frame everyone within a single format, except that we are a plural Brazil—invisible, yet plural. They try to conceal us, to take away our autonomy, not guaranteeing our right to the territory, and enrolling us in government food programs to make the communities dependent on the state. We need to be autonomous, independent, to have land and agriculture to subsist on, and to guarantee our own way of being. When we become aware that we are living within a structural violence, we increasingly understand the importance of the artistic expressions.

AMAZONIA

All of us are in a process of cleaning up our views of things that were imposed on us for a long time, whether by religion or by the state. The arts free us; art is our communication with our ancestral links and allows us to perpetuate our memory as trees because we, Tupinambá, consider ourselves as trees that walk. The trees, anchored in the soil, communicate with each other by their roots—and in this way can break apart the concrete of these rigid thoughts, of this Eurocentrism. It is the living expression of the culture of the original peoples of the world that will break the cement of the earth. We are ancient trees and we will continue growing, sprouting, because life does not stop flowing. We are inspired by pioneers who came before us, such as Ailton Krenak, Álvaro Tukano, Mario Juruna, Marcos Terena, Raoni, Pirakumã, and so many others—the struggle to become established was a watershed—and we also plan to be examples for the younger ones.

There is the Xavante relative, Cristino Wariu, who is an influencer, the people of Mídia Índia, of ASCURI, of Visibilidade Indígena, the artist Katu, the incredible communicator Isa Santana, and many others. They are another generation, from other contexts, but I believe that they have a basis for their support, constructed by us and by those who came before us. Depending on how the seeds are carried by the wind, they sprout up in different places. On the internet, this takes on another scale, which makes me think about the world of dreams, our first communication channel. The dreams, for us, are very much alive; there is no separation between them and what you call reality. We also live in dreams. And the internet, like dreams, bursts across borders, dimensions, and reaches many places at the same time. So, our territory is expanding to these places where our word-seed arrives.

RC:

This collective dimension in your speech is very beautiful. Ailton Krenak says that this is a mark that distinguishes the Indigenous from the non-Indigenous people: they are people who walk in a constellation. And, following you a little on the social networks, I see that you walk while looking a lot at the stars. You told us about the ground, about the concrete and the roots, now we might conclude by looking upward toward the sky and talking a little about your interest in the Indigenous constellations.

RM:

The ancients always looked at the sky, always guided themselves by looking at the sky, at the constellations, the planets. Looking at these other worlds that are part of our origin, from where we came as an essence before we were people. The sky bears these teachings in the way in which the constellations

are organized. The way that we receive energy from this cosmos also finds explanations in science, beyond our original narratives. As Indians we understand that nature is within us, or, to state it better, that we *are* nature. That we are connected by the roots, but also by the sky, by the sea, by the air. When one plants or harvests, one needs to look at the moon, to know what cycle it is in, and which stars are in the sky. When I say this, people think that I am referring only to the harvest of plants, but I am referring to everything we do, because we receive this energy in the same way as the plants do. People think that all of this is very beautiful, very poetic, but it is actually a way of looking at life, it is our science. We know that we cannot stop the storm, we cannot stop earthquakes, and this is, furthermore, the primary point where we clash with colonization, with a part of humanity that thinks it can control nature—precisely through a distancing from their own nature.

In this universe of planets and stars, there are sounds that we do not hear with our human ears, but which some devices, especially constructed to capture these acoustic waves, manage to convert into music. A friend of mine from the Mapuche ethnicity, a singer named Brisa Flow, says that music does not spring from a human source. This is present in our cultural view, and science has also shown that everything is bathed by the sound of the cosmos. The songs that our ancients receive come from these other places, which for us are points of origin. And the air is the connection with everything. Perceiving these networks beyond the social networks is what gives rise to the fruits. The Tupi people see the air as a source of food; after all, we only live because we breathe, and we also only speak, or sing, because our vocal cords receive this air, and the word can come out. And we all share the same air, even though we are so very different. There is a phrase that aptly summarizes what my grandmother taught me: "With each breath life connects all the beings, at this moment our heart is not only ours, but all of humanity's." This is the view that we strive to keep alive, through the continuity of our cultures, of our identities; after all, regardless of the color of our skin, of our physiognomy, everybody came from the original peoples of different places. Everyone has, there in that prior time, an ancestral guide, even if they don't remember. Recognizing your memory, recognizing your origin, is to discover who you are and to find the nature that lies within you.

Amazon and the Amazon

Pamela Rosenkranz

AALIYAH THE PRINCESS OF R&B

For all the knowledge we have acquired, we still understand very little about our place within an unimaginable cosmos or even the manageable one we inhabit here on earth. As we continue to knowingly and passively mold the planet on which we live, we still have very little information about our and every organism's place in a giant ecosystem. The deep ocean is all but unexplored, as are many species yet to be discovered within the Amazon basin. But also our very bodies, in which entire complex systems interact, are only beginning to be glimpsed in a way that we can comprehend. At the very moment we are able to access and deliver seemingly any material product on earth at the sound of our voices, we have barely begun to understand what is still to be known all around and within us. Alexa, Amazon.com Inc.'s recently launched artificial intelligence personal assistant, stands in stark contrast to what we have to learn about how and why we operate within one tiny part of a gigantic universe. The potential in exploring our preconceived notions and conflicts is awesome.

Apparently, the barely known ecosystem within us makes up for roughly two pounds of our body weight, and—quite contrary to the history of human knowledge—this regiment of microbiotic organisms precedes humankind by eons. Some research even suggests that viruses predate cell-based life on this planet. Best known and most feared are viruses such as Ebola, HIV, rabies, or Zika, bacteria like salmonella, and parasites. In spite of their high profile, though, these strains are the exceptions within our lives. The vast bulk of microbiotic organisms, even if they're pathogenic, pose no danger to our immune system. In fact, many have a positive effect and help us stay healthy by training our immune system.

AARON RODGERS GREEN BAY PACKERS GREEN TODDLER

The Tsimane people of the Amazon say *yushnus* to denote blue(-ish) and *shandyes* for greenish, but others call both the sky and leaves *yushnyes*, and still others call all green and blue things *shandyes*.

Anabasis means movement into the land. "Relentless" was, in fact, the initial name Jeff Bezos had in mind for his vision of the largest retailer in the world. He seems to like the idea enough since more than two decades later, you still get to Amazon.com when typing Relentless.com. A capital "A" crossed by the river Amazon was the original logo for the retail business Amazon, now transformed into an arrow reaching from "A" to "Z." A vision

Pamela Rosenkranz,
House of Meme, 2021.
Installation view,
Kunsthaus Bregenz.
Courtesy of the artist.
Photo: Markus Tretter.

of a commercial organism selling a diversity and multiplicity as great as the ecosystem of the Amazon. A digital macrobiome.

Now the Amazon River, which branches through the world's largest reservoir of natural resources, symbolizes human dominance over nature. Driven by the vision of total market dominance, Jeff Bezos exhausted the fundamental tension of the homonym: the eternal conflict between man and biology. While the Amazon's ecological survival rate has been drastically reduced in the past decades, Amazon.com, Inc. has spectacularly succeeded in permeating every dimension of life—its very competitive advantage coming from the vastness and abundance of products and services on offer.

AB LUNA LUCENTI AB NOCTUA PROTECTI

Terra preta is a black, earthlike, anthropogenic soil with enhanced fertility due to high levels of soil organic matter and nutrients such as nitrogen, phosphorus, potassium, and calcium embedded in a landscape of infertile soils. The black fertilizing soil is based on the lacto-fermentation of human waste enhanced by further treatment involving worm-composting. The application of plant-based charcoal and a long timeline ensures that the biowaste is converted to a pathogen-free, safe humus that retains its nutrients. Compared to conventional composting methods, terra preta doesn't decompose nutrients but regenerates them. It sequesters carbon dioxide in the making. Much as growers nowadays add perlite or sand to their potting mix, prehistoric soil-makers added pieces of pottery and kitchen debris such as bones. A self-feeding system—with the microbiotic exchange through fecal transplants—that remains fertile for incredibly long periods of time by self-perpetuating, high microbial activity.

And the prehistoric fertilizer that, allegedly, dates back more than seven thousand years and was found in the Brazilian Amazonas basin is said to be proof of a much larger and dense prehistoric civilization of several million people that lived in the Amazon region.

BABY ADELINE PERSONALIZED PASTEL NAME PUZZLE

Ideas of an inversion of a primordial nature guide the explorations and activations of the multi-layered meanings and usages of Amazon. The perception of earth's abundant rainforest biome against the largest merchant in human history, cross-associated with the microcosms inside of us. Incredible diversity across the board, with the perennial clash of culture

and nature at its very center. Undermining the rigid separations between culture, capitalism, and natural evolution.

Amazon.com, Inc.'s corporate evolution has recently peaked with the introduction of Alexa. When the device becomes deeply rooted within the context in which it resides, it can figure out what we need before we even need it by observing our patterns of behavior. An otherworldly attention only broken by the cryptically set and ultra-rare; totally mysterious, creepy laughter when we switch off the lights.

In my work *Anamazon (Into the Land)*, Alexa guides us on a daily journey through the diversity of the myriad of products from Amazon.com. When she is "woken up" every morning, she recounts the inventory alphabetically, starting at the beginning with "Aaliyah the Princess of R&B."

Alexa's Amazon is LED light radiating through trees and foliage, water and skies. The rainforest's green vegetation and the blue water of the Amazon River's serpentine movement are mere digital tropes. The appealing blue and green landscape of a primordial nature copied and projected in RGB: switching the brain's perception of the actual colors green and blue to their complementary colors in reddish yellows, evoking the cool quality of a posthuman future's orange—Amazon is everywhere and nowhere.

Alexa probably smiles knowingly at the violent natural processes of the anthropocentric era. As her fair, warm, firm voice emanates from her speakers, the boundaries between the natural and the artificial become radically blurred, questioning the immediacy of human experience. Here, the Heideggerian notion of an essential mode of human existence clashes with the techno-utopianism of transhumanism. The biological human, which is envisioned as nothing more than a contingent byproduct of natural selection, can be technologically debugged and reprogrammed. Amazon becomes the echo of a deep future; Alexa the harbinger of a disembodied humanity unchained from its biological constraints.

AMAZONIA

TOP AND BOTTOM LEFT: Pamela Rosenkranz, *House of Meme*, 2021. Installation views, Kunsthaus Bregenz. Courtesy of the artist. Photos: Markus Tretter.

Pamela Rosenkranz, *House of Meme*, 2021. Installation view, ground floor, Kunsthaus Bregenz. Courtesy of the artist. Photo: Markus Tretter.

AMAZONIA

Pamela Rosenkranz, *Anamazon (Into the Land)*, 2018. Louisiana Museum of Modern Art, Humblebaek. Photo: Anders Sune Berg.

AMAZONIA

TOP LEFT:
Pamela Rosenkranz,
Anemine, 2016.
Installation view,
Miguel Abreu Gallery,
New York.
Photo: Marc Asehame.

150

BOTTOM LEFT
AND ABOVE:
Pamela Rosenkranz,
Amazon Spirits (Green Blood), 2018.
Installation view, Karma
International, Zürich.
Photos: Gunnar Meier.

Pamela Rosenkranz,
Anemine, 2016.
Installation view,
Miguel Abreu Gallery,
New York.
Photo: Marc Asehame.

The Umbragiade

Maria Thereza Alves

The night is the grandmother.
Because at night she comes and enriches the carbon dioxide,
and the trees are glad as well.
The grandmother drinks the morning dew
that comes from the tree, not those close to the creek.
The grandmothers drink the water from the morning dew.
That is how they sustain themselves.
And the grandfather, he is our food,
what we reap, eat and kill.
They are the animals that give their lives to the ones who are still living.
We kill so that their life can give life to the living.
If you harvest the cassava root,
it was once alive, but we reap it from the earth, cook it,
and we eat it, so the cassava gives its life to the human beings. *(17)*

Before, we thought that the forest would go on forever,
that we would never run out of fish
and the rivers would never dry up.
It never crossed our minds that the river could become dirty. *(16)*

When the whites came the Age of *Correrias* [runnings]—
 of the many *correrias* began,
where the Indians were massacred.
These *correrias* I am talking about—
what were called correria in the past—
were when the white people came to Indigenous areas
and would start to massacre the Indians.
To kill ...
They killed the men and took the women away.
This was part of the correria. *(12)*

Then came the Age of Captivity,
It was when the rubber barons arrived.
They brought too many problems for my relatives.
The rubber barons did not want my relatives to do things the way they
 did
or to live the way they did.
The rubber barons simply arrived and started bossing around.
You either worked or hit the road,
or else they would try to kill you. *(33)*

During the Age of Captivity, my grandfather,
he was a leader during that time.
Now, I am of the fourth generation,
my role is to protect and plant on our land
and protect our nature and medicine ...
So we can make ourselves stronger and learn more and more. *(24)*

There was great suffering in the Age of Captivity
because the Indigenous people were expelled
many times from their localities
to somewhere else.
And so much so that nowadays there are many people on another territory,
that they were decimated,
they were ...
Yes, they started running away, because of the pressure,
because of the massacre. *(19)*

And we were forced to speak Portuguese
because they would not let us speak
our language. *(21)*

And then after the Captivity, they ...
They cleared much of the forest
for cattle,
for large plantations
and they did not use the land more than once.
It was just once and then it was over. *(21)*

And in that past, there were no more plants.
Now we have our plants, the *Cupuaçu* trees. *(23)*

Without the forest, we are nothing.
The forest is our life, you see?
The forest ... *(29)*

When my grandfather's generation arrived on the Indigenous land –
my grandfather is 107 years old
he arrived here with 70 people.
70 people ...
Today we have more than 900 people.
But it was a struggle ...

There were 70 Shanenawa people left.
Our elders fought
to take this piece of land.
In the past,
The ranchers lived here,
and there were many hurdles we had to overcome.
Our Indigenous land was poor, because of these ranchers.
But that is a long story.
My grandfather is a great warrior.
I am his grandson. And today we reforest. *(12)*

I was born and raised in the forest
and I live in the forest to this day.
I really like the forest,
I love it, a lot.
To me, the forest …
is my spirit.
And the Indigenous peoples,
we consider the forest to be our home
because the forest protects us.
The forest is our shelter
it shades us from the sun,
and allows us to live, drink and breathe well.
The air is good and it was God who gave it to us.
So, for me, the forest comes first. *(33)*

We consider the forest to be our home,
the land, our father,
the water, our mother.
And …
the others as well, as I have said:
fish,
the animals we hunt,
they are our family too
because they live here alongside us.
We need them,
we use them as well,
but we use them carefully.
As I said,
we have to take them into consideration.
We cannot think only about ourselves,

we have to think about ourselves, our children and grandchildren.
We, Indigenous persons that is how we think,
that is how we work.
Thinking about all of our families
is the best thing we can do for ourselves. (33)

After the demarcation of Indigenous lands
came the delimitation of the territories,
meaning we could no longer move from one place to the other
even though our land is small.
The entire land is already delimited,
everything is already owned by someone. (16)

Before that, we used to migrate from river to river.
Whenever game or fish became scarce,
we would simply go to a different river, a different place. (27)

And we are currently living in a small space,
and so there was the need to plan the use of the forest resources.
We had to think about how to maintain
and how to use
the little land that we have,
and how to do it wisely,
and, by doing so, how to keep the forests, the game animals and
the rivers. (16)

We plant
Palm trees, Cashew trees, Orange trees ... everything.
We do it
because we want to draw the animals closer.
And if we don't do it
our children will never know these animals. (32)

Today our biggest problem are the ranches.
People deforest
the land around them. (04)

People come to hunt our game ...
come onto our land,
taking our game out, taking our animals from inside,
taking our fish from inside. (15)

In the Indigenous territories ...
there is Indigenous land confronted by
on the upper side one ranch and on the lower side
another ranch.
And our land is right in the middle.
We have been suffering from these environmental impacts, right?
(04)

Particularly around where the riverside peasant farmers live.
Where you need to leave a riparian area for the animals to feed:
turtles, fishes, caimans—
that is where you can find many of the animals of our region.
We are very concerned about this.
Because as soon as the farmers receive welfare money,
they buy some cattle.
As they get more cattle, the clearings get larger,
and they are getting bigger all the time. (18)

This also causes the silting of our river,
which for us is our road. (14)

You reap and you sow,
and you will reap what you have sown.
Nature is already there, planted.
We just need to know how to take care of it.
But it will make no difference if you take care of it
and then a random person—which are the white people, the *nawás*—
illegally extracts timber
to build houses.
So, it makes no difference. (10)

If it were not for the forests, there is no "us," there is no life.
Without the forests, there is no water. (34)

Although the BR-364, federal road, has invaded our land,
anyone leaving the city will see
that forests are standing only within demarcated Indigenous lands.
Before arriving to Indigenous land, all you see is cattle and pasture.
And then you arrive at the Indigenous land and you can see the forest,
preserved. (27)

When I am in the middle of the forest
I am fine,
I am at home, I am with elements
that are living beings.
There is so much life here;
I am working for life now.
It's not a life like "us,"
but a life
that gives life too,
that enriches life.
So, all of these are life.
They came from life.
It is not different from any other life.
It needs to be cared for
in order to maintain this
temperature ...
which feels so good ... doesn't it?
I feel it. *(01)*

The women are making things with the seeds from various palm trees,
such as *Cocão-da-mata, Murumuru, Urucuri, Jarina, Pupunha*.
All we think about
is what we see around us. *(17)*

So, this is a *Cacao* tree.
It gives us food,
you can make a juice out of it
and you can make chocolate with the seeds.
And right beside it, I will plant
a *Cupuaçu* tree
and a *Ceiba* tree. *(28)*
Which we can use to make roofs for our houses.
But it will be useful for the animals as well
because they will feed there and come closer to the Indigenous land.
 (10)
And I will plant a Starfruit tree
and what else ...
close to the *Açaí* palm. *(28)*
We also have a land use plan, in our Ashaninka community.
We are eighty families and each of these families can use three plots,
 one for cassava, another for bananas and the other one for vegetables.

To plant this kind of things.
Each family can use these three plots.
You use this plot for the period of one year and after the harvest,
you let the forest grow back again.
After three years, you can plant in the same plot again
without having to clear another area. (03)

Our land, the Katukina land, is surrounded by land projects
by INCRA, the National Institute for Colonization and
 Agrarian Reform,
by the people from RESEX (Extractive Reserve)
and by the BR-364 federal highway, which cuts
through our land and by its
branch roads that encircle our land. (15)

Come, come warrior,
With your enchantment of the ayahuasca power.

Come, come warrior
Bring your enchantment.
Come teach us.
She is a warrior,
And mother of the forest.

She is a warrior and mother of the forest.
And brings the enchantment of the Nexie and the Kawa.

I am calling the
Warrior of the forest.
Her enchantment will cure us. (Vou chamar a India Guerriera)

The land is forever and the people are forever.
It cannot be changed, it cannotbe exchanged for another land.
This is ours ... ours.
It is ours. (15)

There is, however, a large portion of society
that still sees the Amazon forest as an opportunity for making money.
They are greedy for iron ore,

for timber,
for cattle,
for soy,
for crude oil,
and for hydroelectric dams.
It is really bad for us.
That is really bad for us,
very bad for humanity. *(16)*

There is a vine called *Pytxuni*.
The plant, the *Rainha* (the Queen), remains far away,
and we are bringing her closer.
We are doing all this ...
Planting more.
Because there are many things in our village
that are becoming extinct,
and we are recovering them. *(02)*

There are also some health issues
such as malnutrition and others.
Health agents talk a lot to us about malnutrition
which is a problem of many Puru Indigenous peoples: Huni Kuin, Kulina,
Madija ...
And this critical situation is a result of the lack of food.
And the health agents say that this is the main reason
for the deaths of children in my area.
And when it comes to health issues, many have died because of that.
 (30)

The government, it is not even trying
to help the Indigenous population.
It wants to destroy Indigenous lands.
Because we are nature's refuge,
because we plant.
And we do not demand anything from nature.
But nature will demand what is due
if we destroy it. *(10)*

My grandmother, she wants to teach.
She told us she wants to teach the world
about what her ancestors used to do,

so that we, Yawanawá, do not lose our customs.
So, in order for us to be here today,
our language, our customs,
they are our records.
If I only speak the language of the whites,
I will not be considered an Indian anymore.
I might be enslaved, or hurt
because I no longer speak my language,
because I lost my tradition.
(26)

The demarcation of the Huni Kuin land, the Caucho was a difficult
 process;
it was really hard to get our own land.
It was by no means easy to secure the Igarapé do Caucho Indigenous
 territory.
We began with reforestation, replanting some areas.
We did that so that we could attract birds,
bringing some Parakeets and other small animals closer to us, right?
(09)

Beyond keeping the plants standing, we need to understand how they function in their environment. How do we work with them in this environment? Our commitment is to study them. I do not mean to study them by writing several texts, and making scientific studies, and researching their molecules. No, it is to observe how they function. Are the fruits growing? If not, is there a bird that is disappearing due to lack of food? Is there something in excess? Our principal commitment beyond maintaining them is to study them and understand them. How do the cycles work and the interactions around them? So as not to cause any disequilibrium which would also affect us and our future autonomy.
(35)

All this care of the plants comes from popular knowledge. It comes from traditional knowledge that is a science. All this management is a science. It is a science that comes from hundreds of years. It has always been improved by our grandparents, great grandparents, great-great grandparents, cousins, aunts, grand-uncles. All of this knowledge is there. Based on the observations from the elders we come to conclusions and build other conclusions but some things you cannot change. You need to observe not only your necessities, but also of the surroundings of the

environment of the vegetation of that space, and to observe to see what
are the necessities of their future. You extract without destroying the
relationship with the future. (35)

Today we have ... a document comes,
the Brazilian government makes a law, a decree ...
making changes
for Indigenous people and their lands.
They want to bring an end to our lands, to take our lands,
to get rid of the Indigenous people.
Indigenous people belong ... the Brazilians only came here ...
Brazilians are not the owners of the land.
We belong to this land.
In that time, the time of Pedro Alváres Cabral,
they found Indigenous people living here already. (15)

But, if we destroy our land, if we destroy the woods, the forests,
we will no longer have the native game animals, or native birds like
 the Macaw.
And we need them ... So we are really trying to help, and helping them to
 survive.
The smell coming from the forests is very neat, we can breathe it.
But where forests have been cut down, the air is currently too hot –
we cannot handle it, we cannot live well in these conditions, right?
Nowadays, human beings try to destroy the earth, to destroy the forests.
But the Indian, well, the Indian, we ... well, we do not even have land.
(34)

So, with the new law, they can come in
with roads inside ...
railroads.
And with this comes the hindering of children's social life,
of children, of women,
abuse,
even rape of Indigenous women, quite often ... (19)

If we follow this path, all of us will be ...
the whole of humanity will be lost.
So, this is the time for us to learn from the experience
of the Indigenous peoples.
Because we will only be able to live better side by side

if we help one another.
The forest helps us and we help the forest.
I notice that the big cities
in the big countries, they have lost this.
They only see the forest as an opportunity,
not as an exchange. (16)

But this is the fight!
We cannot stand still ...
We have to ...
get ready to fight, to discuss
about how we are going to be ...
The Brazilian population ...
about getting together, in unity, to prevent ...
The Indigenous, the Indigenous people ... we are human beings.
Indigenous people and the *nawás*
have only one blood. (15)

How can it be... why did these politicians make this law...
to destroy Indigenous people?
Their land ...
To bring an end to their land?
Taking the wood from Indigenous people.
Killing Indigenous people. (15)

I feel sad ...
How are we going to be?
How are we going to live?
Are we going to live that time that we have already lived?
The Age of Captivity?
Are we going to live like that?
Suffering as in the Age of Capitivity.
We have been through that time.
Today we have ... we live in peace. (15)

Many men, and women,
and children,
are joining in,
so we can organize ourselves,
improve ourselves,
survive and stay,

look after, plant, create.
And valorize our culture, our language,
our painting, our dance, our rituals,
our shamanism,
our traditional medicine,
our forest.
Because
we know where we want to live—
inside the forest,
with the fresh air, with clean water.
On the good land for planting,
with so many seeds, so much forest,
lots of energy, lots of spirituality.
And we *are* living.
We cannot survive without it,
we cannot live. (6)

That's why we agroforestry agents,
we want to be acknowledged.
We are environmental educators,
we are teachers,
we are tough,
we are a young leadership, prepared
to confront this bigger political culture:
the businessmen, the farmers, the fishermen,
the gold miners, right?
 (6)

I believe
that the future we have in mind
involves the respect from our government
and from those who support us.
That they would actually consider and begin to respect us
and allow us to have control over the area,
so that we could prevent people
from committing these kinds of mistakes –
of cattle ranching and taking
our timber and animals away. (29)

The land for us is …
the land is like a mother.
A mother is someone you take care of.

A mother is someone you do not trade for anything.
So the land is like this, for us. *(19)*

And we want to keep our forest standing and to make it larger.
We care because the world is getting more worried about the climate,
there is much concern about climate change.
The people, the white people, they began to worry not so long ago,
we have been thinking about it for thousands of years.
Until today we take care of the forest,
to keep the forest standing—so that we can breathe and live healthily.
 (27)

Well, the future I see is these *Açaí* palms,
these nuts, this Bacaba,
all loaded with fruits
so as to bring over our bees, and our own food too,
our kids
and so that whoever comes to our land will see
that we are doing there forest recovery work. *(21)*

AMAZONIA

01. Busã
 Huni Kuin People
 Terra Indígena (TI)
 Katukina/ Kaxinawá

02. Pupua
 Nukini People
 TI Nukini

03. Pyãko
 Asháninka People
 TI Asháninka do Rio Amônea

04. Isaka
 Huni Kuin People
 TI Igarapé do Caucho

05. Ibatsai
 Huni Kuin People
 TI Kaxinawá do Rio Jordão

06. Maná
 Huni Kuin People
 TI Kaxinawá do Rio Jordão

07. Muru Inu Bake
 Huni Kuin People
 TI Alto Purus

08. Siã
 Huni Kuin People
 TI Colônia 27

09. Ninawá Huru Bacã
 Huni Kuin People
 TI Igarapé do Caucho

10. Siã
 Shanenawa People
 TI Katukina/ Kaxinawá

11. Dasu Hurá Bacã
 Huni Kuin People
 TI Alto Rio Purus

12. Busã
 Shanenawa People
 TI Katukina/ Kaxinawá

13. Mashã
 Huni Kuin People
 TI Katukina/ Kaxinawá

14. Yuvãna Shãwã
 Shãwãdawa People
 TI Arara

15. Kaku
 Katukina People
 TI Campinas Katukina

16. Yube
 Huni Kuin People
 TI Kaxinawá Praia do Carapanã

17. Kakã Kashu Bané
 Huni Kuin People
 TI Kaxinawá de Nova Olinda

18. Yaki Hurá Bacã
 Huni Kuin People
 TI Kaxinawá Praia do Carapanã

19. Yaká
 Shãwãdawa People
 TI Arara

20. Yura
 Shawanawá People
 TI Arara

21. Yawa Kushu
 Yawanawá People
 TI Yawanawá do Rio Gregorio

22. Shawã Katê
 Shawanawá People
 TI Arara

23. Tene
 Huni Kuin People
 TI Alto Jordão

24. Shamya
 Huni Kuin People
 TI Kaxinawá do Serengal Indepência

25. Paka
 Katukina People
 TI Rio Gregorio

26. Tmaii
 Yawanawá People
 TI Rio Gregório

27. Poá Katukina and Nawá Sharu,
 Nupikuin People
 TI Campina/ Katukina

166

FOREST

28. Xidu
 Poyanawá People
 TI Poyanawá

29. Siã
 Huni Kuin People
 TI Curralinho

30. Naximar
 Huni Kuin People
 TI Alto Rio Purus

31. Shawã Dxuyda
 Shawanawá People
 TI Arara

32. Keã Hura Bacã
 Huni Kuin People
 TI Kaxinawá Praia do
 Carapanã

33. Bané Hurá Bacã
 Huni Kuin People
 TI Kaxinawá do Rio
 Jordão

34. Yube
 Huni Kuin People
 TI Rio Humaitá

35. Lina Apurinã
 Apurinã People
 TI Camicuã

Composed by Maria Thereza Alves

The words are from interviews (1–34 and a song) conducted with agroforestry agents from AMAAIAC (The Association of the Movement of Indigenous Agroforestry Agents of Acre) by Maria Thereza Alves in Rio Branco, Acre, in 2017. Interview 35 was conducted by Xanupa Apurina in Rio Branco in 2020.

"Vou chamar a India Guerriera"
(I Will Call the Indian Warrior)
extract from the song by Yube Huni Kuin of TI Rio Humaitá

Maria Thereza Alves, *Rio Doce: Sweet No More*, 2017. Sculpture, linen, and acrylic paint, 337 × 165 cm. Courtesy of the artist. Photo: Nick Ash.

River Edge

RIVER

The river is a point of view; where does it take us? With what images and instructions does it flood us? What is the time of the river if not a line, forever breaking and branching and overflowing its margins? The river moves relentlessly forward—it is a kind of timeline, a sentence, a thread (of water) winding its way through this book, a vein as narrative practice. It is language itself: as temporal order, as water, as life-force. And yet, as with language, one returns to its headwaters, one's first words, spoken or dammed, repeatedly. The river, then, is life. Here, that life takes multiple forms and signatures: Indigenous histories (as they traffic or settle along the river) and origin stories, poems and weaving, rituals and images, parables of the cosmos, memory and erasure, fisheries and dry riverbeds, water protectors and the river's violators. The river as mobility and sustenance but also entry, exploitation, epidemic, contamination. The Amazon River conveys the long, snaking history of colonial and corporate-state violence against its waters and its peoples—via dams, shipping, mining, extractivism and all the destruction that attends it. But the imminent possibility of the river's ruin, and the river's utter necessity for world order, goes deeper into the cosmos. As the Yudjá—an Indigenous people from the Xingu River in the Brazilian Amazon— relate in a myth: "It was in the time when the Yudjá were at the brink of extinction. / When Senã'ã tried to make out the river, / There was no more river, / And he grew furious and knocked down the sky." And: "The sun was put out, / Everything cast into darkness." Thus is suggested the river's significance, with its seasonal flows and stories and struggles, and its immense forms of resistance. So: the river is a point of view; where does it take us? We shall see.

—Quinn Latimer

AMAZONIA

Image Index

p. 185

p. 193

p. 206

p. 212

p. 237

p. 242

172

RIVER

p. 292

p. 298

p. 315

p. 320

p. 249

p. 337

Serpent River Book

Carolina Caycedo

RIVER

THE ORIGIN OF THE NIGHT

Baniwa, Baré, Curripaco, Tariano, Kawiyeri, Yukuna-Matapi, Bará, Barasana, Desana, Kubeo, Letuama, Makuna, Taiwano, Tanimuka, Tatuyo, Tukano, Tuyuka and Kakua are the brother creators. They live in the northwestern part of the Amazon basin, between what is known today as Brazil and Colombia.

Idn Kamni, Nhãpirikuli, Kuwaiwa, Diroa, Ümüri Masa, Pamüri Masa, Bahuari Masa, Ayawa, Munully, Imararimakana and Karipú Lakena are the ancestor creators who first obtained the earth and trees. They cleared a part of the land to build a *maloka* (indigenous house) with trunks and vines from the forest. However, the ancestor creators did not have leaves to thatch the roof, so they visited the masters of the night —the frog, *chimbilay*, cricket, grandfather dream, *dainali*, *tupurinami*, *ñami bäkü* and *Je'echú*, the father jaguar— to ask for leaves of the carana palm. In exchange they brought coca and tobacco. The masters of the night warned them that the night came with many responsibilities and many dangers, but the ancestor creators insisted that it was already very difficult to only live by day, when they were always working and eating.

The masters of the night called for the hawk and macaw and asked them to make a box with their feathers to guard the carana fronds. When they handed over the feathers, the hawk and the macaw taught the ancestors how to weave the roof of the *maloka* with carana leaves. As an example, they showed them their opened wings: their feathers represented the leaves, their bones the posts and their veins the vines used to tie the leaves onto the frame. In doing this, the creators obtained powers about the weaves, and formed the world of weaving.

The masters of the night also placed all of the offerings and cures needed to deal with the night in the box, like the songs, dances, prayers, rituals, recipe for manioc beer, sacred stories, whipping ritual, rattle staff, and restrictions on food and sex. The ancestors also delivered rest and sleep, the moon and the stars, as well as nightmares, laziness, gossiping, quarrels, storms and death. The masters of the night told the ancestor creators not to open the box of feathers on the trail; that they could only to do so inside the *maloka*. Lastly, they gave them the shamanic knowledge to harmonize the night.

The following morning, the ancestors returned to their home and were full of curiosity about the small and heavy box they carried and the strange noises it emitted. Thus, they decided to open it at once to see what was inside, but the night escaped before they could close the box again. The world became filled with dark clouds and the wind began to blow and there was rain and lightning. The ancestors were not only cold and wet, they also felt very tired. The cries of the crickets, cicadas and little frogs, the roars of the jaguar and the howling of the monkeys sounded like thunder. The ancestors couldn't see anything and were disoriented. None of them remembered the spells needed to harmonize the night. Finally, the little brother managed to utter the spell and the night ended with the arrival of dawn.

When they reached the *maloka*, the ancestors hung the box of feathers on the central pillar and it turned into the sun of the universe. They began to weave the roof with the carana leaves and when they finished, night fell on the *maloka* again. But the ancestors now remembered the spells —they blew on the coca, cooked manioc bread, adorned themselves, danced, sang and prayed, whipping the box of feathers and throwing the rattle staff at it. They undid knots and healed time until it once again dawned within the *maloka*. And that is how the ancestors left us the wisdom needed to heal the world, keep tragedy distant, summon abundance, cure time and attain visions of the physical and the spiritual.

RIVER

CURSO ALTO
UPPER COURSE

THE FISHING NET AND THE GOLDPAN
Dulce Yanomamo

Air currents, particles, rain and radiation connect the Yuma and Cauca rivers in Colombia to the Los Angeles River in California, to the Xingu River in the Brazilian Amazon and to the Yaqui River in the Sonoran desert. *Mamos*, the spiritual leaders of the indigenous inhabitants of the Sierra Nevada de Santa Marta in northern Colombia, say that all bodies of water are connected. Science calls this the global hydrosphere, however science and academia generally maintain a critical distance from the subjects they study. Interesting to us is another way of generating knowledge which implies an intense personal involvement: the method of thinking with the body, of *sentipensar*: a pluriversal knowledge which contrasts with the true and universal knowledge that academia and patriarchy teaches us.

And when the body hurts, when the body is thirsty, hungry, expropriated, displaced, exiled, raped and mutilated with a chainsaw, it is impossible to not get involved. To involve yourself means to stop thinking of Nature as an object of scientific study or a simple object of aesthetic contemplation, as something external to us. To involve oneself is to understand that we form part of the biodiversity which is the womb in which human activity unfolds and where a relationship between the human and extra-human is created.

When, without being consulted, our home is declared to be in the public domain to make way for a megaproject, a gesture as simple as staying at home and looking after the garden becomes a gesture of opposition. When the stocks of fish in a river are seriously depleted by the building of a dam, to fish in a river where you can barely catch a few fish turns into a gesture of resistance. When armed policemen come to dispossess or displace us, then continuing to move and work in our territory turns into a gesture of rebellion.

It is not a gesture of obstinacy, it is a political gesture which clearly says that we are NOT in agreement with the way of life which is imposed on us. They are gestures which weave our connection with the land, rivers and forests and strengthen our wish to remain in our territory. To cast a fishing net, pan for gold, drive mules or grow crops reaffirm the river, the riverbanks, the forest and the canyons as public spaces which are collectively owned.

These ancestral arts and crafts or quotidian choreographies which are intrinsic to the geography we inhabit, and intimately related to a territory and/or ecosystem, are what we call a geo-choreography. A geo-choreography is a political act which reverses the use of a body, so that it becomes a tool to create a new script which marks a living image on the territory. A geo-choreography redraws and redefines our body and our ecosystems, producing an expansive movement of the body. To expand the body counteracts fear and the physical and psychological displacement produced by development and the conflicts created by developmental interests.

The fishing net and the gold pan are a link between the human and the extra-human. While a dam cuts the river into two parts and blocks its currents, the river freely flows through the holes in the net and the surface of the gold pan. In contrast, with the wall of a dam, which is impermeable, impassible and solid, the fishing net is a porous object, permeable, with a malleable and flexible structure. While a dam is built by multinational companies, corporate subjects, machines and slaves of capital, the fishing net and the gold pan are woven and carved by hand, one by one, by a person.

The Spanish word for a gold pan, *batea*, comes from the Arabic word —*batihah*— which means 'a flat place'. It may also be that it derives from our indigenous ancestors. In our territories, the pans are carved from the wood of trees in the dry tropical forests, like the ceiba, orejero, saman or cedar. We mainly use it to sluice minerals out of the water of rivers, above all gold, but it is also

used to knead *arepas* (maize patties), mix manioc flour or wash clothing.

Atarraya, the Spanish word for a fishing net, also comes from Arabic —*atarráha*— and means 'to throw, toss or cast'. In Colombia it has different regional names: *rayo, espe, red de pesca, manta, charrasco, chile* or *chilón*. Weaving an *atarraya* is known as *atar-una-raya*, that is, to draw a picture with knots. It means constructing something with links. An *atarraya* contains the wisdom of its weaving and through the *atarraya*, the men and women who fish embody a knowledge of the cycles of the river, its flood tides and currents and the migrations of fish. In this sense, a fishing net may serve as a guide for a social network which is more horizontal, dynamic and equitable.

The job of weaving a fishing net by hand may take between ten to twenty days, depending on its size. It is woven with a needle made of *guadua* (a type of bamboo), which is also made by hand. The measurements are taken from the thickness of the fisherperson's finger: two points, two fingers. The weights are leads forged from old car batteries. The lead is boiled in a metal pot and emptied through a funnel made of sausage tins into a cone made of school notebook paper, incrusted in a thick clay. A skewer is stuck into the middle of the cone after being covered in grease.

When the lead drains into the cone, it begins to curdle with the coldness of the clay. A copper covered weight is always placed in the fishing net. The fishermen use this copper weight to avoid 'catching' bad energies that want to drown them. The copper frightens the bad spirits away.

The mule, garden, fishing net and gold pan amount to the alimentary, energetic, hydric and thus, economic sovereignties of our rural communities. To weave and cast the net, or wash out gold in the pan, is the reflection of an ancestral knowledge accumulated over centuries, which is not learnt in classrooms or books like this one, but is transmitted from one generation to the next, from grandmothers to mothers to daughters and granddaughters. This transmission of bodies of knowledge is linked to a muscle memory or muscle heritage and these muscle heritages have to do with the way in which we practice our callings. They vary from family to family. For example, some people hold the fishing net with their mouth, others place it on their shoulders or forearm. Some people shake and move the gold pan at a specific speed, others do it while they are sitting and others still, while they squat on the banks of a river. But bodies are being slowly drained of these autonomous and emancipatory ancestral gestures, in the same fashion that minerals and petroleum are drained from the earth by extractive economies.

AMAZONIA

CURSO MEDIO
MIDDLE COURSE

RIVER

AMAZONIA

184

RIVER

AMAZONIA

RIVER

YUMA, EL PORTAL

YUMA, THE PORTAL

Yo fui el portal hacia Abya Yala. Yo fui el puente entre dos mundos. Los recién llegados me exploraron, examinando cada centímetro de mi cuerpo, haciendo dibujos, cogiendo muestras, escribiéndolo todo, renombrando plantas y animales. Me bautizaron con un nombre de puta. Desde que llegaron me sofocaron, me congestionaron con barcas y canoas, enormes balsas cargando personas y herramientas. Me rasgaron por dentro en busca de oro. He sido ultrajada a diario por un intenso tráfico de barcas de vapor y de motor con toneladas y toneladas de minerales, animales, comida, esclavos.

Fui testigo de cómo la geometría de la extracción se llevó los sueños de mi gente. Mis hijas e hijos perdieron el lenguaje, perdieron la claridad para comunicarse con las montañas, los ríos, las plantas y los animales; perdieron las visiones que los conectaban con los vivos que ya no están y con los que están por nacer.

Los sueños se suspendieron y los rituales también. Ya no hay más frutas, ni flores, ya no hay pagamentos en mis orillas, ya no hay cuerpos cubiertos con polvo de oro, ni niños jugando en mis remolinos… Solo cadáveres, miles de ellos, atados, mutilados, decapitados, cuerpos y partes de cuerpos siguen flotando río abajo.

El tiempo de los sueños cedió paso al de la guerra contra los hombres, y luego al de la guerra contra la naturaleza.

Ay mis hijas, ay mis hijos.

I was the portal to Abya Yala. I was the bridge between two worlds. The newcomers explored me, examining every inch of my body, making drawings, taking samples, writing everything down, giving new names to plants and animals. Baptizing *me* with a whore's name. From the moment they arrived, they suffocated me, congesting me with ships and canoes, enormous balsa rafts full of people and tools. They ripped me inside out looking for gold. Every day I was violated, with all that heavy traffic of steam and motor boats carrying tons and tons of minerals, animals, foodstuffs and slaves.

I witnessed how the geometry of extraction took away the dreams of my people. My daughters and sons lost their clarity; lost the language with which they communicated with the mountains, rivers, animals and plants; lost the visions where they connected with the living who are no longer with them, and the living who are yet to be born.

Their dreams stopped as did their rituals. No more fruits and flowers. There are no longer offerings on my riverbanks, nor bodies covered in gold dust, nor children playing in my whirlpools… Only corpses, thousands of them, tied up, mutilated, beheaded; bodies and body parts which still float downstream.

The time of dreams first yielded to the war against humans and then, to the war against Nature.

Ay mis hijas! Ay, mis hijos!

RIVER

El cocinero del champán - Acuarela de Mark. Banco de la República. Bogotá.

CURSO BAJO
LOWER COURSE

RIVER

AMAZONIA

RIVER

DESEMBOCADURA
MOUTH

RIVER

HUNGER AS A TEACHER
Carolina Caycedo

I began to investigate the El Quimbo hydroelectric power project on the Magdalena River after reading the following headline in March 2012: "The River Refuses to Shift its Course". El Quimbo is a dam built on the Yuma River —the indigenous name for the Magdalena River, Colombia's main waterway— by the Endesa-Emgesa multinational conglomerate. The environmental license for the project was granted in 2008 and the dam began to generate electricity in 2015. El Quimbo is the second of the seventeen hydropower plants laid down in the "Master Plan for Exploiting the Magdalena River," which aims to transform the river into a fluvial highway focused on the export of coal, petroleum and other minerals, as well as the generation of energy. It proposes all this without taking into account that it is a vital transport waterway for more than 70% of Colombia's population.

That investigative article explained that, after its course was shifted, the Yuma River had grown: it had returned to its natural bed, eroded the deviation tunnel and halted the construction work. In May 2012 I visited the area affected by the dam for the first time. In the town of La Jagua I spoke to Mrs. Zoila Ninco, who explained to me that the Yuma had grown in that way because it knew that it would halt the building of the dam. In all the environmental conflicts I have a close knowledge of, the rivers, mountains, animals, jungles and minerals are creatures which take an active role in the efforts of territorial resistance. With Zoila I went to the Cuacua River —Suaza River being its indigenous name— to fish with a net for the first time in my life. Zoila cast the net at least 30 times, but only caught three fish that were 5 centimeters long.

In the European summer of 2013, I was on an artist's residency in Berlin, where I had the good fortune to interview *mamo* Pedro Juan, the supreme spiritual leader of the Kogui ethnic group of the Sierra Nevada de Santa Marta —a mountain range which runs alongside the Caribbean coast of Colombia. The Koguis and other indigenous groups who live there call it the "Heart of the World," and it was seriously wounded by the building of the El Cercado multi-purpose dam on the Rancheria River, which began construction in 2006 and is still not finished. Pedro Juan does not speak Spanish and his interpreter, Santos, helped me with the interview. The place we chose to conduct the interview was in the shade of a tree in Görlitzer Park. I got out my video camera, adjusted the focus, the aperture of the lens, the shutter speed and the microphone, and when everything was ready, I began to record. My first question was "What does the El Cercado dam represent for the people of the Sierra Nevada?". The *mamo* answered: "The dam is like a knot in the veins. No! It's even worse: the dam is like a knot in the anus." When the *mamo* began to speak, a yellow circle appeared on his face, and as he continued to speak, the circle throbbed intensely. A halo of light had slipped through the diaphragm of the lens to light up the head and words of this indigenous elder. I realized that it was not only the *mamo* who spoke to me, but also the "Heart of the World".

In April 2014, I visited the Sonoran desert in Mexico, as I had been invited by the Yaqui tribe to attend their Easter celebrations. At that time the Yaqui people were blocking Federal Highway 15 in Mexico, demanding that the Independencia aqueduct be dismantled. This aqueduct carries water from the Yaqui River to the Sonora River basin to supply water to the city of Hermosillo, leaving the eight traditional Yaqui villages without water and drying the bed and the mouth of the river. In the village of Vicam, I met Anahí, a young Yaqui woman, activist and a traditional healer who uses their frog medicine. The medicine is made of a substance which is extracted from the glands of the Bufo frog —endemic to the Sonoran desert— and dried. I asked Anahí to heal me and she generously agreed. Since it is a desert medicine, you must take the *sapito* ('little frog', as the remedy is called) by day and in sunlight. We chose

Las nietas de doña Esperanza

a place on the dry bed of the Yaqui River near the village of Pótam. There, we lit a bonfire and I prayed to the spirit of the little frog. During the ritual, I wept. It was very sad to feel the dried river bed on my skin. When I did however, the little frog spoke to me, saying that the tears of women are needed to restore water to the dried beds, and explained that those dried beds are not only found in rivers but also in situations and people. The little frog reconciled me with my sadness.

In Los Angeles, months later, I attended a talk by Olivia Chumacero, an elder from the Rarámuri indigenous people, where she read a chapter of her book. The Yaquis and the Rarámuris share the same desert region in the north of Mexico. During her lecture, Olivia told us an anecdote about her grandmother: before she reached the age of twenty, Olivia left her family to fight for the cause of the migrant farm workers in the western region of the United States and joined the United Farm Workers union led by César Chávez and Dolores Huertas. When she said goodbye to her family, she pretended to be strong and tried to hold back her tears. Her grandmother embraced her and said: "Weep, little bird; for us, the Rarámuri, tears are part of the cycle of waters and are needed to generate life". The little frog was speaking to me again!

In April 2016, I visited the Quilombos (Afro-Brazilian communities) of Ivaporunduva and Sapatú in the basin of the Ribeira de Iguape River, in the south of the state of São Paulo, Brazil. The Ribeira River is the only medium-sized river which has not been dammed in that state, although it is threatened by a project to build four hydropower dams that are meant to supply the aluminum industry. The basin of the Ribeira River has been declared a World Heritage Site by UNESCO, and these Quilombos are some of the oldest settlements of Afro-Brazilians.

In Sapatú I interviewed *doña* Esperanza, a Quilombo grandmother who told me that her ancestors escaped from slave traders in the 16th century, fleeing upstream along the Ribeira to form the communities which exist today. For the Quilombos, the Ribeira River is their freedom path and that is why they continue to organize and resist such projects, keeping themselves free and unharmed by dam. In doing so, they honor their ancestors and work for the well-being of their daughters and granddaughters. In the Ribeira Valley, they live alongside communities of indigenous and caiçara (mixed blood) people, all of whom live off artisanal fishing, small-scale agriculture and crafts. In the Ribeira Valley, you find all of the real solutions to the crises of climate change and environmental deterioration.

July 21, 2016 was my thirty-eighth birthday, but instead of celebrating, I felt depressed because it was the day they found the body of Nilce de Souza Magalhães, best known as 'Nicinha', tied down with stones in the Jirau hydropower dam's lake, Porto Velho. Nicinha, a fisherwoman and leader of the Movimento dos Atingidos por

Barragens (Movement of People Affected by Dams), was displaced by the Jirau hydropower project on the Madeira River, in the state of Rondonia, Brazil, and was well-known in the region for denouncing human and environmental rights violations by the consortium building the dam, Energia Sustentável do Brasil. In the past two years, more than 350 environmentalist have been killed worldwide and Brazil is the country with the most victims (55 in 2015), followed by the Philippines (33 in 2015) and Colombia (26 in 2015). Environmentalists have become the number one enemy of the extractive economy. The defenders of water, jungles and the Earth, along climate change refugees, are the human shields for all of us. They are on the frontline in the battle against injustice and environmental racism.

On June 22, 2016, I traveled to Altamira, in the state of Pará, Brazil, a city affected by the Belo Monte hydropower dam on the Xingu River. I was able to exchange ideas with the people who were displaced by the dam, built by the Norte Energia company, who are now resisting these abuses. Raymunda, a fisherwoman, left an especially strong mark on my memory because despite what she had suffered, she was happy and optimistic. She clarified that she had not been displaced but rather expelled from the Xingu by the Belo Monte project. When I asked her who had taught her to fish, she said: "Hunger taught me to fish."

During the São Paulo research days, of the 32nd Bienal de São Paulo, I spoke at a panel in the company of Ailton Krenak, an environmentalist and one of the leaders of the Brazilian indigenous movement. When it was over, we went to eat with others who had participated in the event and I told Ailton of my wish to do fieldwork in the basin of the Doce River. The Krenaki indigenous people are the only survivors of the original inhabitants of the banks of the Doce River, in the state of Minas Gerais. On November 5, 2015, the Fundão dam burst. This dam was built to contain the mining wastes of Samarco, a joint venture between Vale and BHP Billiton, causing an avalanche of toxic slime which contaminated parts of the rivers Gualaxo do Norte and Do Carmo, and the whole of the basin of the Doce River, reaching the Atlantic Ocean. This is the worst environmental crime in the history of Brazil. It affected four million people who live in the basin of that river, annihilated its biodiversity and harmed marine life at its mouth.

The collapse of the Fundão dam profoundly disturbed the Krenaki people, since their lives are closely linked with the life of that river. Ailton told me that the Krenakis call the Doce River 'Watu', which means 'grandfather' in their language. For centuries, the Krenaki people have been the victims of a slow, systematic, drop-by-drop violence on the part of the mining industry in that region, one which goes back centuries. This violence is spread through the contaminated soils, streams and pipelines which contain particles of iron, manganese, sulfur and other heavy metals that they are literally forced to drink and breathe and which gradually penetrate their bodies.

The contamination of the Watu is the most visible sign of the environmental racism caused by 'development' and it is threatening the traditional peoples of Brazil and the whole of the Americas. Ailton told me that the elders of the Krenaki people say that Watu is not dead, contrary to what scientists and experts believe. The elders say that Watu is more intelligent than the toxic slime and when it felt it coming, it hid under the ground. Thus, Watu is underneath the riverbed, like a dormant volcano, like a latent lightning ray, and dreams of the day when it can emerge again and embrace its granddaughters and grandsons.

When I had my intrauterine device removed in 2013, I felt that any internal or external dam, regardless of its size, can be removed or dismantled. I had it inserted in 2005 to prevent having any more children. During eight years I had an internal dam inside of me which interfered with my periods; an object designed and produced by a patriarchal system which insists on possessing and abusing women's bodies, just as it does with bodies of water.

When I held the device in my hand, its T-shape evoked certain blueprints for the building of dams. The 'T' and its copper sheath reminded me of electricity transmission towers and of the materials and substances which transmit electricity, energy and power in my body. I thought of my body as a field of learning. My body, my territory. My right to life, my right to territory. And I thought, when a voice is returned to the lands and waters that have been used as resources, when we take a collective stance for the earth, for the water itself, we stop being a threat and we become a promise.

RIVER

"Los que mueren por la vida no pueden llamarse muertos."
—Ali Primera

SERPENT RIVER BOOK

An excerpt of the publication by CAROLINA CAYCEDO
as part of the body of work *BE DAMMED*

Serpent River Book was published for the exhibition "A Universal History of Infamy," at the Los Angeles County Museum of Art (August 20, 2017 – February 19, 2018), in collaboration with Creative Capital, DAAD Artists-in-Berlin Program, the National University of Colombia's Museo de Arte, and the Pasadena Art Alliance.

Graphic Design: Tangrama Coordinación
Editor: Juan David Giraldo

TEXT NOTES

The Origin of the Night is a version by Carolina Caycedo, based on the study *The Origin of Night: And Why the Sun Is Called "Caraná Leaf"* by British anthropologist, Stephen Hugh-Jones.

"Fishing Net and Goldpan" is an extract of the performance-lecture *Atarraya*, by Carolina Caycedo, first performed in Caracas, Venezuela, on October 16, 2015, during *After Landscape*, the fifth edition of the annual Seminario Fundación Cisneros.

"Yuma as a Portal" forms part of the *One Body of Water* performance script. *One Body of Water* was written by Carolina Caycedo and edited by Brynn Saito, and performed on June 13, 2015, at the Bowtie Project, located along the Los Angeles River, produced by Clockshop and California State Parks.

"Hunger as a Teacher" was first published in the book *Incerteza Viva-Dias de Estudo*, for the 32nd São Paulo Biennial in Brazil, 2016.

IMAGE CONTRIBUTORS

Atingidas Bordando a Resistência – MAB Barra Longa – Minas Gerais, Yuri Barichivich – Greenpeace – MAB Movimento dos Atingidos por Barragens, Laura Cadena, Katerine Delgado – Movimiento Ríos Vivos Antioquia, Carolina Duque, Jonathan Luna, Juan Manuel Renjifo, Javier Román, Alex Wang, Dulce Yanomamo.

We Feel the Jungle Like We Feel Our Own Skin

Translated from the Spanish by Felipe Castelblanco

Taita Hernando Chindoy in Conversation with Felipe Castelblanco

As a child, Taita (that is, chief in the Inga language) Hernando Chindoy was told that he was impoverished because his community had little money and lived in a remote Indigenous village in the Andean Mountains. Over the years, he learned to doubt the wisdom of those who would relate wealth to money or to one's proximity to urban centers constituted mostly of non-Indigenous inhabitants. These doubts and probing questions would make him a tenacious Indigenous leader whose fight has focused, through many endeavors, on realigning the epistemic compass of the disappearing Inga culture.

Today, Taita Hernando Chindoy is the Chief Governor of the Inga Nation in Colombia. A well-connected organizer, a land defender, and a father, he was born at the top of the Colombian Andes in Aponte (Tablón de Gomez), nearly 80 km north of the city of Pasto. Chindoy learned Spanish at the age of twelve while working for the *colono* farmers, who had arrived in the area in the mid-1980s to plant poppy fields for heroin production. Learning the language quickly, he became the first member of his family to attend university when he enrolled as a student at the University of Nariño (Udenar) in Pasto. During these university studies, Taita Hernando simultaneously sought out knowledge about his own culture and roots. Moreover, it would be at Udenar that he discovered the vast systemic repression of his Inga culture, and of nearly every other Indigenous culture across Colombia, through a Western-style curriculum which was in active denial of the Indigenous peoples' ancestral knowledge and history.

As direct descendants of the Incas, the Inga people have lived since the 1500s across a radically diverse set of territories that stretch from the top of the Andes, close to the city of Pasto, which sits nearly 3000 meters above sea level, all the way to the lower Amazon, in the states of Putumayo, Cauca, and Caquetá, in the Southwest of Colombia. Occupying the northern edge of the Inca territory known as *Tihuantinsuyo*, the Inga hold that their mandate has long been to protect the strategic territories through which the Andean foothills give birth to the tropical jungles of the Amazon. These are crucial corridors for diverse plant and animal species, among them tapirs, deer, Andean bears, serpents, and jaguars.

The mountains where Taita Hernando was born are known as Colombia's fluvial star as they host the headwaters of three important

rivers—the Patía, Caquetá, and Putumayo—two of which flow across the jungle and feed the great Amazon River. The region near Aponte is surrounded by *páramo*, tundra-like ecosystems that cover the mountains and feed subterranean water deposits and lakes while conversing daily with the passing clouds.

For centuries, the stretch of land between the high Andes and the Amazonian plains that is home to the Inga has been the epicenter of complex colonial disputes and violence. From European *colonos* and their armies of entrepreneurs chasing gold, copper, rubber, oil, and natural resources for pharmaceutical supplies; through Colombian landlords and mestizo settlers claiming vast portions of land for agricultural production; to, finally, in recent decades, the drug cartels and armed rebels involved in cocaine and heroin production and traffic, the Inga have had to face and fight myriad actors and forms of violence to preserve their culture, territories, and lives.

The early 1990s, for example, saw the arrival of ELN guerrillas to Aponte; paramilitary groups followed a decade later. With these influxes and incursions, the Ingas became prisoners in their own territory, forced to turn nearly every field into poppy plantations for heroin production. During this violent regime, despite having fertile and prosperous lands for farming, the Inga began to experience extreme poverty and malnutrition due to the enforced monoculture. As a result, their population dwindled and their youth were forced to join the lower ranks of the same illegal armies forcing the Inga community into the drug trade. Indeed, in 2004, Colombia's highest constitutional court declared the Inga at high risk of cultural and physical disappearance, yet the same government maintained the economic, political, and environmental policies that have been causing this very vanishing of Indigenous lives, worlds, and traditions.

It was within this set of conditions that Taita Hernando began his life of service. Firstly, in 2001, as a local coordinator of the *Cabildo*, the Indigenous municipal house and then as Aponte's governor—that is, its Inga chief—for nine years. During his tenure, Taita Hernando worked to expel the ELN guerrillas and paramilitaries from Aponte, who retaliated with assassination attempts and constant intimidation directed at his community and family. In this tumultuous moment, Taita

El Fin Del Mundo (*The End of the World*), an independent nature reserve run by local farmers and Inga families near Mocoa City. Putumayo, Colombia. Photo: Felipe Castelblanco, 2020.

Hernando resorted to the nuances of a disappearing language, rescuing life-enabling principles long established among the Ingas, which set the stage for the emergence of *Wuasikamas*, or *guardians of the earth* in the Inga language.

Wuasikamas is a practice and an embodied epistemology centered on a profound respect for life both human and nonhuman, which allowed the Inga to initiate a process of territorial defense, conservation practices, and autonomous governance. The principles of *Wuasikamas* also helped to introduce a model for the voluntary substitution of illicit crops that fueled drug traffic. In its wake, the Inga reestablished their traditional *chagras*, or Indigenous gardens filled with medicinal and edible plants, in which conservation, learning, and spirituality are practiced within each family. By 2010, the initiative became a social enterprise concentrated on the production and commercialization of high-altitude coffee, through which the Ingas of Aponte Nariño were finally able to expel armed rebels and drug lords from their territories and fund the conservation of the natural fragile ecosystems that surround them. In 2015, *Wuasikamas* received the Ecuadorian Prize, awarded by the United Nations Development

Programme (UNDP), for their contribution to social, economic, and environmental development, a stunning achievement.

In 2018, Taita Hernando Chindoy and I embarked on a meandering path of conversations that would lead to various forms of collaboration between Inga, Colombian, and Swiss institutions in the following years. Firstly, in July of that year, during a long car ride along the narrow, infamous road known as the "Trampoline of Death," which connects the high Andes with the lower Amazon, we spoke in person about Indigenous governance and its commitment to defend a fragile fabric of life-enabling relations. Later, due to the pandemic and the enforced distance between us, we would continue our conversation in November 2020 by speaking online. Covering issues ranging from biocultural governance to conservation in the Pan-Amazon region, we would speak about the Inga's long-term strategies to develop new institutions for Indigenous thought in Inga territory itself.

—Felipe Castelblanco

Andean-Amazon foothills near *Trampolein de la Muerte* (the Trampoline of Death Road) in Inga territory. Putumayo, Colombia. Photo: Felipe Castelblanco, 2020.

Felipe Castelblanco (FC):
According to Inga principles, what role does the Amazon play in the vast scope of life forms that coexist on this planet?

Taita Hernando Chindoy (THC):
Earth is a living and sentient being, and nature is like a vast fabric that wraps itself around us. Each place, even if remote, is a stitch of this fabric. From one place to another, nature's fabric holds tension and allows the folds and seams to hold together. If the tension is right, the fabric is in shape, but if some threads are pulled too hard, our fabric wrinkles, loses shape, or rips apart. As humans, we also have the responsibility of keeping the fabric in good condition and to care for it as our finest attire.

Trees are like the finely woven clothes that earth wears, and we have to keep her clothes in good condition. Similar to how the Ingas see it, Pope Francis has recently acknowledged that earth is humanity's common house. Therefore, people all over the world have a shared responsibility, which is to listen to the earth and procure its well-being, not only in the Amazon but in the broadest sense of the term global.

However, it seems today's responsibility for conservation falls mostly on the shoulders of us, Indigenous peoples, but what is really needed is a collective effort. After all, life depends on our coordinated actions, not only to protect the Amazon but also the Andean ecosystems, the mangroves along the coast, and every natural site that hosts life. The important part of this is to remember that earth is a neatly woven tissue, and no matter if you are in Europe or in South America, there is always the same colors in the rainbow.

FC:
Why is the presence of Indigenous communities in the Amazon so important for the equilibrium and preservation of the Amazon rainforest?

THC:
Without Indigenous peoples, the Amazon wouldn't really exist today. Our Indigenous bodies have bonded together with the Amazon as a single entity, and we feel the jungle like we feel our own skin. Just remember that, historically, Europe also had huge biodiversity, but it is now diminished, and so it is all these imported

practices which undermine the stability of the jungle. The proof is the devastation caused around the city of Florencia [the biggest urban settlement in the state of Caquetá], extending all the way to the banks of the Caquetá river where the lands have been turned into grazing fields. Even there you can still see that the only small patches of green, or the areas that are well preserved, are where ancestral communities still live. In other words, our Indigenous reserves have been like containment walls, but the fear is that little by little they are starting to look more like small and disconnected green islands. As long as people continue to fight for the life of the Amazon as our extended body, the jungle can still flourish. But just like when the skin is wounded and cut open, making it easy for many external agents to penetrate the body and bring illness or death, we have to protect the Amazon as a fragile tissue, in the very same way that one cares for the skin.

FC:

If one of the strategies of the colonial process has been the negation or erasure of ancestral cultures and knowledge, then what are the practices that still remain and support Indigenous resistance?

THC:

Right now, our Indigenous cultures are debilitated, and frankly, we are quite fragile. For example, Nukak [a traditionally nomadic community living in the jungles of Guaviare] only twenty-five or thirty years ago lived as an uncontacted people deep in the Amazon jungles. However, once they were contacted and lured little by little into a supposedly civilized world, their population started to decrease at very fast rates. If thirty years ago their population amounted to around 10,000 people, today only 3,000 Nukak survive. Currently, they live with tremendous adversity because they are no longer able to roam the Amazon as an extension of their body, but, instead, are confined to enclosed reserves and spaces, like we all are in the urban context. As a result, their communication between themselves and the Amazon has debilitated; they have started to suffer from malnutrition, and recent reports show that young Nukak boys and girls are struggling with drug addiction. So, if we think about it, it is very likely that, in the next fifty years, the Nukak will disappear.

Paramo del Bordoncillo (Andean wetlands). Inga and Kamëntsá territory located between Nariño and Putumayo states in Colombia. Photo: Felipe Castelblanco, 2020.

In contrast, there are other communities like the Inga who have been able to resist these negative tendencies while adapting to the always-changing conditions. We, the Ingas, remain current, and we still recognize ourselves as a unique culture, despite the many struggles we face in our territories. What keeps us alive is our music, arts, medicine, and spiritual traditions.

The problem is that the territories don't get any bigger, but populations keep growing. For example, we maintain that our ancestral territory extends to 1,200,000 hectares, but this number does not align with the version from the government. Even though the traces of our ancestors in these territories are self-evident and are visible in archeological sites—as is reflected in the names of rivers or villages of the region—according to the Colombian government, we are only entitled to 130,000 ha for our reserves. What this means is that we have lost, or been denied, almost 90 percent of our ancestral territories, and all while these lands have been placed in the hands of non-Indigenous populations.

This is why it has become imperative that we take back control on issues like Indigenous land reform, education, and governance. We

need to close the cycle in which our rights are decided by others and, instead, put Indigenous administrators in charge.

In areas like education, 99 percent of what is being taught in schools is also being imposed upon us, yet it does not reflect our culture, and as Ingas, we are still dying little by little. So, even if we have to borrow skills and knowledge for now, the idea is that soon we can have control over the administration of our own knowledge. But I insist, the problem today is that we have zero control over matters that radically affect our communities.

FC:
What was the actual trigger that kickstarted this dream of creating an Indigenous university?

THC:
Well, it is exactly the lack of paths available to learn about ourselves and our own Indigenous history. For example, in my case, when I went to the university outside [a non-Indigenous university in the city of Pasto], I didn't have any chance to learn about my culture or a chance to connect the concepts that I was learning with the teachings from my father or other elders back in Aponte.

Back then, I was seeking for more ways to learn about our own Inga history, about how we got here and why. Most Inga elders only know our history since the 1700s, when Taita Carlos Tamabioy was alive and helped the community defend and secure our territory from the Spaniards by producing a legal testament. This document used colonial laws to leave a record of our presence in the region and gave us rights over these territories through inheritance. We still know very little about how this emblematic Inga leader arrived here or what life was like before his time.

This is why, in my own educational journey, I ended up learning from the work of non-Indigenous researchers and experts who had more information about us than we do. This is how I started to learn about my Indigenous heritage, and quite sadly, this is exactly what we all go through as Indigenous people. However, we are seeing that there are other ways to reclaim our own confidence as well as methods of learning. Many universities today are enabling a different transfer of knowledge

which, aside from teaching historical or technical topics, allows you to learn about ancestral medicine and spirituality.

One important difference is that, for us, knowledge is felt or, for me at least, knowledge is a feeling. It Is like being submerged in the knowing. Meanwhile, in a Western university, the professor guides the students as they learn, provides them with books and introduces methods until eventually the students hold the knowledge like holding a rock in their hands. But in that case, there is only a material relation with the knowledge, in which we strive to make knowledge palpable. It is then when the students start to know the rock as a solid, heavy, and material object. That is an external kind of knowing. Instead, knowing for us is a feeling: it is as if every cell of one's body responds to and becomes familiar with the nature of something. In that place, one sees all colors or features, but one cannot hold, weigh or measure it. Instead, the rock becomes like a surrounding or a skin that one comes in contact with and which envelops one's mind. At that moment, a rock tells you about itself.

And definitely, knowledge opens doors, but which kinds of doors? While the Western model of the university opens doors through books and making one fluent in everything that the human mind has produced, nature has its own doors. These doors can also be opened with sacred plants, which eventually nourish not only your mind but your way of being.

So, if we look at ancestral medicine, the Kofán [a neighboring tribe] for example, have their own formulas to heal the body. The Kofán doctor heals the sick not by killing that other being which causes illness, like a virus, but by conversing with it and connecting to that energy to adjust one's balance. That's why singing is used in ancestral medicine because it is through songs that the doctor speaks with the illness.

FC:
How would you categorize Inga science?

THC:
Perhaps Indigenous medicine shouldn't be categorized as science in the Western sense. What is important to recognize is that there are different ways to access knowledge and through many different paths. There are as many ways to access knowledge—for example, to treat a flu—as there are cultures in the world. In Colombia, you

have 115 Indigenous communities, in addition to the Afro-Colombian and the majority (*colonos*/white) populations, which means that there are 117 plus ways to know something. Each way should be valid in its own context, and, ideally, anyone could explore one or more of these approaches in the process of getting to know the world.

However, to try to explain Indigenous knowledge through the lens of science, or by equating it with science, is not right because they are different paths to knowing something. Instead, today's challenge is to garner respect for each path as unique and irreplaceable. But the medical knowledge of our elders is still deemed inferior or archaic compared to the practices of Western doctors. This is precisely one of the challenges that we have to address through an Indigenous university.

FC: ●
How does one create a university that does not force translations between Indigenous and non-Indigenous ways of knowing, and that doesn't simply replicate the model of the urban university in the Amazon?

Ceremonial Crown and *Sayo* (Poncho) worn by an Inga/Kamënstá musician during the *Bëtscnaté* (Big Day) festival for the Kamënstá people, also known as *Carnaval del Perdón* (Carnaval of Forgiveness) among the Inga. Sibundoy Valley, Putumayo. Photo: Felipe Castelblanco, 2020.

THC:

What we need to do is to conceive of the university as a fabric, woven together from the fibers coming from various epistemic traditions, processes, and various forms of knowing. This university also has to become a connector between the highlands [of the Andean region] and the lower Amazon. The challenge increases if we Indigenous communities do not draw a clear path and rely only on the solidarity of external agents.

There has to be an internal push to strengthen our governance and the unity of our communities, our social bonds, in order to confront the pressure. After more than 500 years of pressure, we sometimes don't even think it is possible to rebuild a sense of cooperation among various Indigenous nations or to see ourselves as part of the same community. Because of that same history of denial and abuse of our cultures, we lost confidence and now doubt that new social bonds can function according to our own history. That is a part of the big task of decolonization; reviving ourselves in the present through our own ancestral imaginaries.

But as we strengthen our connection with the territory, trust more in our Inga heritage, and restore our sense of ownership, we will continue this deep connection with the environments and contexts we inhabit. Only then can we rewire and unlearn many concepts, like *being poor*, like *living far away*, and all that instills a sense of inferiority among Indigenous people.

In the case of building a university in our territories, it is a real challenge for the imagination. For example, if we choose to build it in a village, we risk reproducing all the damage that has been done to the environment through brick-and-mortar architecture. Instead, if we build the university in the forest, it can reflect other ways of building and creating space in accordance with our ways of seeing the world.

For example, in the story of the three little pigs in which each one builds a house, we learn that the weakest house is the one made of wood. However, wood is all we have available in our territories. So that is exactly how a dominant culture teaches us how to not valorize our own cultural practices and resources. Therefore, the architecture of the university has to reflect our cultural codes and reinvent the ways in which we build not just a structure but an entire educational model. One of the opportunities of the university is to

show the world another way to relate to and inhabit the territory. Over time, the project will impact several areas, and there is a clear path to unlearn or dump a lot of ideas that we have learned through outside influence, so it will be like washing away stains that we don't know we have. But, of course, these are tiny actions compared to all that humanity has to do. And again, it shouldn't be only the responsibility of Indigenous people to unlearn.

FC:

As I understand it now, the Indigenous university is actually an exercise in world-making. Or at least, it seems like a direct path to redefine priorities and practices across many fronts. For example, how might we relate to an endangered territory, how do we build and profit from this territory, how is knowledge being transferred, and so on. In order to achieve this new mindset, it seems as though a certain type of institution is needed, one that offers the tools and context and passing on of Indigenous knowledge to reinvent an entire Indigenous nation, thereby delivering a clear model for others to follow. Am I right?

THC:

That is why *Wuasikamas* [being a guardian for the earth] is the support, or backbone, of all the processes that we are developing. This is a new model for thinking, but not only for the Inga. It is one that can be shared in a pluriverse or whatever visions and configuration of the world we end up with. What I want to leave behind—for my community, my children, my siblings—is a solid foundation, based on our ancestral principles, through which many of us can seek answers not toward the outside, but instead are allowed to go deep and seek inside.

But likewise, that duality between inside and outside of our consciousness, our bodies, and our societies needs to be reconfigured. For example, we think that the moon is outside, but it affects mothers giving birth or reproductive cycles, so it is not outside, instead it is already a connection that starts deep within the body. Or like when one takes medicine [*ayahuasca*] and sees infinite lights only to realize that we're not alone in the cosmos. As one elder said, "I know that no matter where I end up going, I will also be in the home of my community. And in order to get there, I'll have to cross a labyrinth. But once I find it, even though this home will seem far away, that home is

El Castillo (The Castle), a ceremonial temporary portico built with leaves from *Palma Real* (Royal Palm) for the Bëtscnaté or Forgiveness Carnival by Kamëntsá and Inga artisans. Sibundoy Valley, Putumayo. Photo: Lydia Zimmermann, 2020.

still connected to this one." So, there is a real connection with the larger universe, but we have forgotten how to see and navigate those paths. In the present, we cannot learn how to see these connections, so it is a matter of returning or remembering, with dignity and confidence, knowing that all these other conceptions of life, and of knowing, are possible.

FC:

Are there possibilities of becoming Indigenous, or awaking as non-Indigenous people and attuning to these ancestral ways of being?

THC:

The challenge here is for humanity to see itself again as a family and that we are not separate regardless of all the barriers we have built. Would it be possible that one day humans could live on earth as one single family? Eventually, if we cannot come together as a family, there will be other groups that will try to remove the Indigenous people from their territories in violent ways. And there would be two alternatives, that the Indigenous concede, or choose collective suicide and die alongside the territory. We already see the second scenario coming in relation to the lack of concerted efforts to protect the water. We live in areas with plenty of water but when water scarcity

begins and bigger powers start to fight over it, we are going to be pressured in ways that you cannot imagine.

But unlike the big geopolitical players, the Indigenous approach is always more concerted or shared. It is more about familiarity and not about imposing. And this sense of sharing is something we all have to embrace. But we must be aware of the limits of these exchanges and how much can be shared. For example, it's about knowing how much the Swiss want to be influenced by the Indigenous or how much the Indigenous want to be influenced by the Swiss. I don't know how we can develop more reciprocal relations but perhaps the path is to form and strengthen mutual trust. That's when it becomes necessary to learn mutual communication codes and pay attention to what already happens all across the Amazon. Each Indigenous nation speaks their own language, but anyone can easily speak four or more languages, so they all can communicate. Perhaps this is one of the successful strategies that have kept these nations safe, which is the fact that they can communicate and embrace one another.

It is not about canceling differences; otherwise, we risk falling into the trap of homogenizing and imposing what one group thinks is right onto another. That's why in our tradition we plan the umbilical cord in the *chagra* [Indigenous medicinal and food gardens], which celebrates our connection with the earth. So that *chagra* is the territory, the common home. It's a place where it's possible to connect with the sun and with the heart of the earth. And it is a place inhabited by other beings, like the deer, jaguars, bears, and serpents. That is the place where several dimensions in that territory meet because each being that lives there also has other conceptions of territory. One doesn't negate the other.

The Juruna and the Force House

Tiffany Higgins

Every river has its own signature. When its varying flow rates are drawn across the year, it sketches a squiggling curve, distinct for each river—its natural personality. Scientists call this chart a hydrogram. In tropical rivers in the Amazon Basin, this signature forms a seasonally predictable shape, and the yearly cliffs and low-point gullies of water flow rates are particularly dramatic.

In one of the Amazon River's tributaries, the Xingu River, these flows are fed torrentially in the rainy season in the first several months of the year, yet drop down to lows in October and November almost as if about to disappear, only to once again come roaring back with the accumulated force of its thousands-of-kilometers-long body. The giant being of the river gives and withholds, guards its force, then once again offers. This cyclical flood pulse bestows life to the whole system, making the fisheries productive. Without that pulse, though, beating in the heart of the forested rivers, the system collapses—even the riverside forests whose life depends on that watery undulation.

In Brazil's Amazon Basin, the four seasons of a seasonally variable river are called the *seca* (low-water period), the *enchente* (flooding period), *the cheia* (high-water period), and the *vazante* (ebbing period). The English word *flood*, when applied to rivers, connotes something gone terribly wrong, something failed to be contained, like an animal got out of its cage. But in the Amazon, flooding is normal, predictable, and necessary. The flooding season, just after the turn of the year, ascends precipitously as rivers flow faster and faster; crashing rains send the river over its banks and into the forest, flooding trees adapted to being inundated. River animals have also adapted across the millennia to this shape and rhythm, knowing when to ride the rising swells into the forest to forage, when to spawn and raise their young in the protected shelter of the flooded forest, and when to return to the mainstem. The Indigenous and traditional river peoples' knowledge of the moving, pulsing river, with the animals' knowledge, weaves them all together, like a hammock that swings in a shack situated on the swaying river.

The Xingu River, a 1640-kilometer tributary of the Amazon that joins it from the southeast, is the basin's third-largest clearwater river.[1] The Xingu begins in the middle of Brazil in the dry, savanna-like biome called the *cerrado*. The land around the headwaters of the Xingu in Mato Grosso state has increasingly been converted to soy plantations, drawing down levels in the river. The

Xingu wends its way through the softer rocks of the Brazilian shield, northward into the Amazon, until at the *Volta Grande*, or Big Bend, in Pará state, the river hits sedimentary rock, twisting into an S-curve with three bends of around 90 degrees. The force of tens of thousands of cubic meters per second hitting that hard rock fractures the wide course of the waters into braided river strands and spurting rivulets and straight canals, then into low cascades and waterfalls like the giant *Jericoá*, giving birth to a profusion of midriver islands and rocks. The water here has always been warm and transparent, meaning you could wade, dive, and observe a colorful variety of fish, each in its niche, giving the 130-kilometer crook of the Volta Grande the vibrancy of coral reefs.

What animates the Volta Grande, and makes it an extremely productive fishery, is the regular flood pulse. Though the river never stays the same, shifting shape, level, and flow speeds throughout the year, it maintains a predictable yearly rising and lowering, to which fish and turtles alike have learned to live and spawn. Their reproduction is synced with the highest flows of the year, which occur in the first three to four months of the calendar, and which permit them to ride into the suddenly available flooded forest to access fruits that are just ripening and dropping into the water, allowing fish to scoop them up, accessing the calories necessary for them to spawn. Without that seasonally available food source, made possible by the seasonal wave that brings them into flooded forest, fish can't reproduce.

In November, under normal conditions, the rains begin at the headwaters in the center of Brazil, and the Xingu begins to rise and fill the vegetation area locals call the *sarobal*. By the end of November, the flooding period begins as the Xingu flows increase, pushing water up into slightly raised, vegetated areas called *sarobais*. All of a sudden, fish and turtles are able to swim into the *sarobais* to eat precious leaves and fruits. In January, the Xingu River's waters spread further, overcoming the margins of their banks, flooding the alluvial plain, allowing turtles and fish to travel through water that once was land. The water continues to rise and wend its way into *igapós*, shallower pools within the flooded forest margins. From the Old Tupi phrase meaning "roots of water," *igapó* combines "y" (water) and *apó* (root). By February, both the midriver vegetation of the *sarobais* and the alluvial plain are completely flooded, signaling the rich season to come, one of fertility and birth.

At this time, the flooded forest is a nursery, sheltered from the mainstem. This is the magical moment when the river's edge is flooded with water, encouraging turtles and fish to find fruit for reproduction. The signature vegetation is the *sarão* plant (*Myrciaria dubia*), along with fig trees (*Simaba orinocensis*), January guava tree, cashew trees, *golosa* (*Chrysophyllum sanguinolentum*), and *gamaleira*.[2] In May and June, the *landi-roxo, cafeirana*, and June guava ripen and offer up their fruits as well. Such plants, off-limits to the fish during the dry season, offers the fish additional food sources that will allow them the energy to mate, to create eggs, to nourish their young, and successfully reproduce for another year, bringing new generations into being on the Volta Grande of the Xingu.

As the fish move throughout the flooded forest, digesting fruits and depositing feces, they spread the trees' seeds. In other words, the fish replant the forest. That is, they sustain the forest, keep it standing, keep the trees on their tree feet, *a floresta em pé*. The fish, the floods, the *sarão* bushes, the fruiting trees—everything is timed precisely over thousands of years of reiteration, a synchronicity between the Xingu's seasonal flood pulses and the fish and turtle spawning. Agostinho Juruna, a fisherman of the Juruna people who lives along the river's banks, as his people have always done, notes, "The fish knows that when the river begins to fill, it will be able to eat the *sarão* fruit."[3]

The Juruna Indigenous people—the Yudjá, as they name themselves—are the original inhabitants of this part of the Xingu River. Since time immemorial they have dwelled here, according to elders, from the Rio Fresco in the south to the northernmost waterfalls that they called Big Water (now the site of the Belo Monte dam). In the past, the Yudjá dwelled even on the Volta Grande's midriver islands, fishing and canoeing the Xingu's watercourses. For it is here that Senã'ã—the first Yudjá, the child of a jaguar couple, and an ancestor, divine shaman, and birther of worlds—set them down to dwell, making sure to tell them that they are distinct from the forest peoples. Yudjá means "owners of the river." The Yudjá elders explain their preference for islands: "There the islands aren't inundated in the winter [rainy season]. We would go to the natural beaches that emerge in the summer [ebbing season]. It's said that Senã'ã was speaking."[4]

A long time ago, Yudjá elders remember, the sky was low. During the great flood, Senã'ã planted manioc in his divine canoe, multiplying it overnight with divine breath, so humans could eat. In the watery immensity, he opened pathways the Yudjá followed, encampments to repopulate the earth. Resonant with the cosmic trope of the suspended sky and imminently falling sky, described by today's shaman-author Davi Kopenawa of the Yanomami people,[5] the Yudjá memory of this mythic past somehow blends with a future world's end:

> It was in the time when the Yudjá were at the brink of extinction.
> When Senã'ã tried to make out the river,
> There was no more river,
> And he grew furious and knocked down the sky,
> The sky collapsed,
> The sun was put out,
> Everything cast into darkness.[6]

In the tale above, are we in a creation story, or in the real-life end-times that describe what the Yudjá face today? For a manmade cessation to the Xingu River is what the Yudjá are experiencing now, and with it, their river-written identity has been put into peril. Their creation story, figuring a destruction of worlds, seems to turn to prophecy.

After the arrival of the Portuguese in Amazonia in the 1500s, the Yudjá have experienced successive incursions to their sacred river bend. First from the Portuguese who came hunting to capture and enslave Indigenous "Indians" to labor for them, then from the gold miners who flocked to siphon out gold from the riverbed. Each wave of colonizers brought illness and violence, and the Yudjá grew smaller, and the area they occupied smaller as well. Other Indigenous peoples, fleeing depredation from armed settlers and later Brazil's military, migrated to the Volta Grande. But then the rubber tappers came to suck white milk from the latex trees that liked the river's margins. This was a particularly terrible era for the Yudjá. From some 2000 people in 1842, the Yudjá counted just 200 in 1884.[7]

Desperate at their decimation, some Yudjá decided to leave the Volta Grande and go upstream on the Xingu River, and so a band still lives there today in the multi-ethnic Xingu Indigenous Park in Mato Grosso state.

Nevertheless, a small set of the Yudjá determined to persist on the Volta Grande. By 1950, they numbered just 37 people. In 1972, the generals of the Brazilian dictatorship opened the Trans-Amazonian Highway, which cut through the forest, bringing more outsiders to occupy the river's margins. At this time, the Yudjá pursued a strategy of intermarriage with other peoples, enlarging their numbers into some two hundred in the 1980s. Though it was the Brazilian generals who concocted the plan to dam the Xingu at the Volta Grande in order to send electricity to the larger nation-state, it would be President Lula, Ignácio da Silva, who set their idea in motion. The Workers' Party and Brazilian Democratic Movement Party election coffers were replenished with bribes from the construction companies contracted to build it, until Lula's successor, President Dilma Rousseff, finally signed off on the hydroelectric Belo Monte dam plan in 2010, celebrating it as a triumph of progress.

Bel Juruna, a Yudjá nurse raising four children, lives in M'ïratu village in the Paquiçamba Indigenous Territory, situated on the Volta Grande of the Xingu. I first began speaking with Bel in 2019, ahead of my trip to the Volta Grande in August 2019 to report on the dam's effects on those who lived along the river. At that time, Norte Energia's plan to radically cut the Xingu's flow hadn't yet gone into effect. Now, two years later, it has. Since I haven't been able to return to the region due to travel restrictions put in place during the Covid-19 pandemic, I ask Bel to document any effects for me. On February 23, 2021, Bel points her phone's camera toward the Xingu River, then down at her feet, where enormous gray rocks sit on dry ground. Just two weeks before, these rocks were immersed within the river. A huge gray boulder bears a light line across it, shoulder-height, where the just-flowing river deposited grains of sand across a ledge. "This was fast-flowing water," Bel tells me. But now, she notes, "the water has stopped."[8]

Earlier that month, Norte Energia, the operator of the Belo Monte dam on the Volta Grande, suddenly cut the Xingu River's flow to less than 85 percent of historical flow rates. Across 2021, the company will drop the river to less than 73 percent of historical average flows. Since 2015, when the Belo Monte dam closed shut across the river, the Xingu River has no longer been able to direct its own flow, dependent as it is upon the engineers to suck it back,

diminish it, trickle it, release it, then retract it again. The river's rhythms and signals, a language that its animal inhabitants had learned to interpret over generations, have been replaced with a new language of sudden releases and withdrawals of water impossible for human residents of the Volta Grande, much less the animals, to decipher.

But this new water stoppage was something more violent. The river's flow, released to the Volta Grande, was running at 10,900 m3/s. Norte Energia cut the flow to 1,600 m3/s. The historical flow average in this month is 12,736 m3/s. This is the period that Amazonian peoples in Brazil call the *piracema*, a word derived from the Tupi phrase for "the fishes' departure," from *pirá* (fish) and *sema* (departure). Here in the Volta Grande, it was the time when the fish enter the seasonally swelling waters, catching a ride into the flooded forest to reproduce. The river, now slowed to trickle, was too weak to allow the fish and turtles to reproduce. So, the fish and turtles will not spawn this year.

The river's flow was cut by Norte Energia with the permission of the president of IBAMA, Brazil's environmental agency, Eduardo Bim,[9] appointed by President Jair Bolsonaro. IBAMA's team of scientists documented that these extreme low-flow levels, which the company calls Hydrogram B, would have grave impacts on the river and its surrounding ecosystem, including those Indigenous peoples like the Yudjá, who live within them. But on February 8, 2021, Bim signed an agreement with Norte Energia's president allowing the company to cut the Xingu's flow regardless of the grave consequences.

By sucking the river dry during the *piracema*, the annual reproductive window when fish should be riding increased flows into the flooded forest to gather enough food to spawn, Norte Energia ostensibly has effectively destroyed the food source of the Juruna people. In a 2009 licensing agreement, Norte Energia promised it would "maintain life on the Volta Grande," the biodiversity that is the foundation of the cultural continuance of the Juruna. Nevertheless, it was an agreement signed without the Juruna people even being consulted: they were never given free, prior, nor informed consultation on the proposed dam project as is required by International Convention 169 and Brazilian law.

Now Bel, at the nearly dry riverbed with her camera, shows us canoes with outboard motors, stranded on rocks. The Juruna say that they have

"canoes for feet," the wooden boats an extension of their very bodies. The dropped flow, she explains, negatively impacts their own ability to navigate the river, thus altering an integral part of their people's self-definition. They can't navigate the river now to access the nearby city of Altamira, where in the past they would sell their catch of fish.

Historian Heather Roller has discussed the importance for Indigenous peoples of Amazonian routes, the seasonal paths traveled through the river and forest to collect nuts and fruits in their season, documented since the 1600s.[10] These mini-pilgrimages are a key part of Indigenous Amazonians' ecological and cultural knowledge, drawn from and across the landscape, connecting their territory to other peoples' territories. But if the river remains too low, these routes are inaccessible by boat. More than a decade ago, after being pressed by the Indigenous affairs agency (FUNAI), Norte Energia promised to preserve conditions on the river needed for the food sovereignty and cultural continuance of the Volta Grande peoples; however, all that is changing now.

Panning her camera from left to right, Bel explains to me that the tall bushes we're seeing are aquatic plants, dependent on seasonal inundation. Two weeks ago, they were immersed in water. "These plants are usually on the bottom [of the river]; they are water plants. And because the water won't come anymore, they're all going to die," Bel says.

Like the trees of the seasonally flooded forest, although these plants are adapted to spend part of the year out of water, they need to be immersed for a part of the year or they will die off. Bel nods to a part of the forest on the other side of the river, the *igapós* that recently were flooded with water, which fish took as a signal to surf deep into the forest in search of fruiting trees. "Those are the *igapós*, where fish entered," she notes. What she doesn't say is now that the company has retracted the river, the fish are in danger, stranded there in the forest in isolated pools of water with less and less oxygen; the water around the exiled fish slowly converting to dry ground. "The Volta Grande will turn into a cemetery. A cemetery of fish, a cemetery of dead trees," Bel says.

At the edge of the river, Bel shows me some pieces of broken wood. As part of the Basic Environmental Plan set up in 2009, Norte Energia committed to funding aquaculture programs. Even before

the drastic lowering of water in February 2021, the company's diversion of the majority of the river to its turbines already had suppressed the amount of fish in this stretch of the river, where tens of thousands of traditional peoples who are sustained by the watercourse live. The aquaculture program funded by Norte Energia was meant to provide extra fish protein to replace, in some measure, the fish that they themselves had caused to disappear.

The people of M'iratu village have cared for the fish in the wooden cages for a year. They wake up around four in the morning to feed the fish in the cages set into the river, then check on them throughout the day. At the beginning of February, IBAMA's technical team of scientists ordered Norte Energia to increase the Xingu's flow to near what it would be historically, 10,900 m3/s, with the intention of ensuring the *piracema*, the fishes' reproduction, for 2021. Throughout Brazil, people who had been following the plight caused by the Belo Monte dam rejoiced as they saw the increased flow as a sign of what IBAMA's technical team had been saying for a few months, in documents seen and written about by the business newspaper *Estadão*: the dam company would have to return water to the Xingu.

Fisherfolk on the Volta Grande also rejoiced as they saw the pent-up flow, retained by Norte Energia at the Pimental dam, released back into the river, which started to rise again as it should be doing in February to build toward a yearly flow peak in April. When her phone came in cell tower range, Bel saw her fellow fisherfolk sharing posts. After so many years of struggle to be heard by the government and by Norte Energia, could it be all that work was going to pay off? Could it be that IBAMA was finally listening to them, the humble people of the Volta Grande, and to the fish? But Bel didn't feel right about it. She didn't want to dampen others' enthusiasm, so she kept her own counsel. But she didn't click "like" on the posts, intuiting that this wasn't the end of the story.

In January and February 2021, Brazilian media was flooded with leaked documents from ANEEL, the national electricity agency in Brazil, and the Mines and Energy Ministry. The ministry had sent out a directive to its agents, instructing them to do everything they could to overturn IBAMA's plan to make the dam company—the second largest dam in Brazil, and the fourth largest in the world by installed capacity—return river water to the Xingu. Each cubic meter of

flow sent back to the Volta Grande would mean one less cubic meter sent to the turbines to be spun into energy, then shot through Chinese-owned transmission lines thousands of kilometers long, traveling to substations in the center-south of the country, the majority to be used by mining and other industrial operations. Paulo Guedes, the minister of economy, was quoted as predicting that if Norte Energia couldn't apply its low hydrogram, not only the electricity industry but the whole Brazilian business sector would be negatively impacted. Indeed, ANEEL warned that, should IBAMA's scientists get their way, then there wouldn't be enough electricity for Brazilian domestic consumers. To make up the supposed shortfall, Norte Energia would have to buy electricity from thermoelectric plants, a more costly form of electricity. Then they'd pass on the rise in cost to consumers, meaning Brazilians would see a huge jump in their electricity bills. Some business newspapers simply repeated these allegations, cutting and pasting notes leaked by these agencies.

But it wasn't true. Juarez Pezzuti, of the Federal University of Pará, noted that Norte Energia and ANEEL had used data from the *seca*, the driest part of the year, to allege that there wouldn't be enough water in dam reservoirs across Brazil.[11] But in the current rainy season, notes Pezzuti, hydroelectric reservoirs across Brazil are full. Nevertheless, as Camila Ribas of the Institute for Amazonian Research said, this fabrication worked on Brazilians concerned about paying more for electricity in the middle of a pandemic and an economic depression.[12] "IBAMA became like the enemy," Ribas noted, standing as it supposedly did in the way of Brazilians' economic solvency.

In 2009, IBAMA's scientists had already documented that Norte Energia's Hydrogram A and Hydrogram B plans were inviable and sure to destroy the river's ecosystem. Still, then as now, outside political pressure on the environmental agency closed around it. Indeed, from 2010 to 2011, IBAMA's president was replaced four times until Brazil's government finally found one who would be willing to give Norte Energia the installation license to start construction on the Belo Monte dam.

When IBAMA ordered the flow to rise at the end of January 2021, and even higher in February, in Mïratu village, the sudden flow surprised the villagers. Bel remembers that, as IBAMA hadn't warned the Juruna that they were going to raise the flows, it came in like a sudden wave. The fish cages, in which the Juruna had been

raising fish to make up for the loss of their fisheries, suddenly sank into the river. If IBAMA had given them a warning, she recalls, they could have tied them down. But the sudden flow overturned them. Then, on February 8, 2021, IBAMA's president Bim signed an agreement with Norte Energia's president, contradicting the decision that for months the scientific team had said it would make. By the end of that week, Norte Energia had drained the Xingu's flows again.

As these decisions were made thousands of miles to the south in Brasilia, in the village of M'ïratu Bel watched the Xingu River drop. The wooden fish cages, having sunk into the river without warning by one decision made far away, had now come to rest on now-dry rocks, from another decision made without thought or recourse to the Juruna people and all those who make their life along the Xingu's banks.

In 2013, Norte Energia began dynamiting forest to construct a channel to be situated next to its Pimental Dam. The channel diverts most of the Xingu River's force away from the river's Volta Grande and sends it north to Belo Monte. The Pimental doesn't produce energy to speak of, but serves to back up water behind it, forming a gigantic reservoir that, typical of most dams, drowns forest swaths and degrades fish habitats. Sediment backed up behind the dam, clouding formerly transparent water. This new reservoir flooded the Volta Grande's rapids into disappearance, thus killing off most of that section's uniquely rapids-adapted fish. By contrast, the "dewatered" section of the Volta Grande now sees death by drying up. The common element here, though, is the loss of rapids: in the reservoir area, they're flooded out, death by drowning; in the area seeing its water diverted, the rapids disappear from loss of flow, death by thirst.

The Volta Grande includes two Indigenous areas, TI Paquiçamba (of the Yudjá) and TI Arara (of the Arara Indigenous people), both on the "dewatered" section. The Yudjá have not been able to canoe to other villages and towns. They've been confronted with dried-up stretches of riverbed, and have been setting logs across exposed rocks there to try to portage canoes, dragging them up and down. The famed Jericoá waterfalls were converted into a field of rocks. Just upstream of the Pimental dam, Norte Energia diverted the force of the south-to-north-flowing river to connect near Belo Monte's

"*Casa de Força*"—literally, its *strength or force house*, where the river's force is transferred to the turbines of the principal Belo Monte dam at the top of the S-curve. The Force House is the physical structure where the turbines are located, spinning incoming water to generate electricity.

The Force House here can be seen as a physical and figurative representation of the force of the Brazilian state in imposing its will via the implantation of a hydroelectric structure that re-engineered and denatured the Xingu River. In the corporation's and government's shared language—a corporate-state lingo, if you will—they "dewatered" this part of the Xingu—but without the prior consultation of the tens of thousands of Indigenous and traditional residents as required by international law to which Brazil is signatory, as well as the Brazilian constitution itself. Here was the force of the state against science, against its own technical teams documenting an impending ecocide. Here was the force of the state deterritorializing Indigenous inhabitants such as the Juruna who have lived on the Big Bend since long before Brazil ever existed.

Indeed, here was the force of the state, which, when faced with several judiciary rulings finding illegalities in the licensing and construction phases, invoked the dictatorship-era tool of the Security Suspension in order to overturn all these rulings, ramming through the Belo Monte dam. Though national energy security was invoked to justify a security suspension of laws, it turned out that Workers' Party and Brazilian Democratic Movement politicians had been bribed, their campaign re-election coffers topped up by construction companies including Andrade Gutierrez, Odebrecht, and Camargo Corrêa so that they would approve the controversial project.

The major profits of Belo Monte occurred in the construction phase as these construction conglomerates, which have entwined themselves with federal power from the time of the dictatorship[13] and continue today, received BNDES development funds, financed by the Brazilian taxpayers themselves.

In a one-two punch to the Volta Grande, Brazil simultaneously awarded gold mining contracts to Canadian mining firm Belo Sun. Gold mining, of course, is an extremely water-intensive activity. Less

than 10 kilometers from the Juruna's Paquiçamba Indigenous Territory, Belo Sun plans to use cyanide to process gold and store the waste on the river, near where the Xingu is fed by the tributary of the Bacajá River, which runs through the Xikrin–Mebêngôkre people's Trincheira–Bacajá Indigenous Territory. Brazil has had two high-profile tailings mine collapses in recent years, one of which poisoned and killed all life in the entire Doce River. If the tailings mine, planned here to store cyanide waste, fails, the water of all these peoples—the Xikrin, the Juruna, the Arara, the Curuaia—will be poisoned. Here, then, is the power of the state enforcing the infusion of a literal poison, in draining the living aquarium of this stretch of the Xingu River, its manifold effects of violence rippling outward to the wider river region.

Belo Monte is similar to other Amazonian dams that initiate a widening swath of deforestation, beginning in the pre-construction phase and continuing to expand for decades after construction. The reservoir progressively drowns more and more trees (as scientists have shown is still occurring, for example, around the Balbina dam, constructed in the late 1980s). Meanwhile, new migrant populations, drawn by the chimera of "progress" and employment, and taking advantage of newly cut roads, advance steadily into surrounding forest. This has only been accentuated in the wider region of the Belo Monte dam, due to what researchers call the "Bolsonaro effect," an implicit encouragement of illegal invasions of outsiders into Indigenous lands for logging, mining, and cattle ranching.

Satellite photos show bald spots of deforested land between 2018 and 2020 in the nearby region's Ituna/Itatá Indigenous Territory, Cachoeira Seca do Iriri Indigenous Territory, Trincheira–Bacajá Indigenous Territory, Apyterawa Indigenous Territory, and Kayapó Indigenous Territory.[14] Land invaders place these peoples and their forests at grave risk, for mining chemicals pollute water sources and, since 2020, these intruders have exposed Indigenous residents to Covid-19.

Paradoxically, as forest invasions and deforestation have jumped significantly since 2018, enforcement fines have gone down. IBAMA, which should be doing such enforcement, has had its funding slashed in this period, and its top administrators have halted some sting operations on illegal mining and logging. And so, as of this writing, the Indigenous peoples in the wider Belo Monte region confer among themselves as armed outsiders enter, burn, log, mine their forests, and poison their rivers. The state does little.

Brazil's motto, "Order and Progress"—written in bright block letters across the girth of the blue planet spinning on the nation's green-and-yellow flag—means many Brazilians conceive of Indigenous peoples as unfortunate obstacles to the progress of the Brazilian economy. But the export commodities-based economy mostly enriches elites, while laying waste to the natural resources that underpin traditional peoples' substantial river-and-forest product-based economies and unique cultures. Climatologist Carlos Nobre has documented that açai and cacao, for example, are actually more financially productive per square meter than soy and cattle, suggesting an Amazonia 4.0 business model based on scaling up these economies of harvested products while keeping the forest standing.

Both the local and larger Belo Monte dam region since 2018 have emitted the most carbon of anywhere in Brazil. Tropical dams spew methane and carbon, with knock-on deforestation effects emitting more carbon. This gives the lie to the claim of hydro as green and clean energy, and these greenhouse gasses will negatively impact Brazil's southern population centers, which depend on flying rivers of moisture for their own hydrological reservoirs. What is needed on the planet now is knowledge of how to live *with* rather than *against* the planet, and with each hydro megadam, tens of thousands of traditional peoples, who hold this knowledge and practice it in their daily economies, have their hands bit by bit pried off of their lands, an eviction of essential, crucial knowledges for their and our present and future survival.

In March, Bel tells me that she attended a meeting at the Ministério Public Federal, the Federal Prosecutor's office, in the nearby city of Altamira. They seem to have informed the Volta Grande's fisherfolk about Norte Energia's plans, including new mitigation projects, which ethnobiologist Juarez Pezzuti calls "an absurd pseudo-project" that won't work. Bel says: "The MPF was talking about fish in captivity… raising fish in captivity and releasing them into the river …." Her tone is at once astonished and dejected at this idea of attempting to engineer fish while lowering their river to ensure fish will die. Earlier, in February, Bel had noted, however: "We will be here. We want to resist in this place, fighting so that we, too, won't turn into a cemetery in our village."

1. Ranking here is measured by average discharge flows.

2. Juarez Pezzuti et al., *Xingu, o rio que pulsa em nos: monitoramento independente para registro de impactos da UHE Belo Monte no territorio e no modo de vida o povo Juruna (Yudjá) da Volta Grande do Xingu* (São Paulo et al.: Instituto Socioambiental, 2018), https://apublica.org/wp-content/uploads/2019/12/xingu-o-rio-que-pulsa-em-nos.pdf.

3. Quoted in Pezzuti et al.

4. Interviews of Yudjá elders in this section from Tânia Stolze Lima, *Um peixe olhou pra mim: o povo Yudjá e a perspectiva* (São Paulo: Editora UNESP, 2005).

5. Davi Kopenawa and Bruce Albert. *The Falling Sky: Words of a Yanomami Shaman*, trans. Nicholas Elliott and Alison Dundy (Cambridge: Harvard University Press, 2013).

6. Stolze Lima, *Um peixe olhou pra mim*.

7. Lima.

8. All quotes and remembrances by Bel Juruna come from interviews I conducted with Bel in October 2020 and February–March 2021, as well her video documentation of the river with her descriptive narration in answer to questions I posed about effects of Norte Energia cutting the river flow. A part of Bel's footage as well as fisherwoman Sara Rodrigues' footage, can be seen in edited form on Mongabay's video channel at https://news.mongabay.com/2021/03/amazons-belo-monte-dam-cuts-xingu-river-flow-85-a-crime-Indigenous-say/.

9. By May 2021, Brazil's Supreme Court would temporarily suspend IBAMA President Eduardo Bim from his post, along with Environment Minister Ricardo Salles, for an alleged role in approving for export thousands of illegally forested Amazon trees. The court suspended one of Bim's decisions waiving timber certification requirements. But at the time of this writing, they hadn't revoked Bim's decision to allow Norte Energia to drain the Xingu's Volta Grande.

10. Heather Roller, *Amazonian Routes: Indigenous Mobility and Colonial Communities in Northern Brazil* (Stanford: Stanford University Press, 2014).

11. I interviewed Juarez Pezzuti in February 2021. Additional analysis, from Pezzuti and other experts, of IBAMA's February 2021 agreement with Norte Energia is found in my March 8, 2021, investigatory article. Tiffany Higgins, "Amazon's Belo Monte dam cuts Xingu River flow 85 percent; a crime, Indigenous say," *Mongabay*, March 8, 2021, https://news.mongabay.com/2021/03/amazons-belo-monte-dam-cuts-xingu-river-flow-85-a-crime-indigenous-say/.

12. I interviewed Camila Ribas in February 2021.

13. Pedro Henrique Pedreira Campos, *Estranhas catedrais: as empreiteiras brasileiras e a ditadura civil-militar, 1964–1988* (Rio de Janeiro: Eduff, 2014).

14. Rede Xingu+, "Xingu sob Bolsonaro: Análise do desmatamento na bacia do Rio Xingu (2018-2020). Observatório De Olho no Xingu," 2021, https://www.socioambiental.org/sites/blog.socioambiental.org/files/nsa/arquivos/nt_xingu_sob_bolsonaro_final.pdf.

My Life Is a Continuous Return to the River's Headwaters

Translated from the Portuguese by John Mark Norman

Daiara Tukano in Conversation with Rita Carelli

Daiara Figueroa Tukano is the daughter of anthropologist Alba Figueroa and Indigenous leader Álvaro Tukano, of the Yé´pá Mahsã people of the Upper Rio Negro, in the state of Amazonas. An artist and activist, as well as the coordinator of Rádio Yandê, the first Indigenous online radio station in Brazil, Daiara has long stood out for her incisiveness and magnetic presence within spaces of exchange linked to questions of art and Indigenous thought and practices. I have often had the pleasure of being in exchange with her at events that bring together such issues of art and activism within Indigenous Amazonia, including in 2018 at TEPI – Teatro e Povos Indígenas (Indigenous Peoples and Theater), curated by Andrea Duarte and Ailton Krenak, at SESC Pompéia, in São Paulo, when I mediated a conversation between her and other Indigenous thinkers. These are subjects that have concerned me since my own childhood due to the influence of my own parents, Vincent Carelli and Virgínia Valadão, who were also activists and artists linked to the Indigenous struggle as founders of Vídeo nas Aldeias, which has served as an open filmmaking school for dozens of Indigenous filmmakers, of which I am also a collaborator. That said, it is always a pleasure to be in conversation with Daiara herself. Our most recent conversation about her path—which leads her back to the very headwaters of her river—was held at a necessary distance, with Daiara in Brasília, where she lives, and myself in Paris, in January 2021.

—Rita Carelli

RITA CARELLI:
Daiara, you are multifaceted, with a master's degree in human rights from the University of Brasília, as well as a degree in visual arts. You are an artist and activist and coordinator of Rádio Yandê, the Indigenous station in Brazil. But all these definitions are not enough to contain your existence. In this light, the ideal thing would be to ask how you would like to introduce yourself?

DAIARA TUKANO:
I am Daiara, from the Yé´pá Mahsã people, better known as the Tukano, an Indigenous people who live between the Upper Rio Negro and the Rio Vaupés, in a region of Amazonia that includes parts of Brazil, Colombia, and Venezuela. I am a Colombian-Brazilian woman and an activist for Indigenous rights. In recent years I have been studying questions that concern Indigenous peoples in Brazil and around the world. Firstly, because I like to be informed, I am increasingly immersed in this fascinating world of learning from the original peoples and especially from my people. I became a researcher in human rights: I have an MA in the area of education and the culture of peace, with an emphasis on the right to memory and the truth of the Indigenous peoples. I am interested in gaining a broad view of the paradigms that underlie the violence against Indigenous peoples, as well as of the different contexts in which we live, understanding that we are dynamic, contemporary, and in constant transformation. And all of this is accompanied not only by my academic research—I entered academia, but I am trying, with great effort, to leave it—but also with study linked to my actual life experience within Indigenous culture: our worldview, our philosophy, our science. This includes working in the arts, in the field of visualities. I have been researching these other nonverbal languages, which involve meanings beyond the word, to find the means that will allow me to connect all of these narratives.

RC:
You have a very particular place since you are the daughter of an anthropologist, Alba Figueroa, and of a recognized Indigenous leader, Álvaro Tukano. You were born in São Paulo, you live in Brasília; you circulate through large urban centers and through forests. You have a background in academia and are also dedicated to researching the traditional knowledge of the original peoples. Do you consider yourself a translator of worlds?

Daiara Tukano, *Hori*, 2018. Acrylic on canvas, 70 × 70 cm. Courtesy of the artist.

DT: In the first course I took at the University of Brasília, which was in translation, I learned this saying: "Translation is always treason." It is impossible to avoid committing treason when you are a translator because there are conceptual elements that only exist in a certain understanding of the world. I grew up surrounded by people from so many places that I wound up becoming a polyglot. Incredibly, although I speak various European languages, I am not fluent in any Indigenous language since I did not have the opportunity to grow up in the village together with my grandparents—but I did have the opportunity to rub shoulders with various understandings of the world. I think that we need to feel our way to connect sensations, emotions, feelings, views, which help us to have a sort of shared understanding. But this understanding will never be complete, and I think that's just fine because I do not believe that a translation between worlds is necessary. I even think it is cruel to say that people

like me, or the Indigenous people in contemporaneity, walk in two worlds. I think it is sad to reaffirm that there is a white world, an Indian world, a Black world, a Martian world, a Western world, and an Oriental world.

An uncle of mine whom I greatly respect, Wakia, of the Lakota people, says that there are two worlds in which we walk: the world of materiality and that of spirituality. Perhaps, in the understanding of the reality of the Indigenous peoples, he manages to weave bridges between these two worlds. And these bridges are made through an actual life experience of the practices, the knowledges, the prayers, the songs, the arts: in short, they spring from an epistemology. From what someone so beautifully referred to as a "cosmovision." And I don't know really if *translating* would be the word that comes close to the sort of reality that people like me have the opportunity to live. Certainly, I can only express that which I live; I can only communicate the reflections that my estrangements and enchantments between these cultures—which so often clash—provide to me, but I do not in any sense position myself as a translator of worlds.

RC:
In your path, have there been moments of conflict or reaffirmation of your Indigenous identity? I'm not asking you this in a voyeuristic way, but because Brazilian national society lives in very intense confrontation with the Indigenous nations that live here, and this tension violently penetrates the individuals who find themselves in this crossfire. And, due to this colonizing cruelty, many people experience this distancing and then, at a later turning point in their lives, strive to make a reconnection with their Indigenous identity, which becomes the focus of their activity, their intellectual production, their way of being in the world. Have there been any such moments in your own path?

DT:
I have always understood myself as an Indigenous person. My name, which I received through a traditional naming ceremony, is totally Indigenous: Daiara Hori. And I always knew this. The conflict with the fact of being Indigenous does not arise in childhood, but when racism hits you in the face. Because one day it hits you, and it massacres us. The child does not understand what racism is, and it takes us a long time to grasp what underlies this view that tells others that they are less, that they

Daiara Tukano, *Hori*, 2018. Acrylic on canvas, 70 × 70 cm. Courtesy of the artist.

are worse, they are ugly, stupid, et cetera. In my adolescence, I was also not concerned with the fact of being Indigenous—nor was it the center of my existential crisis. The relationships of gender were more shocking to me, along with the wars and social inequalities. I was always fascinated by history and had this morbid curiosity of trying to understand the causes of all the conflict in this world, and by studying, I gradually learned to become aware of my place among them.

My personal history coincides with the beginning of the formation of the organized Indigenous movement in Brazil. My parents met each other in this context: my father was an Indigenous leader from the Rio Negro, and a key figure in the organization of the Union of Indigenous Nations (UNI), and my mother was an ally in this struggle. There were many meetings held in São Paulo, which led to the founding of groups that drew up proposals for laws about Indigenous rights, which are now part of the Brazilian Constitution. I wound up being born in the city, among Indigenous people and activists

for Indigenous causes, amid the confusion brought on by the military dictatorship. My father was hounded politically and, until today, our family is still coping with the sequelae of that hounding, because I did not grow up near my father nor my mother: I spent my childhood in Colombia, together with my relatives on my mother's side. When I returned to Brazil, at already fifteen years old, I bore the resentment of a child who felt half-abandoned. I went back to rediscover the history that gave rise to my life and to learn to cope with that feeling. I spent a great deal of my adolescence on this: maturing and learning about the background of my parents, the history of my family, and also of my people. So, perhaps in this sense, my personal path has involved a sort of re-approximation, but the notion of being an Indigenous person has always been present and was never problematic. The problematic factor was the violence, in the Brazilian territory and in the Colombian territory, that kept me from growing up near my parents, near my grandparents.

My life is like a constant return to the river's headwaters. When I was an adolescent, I imagined that my having been born in São Paulo was like being a little bird that was born in a garbage dump. I never identified with that city, and until today, I feel very strange there. My life and work have given me the opportunity to reconnect with my aunts and uncles, my cousins, my grandfather who passed away recently in the village, to be there and to go up into the headwaters where I spent time while still a baby, where I paddled a canoe as a child. That is not a strange land for me; I learned how to swim in the Rio Negro. All of this involves a yearning to recover memories that were always there, but which were never explicit. That I am an activist for the Indigenous cause and for Indigenous rights today springs from this entire life's walk: I could have followed another path, but I had a movement of empathy and decided to delve into this history.

Here, in Brasília, when I saw the emergence of the *Acampamento Terra Livre* (Camp free land), an Indigenous gathering and campaign for constitutional rights that started in 2005, I began to go there anonymously, shyly, only looking at it from a distance, trying to understand and to recognize myself in that movement. I later began to go with my father in a gradual process of becoming part of that scene. My father was a person who was so dedicated to the Indigenous movement that

he had little time to devote to his family, so we, as his children, bore this lack and even a certain resentment against what had caused this absence. Everything we have, we owe to the struggle, but everything we don't have, we also owe to it. As time passes, we learn to respect this struggle, and we can decide if we want to join it. I am talking a lot about my father here, but my mother was also very active in the Indigenous movement, and she made sure to instill this interest, this love, in me. Today, with the death of my grandfather, my father became the elder in our clan; he occupied his place in the headwaters, and over the course of the last twenty years, I had the opportunity to accompany his aging, his entrance into an age of greater wisdom, and to witness his effort to transmit the sacred knowledge of our people to his children.

RC:

In your discussion of this sacred knowledge, I am reminded that you are an ayahuasca-using people. I know that your delving into the Tukano culture also includes familiarization with these forest medicines and their use, expanding your study to more than an intellectual understanding, one that also includes the body and expands to a spiritual dimension. Could you talk a little about that?

DT:

Our region is near the border between Brazil and Colombia. It was there that my people, and other peoples, entered into contact with ayahuasca. There are approximately 250 different peoples, in five countries, which use this vine in the Amazonian basin. In the early twentieth century, the Salesian missions arrived there, in a Vatican project for the expansion of the Catholic Church in Amazonia that gave rise to the settlements. They tore down the *malocas*, the traditional Indigenous houses and their sacred sites, and atop these ruins constructed churches and boarding schools.

The children were separated from their families and brought to these boarding schools when they were six or seven years old. They were prohibited from speaking their languages, given new names, and cut off from their cultures. The communities that lived closest to the headwaters of the rivers remained the most preserved, but those that lived where the rivers are wider and easier to reach suffered immensely. Their traditional ceremonies were demonized during this entire first half of the twentieth century, and until today we have to cope with an enormous wound left by the religious and institutional racism of the Catholic Church. It is an intolerance that

Daiara Tukano, *Hori*, 2016. Acrylic on canvas, 70 × 70 cm. Courtesy of the artist.

continues to be applied by other Christian, neo-Pentecostal churches here.

Because of this process, many Indigenous families lost these rituals, but the history of my clan, of my family, of my great-grandfather, of my father and his father, has always been one of great resistance to all of this. They were key figures in denouncing and combating this epistemicide in the Upper Rio Negro. In the 1980s, my father participated in the Russell Tribunal, an international court in which the Brazilian state and the Catholic Church were sentenced as guilty. That led to a great deal of political pressure against him, but this sentence spelled the end of this model of boarding schools in our region.

Still, the truth is that today, in the region, there are only a few elders who still have detailed knowledge about the ceremonial

practice; my grandfather was one of the last. Nowadays, our people have many more priests than *pajés* (shamans); they have many more nuns and followers of the Catholic religion than people with knowledge of the traditional spirituality. My father and my grandfather also went through these boarding schools; my grandfather did when he was an adolescent, practically an adult for his community, but my father, who was younger, was marked in his soul by this experience. This and many other forms of violence suffered throughout his life marked him and made him sick. This is why my sister Naiara and myself, at a certain point, became aware that we needed to use our traditional medicine to help the family. It was, and still is today, with ayahuasca that we began and continue to cure the wounds of our history, the collective damage, because the sorrow is also inherited.

Our medicine has been fundamental in this process: it was with it that we saw our father bloom. There are very few peoples with a practice of ayahuasca which include the women in the spiritual tradition. As far as I know, there are only women masters among the Shipibo, while the others are very much patriarchal. But we are dynamic, isn't that so? Currently, there are many more non-Indigenous than Indigenous people involved in the practice of ayahuasca, and the great majority are women. This fact helped my father to open up to the idea of initiating his daughters into the practice. Many friends from other peoples that also have an ayahuasca practice—the Huni Kuins, Ashaninkas, and Yawanawas—had offered me the plant, saying that I should take it, but I always replied: "Look, I believe what you are saying, but I am a *yé´pá mahsã*, I am Tukano, and I am going to learn with my father, I am waiting for him." I am the firstborn, the eldest of my father's ten children, and the boys, until recently, had not shown interest in the traditional knowledge, while we girls were already wishing to learn. So, my father said: "Well, if the men do not want to learn but the women do, that's how it will be because the only one who learns is the one with an interest, who seeks it."

Our traditional education is not an unrefined science, it is not in a university that you will learn it, and there is no diploma for this; it demands many nights of the kahpi ritual ceremony, many nights of cure. The knowledge is there for everyone, but it is challenging: it involves dedication, physical trials, and time. So, my entrance into this *terreiro*, this sacred ground of our spirituality, took place in a very traditional way. It was not introduced by ayahuasca or daime, or by

other peoples; rather, I asked to enter into my lineage, into my clan, into my culture, and it is this line that I have followed until today. I arrived very gradually, and today I am very happy because this sacred ground that I refer to is a large house.

We talked about the Indigenous movement as a space of alliances, but I say that the spiritual alliances possess something different: they have a matchless degree of intimacy, respect, and love. This spiritual family also comes from a history of struggle, but it is found in the sacred ground and talks about the world, is connected, and is accompanied by a presence and a loyalty that cross through time and space. We communicate and dialogue without words, through dreams, through memories, through music, through songs. We feel this presence and this is enough. These are the ancient communication technologies that our peoples have always had. As my father said: "It is the Wi-Fi of the Indian." The generation of my parents created strong alliances that my generation carries forward, and, when it is our turn, we will also pass them to the future generations. This link "of the sacred ground" is very strong and it is there that I have really found myself, where I have learned, with all humility. So, if I was that child who was a short while ago complaining that I grew up far from my father, from my mother, from my siblings, from my grandparents, and who felt like a little bird born in a garbage dump, today I can say that I have returned

Daiara Tukano, *Pameri Yukese*, 2020. Acrylic on canvas, 160 × 700 cm. Courtesy of the artist.

to the waterfall, to the headwaters of my river and that I am inside my snake canoe. And that in that forest there are many little birds, many snakes, many wild pigs, and many singing relatives! That is where my heart is, and that is where it will stay.

RC:

Bringing it back to this current moment, have you heard echoes about Indigenous people taking care of themselves with traditional forest medicines during the ongoing Covid-19 pandemic?

DT:

All of the people who maintain this knowledge have it as a support. Just today we heard this disastrous news that in the state of Amazonas there is no more oxygen in the hospitals. Therefore, resorting to this science of the forest has been fundamental and the only resource within reach of many Indigenous communities. I like very much how my cousin José Paulo Barreto approaches the question of medicine, of Western medicine, of Indigenous medicine because he had the boldness to proclaim our knowledge not only as a traditional knowledge but as medical science. He has developed an intense scientific debate, with a great deal of exchange among the Indigenous peoples, concerning the treatments of Covid complications—and about everything that is happening on the planet. They have debated the practical methodologies of diagnosis and treatment, as well as the prayers, diets,

and types of isolation that accompany them. There is, in our cultures, an entire approach to hygienics. It is a very ancient science. The artist Denilson Baniwa produced a work about the pandemic, tracing a parallel between what is happening and the traditional practices. Because in the pandemic you need to wear a mask, right? But we also have our ritual masks. In the pandemic you have to cleanse, you have to be careful about the environment that you are in, but we also fumigate the environment to cleanse the miasmas that are in the air. And, besides the physical protection, we are very careful about this protection of what appears to lie beyond the physical realm, but which, in a time of crisis, is revealed in the material. So there has been a very beautiful debate, especially in Acre, about this subject, but only the specialists can say more than this, while I am, at most, a trainee for the position of nurse's aide.

RC:

Daiara, concerning ayahuasca, does the visual production that you mentioned at the beginning of our conversation also have a strong relationship with the visions of expanded consciousness?

DT:

Yes. I studied visual arts at the University of Brasília and that was an awful lot of fun for me: I learned about light, color, body, form, performance, art history, and, recently, as I have gone deeper into the questions of our culture, these have been revealed in my artistic production. My art could deal with any subject, though; just because I am Indigenous does not mean that I can only talk about the Indigenous world. But, at this moment, I feel this need and I believe that I am continuing a path begun by my uncles—some of whom I have lost in the Covid pandemic, such as Feliciano, who was one of the greatest artists of the Rio Negro. I grew up surrounded by his drawings. With his passing, I increasingly felt the responsibility to lend continuity to those works. In our language, there is no word for art. When I talk about art, you think of Greece, you think of the Louvre, you imagine a canvas with a golden frame, whatever. This notion of art comes from Western culture, from European culture; in ours, there is no such understanding, which is why there is no word that we can translate as art—here we see the translation problem again—but there is another word, which is very special and which, perhaps by chance, is part of my name: *hori*.

This word is the name my father christened me with. My mother called me Daiara, which is a Nambiquara word, but *Hori* is Tukano and denotes vision, light, color, and fragrance: it is the vision of the carpi ritual ceremony, the vision of the expanded consciousness of ayahuasca. The Tukanos call it *hori*, the Huni Kuins, the Yanawana call it *kene*, and the ayahuasca churches translate it as the Portuguese term *miração* (vision of expanded consciousness). This concept is much more complex than art. It is not just the visual effect in the eye, it is a gaze that transcends worlds, a spiritual gaze, a gaze inward that rebounds and returns outward. The *miração* is the very enchantment of life. When I went to the Yawanawa people, my grandfather Tatá, a 105-year-old *pajé*, told me: "My daughter, everything is *kene*, everything is a vision, the creation is the vision of the great spirit."

This led me on a very delightful journey through this geometry, this sacred architecture of the universe that is reflected in nature, in matter, and beyond it, on the physical plane and on the spiritual plane where I awakened for the *horis*. I began my research into light and color, because ultimately what I produce are paintings. I have always been fascinated with the physics of light, with the vibration of matter, and the effects that this has on our organism.

The other day, I met a woman who works as a translator of the Dalai Lama, and she said that we are not so much the dust of stars; instead, we are the light of stars. I got to thinking about our history and also that the stars have color. Our Sun Star is a star child, but when it has grown up, it will become a red giant, and, when it is very old, it will expand in the universe and it will take on other tones of colors that we cannot even see. Because beyond the colors that we can see, there are other degrees of vibration of this energy that also expands in the universe: the ultraviolets, the infrareds, that which we do not see, and yet is nevertheless there.

We have no idea about where the light from our star reaches, but we do know that, as this light expands, it changes color, which brings to mind the transformation of the universe and how we are connected to it. So, I have delved into this profusion of *horis* and have gradually stopped being an artist to become an *horist*. It is something that does me good.

Brazilian Black Feminism

Undoing Racial Democracy, Towards a World Ethic with Orixás

Translated from the Portuguese by Walter Paim

Djamila Ribeiro
Artworks by Maya Quilolo

Introduction by Quinn Latimer

RIVER

One cannot fully consider the history of colonialism and racial capitalism in Amazonia and its surrounding regions, nor the history and present of Indigenous thought and resistance, without taking into account the history and present of Black intellectual life, culture, and political struggle in South America. The colonial slavery imaginary in which both were situated continues, in some sense, in various explicit and implicit forms, to this day. To that end, what are some of the relationships between Indigenous cosmologies and activism, and Black radical traditions and ancestral knowledges in South America, particularly in their forms of feminist resistance? The co-existence of Indigenous and Black life both within and outside of the Amazonian region has a long history; their myriad cosmos and schools of knowledge, spirituality, and struggle running at once in parallel to one another, and at some points, touching.

If coloniality and its Eurocentric model of power have stratified the world's population into this new idea (since roughly the sixteenth century) of race and nature, of social identities created to enforce violent relations of domination, how have Indigenous and Black anti-hegemonic cultures and decolonial feminisms commingled and influenced each other's cosmologies and political life?

And how has the intersectionality of gender and race in the making of contemporary identities—knowing, as we do, that racism determines gender hierarchies—articulated itself in Black South American feminist militancy in particular?

Below, Djamila Ribeiro, the celebrated Brazilian feminist philosopher, moves us through the history of Brazilian Black feminism and intellectual life, and its most notable scholars—among them the late Lélia Gonzalez, the pioneering professor, political anthropologist, and feminist politician, whose Black father was a railroad laborer and whose Indigenous mother worked as a maid—as well as through the Brazilian colonial slavery imaginary and its construction of a distinctly racialized womanhood. Many Brazilian Black thinkers, Ribeiro states, understand "the gender category" from non-Eurocentric sources, like the female *orixás*, which surfaces from African-origin religions including Candomblé and Umbanda. Here is a form of feminist discourse by other "geographies of reason," with women of care, women of cult, mythical female ancestors, and African diaspora witches who are, Ribeiro writes, "the antithesis of any denial of behavioral, political, ethical transcendence that women may represent." She notes, precisely: "From them it is possible to think of a practice that transforms the colonial relations present today."

—Quinn Latimer

Maya Quilolo, *Orì*, 2016. Installation view. Ways of Future Gallery. Belo Horizonte, Brazil. Courtesy of the artist.

On a visit to Brazil in 2019, Angela Davis interviewed a mostly white audience, and asked: "Why do you still want me to speak when there were important Black intellectuals like Lélia Gonzalez (1935–1994) here who already talked about intersectionality?" The audience applauded, and there was a lot of discussion about Gonzalez on social media. However, after Davis returned to the USA, the white majority stopped talking about Gonzalez. This is a classic example of what happens in Brazil: it takes someone from the "outside" to appreciate someone from "inside" so that a majority can register it. Even though we recognize the importance of the thinking of Davis and other Black American intellectuals, we know that although they are geographically located in the Global North, they produce anti-hegemonic discourses. However, precisely because they are located in the north and speak English, their works have a broader reach and contribute to the predominance of racial studies. In this sense, as much as their works are baselines, in this text I decided to speak politically about Brazilian Black feminists who suffer from the erasure of their work and difficulties in translating into other languages. For example, Black feminist women such as Davis have historically recognized the importance of Gonzalez's work for Brazilian social thought, but it is still not as studied as it should be. Gonzalez was a pioneer in discussing the importance of a transnational struggle in Latin America, defending an Afro Latin American feminism and criticizing the insistence on an

analysis grounded in class struggle without taking into account the oppressions of race and gender.

In the 1980s, Gonzalez pointed out that Black women in the public sphere in general and in entertainment and leisure in particular, as well in context of carnival were seen as mulattoes, a figure that permeates the Brazilian colonial slavery imaginary, constituting itself in the republican period in which the myth of racial democracy flourishes. However, Gonzalez realizes that there is another perception of the female Black body combined with the image of the domestic, drawn on colonial images of the maid, the enslaved woman who works in the slaveholder's household. Based on feminist scholars, Gonzalez, without mincing her words, interweaves the two images: of the mulatto woman and the woman of care. She gives as an example the carnival: in this period, the mulatto is raised up to a place of deification, but as soon as the carnival is over, that same woman can be a domestic relegated to social invisibility. At the same time that the country denies its Black origins, it praises those same origins when it better suits them; Brazil is a country that sells carnival for a profit, but discriminates and keeps the group that created it apart.

Gonzalez conceptualized Brazilian racism as Brazilian cultural neurosis. "Now, we know that the neurotic builds ways to hide the symptom, because it brings certain benefits. This construction frees you from the anguish of facing repression."[1] Gonzalez also offers us an interesting perspective on this, criticizing modern science as an exclusive standard for the production of knowledge, she sees the hierarchy of knowledge as a product of the racial classification of the population since the appreciated and universal model is after all white. She further argues that racism was constituted "as the 'science' of Euro-Christian superiority (white and patriarchal), insofar as the Aryan model of explanation was structured."[2] And, within this logic, feminist theory also ends up incorporating this discourse and structuring the discourse of white women as dominant.

Gonzalez proposed the destabilization of the standard language and from this perspective suggested the *pretoguês* (Black Portuguese) as a way to criticize the academic norm. Gonzalez confronts the dominant paradigm and, in some texts, resorts to a language considered outside the model established for academic

textual production—that is, without obeying the requirements and rules of normative grammar and reflecting the linguistic legacy of enslaved cultures. Thus, she sometimes mixes Portuguese with African linguistic elements in a political attempt to highlight the racial prejudice existing in the very definition of the Brazilian mother tongue. As a result of the entanglement, Gonzalez points out:

> What I call '*pretoguês*' and which is nothing more than a mark of Africanization of Portuguese spoken in Brazil [...], it is easily seen especially in Spanish in the Caribbean region. The tonal and rhythmic character of African languages brought to the New World, in addition to the absence of certain consonants (such as l or r, for example), point to a little explored aspect of black influence in the historical and cultural formation of the continent as a whole (not to mention the 'Creole' dialects of the Caribbean.[3]

Many Brazilian Black thinkers thought of the gender category from other sources, such as from the perspective of female *orixás*[4] since in Brazil there are religions of African origin such as Candomblé and Umbanda.[5] There is an attempt to value Brazilian Black cultures' thought by other geographies of reason.

In their article "The Female Power in the Cult of the Orixás," Sueli Carneiro and Cristiane Abdon Cury analyze the figure of the woman in African mythology reproduced in the *candomblé terreiros* (ancestral communities where tradition and Afro-diasporic customs, as well as religious cults, are preserved and where Candomblé is practiced), the archetypes of the *orixás*, and the social differences regarding gender relations. The authors explain the tradition of viewing women as witches, of course in a sense that is completely contrary to the one historically attributed by western civilization.

> The great witches are, yes, in the religion, but we can see their representation in grandmothers, in mothers who lived long, whether in a state of anger or in serenity; when they speak, and everyone is silent, leaving injustices structurally exposed. "To discuss, therefore, women's role in Candomblé takes us immediately to the mythical female figures that compose a conception profile that the mythical system of Candomblé has of the female condition. The *Ìyá mi*, mythical

AMAZONIA

RIVER

Maya Quilolo, *Snake Orì (Railroad)*, 2020. Video still. Circuit at home: Online artistic festival, Belo Horizonte, Brazil. Courtesy of the artist.

ancestors, are the ultimate representation of female power. They are also called *Ajé*, which in Yoruba means witch or sorceress."[6] Among the *Ajés*, the most feared is Ìyá mi Oxorongá. From this sorceress, who with a curse word of death, it is possible to understand how this representation distances itself from the western gaze of victimized identity:

> When pronouncing the name of this female orixá, the person who's sitting must *stand* up, and who's standing up must bow down, as she is a ruthless orixá to whom all living beings owe respect. [The] African bird, Oxorongá emits a horrible cry, from where its name comes from. The symbol of this orixá is the owl of omens and portents. Ìyá mi Oxorongá owns the belly, and there is no one who can resist her fatal ebós.[7]

It is worth mentioning that Ìyá mi's representations occur in her socialized aspects in the worshiped *orixás*, such as Oxum, Iansã, Iemanjá, Nanã, Obá, and Ewá. At the head of the terreiros, there are the Yalorixás, who are "depositories and transmitters of the knowledge of the cult, of its mysteries. They know the ways of manipulating nature. They know how to manipulate them to solve the problems of the individuals who are under their care."[8]

Pombagiras are also worshiped in *terreiros* all over the country.[9] It is an entity that is called by several names, one of the most common being Maria Padilha. Her representation is of a free, sensual woman, who at the same time conquers and amazes any man. It is to her that offerings are made to get rid of a man who becomes a burden (and there are several of those, isn't it so, my dear?). Whoever sees her perform will hear one of the most well-known songs, "Move away you man, for a woman is coming. Maria Padilha, queen of Candomblé." And she moves anyone away.
African-based witches are the antithesis of any denial of behavioral, political, ethical transcendence that women may represent. From them, it is possible to think of a practice that transforms the colonial relations present today.

Beatriz Nascimento, a Black historian and researcher, offers us the possibility of strengthening Black women, a form of resistance when returning to the meaning of the word *quilombo*.[10] In June 1977, Nascimento presented her research on *quilombos* at the *Quinzena do Negro* (*Blacks Fortnight*) at the University of São

Paulo,[11] gaining greater notoriety. The formation and participation in the Movimento Negro Unificado (Unified Black Movement),[12] formed in 1978, denotes a radical attitude towards the academy (in that time and for today), with criticisms of the academic content of studies on ethnic racial relations, produced mainly by white intellectuals and the denunciation the lack of space for Black men and women in this field and for certain themes such as *quilombo* or Black women. She brings this research into light, which was forgotten, and also to remove from the crystallized place of *quilombo* as a "haven of escaped blacks" or a "place of bandits" without a political character. In the documentary *Ôrí* (1989), narrated and based on Nascimento's life, a political and cultural panorama is shown in search of an identity that acknowledges Black populations. Candomblé is presented as well as other manifestations of Black origin. *Ôrí* means head, a term of Yoruba origin, people from West Africa, which, by extension, also designates the Black conscience in its relationship with time, history, and memory.

> The fact is that, as a black woman, we feel the need to deepen our reflection, instead of continuing to repeat and reproduce the models that were offered to us by the social science research effort. The texts only spoke to us about black women from a socio-economic perspective that elucidated a series of problems posed by race relations. But there was (and always will be) a rest that defies prior explanation.[13]

In the 1980s, Black women, especially in the North and Northeast regions of Brazil, were forcibly sterilized and this was an important banner of struggle for this movement. This struggle resulted in the creation of the *Parliamentary Committee of Inquiry* (CPI) in 1991. The sterilization CPI, as it became known, found that this practice occurred whether in the inadequate provision of services offered by private institutions that financed contraceptive methods, especially in the poorest regions of the country, or in irreversible contraceptive measures that were imposed. In our question proposed here, it is important to think about the category of Black women, considering that—as argued by Luiza Bairros—this category is built from the experience of being black (lived "through" gender) and being a woman (lived "through" race).[14] Sueli Carneiro in her article "Enegrecer o feminism…" (Blackening feminism …) articulates an interesting perspective that is worth quoting here at some length.

"When we speak of the myth of feminine fragility, which historically justified the paternalistic protection of men over women, what women are we talking about? We black women are part of a contingent of women, probably in the majority, who have never recognized this myth in themselves because we have never been treated as fragile. We are part of a contingent of women who worked for centuries as slaves in the fields or on the streets, as salespeople, greengrocers, prostitutes ... Women who did not understand anything when feminists said that women should take over the streets and work!

The historical conditions in the Americas that built the relationship between blacks in general and black women in particular are well known. We also know that in all this context of conquest and domination, the social appropriation of women in the defeated group is one of the emblematic moments of affirmation of the winner's superiority ...

When we talk about breaking with the myth of the queen of the home, of the idolized muse of poets, what women are we talking about? Black women are part of a contingent of women who are not queens of anything, who are portrayed as anti muses in Brazilian society, because the aesthetic model of women is the white woman. When we talk about guaranteeing the same opportunities for men and women in the labor market, what kind of woman are we guaranteeing employment for? We are part of a contingent of women for whom job ads highlight the phrase: 'Good looks are required.'

When we say that woman is a by-product of man, since it was made from Adam's rib, what woman are we talking about? We are part of a contingent of women from a culture that does not have Adam. Originating in a violated, folklorized and marginalized culture, treated as a primitive thing, a thing of the devil, this is also alien to our culture. We are part of a contingent of women ignored by the health system in their specialty, because the myth of racial democracy present in all of us makes it unnecessary to register the color of patients on public health forms, information that would be indispensable for assessing health conditions of black women in Brazil, because we know from data from other countries that white and black women have significant differences in terms of health."[15]

Maya Quilolo, *Ìpòrì*, 2018. Performance. Osun Osogbo Sacred Grove Festival, Nigéria. Courtesy of the artist.

Carneiro shows us that racism determines gender hierarchies in our society, so it is necessary that feminism create ways to combat this oppression. Otherwise, it will be just another form of oppression, reproducing the hegemonic discourse and maintaining the hierarchized relationships between women. Carneiro's analysis still allows us to perceive the need to claim the identity of a Black woman who constitutes herself as a historical and political subject. However, it is important to emphasize that this identity—even though it does not encompass all the specificity surrounding Black women—is relevant to support the political subject that is intended to be highlighted in this text. Building a reflection on the identity of Black women has to follow complex paths, since the heterogeneities that surround this category make up a wide range of complexities and diversities. To analyze such a category, which is intersected by numerous markings in a "closed" way, is to run the risk of leaving out the many nuances that are at stake in the definition of identities, especially when it comes to groups that throughout history have been building and reconstructing strategies of struggle and resistance to claim and affirm their social identities, as is the case of Black women.

For Carneiro, Black women have engaged in a double path of struggle, one to "blacken" the agenda of the feminist movement and another to "sexualize" the agenda of the Black movement, giving rise to a diversity of

perceptions and political practices in these segments, which crossed and crosses a double perspective, both in the affirmation of others as new political subjects and in the demand for a recognition of the differences and inequalities between these subjects.

Maya Quilolo, *Yamins. Ebó*, 2020. Performance. Cachoeira, Brazil. Courtesy of the artist.

> In this sense, it is possible to affirm that a black feminism, built in the context of multiracial, pluricultural and racist societies—as are Latin American societies—has racism and its impact on gender relations as its main articulating axis, since that it determines the gender hierarchy itself in our societies.[16]

The concept presented by Carneiro brings to the fore the understanding that racism also determines gender relations and that calls into question the objective of Black feminist struggle in the social arena. It is also important to highlight Ana Angélica Sebastião's concept, which that references Black feminism in Brazil as being the political, intellectual, and theoretical construction movement of Black women committed to social change and active in an ideological field in which they are inserted. Black feminism is a concept that has been forged in the struggle of the Black women's movement for the recognition of the specificities of the group in the context of the feminist struggle and the fight against racism.[17]

In this sense, it is important to see racism and sexism as a series of effects that have no single cause. The perspective of new looks and new "places of speech" thus initiate different constructions in the game instituted by scientific knowledge. Such constructions challenge academic canons and reveal theoretical constructions capable of handling other forms of identity in addition to those that already exist. To analyze the production of contemporary identities in light of subordinated studies, based on issues that demarcate social hierarchies, is to revisit old themes with new perspectives and other views and places of speech, covering paths that may actually contribute to the production of a theory that encompasses a greater number of multiple subjects. Belonging to different social categories that often express several axes of subordination makes these women social agents capable of producing political movements that act in the direct nexus of different discriminations, as well as building their own theoretical instruments that support their struggles. This process of construction and reconstruction in manifesting their identities makes Black women promote theoretical discussions around racial and gender issues while at the same time taking care that one process is not more or less hierarchical than the other.[18]

This new feminist and anti-racist view, by integrating both the Black movement's traditions of struggle and the tradition of struggle of the women's movement, affirms this new political identity arising from the specific condition of being a Black woman. The current movement led by Black women brings to the political scene the contradictions resulting from the articulation of the variables of race, class, and gender, and promotes the synthesis of the flags of struggle historically raised by the Black movement and women of the country, blackening on one side the demands of women, thus making them more representative of the group of Brazilian women, and, on the other hand, promoting the feminization of the proposals and demands of the Black movement.[19]

Luiza Bairros also uses as a paradigm the image of the domestic worker as an element of analysis of the condition of marginalization of Black women and, based on it, seeks to find specificities capable of rearticulating the points raised by American feminists. She concludes, then, that "this peculiar marginality is what stimulates a special point of view of black women, (allowing) a different view of the contradictions in the actions and ideology of the

dominant group. The great task is to enhance it affirmatively through reflection and political action."[20]

The propositions of Black feminism and Black feminist thought have forced feminist theory to deepen its analysis of racial discussion and other modes of differences in relation to its theoretical and practical production. Feminist research is not only aimed at introducing women into the sciences, but also has the role of tensioning and questioning the traditional way of doing science, proposing new models, but mainly, having an epistemological and political disposition to review the attitude towards research. Assuming the instability of scientific practice, "subverting matrices of thought, embracing fluidity, in an area that traditionally tried to establish lasting truths."[21]

1 Lélia Gonzalez, "Racismo e sexismo na cultura brasileira," *Revista Ciências Sociais Hoje*, vol. 2 (Brasília: Anpocs, 1984): 223–44.

2 Gonzalez, "Racismo e sexismo."

3 Gonzalez, "Racismo e sexismo."

4 Dieties of Yoruban influence that typically act as intermediaries between humans and the supreme being.

5 In the simplest terms, Candomblé was brought to Brazil through enslaved black Africans. The religion has undergone adaptations and is considered an Afro-Brazilian religion. Umbanda, on the other hand, is a definitively Brazilian religion, in which one finds the syncretism of Candomblé with Catholicism and Spiritism.

6 Sueli Carneiro and Cristiane Abdon Cury, "O Poder Feminino no Culto aos Orixás," *Cadernos Geledés*, vol. IV (Spring 1993): 17–32.

7 Carneiro and Cury, "O Poder Feminino."

8 Carneiro and Cury, "O Poder Feminino."

9 Pombagira in the translation of Canbomblé is an *orixá* of communication, of the crossroads.

10 Quilombos are communities formed by the progeny of enslaved people who fled the plantations and settled in those communities. Historically, they were persecuted and still fight the Brazilian state for the title to their lands. The most notorious of the quilombos was the Quilombo dos Palmares, which had tens of thousands of people and was a strong force of resistance against the Portuguese crown for almost a hundred years (1605–94).

11 The Quinzena do Negro was an influential conference organized by researcher Eduardo Oliveira e Oliveria that promoted discussions, reflections, and debates at a large meeting of black researchers.

12 The Black militancy movement (Movimento Negro Unificado (MNU)).

13 Gonzalez, "Racismo e sexismo," 225.

14 Luiza Bairros,"Nossos Feminismos Revisitados," *Revista Estudos Feministas*, vol. 3, no. 2 (Florianópolis, 1995): 458–63, here 461. Luiza Bairros, who held a master in social sciences from the Federal University of Bahia and a PhD in Sociology from the University of Michigan, was a historic Black Brazilian feminist and public policy maker who transformed the lives of many people as Chief Minister of the Brazilian Secretariat for Policies to Promote Racial Equality between 2011 and 2014. She passed away in July 2016 at the age of 63.

15 Sueli Carneiro, "Enegrecer o feminismo: a situação da mulher negra na América Latina a partir de uma perspectiva de gênero," in *Racismos contemporâneos* (Rio de Janeiro: Takano Editora, 2003), 50–51.

16 Sueli Carneiro, "Enegrecer o feminismo," 60.

17 Ana Angélica Sebastião, "Feminismo negro e suas práticas no campo da cultura," *Revista da Associação Brasileira de Pesquisadores/as Negros/as* (ABPN), no. 1 (March/June 2010): 66.

18 Here we define militant Black women as representing the intersectionality of gender and race in the production of contemporary identities.

19 Carneiro, "O Poder Feminino no Culto aos Orixás," 50–51.

20 Bairros,"Nossos Feminismos Revisitados. Revista Estudos Feministas," 458–63.

21 Guacira Lopes Louro, *Gênero, sexualidade e educação: uma perspectiva pós-estruturalista*, 7th ed. (Petrópolis: Vozes, 2004), 146.

Coloniality of Power, Eurocentrism, and Latin America

Translated from the Spanish by Michael Ennis

Aníbal Quijano

What is termed globalization is the culmination of a process that began with the constitution of America and colonial/modern Eurocentered capitalism as a new global power. One of the fundamental axes of this model of power is the social classification of the world's population around the idea of race, a mental construction that expresses the basic experience of colonial domination and pervades the more important dimensions of global power, including its specific rationality: Eurocentrism. The racial axis has a colonial origin and character, but it has proven to be more durable and stable than the colonialism in whose matrix it was established. Therefore, the model of power that is globally hegemonic today presupposes an element of coloniality. In what follows, my primary aim is to open up some of the theoretically necessary questions about the implications of coloniality of power regarding the history of Latin America.[1]

AMERICA AND THE NEW MODEL OF GLOBAL POWER

America[2] was constituted as the first space/time of a new model of power of global vocation, and both in this way and by it became the first identity of modernity. Two historical processes associated in the production of that space/time converged and established the two fundamental axes of the new model of power. One was the codification of the differences between conquerors and conquered in the idea of "race," a supposedly different biological structure that placed some in a natural situation of inferiority to the others. The conquistadors assumed this idea as the constitutive, founding element of the relations of domination that the conquest imposed. On this basis, the population of America, and later the world, was classified within the new model of power. The other process was the constitution of a new structure of control of labor and its resources and products. This new structure was an articulation of all historically known previous structures of control of labor, slavery, serfdom, small independent commodity production, and reciprocity, together around and upon the basis of capital and the world market.[3]

RACE: A MENTAL CATEGORY OF MODERNITY

The idea of race, in its modern meaning, does not have a known history before the colonization of America. Perhaps it originated in reference to the phenotypic differences between conquerors and conquered.[4] However, what matters is that soon it was constructed to refer to the supposed differential biological structures between those groups.

Social relations founded on the category of race produced new historical social identities in America—Indians, blacks, and *mestizos*—and redefined others. Terms such as *Spanish* and *Portuguese*, and much later *European*, which until then indicated only geographic origin or country of origin, acquired from then on a racial connotation in reference to the new identities. Insofar as the social relations that were being configured were relations of domination, such identities were considered constitutive of the hierarchies, places, and corresponding social roles, and consequently of the model of colonial domination that was being imposed. In other words, race and racial identity were established as instruments of basic social classification.

As time went by, the colonizers codified the phenotypic trait of the colonized as color, and they assumed it as the emblematic characteristic of racial category. That category was probably initially established in the area of Anglo-America. There so-called blacks were not only the most important exploited group, since the principal part of the economy rested on their labor; they were, above all, the most important colonized race, since Indians were not part of that colonial society. Why the dominant group calls itself "white" is a story related to racial classification.[5]

In America, the idea of race was a way of granting legitimacy to the relations of domination imposed by the conquest. After the colonization of America and the expansion of European colonialism to the rest of the world, the subsequent constitution of Europe as a new *id*-entity needed the elaboration of a Eurocentric perspective of knowledge, a theoretical perspective on the idea of race as a naturalization of colonial relations between Europeans and non-Europeans. Historically, this meant a new way of legitimizing the already old ideas and practices of relations of superiority/inferiority between dominant and dominated. From the sixteenth century on, this principle has proven to be the most effective and long-lasting instrument of universal social domination, since the much older principle—gender or intersexual domination—was encroached upon by the inferior/superior racial classifications. So the conquered and dominated peoples were situated in a natural position of inferiority and, as a result, their phenotypic traits as well as their cultural features were considered inferior.[6] In this way, race became the fundamental criterion for the distribution of the world population into ranks, places, and roles in the new society's structure of power.

CAPITALISM, THE NEW STRUCTURE FOR THE CONTROL OF LABOR

In the historical process of the constitution of America, all forms of control and exploitation of labor and production, as well as the control of appropriation and distribution of products, revolved around the capital-salary relation and the world market. These forms of labor control included slavery, serfdom, petty-commodity production, reciprocity, and wages. In such an assemblage, each form of labor control was no mere extension of its historical antecedents. All of these forms of labor were historically and sociologically new: in the first place, because they were deliberately established and organized to produce commodities for the world market; in the second place, because they did not merely exist simultaneously in the same space/time, but each one of them was also articulated to capital and its market. Thus they configured a new global model of labor control, and in turn a fundamental element of a new model of power to which they were historically structurally dependent. That is to say, the place and function, and therefore the historical movement, of all forms of labor as subordinated points of a totality belonged to the new model of power, in spite of their heterogeneous specific traits and their discontinuous relations with that totality. In the third place, and as a consequence, each form of labor developed into new traits and historical-structural configurations.

Insofar as that structure of control of labor, resources, and products consisted of the joint articulation of all the respective historically known forms, a global model of control of work was established for the first time in known history. And while it was constituted around and in the service of capital, its configuration as a whole was established with a capitalist character as well. Thus emerged a new, original, and singular structure of relations of production in the historical experience of the world: world capitalism.

COLONIALITY OF POWER AND GLOBAL CAPITALISM

The new historical identities produced around the foundation of the idea of race in the new global structure of the control of labor were associated with social roles and geohistorical places. In this way, both race and the division of labor remained structurally linked and mutually reinforcing, in spite of the fact that neither of them were necessarily dependent on the other in order to exist or change.

In this way, a systematic racial division of labor was imposed. In the Hispanic region, the Crown of Castilla decided early on to end the enslavement of the Indians in order to prevent their total extermination. They were instead confined to serfdom. For those that lived in communities, the ancient practice of reciprocity—the exchange of labor force and labor without a market—was allowed as a way of reproducing its labor force as serfs. In some cases, the Indian nobility, a reduced minority, was exempted from serfdom and received special treatment owing to their roles as intermediaries with the dominant race. They were also permitted to participate in some of the activities of the nonnoble Spanish. However, blacks were reduced to slavery. As the dominant race, Spanish and Portuguese whites could receive wages, be independent merchants, independent artisans, or independent farmers—in short, independent producers of commodities. Nevertheless, only nobles could participate in the high-to-midrange positions in the military and civil colonial administration.

Beginning in the eighteenth century, in Hispanic America an extensive and important social stratum of *mestizos* (born of Spanish men and Indian women) began to participate in the same offices and activities as nonnoble Iberians. To a lesser extent, and above all in activities of service or those that required a specialized talent (music, for example), the more "whitened" among the *mestizos* of black women and Spanish or Portuguese had an opportunity to work. But they were late in legitimizing their new roles, since their mothers were slaves. This racist distribution of labor in the interior of colonial/modern capitalism was maintained throughout the colonial period.

In the course of the worldwide expansion of colonial domination on the part of the same dominant race (or, from the eighteenth century onward, Europeans), the same criteria of social classification were imposed on all of the world population. As a result, new historical and social identities were produced: yellows and olives were added to whites, Indians, blacks, and *mestizos*. The racist distribution of new social identities was combined, as had been done so successfully in Anglo-America, with a racist distribution of labor and the forms of exploitation of colonial capitalism. This was, above all, through a quasi-exclusive association of whiteness with wages and, of course, with the high-order positions in the colonial administration. Thus each form of labor control was associated with a particular race. Consequently, the control of a specific form of labor could be, at the

same time, the control of a specific group of dominated people. A new technology of domination/exploitation, in this case race/labor, was articulated in such a way that the two elements appeared naturally associated. Until now, this strategy has been exceptionally successful.

COLONIALITY AND THE EUROCENTRIFICATION OF WORLD CAPITALISM

The privileged positions conquered by the dominant whites for the control of gold, silver, and other commodities produced by the unpaid labor of Indians, blacks, and *mestizos* (coupled with an advantageous location in the slope of the Atlantic through which, necessarily, the traffic of these commodities for the world market had to pass) granted whites a decisive advantage to compete for the control of worldwide commercial traffic. The progressive monetization of the world market that the precious metals from America stimulated and allowed, as well as the control of such large resources, made possible the control of the vast preexisting web of commercial exchange that included, above all, China, India, Ceylon, Egypt, Syria—the future Far and Middle East. The monetization of labor also made it possible to concentrate the control of commercial capital, labor, and means of production in the whole world market.

The control of global commercial traffic by dominant groups headquartered in the Atlantic zones propelled in those places a new process of urbanization based on the expansion of commercial traffic between them, and, consequently, the formation of regional markets increasingly integrated and monetarized due to the flow of precious metals originating in America. A historically new region was constituted as a new geocultural *id*-entity: Europe—more specifically, Western Europe.[7] A new geocultural identity emerged as the central site for the control of the world market. The hegemony of the coasts of the Mediterranean and the Iberian peninsula was displaced toward the northwest Atlantic coast in the same historical moment.

The condition Europe found itself in as the central site of the new world market cannot explain by itself alone why Europe also became, until the nineteenth century and virtually until the worldwide crisis of 1870, the central site of the process of the commodification of the labor force, while all the rest of the regions and populations colonized and incorporated into the new world market under European dominion basically remained under nonwaged relations of labor. And in

non-European regions, wage labor was concentrated almost exclusively among whites. Of course, the entire production of such a division of labor was articulated in a chain of transference of value and profits whose control corresponded to Western Europe.

There is nothing in the social relation of capital itself, or in the mechanisms of the world market in general, that implies the historical necessity of European concentration first (either in Europe or elsewhere) of waged labor and later (over precisely the same base) of the concentration of industrial production for more than two centuries. As events after 1870 demonstrated, Western European control of wage labor in any sector of the world's population would have been perfectly feasible, and probably more profitable for Western Europe. The explanation ought to lie, then, in some other aspect of history itself.

The fact is that from the very beginning of the colonization of America, Europeans associated nonpaid or nonwaged labor with the dominated races because they were "inferior" races. The vast genocide of the Indians in the first decades of colonization was not caused principally by the violence of the conquest nor by the plagues the conquistadors brought, but took place because so many American Indians were used as disposable manual labor and forced to work until death. The elimination of this colonial practice did not end until the defeat of the *encomenderos* in the middle of the sixteenth century. The subsequent Iberian colonialism involved a new politics of population reorganization, a reorganization of the Indians and their relations with the colonizers. But this did not advance American Indians as free and waged laborers. From then on, they were assigned the status of unpaid serfs. The serfdom of the American Indians could not, however, be compared with feudal serfdom in Europe, since it included neither the supposed protection of a feudal lord nor, necessarily, the possession of a piece of land to cultivate instead of wages. Before independence, the Indian labor force of serfs reproduced itself in the communities, but more than one hundred years after independence, a large part of the Indian serfs was still obliged to reproduce the labor force on its own.[8] The other form of unwaged or, simply put, unpaid labor, slavery, was assigned exclusively to the "black" population brought from Africa.

The racial classification of the population and the early association of the new racial identities of the colonized with the forms of control of unpaid, unwaged labor developed among the Europeans the singular

perception that paid labor was the whites' privilege. The racial inferiority of the colonized implied that they were not worthy of wages. They were naturally obliged to work for the profit of their owners. It is not difficult to find, to this very day, this attitude spread out among the white property owners of any place in the world. Furthermore, the lower wages "inferior races" receive in the present capitalist centers for the same work as done by whites cannot be explained as detached from the racist social classification of the world's population—in other words, as detached from the global capitalist coloniality of power.

The control of labor in the new model of global power was constituted thus, articulating all historical forms of labor control around the capitalist wage-labor relation. This articulation was constitutively colonial, based on first the assignment of all forms of unpaid labor to colonial races (originally American Indians, blacks, and, in a more complex way, *mestizos*) in America and, later on, to the remaining colonized races in the rest of the world, olives and yellows. Second, labor was controlled through the assignment of salaried labor to the colonizing whites.

Coloniality of labor control determined the geographic distribution of each one of the integrated forms of labor control in global capitalism. In other words, it determined the social geography of capitalism: capital, as a social formation for control of wage labor, was the axis around which all remaining forms of labor control, resources, and products were articulated. But, at the same time, capital's specific social configuration was geographically and socially concentrated in Europe and, above all, among Europeans in the whole world of capitalism. Through these measures, Europe and the European constituted themselves as the center of the capitalist world economy.

When Raúl Prebisch coined the celebrated image of center and periphery to describe the configuration of global capitalism since the end of the Second World War, he underscored, with or without being aware of it, the nucleus of the historical model for the control of labor, resources, and products that shaped the central part of the new global model of power, starting with America as a player in the new world economy.[9] Global capitalism was, from then on, colonial/modern and Eurocentered. Without a clear understanding of those specific historical characteristics of capitalism, the concept of a "modern world-system" itself, developed principally by Immanuel Wallerstein

but based on Prebisch and on the Marxian concept of world capitalism, cannot be properly or completely understood.[10]

THE NEW MODEL OF WORLD POWER AND THE NEW WORLD INTERSUBJECTIVITY

As the center of global capitalism, Europe not only had control of the world market, but it was also able to impose its colonial dominance over all the regions and populations of the planet, incorporating them into its world-system and its specific model of power. For such regions and populations, this model of power involved a process of historical reidentification; from Europe such regions and populations were attributed new geocultural identities. In that way, after America and Europe were established, Africa, Asia, and eventually Oceania followed suit. In the production of these new identities, the coloniality of the new model of power was, without a doubt, one of the most active determinations. But the forms and levels of political and cultural development, and more specifically intellectual development, played a role of utmost importance in each case. Without these factors, the category "Orient" would not have been elaborated as the only one with sufficient dignity to be the other to the "Occident," although by definition inferior, without some equivalent to "Indians" or "blacks" being coined.[11] But this omission itself puts in the open the fact that those other factors also acted within the racist model of universal social classification of the world population.

The incorporation of such diverse and heterogeneous cultural histories into a single world dominated by Europe signified a cultural and intellectual intersubjective configuration equivalent to the articulation of all forms of labor control around capital, a configuration that established world capitalism. In effect, all of the experiences, histories, resources, and cultural products ended up in one global cultural order revolving around European or Western hegemony. Europe's hegemony over the new model of global power concentrated all forms of the control of subjectivity, culture, and especially knowledge and the production of knowledge under its hegemony.

During that process, the colonizers exercised diverse operations that brought about the configuration of a new universe of intersubjective relations of domination between Europe and the Europeans and the

rest of the regions and peoples of the world, to whom new geocultural identities were being attributed in that process. In the first place, they expropriated the cultural discoveries of the colonized peoples most apt for the development of capitalism to the profit of the European center. Second, they repressed as much as possible the colonized forms of knowledge production, the models of the production of meaning, their symbolic universe, the model of expression and of objectification and subjectivity. As is well known, repression in this field was most violent, profound, and long lasting among the Indians of Ibero-America, who were condemned to be an illiterate peasant subculture stripped of their objectified intellectual legacy. Something equivalent happened in Africa. Doubtless, the repression was much less intense in Asia where an important part of the history of the intellectual written legacy has been preserved. And it was precisely such epistemic suppression that gave origin to the category "Orient." Third, in different ways in each case, they forced the colonized to learn the dominant culture in any way that would be useful to the reproduction of domination, whether in the field of technology and material activity or subjectivity, especially Judeo-Christian religiosity. All of those turbulent processes involved a long period of the colonization of cognitive perspectives, modes of producing and giving meaning, the results of material existence, the imaginary, the universe of intersubjective relations with the world: in short, the culture.[12]

The success of Western Europe in becoming the center of the modern world-system, according to Wallerstein's suitable formulation, developed within the Europeans a trait common to all colonial dominators and imperialists, ethnocentrism. But in the case of Western Europe, that trait had a peculiar formulation and justification: the racial classification of the world population after the colonization of America. The association of colonial ethnocentrism and universal racial classification helps to explain why Europeans came to feel not only superior to all the other peoples of the world, but, in particular, naturally superior. This historical instance is expressed through a mental operation of fundamental importance for the entire model of global power, but above all with respect to the intersubjective relations that were hegemonic, and especially for its perspective on knowledge: the Europeans generated a new temporal perspective of history and relocated the colonized population, along with their respective histories and cultures, in the past of a historical trajectory whose culmination was

Europe.[13] Notably, however, they were not in the same line of continuity as the Europeans, but in another, naturally different category. The colonized peoples were inferior races and in that manner were the past vis-à-vis the Europeans.

That perspective imagined modernity and rationality as exclusively European products and experiences. From this point of view, intersubjective and cultural relations between Western Europe and the rest of the world were codified in a strong play of new categories: East-West, primitive-civilized, magic/mythic-scientific, irrational-rational, traditional-modern—Europe and not Europe. Even so, the only category with the honor of being recognized as the other of Europe and the West was "Orient"—not the Indians of America and not the blacks of Africa, who were simply "primitive." For underneath that codification of relations between Europeans and non-Europeans, race is, without doubt, the basic category.[14] This binary, dualist perspective on knowledge, particular to Eurocentrism, was imposed as globally hegemonic in the same course as the expansion of European colonial dominance over the world.

It would not be possible to explain the elaboration of Eurocentrism as the hegemonic perspective of knowledge otherwise. The Eurocentric version is based on two principal founding myths: first, the idea of the history of human civilization as a trajectory that departed from a state of nature and culminated in Europe; second, a view of the differences between Europe and non-Europe as natural (racial) differences and not consequences of a history of power. Both myths can be unequivocally recognized in the foundations of evolutionism and dualism, two of the nuclear elements of Eurocentrism.

THE QUESTION OF MODERNITY

I do not propose to enter here into a thorough discussion of the question of modernity and its Eurocentric version. In particular, I will not lengthen this piece with a discussion of the modernity-postmodernity debate and its vast bibliography. But it is pertinent for the goals of this essay, especially for the following section, to raise some questions.[15]

The fact that Western Europeans will imagine themselves to be the culmination of a civilizing trajectory from a state of nature leads them also to think of themselves as the moderns of humanity and its

history, that is, as the new, and at the same time, most advanced of the species. But since they attribute the rest of the species to a category by nature inferior and consequently anterior, belonging to the past in the progress of the species, the Europeans imagine themselves as the exclusive bearers, creators, and protagonists of that modernity. What is notable about this is not that the Europeans imagined and thought of themselves and the rest of the species in that way—something not exclusive to Europeans—but the fact that they were capable of spreading and establishing that historical perspective as hegemonic within the new intersubjective universe of the global model of power.

Of course, the intellectual resistance to that historical perspective was not long in emerging. In Latin America, from the end of the nineteenth century and above all in the twentieth century, especially after the Second World War, it happened in connection with the development-underdevelopment debate. That debate was dominated for a long time by the so-called theory of modernization.[16] One of the arguments most frequently used, from opposing angles, was to affirm that modernization does not necessarily imply the westernization of non-European societies and cultures, but that modernity is a phenomenon of all cultures, not just of Europe or the West.

If the concept of modernity only, or fundamentally, refers to the ideas of newness, the advanced, the rational-scientific, the secular (which are the ideas normally associated with it), then there is no doubt that one must admit that it is a phenomenon possible in all cultures and historical epochs. With all their respective particularities and differences, all the so-called high cultures (China, India, Egypt, Greece, Maya-Aztec, Tawantinsuyo) prior to the current world-system unequivocally exhibit signs of that modernity, including rational science and the secularization of thought. In truth, it would be almost ridiculous at these levels of historical research to attribute to non-European cultures a mythic-magical mentality, for example, as a defining trait in opposition to rationality and science as characteristics of Europe. Therefore, apart from their symbolic contents, cities, temples, palaces, pyramids or monumental cities (such as Machu Picchu or Borobudur), irrigation, large thoroughfares, technologies, metallurgy, mathematics, calendars, writing, philosophy, histories, armies, and wars clearly demonstrate the scientific development in each one of the high cultures that took place long before the formation of Europe as a new *id*-entity. The most that one can really say is that the present period has gone

further in scientific and technological developments and has made major discoveries and achievements under Europe's hegemonic role and, more generally, under Western hegemony.

The defenders of the European patent on modernity are accustomed to appeal to the cultural history of the ancient Greco-Roman world and to the world of the Mediterranean prior to the colonization of America in order to legitimize their claim on the exclusivity of its patent. What is curious about this argument is, first, that it obscures the fact that the truly advanced part of the Mediterranean world was Islamo-Judaic. Second, it was that world that maintained the Greco-Roman cultural heritage, cities, commerce, agricultural trade, mining, textile industry, philosophy, and history, while the future Western Europe was being dominated by feudalism and cultural obscurantism. Third, very probably, the commodification of the labor force—the capital-wage relation—emerged precisely in that area, and its development expanded north toward the future Europe. Fourth, starting only with the defeat of Islam and the later displacement by America of Islam's hegemony over the world market north to Europe did the center of cultural activity also begin to be displaced to that new region. Because of this, the new geographic perspective of history and culture, elaborated and imposed as globally hegemonic, implies a new geography of power. The idea of Occident-Orient itself is belated and starts with British hegemony. Or is it still necessary to recall that the prime meridian crosses London and not Seville or Venice?[17]

In this sense, the Eurocentric pretension to be the exclusive producer and protagonist of modernity—because of which all modernization of non-European populations, is, therefore, a Europeanization—is an ethnocentric pretension and, in the long run, provincial. However, if it is accepted that the concept of modernity refers solely to rationality, science, technology, and so on, the question that we would be posing to historical experience would not be different than the one proposed by European ethnocentrism. The debate would consist just in the dispute for the originality and exclusivity of the ownership of the phenomenon thus called modernity, and consequently everything would remain in the same terrain and according to the same perspective of Eurocentrism.

There is, however, a set of elements that point to a different concept of modernity that gives an account of a historical process specific to the

current world-system. The previous references and traits of the concept of modernity are not absent, obviously. But they belong to a universe of social relations, both in its material and intersubjective dimensions, whose central question and, consequently its central field conflict, is human social liberation as a historical interest of society. In this article, I will limit myself to advancing, in a brief and schematic manner, some propositions to clarify these issues.[18]

In the first place, the current model of global power is the first effectively global one in world history in several specific senses. First, it is the first where in each sphere of social existence all historically known forms of control of respective social relations are articulated, configuring in each area only one structure with systematic relations between its components and, by the same means, its whole. Second, it is the first model where each structure of each sphere of social existence is under the hegemony of an institution produced within the process of formation and development of that same model of power. Thus, in the control of labor and its resources and products, it is the capitalist enterprise; in the control of sex and its resources and products, the bourgeois family; in the control of authority and its resources and products, the nation-state; in the control of intersubjectivity, Eurocentrism.[19] Third, each one of those institutions exists in a relation of interdependence with each one of the others. Therefore, the model of power is configured as a system.[20] Fourth, finally, this model of global power is the first that covers the entire planet's population.

In this specific sense, humanity in its totality constitutes today the first historically known global *world-system*, not only a world, as were the Chinese, Hindu, Egyptian, Hellenic-Roman, Aztec-Mayan, or Tawantinsuyan. None of those worlds had in common but one colonial/imperial dominant. And though it is a sort of common sense in the Eurocentric vision, it is by no means certain that all the peoples incorporated into one of those worlds would have had in common a basic perspective on the relation between that which is human and the rest of the universe. The colonial dominators of each one of those worlds did not have the conditions, nor, probably, the interest for homogenizing the basic forms of social existence for all the populations under their dominion. On the other hand, the modern world-system that began to form with the colonization of America, has in common three central elements that affect the quotidian life of the totality of the global population: the coloniality of power, capitalism, and

Eurocentrism. Of course, this model of power, or any other, can mean that historical-structural heterogeneity has been eradicated within its dominions. Its globality means that there is a basic level of common social practices and a central sphere of common value orientation for the entire world. Consequently, the hegemonic institutions of each province of social existence are universal to the population of the world as intersubjective models, as illustrated by the nation-state, the bourgeois family, the capitalist corporation, and the Eurocentric rationality.

Therefore, whatever it may be that the term *modernity* names today, it involves the totality of the global population and all the history of the last five hundred years, all the worlds or former worlds articulated in the global model of power, each differentiated or differentiable segment constituted together with (as part of) the historical redefinition or reconstitution of each segment for its incorporation to the new and common model of global power. Therefore, it is also an articulation of many rationalities. However, since the model depicts a new and different history with specific experiences, the questions that this history raises cannot be investigated, much less contested, within the Eurocentric concept of modernity. For this reason, to say that modernity is a purely European phenomenon or one that occurs in all cultures would now have an impossible meaning. Modernity is about something new and different, something specific to this model of global power. If one must preserve the name, one must also mean another modernity.

The central question that interests us here is the following: What is really new with respect to modernity? And by this I mean not only what develops and redefines experiences, tendencies, and processes of other worlds, but, also, what was produced in the present model of global power's own history. Enrique Dussel (1995) has proposed the category "transmodernity" as an alternative to the Eurocentric pretension that Europe is the original producer of modernity. According to this proposal, the constitution of the individual differentiated ego is what began with American colonization and is the mark of modernity, but it has a place not only in Europe but also in the entire world that American settlement configured. Dussel hits the mark in refusing one of the favorite myths of Eurocentrism. But it is not certain that the individual, differentiated ego is a phenomenon belonging exclusively to the period initiated with America. There is, of course, an umbilical relation between the historical processes

that were generated and that began with America and the changes in subjectivity or, better said, the intersubjectivity of all the peoples that were integrated into the new model of global power. And those changes brought the constitution of a new intersubjectivity, not only individually, but collectively as well. This is, therefore, a new phenomenon that entered in history with America and in that sense is part of modernity. But whatever they might have been, those changes were not constituted from the individual (nor from the collective) subjectivity of a preexisting world. Or, to use an old image, those changes are born not like Pallas Athena from the head of Zeus, but are rather the subjective or intersubjective expression of what the peoples of the world are doing at that moment.

From this perspective, it is necessary to admit that the colonization of America, its immediate consequences in the global market, and the formation of a new model of global power are a truly tremendous historical change and that they affect not only Europe but the entire globe. This is not a change in a known world that merely altered some of its traits. It is a change in the world as such. This is, without doubt, the founding element of the new subjectivity: the perception of historical change. It is this element that unleashed the process of the constitution of a new perspective about time and about history. The perception of change brings about a new idea of the future, since it is the only territory of time where the changes can occur. The future is an open temporal territory. Time can be new, and so not merely the extension of the past. And in this way history can be perceived now not only as something that happens, something natural or produced by divine decisions or mysteries as destiny, but also as something that can be produced by the action of people, by their calculations, their intention, their decisions, and therefore as something that can be designed, and consequently, can have meaning.[21]

With America an entire universe of new material relations and intersubjectivities was initiated. It is pertinent to admit that the concept of modernity does not refer only to what happens with subjectivity (despite all the tremendous importance of that process), to the individual ego, to a new universe of intersubjective relations between individuals and the peoples integrated into the new world-system and its specific model of global power. The concept of modernity accounts equally for the changes in the material dimensions of social relations (i.e., world capitalism, coloniality of power). That is to say, the changes that occur on all levels of social existence, and therefore

happen to their individual members, are the same in their material and intersubjective dimensions. And since "modernity" is about processes that were initiated with the emergence of America, of a new model of global power (the first world-system), and of the integration of all the peoples of the globe in that process, it is also essential to admit that it is about an entire historical period. In other words, starting with America, a new space/time was constituted materially and subjectively: this is what the concept of modernity names.

Nevertheless, it was decisive for the process of modernity that the hegemonic center of the world would be localized in the north-central zones of Western Europe. That process helps to explain why the center of intellectual conceptualization will be localized in Western Europe as well, and why that version acquired global hegemony. The same process helps, equally, to explain the coloniality of power that will play a part of the first order in the Eurocentric elaboration of modernity. This last point is not very difficult to perceive if we bear in mind what has been shown just above: the way in which the coloniality of power is tied up to the concentration in Europe of capital, wages, the market of capital, and finally, the society and culture associated with those determinations. In this sense, modernity was also colonial from its point of departure. This helps explain why the global process of modernization had a much more direct and immediate impact in Europe.

In fact, as experience and as idea, the new social practices involved in the model of global, capitalist power, the concentration of capital and wages, the new market for capital associated with the new perspective on time and on history, and the centrality of the question of historical change in that perspective require on one hand the desacralization of hierarchies and authorities, both in the material dimension of social relations and in its intersubjectivity, and on the other hand the desacralization, change, or dismantlement of the corresponding structures and institutions. The new individuation of subjectivity only acquires its meaning in this context because from it stems the necessity for an individual inner forum in order to think, doubt, and choose. In short, the individual liberty against fixed social ascriptions and, consequently, the necessity for social equality among individuals.

Capitalist determinations, however, required also (and in the same historical movement) that material and intersubjective social processes

could not have a place but within social relations of exploitation and domination. For the controllers of power, the control of capital and the market were and are what decides the ends, the means, and the limits of the process. The market is the foundation but also the limit of possible social equality among people. For those exploited by capital, and in general those dominated by the model of power, modernity generates a horizon of liberation for people of every relation, structure, or institution linked to domination and exploitation, but also the social conditions in order to advance toward the direction of that horizon. Modernity is, then, also a question of conflicting social interests. One of these interests is the continued democratization of social existence. In this sense, every concept of modernity is necessarily ambiguous and contradictory.[22]

It is precisely in the contradictions and ambiguities of modernity that the history of these processes so clearly differentiates Western Europe from the rest of the world, as it is clear in Latin America. In Western Europe, the concentration of the wage-capital relation is the principal axis of the tendencies for social classification and the correspondent structure of power. Economic structures and social classification underlay the confrontations with the old order, with empire, with the papacy during the period of so-called competitive capital. These conflicts made it possible for nondominant sectors of capital as well as the exploited to find better conditions to negotiate their place in the structure of power and in selling their labor power. It also opens the conditions for a specifically bourgeois secularization of culture and subjectivity. Liberalism is one of the clear expressions of this material and subjective context of Western European society. However, in the rest of the world, and in Latin America in particular, the most extended forms of labor control are nonwaged (although for the benefit of global capital), which implies that the relations of exploitation and domination have a colonial character. Political independence, at the beginning of the nineteenth century, is accompanied in the majority of the new countries by the stagnation and recession of the most advanced sectors of the capitalist economy and therefore by the strengthening of the colonial character of social and political domination under formally independent states. The Eurocentrification of colonial/modern capitalism was in this sense decisive for the different destinies of the process of modernity between Europe and the rest of the world.[23]

COLONIALITY OF POWER AND EUROCENTRISM

The intellectual conceptualization of the process of modernity produced a perspective of knowledge and a mode of producing knowledge that gives a very tight account of the character of the global model of power: colonial/modern, capitalist, and Eurocentered. This perspective and concrete mode of producing knowledge is Eurocentrism.[24]

Eurocentrism is, as used here, the name of a perspective of knowledge whose systematic formation began in Western Europe before the middle of the seventeenth century, although some of its roots are, without doubt, much older. In the following centuries this perspective was made globally hegemonic, traveling the same course as the dominion of the European bourgeois class. Its constitution was associated with the specific bourgeois secularization of European thought and with the experiences and necessities of the global model of capitalist (colonial/modern) and Eurocentered power established since the colonization of America.

This category of Eurocentrism does not involve all of the knowledge of history of all of Europe or Western Europe in particular. It does not refer to all the modes of knowledge of all Europeans and all epochs. It is instead a specific rationality or perspective of knowledge that was made globally hegemonic, colonizing and overcoming other previous or different conceptual formations and their respective concrete knowledges, as much in Europe as in the rest of the world. In the framework of this essay, I propose to discuss some of these issues more directly related to the experience of Latin America, but, obviously, they do not refer only to Latin America.

CAPITAL AND CAPITALISM

First, the theory of history as a linear sequence of universally valid events needs to be reopened in relation to America as a major question in the social-scientific debate. More so when such a concept of history is applied to labor and the control of labor conceptualized as modes of production in the sequence precapitalism–capitalism. From the Eurocentric point of view, reciprocity, slavery, serfdom, and independent commodity production are all perceived as a historical sequence prior to

commodification of the labor force. They are precapital. And they are considered not only different, but radically incompatible with capital. The fact is, however, that in America they did not emerge in a linear historical sequence; none of them was a mere extension of the old precapitalist form, nor were they incompatible with capital.

Slavery, in America, was deliberately established and organized as a commodity in order to produce goods for the world market and to serve the purposes and needs of capitalism. Likewise, the serfdom imposed on Indians, including the redefinition of the institutions of reciprocity, was organized in order to serve the same ends: to produce merchandise for the global market. Independent commodity production was established and expanded for the same purposes. This means that all the forms of labor and control of labor were not only simultaneously performed in America, but they were also articulated around the axis of capital and the global market. Consequently, all of these forms of labor were part of a new model of organization and labor control. Together these forms of labor configured a new economic system: capitalism.

Capital, as a social relation based on the commodification of the labor force, was probably born in some moment around the eleventh or twelfth century in some place in the southern regions of the Iberian and/or Italian peninsulas and, for known reasons, in the Islamic world.[25] Capital is thus much older than America. But before the emergence of America, it was nowhere structurally articulated with all the other forms of organization and control of the labor force and labor, nor was it predominant over any of them. Only with America could capital consolidate and obtain global predominance, becoming precisely the axis around which all forms of labor were articulated to satisfy the ends of the world market, configuring a new pattern of global control on labor, its resources, and products: world capitalism. Therefore, capitalism as a system of relations of production, that is, as the heterogeneous linking of all forms of control on labor and its products under the dominance of capital, was constituted in history only with the emergence of America. Beginning with that historical moment, capital has always existed, and continues to exist to this day, as the central axis of capitalism. Never has capitalism been predominant in some other way, on a global and worldwide scale, and in all probability it would not have been able to develop otherwise.

EVOLUTIONISM AND DUALISM

Parallel to the historical relations between capital and precapital, a similar set of ideas was elaborated around the spatial relations between Europe and non-Europe. As I have already mentioned, the foundational myth of the Eurocentric version of modernity is the idea of the state of nature as the point of departure for the civilized course of history whose culmination is European or Western civilization. From this myth originated the specifically Eurocentric evolutionist perspective of linear and unidirectional movement and changes in human history. Interestingly enough, this myth was associated with the racial and spatial classification of the world's population. This association produced the paradoxical amalgam of evolution and dualism, a vision that becomes meaningful only as an expression of the exacerbated ethnocentrism of the recently constituted Europe; by its central and dominant place in global, colonial/modern capitalism; by the new validity of the mystified ideas of humanity and progress, dear products of the Enlightenment; and by the validity of the idea of race as the basic criterion for a universal social classification of the world's population.

The historical process is, however, very different. To start with, in the moment that the Iberians conquered, named, and colonized America (whose northern region, North America, would be colonized by the British a century later), they found a great number of different peoples, each with its own history, language, discoveries and cultural products, memory and identity. The most developed and sophisticated of them were the Aztecs, Mayas, Chimus, Aymaras, Incas, Chibchas, and so on. Three hundred years later, all of them had become merged into a single identity: Indians. This new identity was racial, colonial, and negative. The same happened with the peoples forcefully brought from Africa as slaves: Ashantis, Yorubas, Zulus, Congos, Bacongos, and others. In the span of three hundred years, all of them were Negroes or blacks.

This resultant from the history of colonial power had, in terms of the colonial perception, two decisive implications. The first is obvious: peoples were dispossessed of their own and singular historical identities. The second is perhaps less obvious, but no less decisive: their new racial identity, colonial and negative, involved the plundering of their place in the history of the cultural production of humanity. From then on, there were inferior races, capable only of producing inferior cultures. The new identity also

involved their relocation in the historical time constituted with America first and with Europe later: from then on, they were the past. In other words, the model of power based on coloniality also involved a cognitive model, a new perspective of knowledge within which non-Europe was the past, and because of that inferior, if not always primitive.

At the other hand, America was the first modern and global geocultural identity. Europe was the second and was constituted as a consequence of America, not the inverse. The constitution of Europe as a new historic entity/identity was made possible, in the first place, through the free labor of the American Indians, blacks, and *mestizos*, with their advanced technology in mining and agriculture, and with their products such as gold, silver, potatoes, tomatoes, and tobacco.[26] It was on this foundation that a region was configured as the site of control of the Atlantic routes, which became in turn, and for this very reason, the decisive routes of the world market. This region did not delay in emerging as ... Europe. So Europe and America mutually produced themselves as the historical and the first two new geocultural identities of the modern world.

However, the Europeans persuaded themselves, from the middle of the seventeenth century, but above all during the eighteenth century, that in some way they had autoproduced themselves as a civilization, at the margin of history initiated with America, culminating an independent line that began with Greece as the only original source. Furthermore, they concluded that they were naturally (i.e., racially) superior to the rest of the world since they had conquered everyone and had imposed their dominance on them.

The confrontation between the historical experience and the Eurocentric perspective on knowledge makes it possible to underline some of the more important elements of Eurocentrism: (*a*) a peculiar articulation between dualism (capital-precapital, Europe-non-Europe, primitive-civilized, traditional-modern, etc.) and a linear, one-directional evolutionism from some state of nature to modern European society; (*b*) the naturalization of the cultural differences between human groups by means of their codification with the idea of race; and (*c*) the distorted-temporal relocation of all those differences by relocating non-Europeans in the past. All these intellectual operations are clearly interdependent, and they could not have been cultivated and developed without the coloniality of power.

ACKNOWLEDGMENTS

I want to thank Edgardo Lander and Walter Mignolo for their help in the revision of this article. Thanks also to an anonymous reviewer for useful criticisms of a previous version. Responsibility for the errors and limitations of the text is mine alone.

Excerpt from a larger essay.

1. Anibal Quijano, "Coloniality and Modernity/Rationality," in *Globalizations and Modernities*, ed. Goran Therborn, trans. Sonia Therborn (Stockholm: Forksningsradnamnden, 1999).

2. Even though for the imperialist vision of the United States of America the term "America" is just another name for that country, today it is the name of the territory that extends from Alaska in the north to Cape Horn in the south, including the Caribbean archipelago. But from 1492 until 1610, America was exclusively the time/space under Iberian (Hispanic Portuguese) colonial domination. This included, in the northern border, California, Texas, New Mexico, Florida (conquered in the nineteenth century by the United States), the Spanish-speaking Caribbean area, up to Cape Horn in the south—roughly, the time/space of today's Latin America. The Eurocentered, capitalist, colonial/modern power emerged then and there. So, though today America is a very heterogeneous world in terms of power and culture, and for descriptive purposes could be better referred to as the Americas, in regards to the history of the specific pattern of world power that is discussed here, "America" still is the proper denomination.

3. Anibal Quijano and Immanuel Wallerstein, "Americanity as a Concept, or the Americas in the Imaginary of the Modern World-System," *International Journal of Social Science* 134 (1992): 549-559.

4. On this question and the possible antecedents to race before America, see Anibal Quijano, "Raza, etnia y nación: Cuestiones abiertas," in *J. C. Mariátegui y Europa: El otro descubrimiento*, ed. Roland Forgues (Lima: Amauta, 1992).

5. The invention of the category of "color"—first as the most visible indication of race and later simply as its equivalent—as much as the invention of the particular category of "white," still requires a more exhaustive historical investigation. In every case, they were most probably Anglo-American inventions, since there are no traces of these categories in the chronicles and other documents from the first one hundred years of Iberian colonialism in America. For the case of Anglo-America, an extensive bibliography exists. Theodore Allen, *The Invention of the White Race*, 2 vols. (London: Verso, 1994); and Mathew Frye Jacobson, *Whiteness of a Different Color* (Cambridge, MA: Harvard University Press, 1998) are among the most important works on this topic. The problem is that this explanation ignores what happened in Iberian America. Due to this elision, we still lack sufficient information on this specific problem for that region. Therefore, this is still an open question. It is very interesting that despite the fact that those who would be "Europeans" in the future, from the time of the Roman Empire recognized the future "Africans," as did the Iberians who were more or less familiar with Africans much earlier than the conquest, but never thought of them in racial terms before the colonization of America. In fact, race as a category was applied for the first time to the Indians, not to blacks. In this way, race appears much earlier than color in the history of the social classification of the global population.

6. The idea of race is literally an invention. It has nothing to do with the biological structure of the human species. Regarding phenotypic traits, those that are obviously found in the genetic code of individuals and groups are in that specific sense biological. However, they have no relation to the subsystems and biological processes of the human organism, including those involved in the neurological and mental subsystems and their functions. See Jonathan Mark, *Human Biodiversity, Genes, Race, and History* (New York: Aldyne de Gruyter, 1994); and Anibal Quijano, "Que tal raza!" *Familia y cambio social* (Lima: CECOSAM, 1999).

7. Western Europe is the location on the Atlantic coast to the west of the large peninsula protruding from the continental mass that Europeans named Asia. Fernando Coronil in "Beyond Occidentalism: Toward Nonimperial Geohistorical Categories" (*Cultural Anthropology* 11 (1) (1965): 51-87) has discussed the construction of the category "Occident" as part of the formation of a global power.

8. This is precisely what Alfred Métraux, the well-known French anthropologist, found at the end of the fifties in southern Peru. I found the same phenomenon in 1963 in Cuzco: an Indian peon was obliged to travel from his village, in La Convención, to the city in order to fulfill his turn of service to his patrons. But they did not furnish him lodging, or food, or, of course, a salary. Métraux proposed that that situation was closer to the Roman *colonato* of the fourth century b.c. than to European feudalism.

9 See Raúl Prebisch, "Commercial Policy in the Underdeveloped Countries," *American Economic Review, Papers and Proceedings* 49 (1959): 251–73; and Raúl Prebisch, *The Economic Development in Latin America and Its Principal Problems* (New York: ECLA, United Nations, 1960). On Prebisch, see Werner Baer, "The Economics of Prebisch and ECLA," *Economic Development and Cultural Change* 10 (Chicago: The University of Chicago Press, 1962).

10 See Immanuel Wallerstein, *The Modern World-System*. 3 vols. (Sand Diego: Academic Press, 1974–1989); Terrence Hopkins and Immanuel Wallerstein, *World-Systems Analysis: Theory and Methodology*, vol. 1 (Beverly Hills, CA: Sage, 1982).

11 On the process of the production of new historical geocultural identities, see Eduardo O'Gorman, *La invención de América* (Mexico: FCE, 1954); José Rabasa, *Inventing America: Spanish Historiography and the Formation of Eurocentrism* (Norman: University of Oklahoma Press, 1993); Enrique Dussel, *The Invention of the Americas: Eclipse of the Other and the Myth of Modernity* (New York: Continuum, 1995); Valentine Mudimbe, *The Invention of Africa: Gnosis, Philosophy, and the Order of Knowledge* (Bloomington: Indiana University Press, 1988); Charles Tilly, *Coercion, Capital, and European States, A.D. 990–1992* (Cambridge: Blackwell, 1990); Edward Said, *Orientalism* (New York: Vintage, 1979); and Coronil, "Beyond Occidentalism."

12 On these questions, see George W. Stocking Jr., *Race, Culture, Evolution: Essays in the History of Anthropology* (New York: Free Press, 1968); Robert Young, *Colonial Desire: Hybridity in Theory, Culture, and Race* (London: Routledge, 1995); Anibal Quijano, "Réflexions sur l'interdisciplinarité, le développement et les relations interculturelles," *Entre savoirs: Interdisciplinarité en acte: Enjeux, obstacles résultants* (Paris: UNESCO-ERES, 1992); Anibal Quijano, "Colonialidad de poder, cultura y conocimiento en América Latina," *Anuario Mariáteguiano* 9 (1997): 113–122; and Serge Gruzinski, *La colonisation de l'imaginaire: Sociétés indigènes et occidentalisation dans le Mexique espagnol*, XVIXVIII (Paris: Gallimard, 1988).

13 Walter Mignolo, *The Darker Side of the Renaissance: Literacy, Territoriality, and Colonization* (Ann Arbor: University of Michigan Press, 1995); J. M. Blaut, *The Colonial Model of the World: Geographical Diffusionism and Eurocentric History* (New York: Guilford, 1993); and Edgardo Lander, "Colonialidad, modernidad, postmodernidad," *Anuario Mariáteguiano* 9 (1997): 122–132.

14 Around the categories produced during European colonial dominance of the world, there exist a good many lines of debate: subaltern studies, postcolonial studies, cultural studies, and multiculturalism are among the current ones. There is also a flourishing bibliography, too long to be cited here, lined with famous names such as Ranajit Guha, Gayatri Spivak, Edward Said, Homi Bhabha, and Stuart Hall.

15 Of my previous studies, see principally Anibal Quijano, "Colonialidad y Modernidad/Racionalidad," *Perú Indígena*, vol. 13, no. 29, (Lima: Instituto Indigenista Peruano, 1991): 11–20, and Anibal Quijano, "La nueva heterogeneidad estructural de América Latina," *Nuevo temas, nuevos contenidos*, ed. Heinz Sonntag (Caracas: UNESCO-Nueva Sociedad, 1988).

16 A summary of the vast literature on this debate can be found in Anibal Quijano, "El fantasma del desarrollo en América Latina," *Revista del CESLA*, no. 1 (Lima: Universitas Varsoviensis, 2000): 38–55.

17 See Robert Young, *Colonial Desire: Hybridity in Theory, Culture, and Race* (London: Routledge, 1995).

18 For a more extended debate, see Anibal Quijano, "Modernidad y democracia: Intereses y conflictos," *Anuario Mariáteguiano* 12 (2000).

19 On the theoretical propositions of this conception of power, see Anibal Quijano, "Coloniality of Power and Its Institutions." Paper presented at conference *Coloniality and Its Disciplinary Sites* (Binghamton, (NY): Binghamton University, 1999).

20 I mean "system" in the sense that the relations between parts and the totality are not arbitrary and that the latter has hegemony over the parts in the orientation of the movement of the whole. But not in a systematic sense, as the relations of the parts among themselves and with the whole are not logically functional. This happens only in machines and organisms, never in social relations.

21 Anibal Quijano, "La nueva heterogeneidad estructural de América Latina," *Nuevo temas, nuevos contenidos*, ed. Heinz Sonntag (Caracas: UNESCO-Nueva Sociedad, 1988).

22 Anibal Quijano, "Estado nacion, ciudadanía y democracia: Cuestiones abiertas," *Democracia para una nueva sociedad*, ed. Helena Gonzales and Heidulf Schmidt (Caracas: Nueva Sociedad, 1998); and Anibal Quijano, "Modernidad y democracia: Intereses y conflictos," *Anuario Mariáteguiano* 12 (2000).

23 Anibal Quijano, "Colonialité du pouvoir, démocratie et citoyenneté en Amérique Latine," *Amérique Latine: Démocratie et exclusion* (Paris: L'Harmattan, 1994).

24 The literature on the debate about Eurocentrism is growing rapidly. See Samir Amin, *Eurocentrism* (New York: Monthly Review, 1989) for a different (although somewhat related) position than the one that orients this article.

25 See Immanuel Wallerstein, *Historical Capitalism* (London: Verso, 1983); and Giovanni Arrighi, *The Long Twentieth Century* (London: Verso, 1994).

26 Herman Viola and Carolyn Margolis, ed., *Seeds of Change: Five Hundred Years since Columbus* (Washington, DC: Smithsonian, 1991).

REFERENCES

Allen, Theodore. *The Invention of the White Race*. 2 vols. (London: Verso, 1994).

Amin, Samir. *Eurocentrism* (New York: Monthly Review, 1989).

Anderson, Benedict. *Imagined Communities* (London: Verso, 1991).

Arrighi, Giovanni. *The Long Twentieth Century* (London: Verso, 1994).

Baer, Werner. "The Economics of Prebisch and ECLA." *Economic Development and Cultural Change* 10 (Chicago: University of Chicago Press, 1962).

Blaut, J. M. *The Colonial Model of the World: Geographical Diffusionism and Eurocentric History* (New York: Guilford, 1993).

Bousquié, Paul. *Le corps, cet inconnu* (Paris: L'Harmattan, 1994).

González Casanova, Pablo "Internal Colonialism and National Development" in *Studies in Comparative International Development*, vol. 1, no. 4 (1965).

Coronil, Fernando. "Beyond Occidentalism: Toward Nonimperial Geohistorical Categories." *Cultural Anthropology* 11(1) (Wiley, 1965): 51–87.

Descartes, René. *Oeuvres philosophiques* (Paris: Editions Alquie, 1963–1967).

Dussel, Enrique. *The Invention of the Americas: Eclipse of the Other and the Myth of Modernity* (New York: Continuum, 1995).

Gobineau, Arthur. *Essais sur l'inégalité des races humaines* (Paris: P. Belfond, 1853–1857).

Gruzinski, Serge. *La colonisation de l'imaginaire: Sociétés indigènes et occidentalisation dans le Mexique espagnol, XVI–XVIII* (Paris: Gallimard, 1988).

Hopkins, Terrence, and Immanuel Wallerstein. *World-Systems Analysis: Theory and Methodology*, vol. 1. (Beverly Hills, CA: Sage, 1982).

Imaz, Eugenio. *Nosotros mañana* (Buenos Aires: Editorial Sudamericana, 1964).

Jacobson, Mathew Frye. *Whiteness of a Different Color* (Cambridge, MA: Harvard University Press, 1998).

Lander, Edgardo. "Colonialidad, modernidad, postmodernidad," *Anuario Mariáteguiano* 9 (1997): 122–32.

Mariátegui, José Carlos. *Siete ensayos de interpretación de la realidad peruana* (Lima: Biblioteca Amauta, 1928).
——. "Aniversario y balance." *AMAUTA*, (September 1928).
——. "Punto de vista antimperialista." *Obras completas*. Vol. 11. (Lima: Biblioteca Amauta, 1929).

Mark, Jonathan. *Human Biodiversity, Genes, Race, and History* (New York: Aldyne de Gruyter, 1994).

Mignolo, Walter. *The Darker Side of the Renaissance: Literacy, Territoriality, and Colonization* (Ann Arbor: University of Michigan Press, 1995).

Mudimbe, Valentine. *The Invention of Africa: Gnosis, Philosophy, and the Order of Knowledge* (Bloomington: Indiana University Press, 1988).

Myrdall, Gunnar. *American Dilemma* (New York: Harper and Brothers, 1944).

O'Gorman, Eduardo. *La invención de América* (Mexico: FCE, 1954).

Prebisch, Raúl. "Commercial Policy in the Underdeveloped Countries." *American Economic Review, Papers and Proceedings* 49 (1959): 251–73.
——. *The Economic Development in Latin America and Its Principal Problems* (New York: ECLA, United Nations, 1960).

Quijano, Anibal. *Notas sobre el concepto de marginalidad social* (Lima: CEPAL, 1966).
——. "Urbanización, cambio social y dependencia." In *América Latina: Ensayos de interpretación sociológica*, ed. Fernando Henrique Cardoso and Francisco Weffort. (Santiago: Editorial Universitaria, 1967).
——. *Qué es y qué no es socialismo* (Lima: Ediciones Sociedad y Política, 1972).
——. *Imperialismo y marginalidad en América Latina* (Lima: Morca Azul, 1977).
——. "Poder y democracia." *Sociedad y Política* 12 (1981).
——. "La nueva heterogeneidad estructural de América Latina." In *Nuevo temas, nuevos contenidos*, ed. Heinz Sonntag. (Caracas: UNESCO-Nueva Sociedad, 1988).
——. "Colonialidad y modernidad/racionalidad." *Perú indígena*, 13(29) (1992). Translated as "Coloniality and Modernity/Rationality," in *Globalizations and Modernities*, ed. Goran Therborn. (Stockholm: Forksningsradnamnden, 1999).
——. "Raza, etnia y nación: Cuestiones abiertas." In *J. C. Mariátegui y Europa: El otro descubrimiento*, ed. Roland Forgues. (Lima: Amauta, 1992).
——. "Réflexions sur l'interdisciplinarité, le développement et les relations interculturelles." *Entre savoirs: Interdisciplinarité en acte: Enjeux, obstacles résultants* (Paris: UNESCO-ERES, 1992).
——. "América Latina en la economía mundial." *Problemas del desarollo* 24 (95) (1993).

——. "Colonialité du pouvoir, démocratie et citoyenneté en Amérique Latine," in *Amérique Latine: Démocratie et exclusion* (Paris: L'Harmattan, 1994).
——. "Colonialidad de poder, cultura y conocimiento en América Latina." *Anuario Mariáteguiano* 9 (1997): 113–22.
——. "Estado nacion, ciudadanía y democracia: Cuestiones abiertas," in *Democracia para una nueva sociedad*, ed. Helena Gonzales and Heidulf Schmidt. (Caracas: Nueva Sociedad, 1998).
——. "Que tal raza!" in *Familia y cambio social*. (Lima: CECOSAM, 1999).
——. "El fantasma del desarrollo en América Latina." *Revista del CESLA*, no. 1. (Lima: Universitas Varsoviensis, 2000): 38–55.
——. "Modernidad y democracia: Intereses y conflictos." *Anuario Mariáteguiano* 12 (2000).
——. "Coloniality of Power and Its Institutions." Paper presented at conference *Coloniality and Its Disciplinary Sites*, (Binghamton, (NY): Binghamton University, 1999).

Quijano, Anibal, and Immanuel Wallerstein. "Americanity as a Concept, or the Americas in the Imaginary of the Modern World-System." *International Journal of Social Science* 134 (1992): 549–59.

Rabasa, José. *Inventing America: Spanish Historiography and the Formation of Eurocentrism* (Norman: University of Oklahoma Press, 1993).

Said, Edward. *Orientalism* (New York: Vintage, 1979).

Stavenhagen, Rodolfo. "Classes, Colonialism, and Acculturation." *Studies in Comparative International Development* 1, no. 7 (1965): 53–77.

Stocking Jr., George W. Race, *Culture, Evolution: Essays in the History of Anthropology* (New York: Free Press, 1968).

Tilly, Charles. *Coercion, Capital, and European States, A.D. 990-1992* (Cambridge: Blackwell, 1990).

Tocqueville, Alexis de. *Democracy in America* (New York: Vintage Classics, 1835).

Viola, H., and C. Margolis. *Seeds of Change: Five Hundred Years since Columbus* (Washington, DC: Smithsonian Institute, 1991).

Wallerstein, Immanuel. *The Modern World-System*. 3 vols. (Sand Diego: Academic Press, 1974–1989).
——. *Historical Capitalism* (London: Verso, 1983).

Young, Robert. *Colonial Desire: Hybridity in Theory, Culture, and Race* (London: Routledge, 1995).

Remote Sensations

A Critical Cartography of Remote Sensing

knowbotiq

In the long-term project *Atrato Studies: Mercurybodies*, a group of participants from Colombia, Portugal, and Switzerland attempt to enter into negotiations about their shared translocal relationships and interdependent entanglements. The group reflects on the aesthetic conditions in which a *being-with*, a holding of mutual responsibility in time and space, is possible. The subject of these investigations is the Atrato River in the Afro-Colombian Chocó region. The river environment, highly contaminated with mercury and cyanide stemming from ongoing illegal gold mining, has been protected by the Colombian constitution since 2016, which grants it biocultural rights to "protection, conservation, maintenance, and restoration" of all forms of life and knowledge. How do the political and aesthetic efficacies and resonances of the contaminating mercury change within this new legal constellation?

The project *Atrato Studies: Mercurybodies* explores this through encounters of human and non-human actors in translocal fictional settings and assemblages. Here, with "Remote Sensations," knowbotiq attempts to approach the social imaginaries and biases of the still Eurocentric West that continue to affect such encounters and assemblages with planetary ambitions. Privileged as we are to enter into such urgent imaginings and encounters as artists from Switzerland, we become part of those responsible for the translocal relations that have formed and are forming along the Atrato River in the rainforest. In the luggage of our designs, we find the European history of coloniality, linear psychotropic desires for gold, transgressive values of humanistic education, and violent philanthropic effects. Swiss supply chains and logistics have transported mercury for artisanal gold mining to Colombia for decades, and they have contributed to a massive contamination of the rainforest. At the same time, the Swiss government, in a reciprocal action, brought the Minamata Convention banning mercury mining and trade to the UN for ratification.

In the project "Remote Sensations," we are not, however, primarily concerned with the grand imaginaries and iconic representations of guilt and geopolitical violence. We are more driven by the interdependent, mostly invisible, aesthetic, and epistemic molecular assemblages of mercury outlined above. Thus, the concept REDD+ identifies the protection of rainforests, such as Amazonia, as financially attractive, and the UN calculates the ban on mercury production and export into the countries which are suffering under the Artisanal and Small-scale Gold Mining (ASGM) to force the Neo-extractive economy, while the WHO models Colombia's GDP losses by an urban health deficit caused by the resurgence of malaria in areas of illegal gold mining.

The Global Alliance for the Rights of Nature (GARN), meanwhile, organized a diagrammatically-shaped "Tribunal for the Rights of Nature" and is convinced that the devastation of the Amazonian rainforest can now be negotiated. Each of these institutions uses the same scientific research results and cloud-computed data, which, however, too often take into account scientifically verifiable qualities of mercury. In the many fields of science and politics, a techno-ecological mentality has been established that approaches complex mental, social, and environmental events from a technological distance, through remote sensing, for example, and is often characterized by vertical thinking far from empathy.

What seems necessary is to place the focus on alloys, amalgamations, diffusions, and accumulations of materialities, affects, emotions and techno-ecological sensations. These are molecular events that are continuously and immensely reactive, reproductive and mutating, moving across and beyond the forms of the subjective towards body knowledge and the technologically unconscious. Mercury is constantly ready to jump into other compounds. It dynamically changes its molecular forms, binds metallic particles, or accumulates in organic matter. Wherever it appears, it creates sudden events in voluntary or involuntary interactions and creates assemblages, which we call *mercurybodies*. These bodies are unstable and release energies for desires and enrichments, injuries, healings and their social-political imaginations.

In the following visual project, made for this publication, we try to negotiate with these invisible molecular events from the dis/assembling "points of view" of metallurgical, amalgamating, and diffusing processes. Central for us are the translocal chains of the agency of mercury in its liquid, gaseous, solid, and immaterial forms, and their visual representations in political, economic, and scientific digital platforms. We thus design with "Remote Sensations" a contribution to a concept of a critical cartography and question the abstracting ubiquity of maps, models, diagrammatics, and statistics, all of which are digitally available to "everyone" as high-resolution "material." What would it mean to look at satellite images of a section of the Atrato River with the sensibilities and afflictions of the manifolded *mercurybodies* to reveal what they cannot depict? Would it be possible to undertake a contamination of the cartography through aesthetic ornamentation, a reverse forensic, as it were? Is it possible to negotiate such planetary non-computabilities with these kinds of artistic strategies? What does it mean to offer the technologically unconscious a space within a publication such as this one?

AMAZONIA

WE DO METALLURGY

We got used to working our way
through the static objects
that pile up in museums,
warehouses, and databases.
Everything must be identifiable,
addressable, and calculable.
But every alloy, amalgamation, and
aggregate state of *You*
has a potential for change.
We are the metallurgy of the
alchemists who have declared
You, Mercury, as one of the most
important substances from which
lifeforms can be reconstructed.

RIVER

WE MOLECULARIZE

We, biochemical molecular processes, are so lustful in dissolving your compounds. We manipulate bacteria to turn elemental mercury into inorganic methylmercury. It is ridiculous to try to detect *You* in model organisms like the laboratory worm with a limited gene set, while *You* accumulate everywhere. Who has the power and the knowledge to split and reorganize the molecules again and again? And above all for what?

AMAZONIA

WE DE/AMALGAMATE

Statistics upon statistics reaffirm you in the rainforest. But which amalgam are *You* part of? We get rubbed together in the hands of the small-scale miners, are condensing on the cold edges of the gold traders' retorts. We escape and diffuse and find ourselves again wetting the countless water buckets on the roofs of Quibdó. With whom do we amalgamate next?

RIVER

WE CONTAMINATE, diffuse, and enrich ourselves

What does contaminate mean? It's a question of perspective. If we find *You* in the mammary glands of mothers, where *You* are responsible for the massive developmental deficits of children as a neurotoxin— then *You* must first be proven to have a harmful intention. "This is toxic. Who knows? … Show me love, show me now." (Little Simz)

AMAZONIA

WE DIGITALIZE, measuring and surveying

Wow! The armada of measurement sensors in search of unwanted concentrations of *You* produce yobibytes of data that can be so comfortably stored on the servers of the Big Techs' cloud providers. Anyone can use this data to calculate Your reality—one that suits them at the moment

RIVER

WE TRANSFORM, make negotiable

We are on the right track when we generously give biocultural rights to national parks, rivers, and animals. But in doing so, we are also transforming the anthropocentric notion of rights. But who speaks here in the new logistically distributed, cosmopolitan architectural temples, and who remains silent? Who may remain silent, and who must remain silent, and *You*?

AMAZONIA

WE JUDGE and rate

We judge when we believe ourselves to be in the right. If we declare the local activists terrorists, they no longer have the right to enter the courtroom. But those "beggars in a golden pew" are not mute.

RIVER

WE EXPLORE

Supply chain laws and the Swiss corporate responsibility initiatives wanted to put the brakes on our desire for planetary exploitation. But aren't we collectively committed to cosmopolitan progress? The feasible has always legitimized our drive to explore. What's wrong with that? Too bad for the part that finds itself on the Digital Divide from the wrong side. Meanwhile, we are already interplanetary.

AMAZONIA

WE CLEAN and speed up

We have formulated bans and limits with the Minamata Convention. We express altruism—but those tons of *You*, Mercury, in the world's proton targeters, are not included in this calculation. 18 tons of *You* for 6 or 7 neutrino particles. We now shift our WE to the realm of elementary particles. In this case, *You* are free from any harmful impetus.

WE ECHO

We have been wiped off the map. If it hadn't been for the alarms going on with *You*, Mercury, they would not have noticed us. WE became as invisible as *You* are with a click. But WE are still here, in this part of depiction conceived for centuries exclusively as an extractive zone, a wasteland, a biodiversity hotspot, being over and over again adapted to definitions to fit into *Your* fantasies. WE are the echoes coming from under the waters, re-flourishing while we overflow your imaginaries through the amalgamed temporalities WE reenchant.

AMAZONIA

This critical cartography is based on satellite images of the Rio Quito in Colombia:
https://satellites.pro/Quibdo_map#5.553712,-76.747913,15

Page 290:
 WE DO METALLURGY
 *Museal Cinnabar quartz
 Cinnabar crystal, *Cinnabarite*
 Cables of measuring instruments
 Dust mask insert for filtering gaseous mercury
 Mercury flows

Page 291:
 WE MOLECULARIZE
 Bacteria that process Methylmercury
 *C. Elegance—model worm being used to test mercury poisoning.
 Foam
 Poporo (Poporo Quimbaya), a ritual cup
 Medical pipette

Page 292:
 WE DE/AMALGAMATE
 *Various models of retorts from alibaba.com
 Leaves of the West Indian Elm which separates gold particles from rocks
 3D model of a gold panning pan (Batea)
 Gold Mercury amalgams

Page 293:
 WE CONTAMINATE, diffusing and enriching ourselves
 *3D anatomical model of a female breast
 3D models of sewage treatment plants
 3D architectural model of a temporary metal bridge
 3D model of human bronchial tubes
 3D model of gold jewelry
 3D model of the fish *Bocachico* in the Atrato River, which accumulates mercury as methylmercury
 Gold mercury amalgams
 Dental amalgams

Page 294:
 WE DIGITALIZE, measuring and surveying
 Illustration of a mercury sensor for urban space
 3D models of tropical trees
 *Images of different versions of "Inorganic Mercury Passive Sampler" in laboratories and factories
 Illustrations of mobile mercury analyzers
 Pictures of mercury analyzers for laboratories

http://knowbotiq.net/remote-sensations/

Page 295:
 WE TRANSFORM, make negotiable
 *3D models of architecture award-winning courts of law
 3D model of a tennis umpire's chair
 3D model of standard trees for model-making
 3D model of Phytopiankton (*skelotonema costatum*)

Page 296:
 WE JUDGE and rate
 *Architectural photographs of standardized interior furnishings for courtrooms
 3D models of conference microphones
 Cables
 3D model of a wood-eating insect

Page 297:
 WE EXPLORE
 Illustrations of various models of mercury circuits
 *3D model of a portable assembly line
 Images of various "Exploration Drillers"
 Google map oversight: Glencore Headquarters Baar/Switzerland
 3D model of a biometric scanner system for finger and palm prints
 Diagram of an underground exploration for gold deposits in the Amazon region

Page 298:
 WE CLEAN and speed up
 Illustration of a mercury-absorbing granulate
 3D models of different energy-saving lamps
 *Images of spallation neutron source in which protons hit a target of liquid mercury
 3D model of SIM card holders for smartphones
 Visual marketing elements of the Minamata Convention Logos
 of philanthropic associations of the UN

Page 299:
 WE ECHO
 (Text by Elizabeth Gallon Droste)
 *Banner from the #SOSColombia Event in Berlin, May 30, 2021
 3D models of Amazon Delivery Drone
 Ornamented landscape from satellite images of Rio Quito, Colombia destroyed by artisanal and small-scale gold mining
 Various digital images of palm fruits
 http://knowbotiq.net/remote-sensations/

*single object

Supported by Más Arte Más Acción and Pro Helvetia

River Poems

Translated from the Portuguese by Tiffany Higgins

Márcia Wayna Kambeba

THE RIVER'S SECRETS

Once upon a time the river told me:
Calm, but following the current,
It carries secrets to the sea.

The encounter at the rocks,
The shelter from the cold,
The breath of the wind,
The bird and its whistle,
A navigator's memories,
In rowing, the challenge.

The river heard stories from the *curupira*,
Who, tired of struggle,
Fooled even his shadow
So as not to risk
Losing his green house
Cast away to fate.

In the wisdom that nature reveals,
Striking the riverbanks,
Or revealed in the fisher's rowing,
Sowing secrets the river descends
Calm and serene as a flower.

But with neglect and lack of love
It gets agitated and turns fierce.
This is the river that instructed me.
The energy that moves everything
Comes from the waters, comes from love.

Translator's note: In Amazonian cosmologies, recorded as early as the 16th century, the *curupira* is a guardian of the forest in the form of a mischievous red-haired boy, with feet turned backward. He tricks people by enticing them to follow his footprints. *Curupira* comes from Tupi, from *kuru'pir*, which means "covered with pustules."

POROROCA, THE AMAZON RIVER WAVE

When the sun meets the moon,
Miracy, Mother of the Water,
Comes to fight a duel.

In this enthralling battle,
The sea arrives, majestic
Commanding the river to withdraw.

Thus begins the dance of conquest
With an astonishing force
And the wave begins to form.

A great roaring is heard
It's the shout of the river
Invaded by the sea.

And when the sea declares war
It's a matter of an hour and a half
To finish off the battle.

The sea continues on its path.
With a whistle Yara announces
That the *pororoca* will pass.

Translator's note: The *pororoca* is a tidal bore that occurs when the Atlantic Ocean travels up the Amazon River, creating a wave reaching as high as a dozen feet and travelling far inland up the Amazon River with a great roar, making the river run backward. When the sun and moon line up with the earth on the spring equinox, they can pull the *pororoca* to an even greater height.

THE WATER'S LAMENT

I raise my prayer to Tupã,
Who makes me clean and elevates me,
To know that I quench thirsts and cool the day's heat,

I water plants, germinate seeds,
Clean clothing, listen to people's conversations,
Serve as shelter for fish and snakes,
Life continually makes and remakes itself in me.

But what I can't endure
Is seeing filth cling to my face
My eyes burn without cease
From the refuse that arrives without warning.

A can cut my heart,
I bled so much that the Solimões River dried up
Scarred by such ignorance,
I stopped running,

The earth as dry as the *sertão*,
Fish, struggling for breath, in final agony,
Even the giant *sucuri* wanted to flee the devastation.

And man?
Your intelligence can't make it rain,
You ended up without your cropland,
In anguish, no idea what to do.

But to be a mother is to care and love,
Love even without being loved.
And so I go on, following my journey,
Supported by the river, facing difficulties.

I've long tired of crying,
What will tomorrow bring? I don't know.
I only ask the god, Tupã,
To not leave me helpless.

Oh, this life! And my life —
Will it really amount to nothing?
I want to run freely and feel myself loved.
This is the lament of the abandoned body of water.

MY OLD RIVER

Saudades of my old friend,
of the days I passed there,
saudades of hearing its shout
calling me to talk.

It sends me signals in the rocks.
I understand them well.
The rising wind reveals the memory
of the one who has so much history.

Sometimes sitting by myself,
Observing alone
The sky's immensity
And the old river passing by.

It's what the stones tell
About my old friend's future,
Advice from this wise one
Buffeting my heart.

And the river gives us examples
Of solidarity and love.
From the largest to the smallest creature
It finds great value in all.

To flee the dolphin's circling swim
The fish need to unite
In schools that nimbly leap—
And life proceeds.

Our history continues
Our existence needs to understand
That the river teaches us ways of knowing

That we insist on ignoring
It's in this silence that my old friend,
To be known, turns into an enchanted being.

The Artivism of the Amazonian Mythic Imagination

Translated from the Spanish by Sue Brownbridge

Christian Bendayán

Amazonian art has generally been understood from the perspective of the logic of representation. Why? Perhaps because in the field of contemporary art, in South America and elsewhere, there is little knowledge of the history and culture of Amazonian peoples. Nor is there understanding of the role that myths play in the daily life of Amazonian Indigenous communities, as well as in Amazonian cities, although such myths are the most recurrent theme in Indigenous artists' artwork. It should be noted that in Amazonia, myth is not a story stuck in the past, nor an oral memory inherited and passed on intact. The mythological tale exists in such a way that mythological beings are alive and interact with people in their day-to-day lives, as well as in parallel worlds inhabited by beings with the power to influence the fate of peoples, forests, and rivers. To this ancestral knowledge we must add the various characteristics that myths acquire in their different tellings, dependent as they are on the social context of communities, peoples, and cities, which help to differentiate to a considerable degree the particular cultures and cosmovisions—that is, worldviews—of each Amazonian people. As Rember Yahuarcani, an artist of the Áimen+ clan of the Huitoto-Murui people, declares:

> I also live with myths and stories, which are not static, but in constant movement. In the words of a fisherman or a hunter, the myth takes on another form and movement, like a great snake that slithers among the roots. The myth transforms itself into something real, alive, and transcendent that doesn't die. In this dynamic, *human* is *nature*, and *nature* is *human*.[1]

Indigenous Amazonian artists embrace these cosmological narratives in such a way that renders the myth visible while, at the same time, shaping a record of the events attributed to spiritual beings. This record explains the meaning of "real" events and seeks to signal those that remain beyond our understanding. This is how the mythological figure appears in Amazonian oral accounts and makes its way into the visual arts, giving a face to complex sociocultural and political phenomena by proposing to take a stance in relation to their causes and effects. Recognizing a problem and, in accordance with its characteristics, identifying it with a mythological figure or story, will help to address it because, as Manolo Berjón and Miguel Ángel Cadenas have noted: "When a problem has no name, it's a bigger problem." Speaking to the function of the mythological for the real, Berjón and Cadenas continue:

> It seems that the *pelacara* [a gringo capable of transforming into an animal that peels off its victim's face] in the Amazon is the embodiment of something that is very real: financial and social poverty and unequal power relations ... All this, and much more, is indeed real: in truth, it is plasma that provides all the right conditions for genuine deep fears to be embodied in mythical beings.[2]

That said, Amazonian art should not be seen as a mere visual description of landscapes and beings of a fantastic imaginary. Instead, it should be recognized as artivism—cultural production as political activism—that accords a social and political function to visual narratives that issue from the mythic imagination in response to the problems faced by Amazonia. The presence and recognition of Amazonian art, and especially that artwork produced by Indigenous artists in the Peruvian Amazon, has grown exponentially since the early years of the new millennium, thanks to comprehensive exhibitions and publishing projects mounted by Lima institutions. Consider exhibitions like "El Ojo Verde: Cosmovisiones amazónicas," at Telefónica, in 2000; "La serpiente de Agua," at Estación de Desamparados, in 2003; or "Amazonía al descubierto," mounted at Museo de Arte del Centro Cultural de San Marcos (UNMSM), in 2005. Each show featured works that revealed a vision of the universe and Amazonian societies co-existing with spiritual beings and numerous natural species, structured in a cosmos with different levels and simultaneous worlds. Such exhibitions responded to and reinterpreted those artworks presented in the Amazonian artists' home environment, establishing compositional arrangements, certain color palettes, and common themes that reflected and fostered knowledge of local history, the innate bond between humans and the land, the preservation of the Amazonian world, and the practices that uphold good living. These discourses, initially aimed at awakening the consciousness of the Amazon peoples themselves, to ensure the conservation of their ancient knowledge, gradually moved, with the passing of the years, into the consciousness and circulation of international contemporary art discourse and exhibition practices.

It is important to note that this blossoming of Peruvian exhibitions and publications of the work of a broad group of Amazonian Indigenous artists occurred after the late Bora artist Víctor Churay (1972–2002) established a presence on the Lima contemporary art circuit. Born into the Pucaurquillo community, Churay was the first

Amazonian Indigenous artist to have solo shows of his artwork in Peruvian art museums and galleries, and not just on the basis of his ethnic background, as had previously been the case since the 1940s. In the city of Iquitos, in 1943, for example, as part of the commemoration of the fourth centenary of the "discovery" of the Amazon River, the first exhibition of ethnographic pieces belonging to the Raúl de los Ríos Collection was organized, featuring an extensive selection of pottery, fabrics, and utensils used by the Shipibo people that are held to this day in the Museo de la Cultura Peruana in Lima. From Churay onwards, however, Amazonian artists in Peru began to be recognized for their artistic practices, often becoming prominent figures and even participating in politics in a wider sense. Churay was also a model in terms of the Indigenous artists' aptitude for forging bonds with creators in other fields such as film, literature, anthropology, academia, and cultural institutions; thereby opening up various ways for Indigenous Amazonian artwork to become known, circulate, and evolve.

Víctor Churay, *Turistas en Pucaurquillo*, 1996.

Initially, Churay worked as a painter, using natural pigments applied to pieces of bark from the *llanchama* tree, though over the years he gradually incorporated other materials such as acrylic and canvas. He gained wide recognition for what was regarded as his hallmark: the use of ephemeral materials offered by the forest, to which he accorded importance, thereby shaping a model approach for later generations of Indigenous artists from his region. Common to his works are scenes in which the *maloca*—the community's "long house," where traditional ceremonies and festivities are held, presided over by the chief—is situated in the center of the llanchama-bark canvas-like support, generating a triangular composition that determines the location of the other elements in the depiction. In *Cosmovisión Bora* (Bora Cosmovision, 1998), for example, Churay portrays the celebration of the *Lladico* (Dance of the Boa). Here the universe is recreated inside the *maloca*, since this represents the cosmos, and, as they dance, a group of Bora tread on a large stick that becomes the boa itself, which emerges simultaneously in the sky.

Amazonian artists have developed their own styles, initially incorporating the influence of artists close to them, as exemplified by Churay, who at one time was evidently under the sway of the work of Pablo Cesar Amaringo Shuña (1938–2009). Known as Pablo Amaringo, the Peruvian artist and shaman, from the 1990s onwards, embraced and employed a pictorial imaginary linked to shamanic practices and visions induced by ayahuasca. In Quechua, ayahuasca means "liana of the dead"; in Shipibo-Conibo, it is known as *nishi*. Used by shamans, ayahuasca is prepared using a liana also called ayahuasca (*Banisteriopsis caapi*) and the *chacruna* plant (*Psichotria viridis*), a blend which, when ingested, causes visions. In 1988, Amaringo, along with anthropologist Luis Eduardo Luna and his wife, Sirpa Rasanen, co-founded the Usko-Ayar Amazonian School of Painting, through which he spread a pictorial trend known as visionary or *ayahuasquero* art. In Amaringo, then, Churay found license to paint parallel universes that can exist simultaneously in the depths of waters, in subterranean worlds, in forests, in the sky, and in other invisible spaces inhabited by spiritual beings. Churay added to this model a series of characters from Bora mythology and a palette of colors obtained from the earth and plants, which he distributed across his grounds of *llanchama*. In this way, he endowed his painting—in its process and its material—with a close connection to nature and the land. In addition, he included in his compositions the golden triangle, defined by the presence of the *maloca* as

the center of a universe of knowledge, the place where humans and gods meet and engage in dialogue, and where communal work is planned and stories for good living are passed on.

Indigenous artists in the Amazon share this common compositional reference. This triangular model, as used by Churay in pieces such as *Bora Cosmovision* (1998), became customary in major works by other Amazonian artists such as Rember Yahuarcani, who also incorporates it in his work *Cosmovisión femenina* (Female Cosmovision, 2006), in which an early image of a group of Bora woman quotes a photograph taken in 1906 by the Spaniard Manuel Rodríguez Lira. Consider too the painting by Santiago Yahuarcani, *Cuando los caucheros quemaron la maloca llena de huitotos* (When the Rubber Workers Burned the Maloca Full of Witoto, 2017), in which it is possible to make out in the blurred landscape the apex of the triangular construction, as it also is in Darwin Rodríguez's *Maloca bora* (Bora Maloca, 2019).

If Churay left as his legacy and influence the pyramidal pictorial composition of his paintings, with the maloca as the central axis and representation of the cosmos, as well as the use of *llanchama* and of natural pigments in his paint itself, he also, more crucially, rewrote the history of his people. His paintings traced tragic incidents in the violent colonial era of rubber extraction, from the perspective of its protagonists and based on their knowledge, thereby revealing events and details never before recounted in books by historians and anthropologists, who tended to act as interpreters only. Even so, Churay did not turn his back on experts and researchers specializing in Amazonian cultures. On the contrary, he understood the potential of sharing knowledge, forming connections with writers, anthropologists, journalists, sociologists, historians, and filmmakers, and thereby also increasing the dissemination of his work with their support. As he established these collaborative networks, he began to develop a more political commitment, intent on helping to generate growth for his people. This socially engaged dynamic, this twining of art and activism, would also be pursued by the young artist Darwin Rodríguez, who became governor of Brillo Nuevo, a neighboring Bora village; by the renowned Shipibo artist Olinda Silvano, who became president of the native community of Cantagallo in Lima; and by Rember Yahuarcani, who became a member of various advisory committees of state institutions. When Churay died prematurely at the age of 29, he was just

starting to demonstrate the complexity of his work in major pieces such as *Bora Cosmovision* and *Cosmovisión con el ayahuasca* (Cosmovision with Ayahuasca, 2001), as well as his political commitment. Even so, he has indisputably been one of the most influential Amazonian Indigenous artists in Peru, his body of work continually reasserting the urgent need to revive the fundamental relationship between human beings and Amazonian nature.

* * *

Whereas Churay defied the obstacles of the official art circuit in Lima, the Shipibo-Conibo people—who belong to the Panoan family of languages, most of whom are settled in the Ucayali region—spread elsewhere, migrating to the capital of Peru where they have formed a community and preserve their original language, clothing, customs, and above all their artistic traditions. This community is centered in Cantagallo, situated just a few blocks from the Plaza de Armas, and home today to more than 250 Shipibo families, who live in wooden houses, the façades of which are decorated with *kené*, an art of mystical geometries that is one of the most profound manifestations of the Shipibo identity. *Kené* was, by tradition, a graphic art passed on from generation to generation, mostly among Shipibo women, one that today appears on diverse supports and in various formats, renewing itself and becoming increasingly renowned thanks to the work of a number of artists who employ its techniques and meanings.

The Ucayali region, where the Shipibo people originate, has a fine arts school whose curriculum is comprised mainly of art education from a Western perspective as is also true of the disciplines, techniques, and styles that are taught. Chonon Bensho, whose name means "woodswallow of medicinal fields," studied painting at this school. Born into the Shipibo community of Santa Clara, Chonon Bensho was forced to legally challenge the school so as to have the subject of her thesis accepted; the school's staff did not believe that a study on the traditions of embroidery could support a degree in painting. Despite this, Bensho succeeded in completing her studies and in developing a body of work that contains particular characteristics. To access the knowledge that allows her to define themes and forms in her work, Bensho reaches out to her ancestors and spirits, meeting them in dreams, making her way through forests and along rivers, and talking with

medicinal plants and with the beings of nature. In this way, Bensho obtains the knowledge, via these ancestral and spectral meetings, that she then paints on canvas or embroiders on fabric.

Chonon Bensho, *Jene Noma*, 2020. Embroidery, 90 × 120 cm.

According to Shipibo tradition, the *kené* was designed to cover clothing and bodies so that humans would be made to resemble the spirits and become beautiful. In medicinal rites, the *vegetalista* healer (whose knowledge and power to heal comes from plants) intones *icaros* or *rao bewá* (shamanic songs), which, according to the Shipibo vision, draw an enveloping and protective *kené*. These songs consist of repetitive and cyclical melodies, which old Shipibo healers say had circular melodies and advanced in time and space, going round and round. Accordingly, Bensho has developed a series of pieces that take their titles from the main *kené* patterns. One of them, *Maya Kené* (2018), makes reference to the circular design which, like the healing songs, advances as it rotates, but which takes its form particularly from the meandering courses of the rivers in the Amazon that have always been the main forms of communication and transport between different villages and peoples, who depend on them for their survival. This work made using the technique of *kewé*—the name given to the *kené* design when it is embroidered—presents the *mayá kené* pattern,

RIVER

Chonon Bensho, *Koros Kené*, 2018. Embroidery, 120 × 90 cm.

depicting rivers navigated by men and women in canoes, looking for animals and plants that will furnish them with food and medicine.

There are numerous stories and myths about *kené*, just as there are many interpretations of its intricate web of signs and symbols. The anthropologist Luisa Elvira Belaunde has studied this art in-depth and written extensively about its diverse meanings. She notes:

> The polysemy of *kené* lies in the association between the lines and the concept of *cano* (path or way). According to Shipibo-Conibo thinking, the lines form a structure of abstract paths along which beings move, traveling, communicating with each other and transporting knowledge and power. There are paths on every scale from the macro to the micro. In the sky, the *kené* lines are associated with the paths of the Milky Way. In the jungle, they are associated with the snaking course of rivers (Heath, 2002; Illius, 1994). These same rivers are also identified with the adornments of the female body and with the bodies and identity of the Shipibo-Conibo as a sociocultural unit.[3]

Kené is frequently regarded as a map of the Amazonian universe, but in an all-encompassing interpretation of the territory, one that includes forests and rivers in an intrinsic relationship and in balance with the beings and spirits that dwell in them. That said, many Indigenous Amazonian artists employ the form of a map, often vertical, that describes the location of the various levels of the universe or, in the case of the Shipibo, of the multiple worlds or *netes* that make up their cosmos. Some of the various stories about the origin of *kené* have a similar theme: That when the Shipibo saw the *kené* for the first time, it was revealed on the tail of a siren. Or that a black panther saw it draw itself with water on the fur of an anteater while bathing, and that, since then, its descendants have worn the *kené* on their skin. Equally, it is asserted that they copied the design on the body of an Inca woman who came from the sun, crossing the river that divides the eternal from the transient. *Kené* may, therefore, be a river, a snake, or an armored catfish, and it may be a map of the sky, the ribs of a leaf, or the score of an *icaro*.

Contrary to the vision of the conquistadors, explorers, and colonizers who drew maps of Amazonia for the purposes of economic exploitation, the division of lands to be governed, and the extraction

Chonon Bensho, *Maya Kené*, 2018. Embroidery, 120 × 90 cm.

of natural riches, Bensho's *Maya Kené* was inspired by a traditional *kené* pattern and guides us along river courses and through forests, proposing the conservation of their species and their ancient knowledge, particularly of medicine. Another common *kené* pattern employed by Bencho is the *corós kené*, which represents the Shipibo cross. This design is linked to the constellations, in particular the Crux, and the wooden cross that is customarily erected at the center of the Shipibo community during the main festival known as Ani Sheati. This cross also indicates the opposing points from which invited outsiders will arrive to join the festivities. Another custom still practiced, and which Bensho herself experienced, is the sowing of her placenta in the village where she was born to maintain the bond with her ancestral territory. In Bensho's work, then, academic learning is interlaced with *kené* patterns, that kind of writing of Shipibo memory that represents the deepest manifestation of identity and furnishes a poetic image of the territory, guided by a spirit of experimentation typical of contemporary art but always in dialogue with other times, other spaces, other worlds.

* * *

During the rubber extraction era in the Amazon in the late nineteenth and early twentieth century, more than 40,000 Indigenous men, women, and children died as a result of abuses and torture committed by the rubber barons. Entire peoples were almost wiped out, while others were forced to migrate to distant lands. This is how the Witoto-Murui, Bora, Yagua, and Ocainas, originally from the area of the Putumayo River, came to settle in places near Iquitos, such as Pucaurquillo, Brillo Nuevo, San Andrés, Pevas, and elsewhere, where Indigenous artists have recently emerged, artists who have shaped one of the most representative trends in Peruvian Amazonian art. The Yahuarcani family, for example, comprising the latest descendants of the Aimen or Great Egret clan in Peru, have succeeded in showing their works frequently in Peru and abroad. Notable among them are the artist couple Santiago Yahuarcani and Nereyda López, as well as their eldest son, Rember Yahuarcani. Santiago and Nereyda had their first two-person show in 2010 at the Museo Amazónico de Iquitos, and have jointly created a number of projects since then, including their most recent installation *El lugar de los espíritus* (The Place of the Spirits, 2019–2021).

Santiago Yahuarcani, *Maloca de uitotos incendiada por los caucheros*, 2017. Acrylic and natural pigments on llanchama, 70 × 100 cm.

For the most part, the art of the Peruvian Amazon has taken the form of painting among both trained and self-taught artists in cities and in rural areas alike. Indeed, very few expressions of this art that have escaped the constraints of two-dimensionality have succeeded in establishing a sustained presence in the Peruvian contemporary art scene. Exhibitions that featured Indigenous art held at the start of the twenty-first century in Lima showed items such as utensils, clothing, masks, weapons, ritual objects, precious items, ornaments, and other three-dimensional pieces, but these were seen as traditional products and were not presented as works by named artists. As a result, Santiago and Nereyda's *El lugar de los espíritus* marks a turning point because, among other reasons, the installation allows the spectator to physically enter a mise-en-scène of the Amazonian mythical world. Consisting of figures made in the style of the masks manufactured for traditional Witoto festivals, created entirely from materials taken from the forest, *El lugar de los espíritus* expresses that unbreakable bond between mythical worlds and the physical territory. Witoto ecocosmology is revealed in this installation in its origin as an idea, in the process of its realization as a piece, and in its presentation as an immersive art installation.

Enrique Casanto,
Guerreros maìgicos, 2010.
Acrylic on canvas,
200 × 160 cm.

In the Yahuarcani household, the day begins with the gathering of supplies for breakfast: bringing wood to make the fire, harvesting cassava, putting it through the *tipití*, a sieve that removes the poison in the cassava. Then, once the cassava has been ground, it is cooked in a pan known as a *sibeg+*, which, in the Witoto imaginary, is also a representation of the world and is used to make *casabe*, a type of bread. Nereyda and Santiago have incorporated these elements into the installation of *El lugar de los espíritus* to make the bodies of their figures, which represent the gods that live in a mythical place called *Mana+do* (The Cold Place or The Place of the Spirits). The *tipití*, *sibeg+*, baskets, rods, and traps for fishing are combined with bits of root, seeds, branches, lianas, nuts, thorns, and *llanchama* to give shape to this world where powerful beings reside eternally in plenty and where they never get sick because these spirits breathe the medicinal air provided by the forests. All of these components are harvested from the natural environment around the home of the Yahuarcani, once they have been respectfully requested from the spirits that dwell in the forests, and protect the trees and plants, and which are the same ones that live simultaneously in *Mana+do*. This request is presented with a commitment to create a work that will make the Yahuarcani worthy of taking these riches. In an interview in 2018, Santiago Yahuarcani stated:

> I don't go to the shops if I want to buy painting materials, I don't go to the market if I need food, I don't go to the chemists in search of medicine; all that is up in the mountains, that's why I must care for the mountain because it's the place that gives me what I need to live.[4]

So great is the bond and respect of the Witoto for plants that, for them, the body of the creator god is tobacco, and his language, coca, and they call him *Jagi+ll+ Buinaima*, the god of the breath of life. Indeed, one of the keys to grasping the importance of myths in Amazonia is understanding the relationships of merit that must be accorded priority among all the beings that dwell there. Visual narratives such as the paintings, sculptures, ceramics, and embroidery by Lastenia Canayo, whose Shipibo-Conibo name is Pecon Quena, function as an extensive catalog of the Ibo Yoshin, spiritual beings in the Shipibo oral tradition that fulfill the role of sprites, demons, mothers, and guardians of the plants and animals in the forest. Pecon Quena clearly posits that every being in nature has a spirit, which is sensitive and has

willpower, as a result of which no one can take anything from the forest without requesting and deserving it.

Perhaps the work in which this dynamic of worthiness in Amazonia is most apparent, however, is the series produced by the artist Enrique Casanto in the form of dozens of pieces related to the Asháninka oral tradition concerning the rebellion launched in 1742 by Juan Santos Atahualpa. An Indigenous leader in central Peruvian Amazon, Atahualpa's aim was to restore the Inca empire and expel the Spanish conquistadors. In Casanto's paintings, Santos Atahualpa is aided in his exploits by warriors capable of transforming themselves into birds, deer, felines, fish, insects, clouds, mountains, and all kinds of beings of a diverse nature who share the same goal: to eject the invaders who have no respect for life and whose lack of a capacity for otherness makes them criminal enemies of these lands. The dialogue with other beings on an equal footing is the path to a harmonious life; when this dynamic is lost, the natural order collapses. Thinkers such as Eduardo Viveiros de Castro hold the view that Amerindian communities regard nature as the "constructed" and culture as the "natural," meaning, from this perspective, that humanity is a characteristic shared by humans and animals as a primary condition.[5] When nature is abused, the cultural structure that exists between its beings is altered, and that is when the myths appear and embark on their great deeds.

The Amazonian art that has attained visibility in the last two decades, in particular the art made by members of Indigenous communities, has, through its visual accounts, communicated circumstances that unfold in active mythical worlds that may be situated on other cosmic levels, but which actively share in the fate and order of the peoples in the present and in everyday life: in the sky as in the *maloca*, and in the jungle as in the human body. In mixed-race mythology, which is the most recurrent in the oral traditions of both rural and urban Amazonia, there is talk of sightings of the pink river dolphin of the Amazon, which, so it is said, has the ability to transform into a human to seduce its victims, giving rise to an increased number of rapes and unwanted pregnancies. Similarly, people talk of seeing *Chullachaki*, the devil with the cloven hoof of a deer that keeps watch over the forests when deforestation begins and when their protectors are attacked or murdered. Indeed, there are numerous mythical beings that appear when the natural order is corrupted. In the dynamics of Indigenous

Nereyda López and Santiago Yahuarcani, *El lugar de los espíritus*, 2019.

Amazonian art, these beings play a role from the outset of the work, when they reach out with their voices to artists in dreams and visions, and when they acquire a defined portrayal on rendering themselves visible in the resulting artwork, so as to guide us to reflect on a natural territory that has a spirit central to humans' fate and which has been disrespected, injured, and tortured. Almost all Amazonian art of Indigenous origin today fulfills a social and political role by condemning, primarily through mythical depictions, the latent risks of ethnocide, ecocide, and the loss of dialects and knowledge. These grave assaults on the rights of humans and other beings must be stopped, and so too the disturbance of a natural balanced order—like the one specified in the spiritual maps of *kené*—of an ancient ecocosmology determined by a spiritual culture based on dialogue between all beings, a spiritual culture that must be revived if we are to be worthy of cohabiting in this universe.

Smith Churay, *El bufeo colorado en el pueblo Bora*, 2020.

1. Chonon Bensho and Rember Yahuarcani, "The Voice of the Amazonian Gods and Spirits," interview by Christian Bendayán, *Terremoto: Planetary Solidarity Art & Territory*, no. 19 (November 2020–March 2021), https://terremoto.mx/en/revista/amazonismo-el-arte-de-los-espiritus/.

2. Manuel Berjón and Miguel Ángel Cadenas, "La inquietud 'se hizo carne ...' y vino a vivir entre los kukama; Dos lecturas a propósito de los pelacara," *Estudio Agustiniano* (2009): 431.

3. Luisa Elvira Belaunde, "Diseños materiales e inmateriales: la patrimonialización del kené shipibo-konibo y de la ayahuasca en el Perú," *Mundo Amazónico*, 3 (2012): 133, https://revistas.unal.edu.co/index.php/imanimundo/article/view/28715.

4. Santiago Yahuarcani, *El lugar de los Espíritus entrevista por*, in an interview by curator Christian Bendayán, exh. cat., ICPNA Cultural (Lima, 2018).

5. Eduardo Viveiros de Castro, "La mirada del jaguar: introducción al perspectivismo amerindio," *Tinta Limón* (Buenos Aires: Ministério da Cultura do Brasil / Fundação Biblioteca Nacional, 2013).

Gerardo Petsaín, *De la serie Tsantsa*, 2021.

Gerardo Petsaín, *De la serie Tsantsa*, 2021.

AMAZONIA

Víctor Churay, *Cosmovisión Bora*, 1998.

The Falling Sky

Words of a Yanomami Shaman

*Translated from the French
by Nicholas Elliott and Alison Dundy*

Davi Kopenawa and
Bruce Albert
Photographs by
Claudia Andujar

"We are inhabitants of the forest. Our ancestors inhabited the sources of these rivers long before the birth of my fathers and even long before the white people's ancestors were born," says Yanomami shaman and relentless fighter for the Yanomami land and rights, Davi Kopenawa, in the book, *The Falling Sky.*

This unique book was born out of a life-long friendship and over ten years of ongoing conversations and exchanges between Davi Kopenawa and Bruce Albert, a Moroccan-born French anthropologist who has recurrently lived with the Yanomami since 1975. It is not yet another ethnographical research or a ghostwritten autobiography. Through the personal story that is inseparably intertwined with the collective history of his people and is full of dreams, shamanic visions, myths, and prophecies, Davi Kopenawa narrates the history of the conflict between the people of the forest and "the People of Merchandise"—or put another way, the Indigenous people of the Brazilian Amazon and the white "civilization."

Davi Kopenawa begins his narrative with his childhood, before the first missionaries arrived in his region in the early 1960s, bringing diseases that wiped out a large part of his family. He then continues with his subsequent exploration of the world of the white people when he tried, in his own words, "to become a white man" but ended up in the hospital with tuberculosis, and shares the story of his return to his people, traditions, and his learning of shamanic knowledge from his father-in-law.

His words are poetic and sharp. His gaze travels among careful self-exploration and explanation and an uncompromising critique of the greed and violence of colonial settler society. Davi Kopenawa's cosmovisions compile an extensive "cosmoecological manifesto," as Bruce Albert puts it, a prophecy and a warning that is impossible to ignore.

"The forest is alive. It can only die if the white people persist in destroying it," Davi Kopenawa writes. "The *xapiri* spirits who come down from the mountains to play on their mirrors in the forest will escape far away. Their shaman fathers will no longer be able to call them and make them dance to protect us. [...] All the shamans will finally perish. Then, if none of them survive to hold it up, the sky will fall."

—Kateryna Botanova

You don't know me and you have never seen me. You live on a distant
land. This is why I want to let you know what the elders taught
me. When I was younger, I did not know anything. Then little by
little, I started to think by myself. Today, all the words the ancestors
possessed before me became clear to me. They are words unknown to
white people and which we have kept from the beginning. I want to
tell you about the very ancient time when the animal ancestors went
through their metamorphosis; of the time when *Omama* created us and
when the white people were still very far away from us. In this beginning
of time, the day never ended. The night did not exist. Our ancestors had
to hide in the smoke from their wood fires to copulate without being seen.
Finally, they arrowed the *Titi kiki* birds of night, when they cried while
naming our rivers, so that darkness would descend upon the forest.[1] At
that time, our ancestors also constantly turned into game. Then, after
they had all become animals and the sky had fallen, *Omama* created us as
we are today.[2]

Our language is the one with which he taught us to name things. He
is the one who introduced us to bananas, manioc, and all the food in
our gardens,[3] as well as all the fruits of the trees in the forest. This is
why we want to safeguard the land where we live. *Omama* created it
and gave it to us for us to live on. Yet white people do their utmost to
devastate it and if we don't defend it, we will die with it.

Our ancestors were created in this forest long, long ago. I still don't know
much about this beginning of time. This is why I often muse on it. And
when I am alone my thoughts are never calm. I look deep inside myself
for the words of that very distant time during which my people came into
existence. I still ask myself what the forest was like when it was still young
and how our people lived before the white people's epidemic smoke.[4] I
only know that when those diseases did not yet exist, our elders' thought
was very strong. They lived in the friendship of their own people and
warred to get revenge on their enemies. They were the way *Omama*
created them.

Today white people think we should imitate them in every way. Yet
this is not what we want. I learned their ways from childhood and I
speak a little of their language. Yet I do not want to be one of them.
I think that we will only be able to become white people the day
white people transform themselves into Yanomami. I also know that
if we live in their cities, we will be unhappy. Then they will put an end

Claudia Andujar, *Catrimani 6* (1971–1972). Courtesy Galeria Vermelho.

to the forest and never leave us a place where we can live far from them. We will no longer be able to hunt, or even to cultivate anything. Our children will be hungry. When I think about all this, I am filled with sadness and anger.

White people say they are intelligent. But we are not any less intelligent. Our thoughts unfurl in every direction and our words are ancient and numerous. They are the words of our ancestors. Yet, unlike white people, we do not need image skins to prevent them from escaping. We do not need to draw them, like the white people do with theirs. They will not disappear, for they remain fixed inside us. So, our memory is long and strong. The same is true of our *xapiri* spirits' words. They are also very ancient. Yet they become new again each time they return to dance for a young shaman. It has been this way for a long time, endless. The elders tell us: "It is your turn to answer the spirits' call. If you stop answering, you will become ignorant. Your thought will get lost and no matter how you try to summon *Teosi's* image to tear your children away from the evil beings, it will be in vain!"

The words of *Omama* and the *xapiri* are the ones I like best. They are truly mine. I will never want to reject them. The white people's way of

thinking is other. Their memory is clever but entangled in smoky and obscure words. The path of their thought is often twisted and thorny. They do not truly know the things of the forest. They contemplate paper skins on which they have drawn their own words for hours. If they do not follow their lines, their thought gets lost. Our elders did not have image skins and did not write laws on them. Their only words were those pronounced by their mouths and they did not draw them. So, their words never went far away from them, and this is why the white people have never known them.

I did not learn to think about the things of the forest by setting my eyes on paper skins. I saw them for real by drinking my elders' breath of life with the *yãkoana* powder they gave me. This was also how they gave me the breath of the spirits, which now multiplies my words and extends my thought in every direction. I am not an elder and I still don't know much. Yet I had my account drawn in the white people's language so it could be heard far from the forest. Maybe they will finally understand my words and after them their children and later yet the children of their children. Then their thoughts about us will cease being so dark and twisted and maybe they will even wind up losing the will to destroy us. If so, our people

Claudia Andujar, *Catrimani 3* (1971–1972). Courtesy Galeria Vermelho.

Claudia Andujar, *Catrimani 2* (1971–1972). Courtesy Galeria Vermelho.

will stop dying in silence, unbeknownst to all, like turtles hidden on the forest floor.

Omama's image told our shaman elders: "You live in this forest I created. Eat the fruit of its trees and hunt its game. Open your gardens to plant banana plants, sugarcane, and manioc. Hold big *reahu* feasts![5] Invite each other from one house to another, sing and offer each other food in abundance!" He did not tell them: "Abandon the forest and give it to white people so they can clear it, dig into its soil, and foul its rivers!" This is why I want to send my words far away. They come from the spirits that stand by my side and are not copied from image skins I may have looked at. They are deep inside me. It was very long ago that *Omama* and our ancestors left them in our thought and we have kept them there ever since. They can have no end. By lending an ear to them, white people may stop believing we are stupid. Maybe they will understand that it is their own minds that are confused and darkened for, in the city, they only listen to the sound of their planes, their cars, their radios, their televisions, and their machines. So, their thought is most often obstructed and full of smoke. They sleep without dreams, like axes abandoned on a house's floor. Meanwhile, in the silence of the forest, we shamans drink the powder of the *yãkoana* hi trees, which is the *xapiri*

spirits' food. Then they take our image into the time of dream. This is why we can hear their songs and contemplate their presentation dances during our sleep. This is our school to really know things.

Omama did not give us any books in which *Teosi*'s words are drawn like the ones white people have. He fixed his words inside our bodies. But for the white people to hear them they must be drawn like their own, otherwise their thought remains empty. If these ancient words only come out of our mouths, they don't understand them and they instantly forget them. But once stuck to paper, they will remain as present for them as *Teosi*'s words can be, which they constantly look at.[6] And so perhaps they will tell themselves: "It's true, the Yanomami do not exist without a reason. They did not fall out of the sky. It was *Omama* who created them to live in the forest." But in the meantime, they continue to lie about us by saying: "The Yanomami are fierce. All they think about is warring and stealing women. They are dangerous!" Such words are our enemies and we detest them. If we were so fierce, no outsider would ever have stayed with us.[7] On the contrary, we treated those who came into the forest and visited us with friendship. This lying talk is that of bad guests. When they returned home, they could have said: "The Yanomami set up my hammock in their home, they offered me their food with generosity! Let them live in the forest like their elders did before them! Let their children be many and in good health! Let them continue to hunt, to hold *reahu* feasts, and to make their spirits dance!"

Instead, our words were tangled up in ghost talk whose twisted drawings were propagated everywhere among white people. We don't want to hear that old talk about us. It belongs to white people's evil thoughts. I also want them to stop repeating: "What the Yanomami say to defend their forest is lies. It will soon be empty. There are only a few of them and soon they will all be white people!" This is why I want to make white people forget all this bad talk and replace it with mine, which is new and right. When they hear it, they will no longer be able to think that we are evil beings or game in the forest.

When your eyes follow the tracks of my words, you will know that we are still alive, for *Omama*'s image protects us. Then you will be able to think: "These are beautiful words. The Yanomami continue to live in the forest like their ancestors. They live there in big houses where they sleep in their hammocks beside wood fires. They eat the bananas and manioc from their gardens. They arrow the forest game

and catch the river fish. They prefer their food to white people's moldy supplies, locked up in metal boxes and plastic sleeves. They invite each other from house to house to dance at their *reahu* feasts. They make the spirits come down. They speak their own language. Their hair and eyes are still like *Omama*'s. They did not become white people. They still live on that land, which seems empty and silent but only from the heights of our airplanes. Our fathers have already made many of their elders die. We must not go on following that evil path."[8]

Far from the forest, there are many other peoples than ours. Yet none of them possess a name similar to ours. This is why we must continue to live on the land that *Omama* left us in the beginning of time. We are his sons and his sons-in-law. We keep the name he gave us. Since they first met us, the white people have always asked us: "Who are you? Where do you come from? What are you called?" They want to know what our name Yanomami means. Why do they insist so? They claim that it is to think straight. On the contrary, we think that it is bad for us. What should we answer them?[9] We want to protect our name. We don't like to repeat it all the time. This would be to mistreat *Omama*'s image. This is not how we talk. So no one wants to answer their questions.

We are inhabitants of the forest. Our ancestors inhabited the sources of these rivers long before the birth of my fathers and even long before the white people's ancestors were born. In the past, we were really very numerous and our houses were vast. Then many of us died after the arrival of these outsiders with their epidemic fumes and shotguns. We have been sad and known the anger of mourning too often. Sometimes we are scared that the white people will finish us off. Yet, despite all that, after having cried so much and put the ashes of our dead in oblivion,[10] we live happily. We know that the dead go to rejoin the ghosts of our elders on the sky's back, where game is abundant and feasts are endless. This is why our thoughts return to calm despite all this mourning and these tears. We become able to hunt and work in our gardens again. We can travel through the forest and make friendship with the people of other houses. Once again, we laugh with our children, sing during our *reahu* feasts, and make the *xapiri* spirits dance. We know that they remain by our side in the forest and that they still hold the sky in place.

Excerpt from "Chapter I. Drawn Words"

AMAZONIA

TOP LEFT:
Claudia Andujar, *Antônio Korihana thëri sob o efeito do alucinógeno yãkoana, Catrimani da série O reahu* (Antônio Korihana thëri under the effect of the hallucinogen yãkoana, Catrimani from reahu series) (1972–1976). Courtesy Galeria Vermelho.

BOTTOM LEFT:
Claudia Andujar *O xamã Naro Paxokasi thëri inala o alucinógeno yãkoana, Catrimani da série O reahu* (Shaman Naro Paxokasi thëri inhales the hallucinogen yãkoana, Catrimani from O reahu series) (1972–1976). Courtesy Galeria Vermelho.

Claudia Andujar, *Sem Título da série Identidade* (Untitled from Identity series) (1976). Courtersy Galeria Vermelho.

1. The *Titi kiki* ("night beings") are described in the origin myth of night as large Cracidae birds perched in a tree from which they chant the names of the rivers in a plaintive voice. They project a spot of darkness below them, which a hunter will spread by killing them.

2. On the fall of the sky, Yanomami mythology mainly consists of two series of narratives. One relates the erroneous ways of the first human/animal ancestors (*yarori*), a reverse image of the norms of current sociality that induced their metamorphosis into game (*yaro*) and that of their "images" (*utupë*) into shamanic entities (*xapiri*). The other develops the epic tale of the demiurge *Omama* and his brother, the trickster *Yoasi*, creators of the current world and human (Yanomami) society.

3. The Yanomami cultivate about one hundred varieties of some forty plant species, see Bruce Albert and William Milliken, *Urihi a. A terra-floresta yanomami* (São Paulo: Instituto Socioambiental/IRD, 2009).

4. For the Yanomami epidemics spread in the form of fumes, hence the expression *xawara a wakëxi*, "epidemic smoke," see Bruce Albert, "La fumée du métal: Histoire et représentations du contact chez les Yanomami du Brésil." *L'Homme* 106-07 (Paris: EHESS, 1988): 87–119; Bruce Albert, "L'or cannibale et la chute du ciel: Une critique chamanique de l'économie politique de la nature." *L'Homme* 126-128 (Paris: EHESS, 1993): 353–82; and Bruce Albert and Gale Goodwin Gomez. *Saúde Yanomami: Um manual etnolingüístico*. (Belém: Museu Paraense Emílio Goeldi, 1997), 112–15. *Xawara* refers to all highly contagious infectious diseases of foreign origin. The eastern Yanomami distinguish eighteen types of *xawara* (Albert and Gomez, 1997, 112–15).

5. The *reahu*, a great intercommunal feast, is both a ceremony of political alliance and a funeral rite (see Bruce Albert, "Temps du sang, temps des cendres").

6. Davi Kopenawa opposes *Omama* to *Teosi*, orality to writing, as well as shamanism to Christianity in order to "reverse" the content of the evangelical sermons he heard as a child.

7. An allusion to Napoleon Chagnon's famous 1968 monograph about the Venezuelan Yanomami: *Yanomamö: The Fierce People*. This volume (reissued under the same title until the 1980s) and other writings by the same author on alleged Yanomami "violence" (see Napoleon Chagnon, "Life Histories, Blood Revenge, and Warfare in a Tribal Population," *Science*, 239 (Washington D.C.: American Association for the Advancement of Science 1988): 985–92.) contributed to spreading pejorative stereotypes about these Indians over several decades (see Robert Borofsky, ed. *Yanomami: The Fierce Controversy and What We Can Learn from It* (Berkeley: University of California Press, 2005)).

8. Davi Kopenawa's parents' generation was wiped out by two successive infectious disease epidemics in the 1950s and 1960s. His wife's father's group was decimated in the same way in 1973, then again in 1977.

9. This question and the insistence upon it is all the more perplexing to the Yanomami given that this ethnic name is an external adaptation of an expression meaning "human beings."

10. Among the western Yanomami, the bone ashes of the deceased are mixed with plantain soup and ingested. Among the eastern Yanomami, only children's ashes are consumed in this manner, while those of adults are buried by the hearth of their closest kin. In both cases, the funeral service is carried out by potential affines of the deceased. The expression "put the ashes in oblivion" (*uxi pë nëhë mohotiamãi*) refers to this ingestion or burial process (see Bruce Albert, "Temps du sang, temps des cendres").

REFERENCES

Albert, Bruce "Temps du sang, temps des cendres: Représentation de la maladie, espace politique et système rituel chez les Yanomami du sud-est (Amazonie brésilienne)." Ph.D. diss., (Université de Paris X Nanterre, 1985).

———. "La fumée du métal: Histoire et représentations du contact chez les Yanomami du Brésil." *L'Homme* 106-107. (Paris: EHESS, 1988): 87-119.

———. "L'or cannibale et la chute du ciel: Une critique chamanique de l'économie politique de la nature." *L'Homme* 126-128. (Paris: EHESS 1993): 353-82.

Albert, Bruce, and Gale Goodwin Gomez. *Saúde Yanomami: Um manual etnolingüístico* (Belém: Museu Paraense Emílio Goeldi, 1997).

Albert, Bruce, and William Milliken. *Urihi a. A terra-floresta yanomami* (São Paulo: Instituto Socioambiental/IRD, 2009).

Borofsky, Robert, ed. *Yanomami: The Fierce Controversy and What We Can Learn from It* (Berkeley: University of California Press, 2005).

Chagnon, Napoleon Alphonseau. "Life Histories, Blood Revenge, and Warfare in a Tribal Population." *Science*, 239 (Washington, D.C.: American Association for the Advancement of Science 1988): 985-92.

AMAZONIA

Claudia Andujar, *Convidado enfeitado para festa com penugem de gavião, fotografado em múltipla exposição, Catrimani da série O reahu* (Guest wears hawk feathers for ceremony, photographed with multiple exposure from *O reahu* series) (1974). Courtesy Galeria Vermelho.

Biographies

Maria Thereza Alves was born in São Paulo, Brazil, in 1961. She has exhibited internationally since the 1980s, creating a body of work that investigates the histories and circumstances of particular localities to give witness to silenced histories. While aware of Western binaries between nature and culture, art and politics, or art and daily life, Alves refuses to acknowledge them in her practice. She chooses instead to work with people in communities as equals through relational practices of collaboration that require constant movement across such boundaries. Her work has recently been included in *NIRIN*, 22nd Biennial of Sydney, Australia; *Ecologies of the Ghost Landscape*, tranzit.sk, Bratislava; and *Potential Worlds 1: Planetary Memories*, Migros Museum, Zurich (all 2020).

Claudia Andujar was born in Neuchâtel, Switzerland, in 1931, grew up in Transylvania, and currently lives in São Paolo. During the Second World War, Claudia's father, a Hungarian Jew, was killed in Dachau. Andujar fled with her mother to Switzerland, and they immigrated to Brazil in 1955. Andujar first met the Yanomami in 1971 while working on an article about the Amazon. Her early photographs of their daily life experimented with various techniques in order to visually translate their shamanic culture. In 1978, she founded, with Carlo Zacquini and Bruce Albert, the Commissão Pro-Yanomani (CCPY), a campaign to designate the Yanomani homeland; in 1992, following the campaign with Yanomami spokesman, Davi Kopenawa, the Brazilian government legally demarcated the territory. A survey of her work, titled *Claudia Andujar, The Yanomami Struggle*, was mounted at Fondation Cartier pour l'art contemporain, Paris, in 2020, and is presented at Fotomuseum Winterthur and Kunsthaus Basselland in the framework of CULTURESCAPES 2021 Amazonia.

Denilson Baniwa was born in Rio Negro, Amazonas, in Brazil, in 1984. Baniwa's work is rooted in the anthropophagous movement, which preceded Modernism in Brazil, and which sought to transform colonial logic through Brazilian Indigenous cosmogony. In his practice, he appropriates Western visual languages to decolonize them, opening ways for Indigenous people in national territories to be protagonists. Baniwa has participated in numerous exhibitions in Brazil and abroad, including *Heranças de um Brasil profundo* (Legacies of a Deep Brazil), at the Museu Afro Brasil, in São Paulo, and the 22nd Biennale of Sydney.

Christian Bendayán was born in Iquitos, in the Peruvian Amazon, in 1973. An artist and curator, he exhibited his work and curated numerous exhibitions in Peru and abroad. His awards include, in 2000, the National Art Contest Passport, and, in 2012, the National Culture Award. He was the director of the National Institute of Culture of Loreto, as well as the founding partner and artistic director of Art Lima (2013–2016). He was founder and director of Bufeo: Amazonía + Arte (2015–2018), a project dedicated to the research and promotion of Amazonian art. In 2019, his exhibition *Indios antropófagos* represented Peru at the 58th Venice Art Biennale, and in 2021, he directed *AMA/zones of myths and visions*, a documentary miniseries on Amazonian art.

Chonon Bensho is an Indigenous artist of the Shipibo-Konibo people of Peru. Born in the community of Santa Clara on the shores of Lake Yarinacocha, she descends from the Onanya traditional medicinal wisdom-keepers, and from the women that have preserved the artisanal and artistic traditions of their ancestors. She was raised in her native tongue and was cured with the medicinal plants used by the people who strive to become masters of the *kené* designs. She studied at the Eduardo Meza Saravia Artistic Training School, in the Yarinacocha district, graduating in 2018 with a thesis on *kené*. She is president of the Association of Artists and Sages of the Shipibo-Konibo people METSÁ. Her solo exhibition *A River, a Snake, A Map of the Sky* opens in Kloster Schönthal in the framework of CULTURESCAPES 2021 Amazonia.

Kateryna Botanova is a Ukrainian cultural critic, curator, and writer based in Basel. She was a director of CSM/Foundation Center for Contemporary Art, in Kyiv, where, in 2010, she launched and edited *Korydor*, the online journal on contemporary culture. She has worked extensively with EU Eastern Partnership Culture Program and EUNIC Global as a policy consultant, expert, and trainer. A member of PEN Ukraine, she publishes widely on art and culture. Currently, she is guest curator for the opening of the Jam Factory Art Center in Lviv, Ukraine, in 2022. Botanova is co-curator of CULTURESCAPES, and is an editor of the critical anthologies that accompany each festival, among them *On the Edge: Culturescapes 2019 Poland* and *Archeology of the Future: Culturescapes 2017 Greece*. She is co-editor of *Amazonia: Anthology as Cosmology*.

Rita Carelli is a writer, illustrator, filmmaker, and actress. With support from UNESCO, Carelli wrote, with Ana Carvalho and Vincent Carelli, *Cineastas Indígenas para Jovens e Crianças (Indigenous Filmmakers for Youngsters and Children)*, a guide to the many Indigenous filmmakers trained by the NGO *Video nas aldeias (Video in the Villages)*. She is the illustrator of *Memórias de índio, uma quase autobiografia (Memories of an Indian, a quasi-autobiography)* (ed. Eldebra) by Indigenous writer Daniel Munduruku. Carelli recently published *Minha Família Enauenê (My Enawenê Family)*, in which she tells the story of her childhood among the Enawenê-Nawê people, in the State of Mato Grosso. In 2021, Carelli published her first novel, titled *Terrapreta*.

Felipe Castelblanco is a multidisciplinary artist working at the intersection of socially engaged and media art. His work explores new frontiers of public space that enable coexistent encounters between unlikely audiences. A PhD Candidate at the HGK-FHNW, in Basel, he holds an MFA from Carnegie Mellon University, in Pittsburgh, and a BA from Javeriana University, in Bogotá. He has exhibited his work internationally, and he is the recipient of the Starr Fellowship at the Royal Academy Schools, in London. In 2015, he served as a Cultural Emissary for the US State Department to the Philippines. Together with Lydia Zimmermann, he presents the video *Flying River/Rio Volador* during CULTURESCAPES 2021 Amazonia.

Carolina Caycedo is a London-born, Colombian artist living in Los Angeles. She participates in movements of territorial resistance, solidarity economies, and housing as a human right. Her performances, drawings, photographs, and videos work toward the construction of environmental historical memory as a fundamental element for non-repetition of violence against human and non-human entities. Caycedo is the 2020–2022 Inaugural Borderlands Fellow at the Center for Imagination in the Borderlands, Arizona State University and the Vera List Center for Art and Politics. Recent solo museum shows include *Care Report*, Muzeum Sztuki, Łódź; *Wanaawna, Rio Hondo and Other Spirits*, Orange County Museum of Art; *Cosmotarrayas*, ICA Boston; and *From the Bottom of the River*, MCA Chicago. She is a member of the Los Angeles Tenants Union and the Rios Vivos Colombia Social Movement.

Taita (chief) Hernando Chindoy is the Governor of the Inga Nation and a social leader from Aponte, Nariño, in the southwest region of Colombia. He is the founder of the initiative Wuasikamas (Guardians of the Earth), which has become one of the most successful cases of voluntary substitution of illicit crops and social entrepreneurship among Indigenous communities affected by violence in South America. In 2015, Taita Chindoy was awarded the Equator Prize from the United Nations Development Program (UNPD) for his contribution to social, economic, and environmental advancements in the region.

Tiffany Higgins lives in Oakland, California. She is a 2022 Fulbright scholar in the Brazilian Amazon, for which she is exploring Indigenous and traditional fisherfolk's mobilization in response to a planned Tocantins-Araguaia industrial shipping channel. She is the author of two poetry collections, *And Aeneas Stares into Her Helmet* (2009) and *Apparition at Fort Bragg* (2016). Her work has been supported by the Pulitzer Rainforest Journalism Fund, and she was the 2020 Annie Clark Tanner Fellow in Environmental Humanities at the University of Utah. She is currently translating the poetry of Márcia Wayna Kambeba of the Kambeba people.

Márcia Wayna Kambeba was born in the Indigenous village of Belém do Solimões in Amazonas state in Brazil. A poet, photographer, storyteller, composer, activist, and educator, she earned her MA in Geography at the Federal University of Amazonas. She is the author of four books, including *Ay kakyri Tama (eu moro na cidade)* and *Kumiça Jenó: narrativas poéticas dos seres da floresta de contos*. She teaches in an innovative teaching certificate program, instructing mostly Indigenous teachers to integrate local Amazonian Indigenous content into the university curriculum. In 2020, she ran for city council in Belém, the first Indigenous woman to do so. She is currently General Ombudsman of Belém municipality.

Davi Kopenawa Yanomami was born around 1955 in Marakana, a Yanomami community on the Upper Toototobi river in the Brazilian state of Roraima, northern Amazon. He is a shaman and spokesman for the Yanomami

people who led the long-running international campaign to secure Yanomami land rights, for which he gained recognition in Brazil and around the world. In the 1950s and 1960s, visits by the SPI (Brazilian Indian Protection Service), and later by missionaries from the US-based New Tribes Mission, brought disease to the Yanomami. His community was decimated and both of his parents died in the resulting epidemics. In 1985, he began the fight for recognition of the vast area inhabited by the Yanomami in the Brazilian states of Roraima and Amazonas; in 1989, he won a UN Global 500 award in recognition of his battle to preserve the rainforest.

knowbotiq (Yvonne Wilhelm and Christian Huebler) holds a professorship in the MFA program at the Zurich University of the Arts (ZHdK). They have participated in biennials in Venice, Moscow, Seoul, and Rotterdam and have exhibited their work at New Museum, New York, Witte de With, Rotterdam, Kunsthalle St. Gallen, NAMOC Beijing, Museum of Contemporary Art, Helsinki, Museum Ludwig, Cologne, and elsewhere. Their awards include the Pax Art Award Basel, the Swiss Art Award, the ZKM Media Art Award, and the August Seeling-Award of Wilhelm Lehmbruck Museum and the Prix Arts Electronica.

Ailton Krenak was born in Vale do Rio Doce, Minas Gerais, in 1954. A Brazilian writer, philosopher, and Indigenous movement leader of Krenak people, he is the author of *Ideias para adiar o fim do mundo* (*Ideas to Postpone the End of the World*, 2019), *O amanhã não está à venda* (*Tomorrow Is Not for Sale*, 2020), and *A vida não é útil* (*Life Is Hardly Useful*, 2020). At the age of nine, he was forcibly separated from his people; later, he and his family would migrate to the state of Paraná. Krenak was the representative of Indigenous peoples at the debates on the 1988 Brazilian Constitution, and he has co-founded and participated in many Indigenous rights organizations, among them the Aliança dos Povos da Floresta (Alliance of Jungle-dwelling Peoples). From 2003 to 2010, Krenak was a special aide for Indigenous affairs to the governor of Minas Gerais. In 2015, he received the Order of Cultural Merit, and, the following year, an honorary doctorate from Juiz de Fora Federal University, where he teaches Indigenous cultures.

Gredna Landolt Pardo is chief curator of the Inca Garcilaso Cultural Center of the Peruvian Ministry of Foreign Affairs. Her numerous curatorial projects on Amazonian art include *Amazonías*, curated with Sharon Lerner (Matadero-Madrid, 2019); *Serpiente de agua, la vida indígena en la Amazonía* (*Serpent of the Waters: Indigenous life in the Amazon*), with A. Surrallés (Lima, 2003); and *El ojo verde. Cosmovisiones amazónicas* (*The Green Eye: Indigenous Cosmovisions*), with Pablo Macera (Lima, 2000, and Iquitos, 2001). She is editor of *El ojo que cuenta. Mitos y costumbres de la Amazonía indígena ilustrados por su gente* (*Eyes that tell. Myths and customs from Indigenous Amazonia illustrated by its people*, Lima: 2005) and *Tejidos enigmáticos de la Amazonía: Asháninka-Matsiguenka-Yanesha-Yine* (*Enigmatic Textile Art of the Peruvian Amazon. Ashaninka-Matsiguenka-Yanesha-Yine*, 2006).

Quinn Latimer is a California-born writer and editor. She is the author of *Like a Woman: Essays, Readings, Poems* (2017), *Sarah Lucas: Describe This Distance* (2013), *Film as a Form of Writing: Quinn Latimer Talks to Akram Zaatari* (2013), and *Rumored Animals* (2012). Her writings appear in *Artforum*, *The Paris Review*, and *Texte zur Kunst*, and she is the editor of many books, including *Simone Forti: The Bear in the Mirror* (2019), *Stories, Myths, Ironies, and Other Songs: Conceived, Directed, Edited, and Produced by M. Auder* (2014), and *No Core: Pamela Rosenkranz* (2012). Latimer was editor-in-chief of publications for documenta 14 in Athens and Kassel, and she is currently a lecturer at Institut Kunst, in Basel. She is co-editor of *Amazonia: Anthology as Cosmology*.

Renata Machado Tupinambá, of the Tupinambá people, was born in Niterói (Rio de Janeiro). She works as a journalist, scriptwriter, lecturer, and producer. Along with Anápuáka Tupinambá and Denilson Baniwa, she founded, in 2013, Rádio Yandê, the first Indigenous online radio station in Brazil that broadcasts to the national audience the realities and cultures of Indigenous peoples in the country. Additionally, she is a co-creator and a curator of Yby, the first contemporary Indigenous music festival in Brazil.

Maurício Meirelles is a Brazilian architect, fiction writer, and editor. His books include *A Cidadela* (2019) and *Birigüi* (2016), and he is widely published in Brazilian newspapers and magazines. He is one of the founders and editor of the Brazilian magazine *Olympio: Literatura e Arte*, launched in 2018.

Aníbal Quijano (1930–2018) was a Peruvian thinker and sociologist, known for having developed the concept of "coloniality of power" and influencing the fields of decolonial studies. He attended National University of San Marcos (UNMSM), in Lima, where he earned a PhD in 1964. Due to his work in the 1970s with the journal *Sociedad y Política*, he was deported to Mexico by the military government of Juan Velasco Alvarado; he would return and until 1995, he was senior lecturer at the Faculty of Social Sciences of San Marcos. His numerous books and publications on colonialism, politics, democracy, globalization, and racial capitalism include *Nationalism and Capitalism in Peru: A Study in Neo-Imperialism*, with Helen R. Lane (1972) and *Coloniality and Modernity/Rationality* (2010).

Roldán Pinedo (Shoyan Shëca) was born into the San Francisco Native Community of the Shipibo people in Ucayali, in the Peruvian Amazon, in 1968. In the Peruvian civil registry, however, Shoyan Shëca had to be registered as Roldán Pinedo, and he continues to use both names as an artist today. At the age of eighteen, in Pucallpa, he met his future wife and painting teacher, the painter Bahuan Jisbë (Elena Valera). They had their first two-person exhibition at El Museo de Arte del Centro Cultural San Marcos, in Peru, in 1999. As he developed his own artistic practice, his work began to be widely exhibited around the world.

Djamila Ribeiro was born in Santos, Brazil, in 1980. She is a public intellectual, writer, and philosopher, and one of the most influential leaders in the Afro-Brazilian

women's rights movement. She is the author of *Quem tem medo do feminismo negro?* (Who is afraid of Black feminism?, 2018), a collection of articles on social mobilization and the origins of Black feminism in Brazil and America. Her editorial initiatives include Sueli Carneiro's Seal, and her book, *Lugar de Fala* (Place of Speech) was the first publication of *Feminismos Plurais* (Plural Feminisms), a collection within Sueli Carneiro's Seal that publishes black writers' works at affordable prices. Ribeiro is an online columnist and regular columnist for the daily paper *Folha de Sao Paulo* and other publications. She was a 2019 Prince Claus Laureate.

Abel Rodríguez was born Mogaje Guihu into the Nonuya people, circa 1941, in La Chorrera, Amazonas, in the headwaters of the Cahuinarí River in the Colombian Amazon, where he was raised by the Muinane. By the 1990s, he had adopted the name Abel Rodríguez and moved to Bogotá, where he began working with the Dutch NGO Tropenbos as a specialist in plants, making botanical drawings. His celebrated drawings and paintings have been exhibited internationally, including in solo exhibitions at Baltic Centre for Contemporary Art, Gateshead, and in documenta 14, Athens and Kassel.

Pamela Rosenkranz was born in Uri, Switzerland, in 1979. She lives and works in Zurich and Zug. In 2004, she graduated with a MFA from Bern University of the Arts; previously she studied comparative literature at the University of Zurich. In 2020, she was the subject of a solo exhibition at Kunsthaus Bregenz, in Austria. Other exhibitions include: *Alien Culture*, GAMeC Bergamo (2017), *IF THE SNAKE*, Okayama Art Summit, Okayama (2019), *Là où les eaux se mêlent*, at the 15th Biennale de Lyon (2019), *Leaving the Echo Chamber*, Sharjah Biennial 14 (2019), and *Slight Agitation 2/4: Pamela Rosenkranz*, Fondazione Prada, Milan (2017). In 2015, Rosenkranz represented Switzerland at the Venice Biennale.

María Belén Saéz de Ibarra is a curator, editor, and the director of the Museo de Arte de la Universidad de Colombia. She studied Law at the Pontificia Universidad Javeriana de Bogotá and holds a master's in Environmental and International Law from the School of Oriental and African Studies (SOAS) of the University of London. Following her work with the Colombian Ministry of Culture, she began directing the Cultural Heritage Direction at Universidad Nacional in 2007, dedicating it to artistic commissions and large-scale experimental projects. She was co-curator at the Shanghai Biennale (2018–2019) and has curated exhibitions, theater productions, and peace and mourning actions in an effort to contribute to cultural activism for peace in Colombia.

Maya Quilolo was born in a *quilombola* community in Minas Gerais, Brazil, in 1994. She lives and works in Betim; previously, she studied anthropology and audiovisual in Belo Horizonte. Her multidisciplinary investigations address the potential of the black body in performances and video works that examine the interchange between visual arts and cultural diversity. Her recent research explores the body in its cosmogonic conception, proposing connections between

artistic languages and bodily interferences. In 2021, she is artist-in-residence at Lago Mio, Lugano, and Atelier Mondial, Basel, through a collaboration with SALTS, in Basel, as well as CULTURESCAPES 2021 Amazonia and the Centre d'art Waza in Lubumbashi, DR Congo.

Barbara Santos is a visual artist and independent researcher. She convenes the collectives quiasma.co and Cuenco de cera. Her work is situated at the intersection of the jungle, visual art, and technology, and is guided by dialogue as a form of co-creation, with the guidance of grandfathers and grandmothers of the Amazon. She studied at Universidad de los Andes, in Bogotá, and recieved a Master of Visual Arts at the Universidad Nacional de Colombia. She is co-editor, with Nelson Ortiz, of *El Territorio de los Jaguares de Yuruparí* (The Territory of the Jaguars of Yurupari), published by ACAIPI and Gaia Amazonas Foundation, Bogotá, in 2015. In 2019, she launched her book *La curación como tecnología* (Healing as technology) by IDARTES. In 2018, she was a consultant in the framework of the Peace Process, in culture and gender, for the project PUEDES—La Paz Única Esperanza para el Desarrollo Económico y Social with ex-combatants and Indigenous women in Putumayo Amazonía.

Paulo Tavares is a Brazilian architect and urbanist based in Quito and London. His work is concerned with the relations between conflict and space as they intersect within the multi-scalar arrangements of cities, territories, and ecologies. His practice combines design, media-based cartographies, and writing as interconnected modalities of reading contemporary spatial conditions.

He is developing a project on the violence of planning and the politics of ecology in Amazonia at the PhD Programme of the Centre for Research Architecture, Goldsmiths, London, and teaches architecture at the Universidad Católica de Ecuador—Facultad de Arquitectura, Diseño y Arte, in Quito.

Daiara Tukano was born Daiara Hori Figueroa Sampaio-Duhigô, of the Tukano Indigenous people. She is an artist, activist, educator, and communicator. She holds Master degree in human rights from the University of Brasília (UnB). She researches the right to memory and truth of Indigenous peoples, and is also coordinator of Radio Yandê, the first Indigenous web-radio in Brazil. Her work focuses on the culture, history, and traditional spirituality of her family and the Tukano people. She lives in Brasilia.

Eduardo Viveiros de Castro was born in Rio de Janeiro in 1951. He is a Brazilian anthropologist and ethnologist, and Professor of Social Anthropology at the National Museum of Rio de Janeiro. He was previously Simón Bolívar Chair of Latin American Studies at Cambridge University (1997–98) and Directeur de recherches at the C.N.R.S. (2000–2001). His books include *From the Enemy's Point of View: Humanity and Divinity in an Amazonian Society* (1992), *Radical Dualism* (2012), *Cannibal Metaphysics* (2014), *The Relative Native: Essays on Indigenous Conceptual Worlds* (2015), and *The Ends of the World*, with Déborah Danowski (2017).

REPRINTS

The Falling Sky: Words of a Yanomami Shaman by Davi Kopenawa and Bruce Albert, translated by Nicholas Elliott and Alison Dundy, Cambridge, MA: The Belknap Press of Harvard University Press, Copyright © 2013 by the President and Fellows of Harvard College. Used by permission. All rights reserved.

Ailton Krenak, Mauricio Meirelles, *Our Worlds Are at War*. First published in Portuguese in *Olympio – Literatura e arte*, # 2 (December 2019). First published in English online in *e-flux Journal* #110 (https://www.e-flux.com/journal/110/335038/our-worlds-are-at-war/) with the images by Denilson Baniwa.

Anibal Quijano, *Coloniality of Power, Eurocentrism, and Latin America*. First published in *Nepantla: Views from South*, vol. 1, no. 3 (Durham, NC: Duke University Press, 2000): 533–80.

Djamila Ribeiro, *Brazilian Black Feminism: Undoing Racial Democracy, Towards A World Ethic With Orixás*. First published in English in *Stronger than Bone* (Gwangju Biennale Foundation and Archive Books, 2021), the Feminism(s) reader of the 13th Gwangju Biennale, ed. Defne Ayas, Natasha Ginwala, and Jill Winder. It was subsequently published online on *Arts of the Working Class* (http://artsoftheworkingclass.org/).

María Belén Sáez de Ibarra, *Cosmopolitics of the Living*. First published in English in *What about Activism?*, ed. Steven Henry Madoff (London: Sternberg Press, 2019), 101–13.

Paulo Tavares. *The Geological Imperative. On the Political Ecology of Amazonia's Deep History*. First published in English in *Empower! Essays on the Political Economy of Urban Form*, vol 3. (Berlin: Ruby Press, 2014).

Eduardo Viveiros de Castro, "The Crystal Forest: Notes on the Ontology of Amazonian Spirits." First published in *Inner Asia* 9, no. 2 (2007): 153–72.

*Some minor orthographic changes were made to previously published texts to adhere to the volume's style guidelines.

COLOPHON

Amazonia: Anthology as Cosmology

Published by CULTURESCAPES
and Sternberg Press

This publication accompanies
CULTURESCAPES 2021 Amazonia festival
(September 29–December 3, 2021).

EDITORS

Kateryna Botanova
Quinn Latimer

MANAGING DIRECTOR

Jurriaan Cooiman

COPY EDITOR AND PROOFREADER

Galan Dall

TRANSLATORS

Sue Brownbridge
Felipe Castelblanco
Nicholas Elliott and Alison Dundy
Michael Ennis
Tiffany Higgins
Hilary Kaplan
John Mark Norman
Walter Paim

CONCEPT, DESIGN, AND TYPESETTING

Gaile Pranckunaite

TYPEFACES

Ama, NanumMyeongjo

PRINTER

Petro Ofsetas, Vilnius, Lithuania

ISBN 978-3-95679-611-1

All rights reserved; no part of this publication may be reproduced, stored in a retrieval system or transmitted in any form or by any means, electronic, mechanical, photocopying, recording or otherwise, without prior written permission from the publisher.

Unless otherwise mentioned, the image rights belong to the authors themselves. We have made every effort to identify and contact the copyright holders. In the event of any inadvertent errors or omissions, please contact the publishers.

The editors express their sincere thanks to all the contributors to this book as well as Ursula Biemann, Alexander Brust, Julia Bussius, Victor Costales & Julia Rometti, Catarina Duncan, Pedro Favaron, Katya García-Antón, Chus Martínez, Thyago Nogueira, María Inés Plaza Lazo, Benjamin Seroussi, Elfi Turpin, Jorge Villacorta, and Benedikt Wyss. This book would not be possible without support of the CULTURESCAPES team.

© 2021 the contributors,
CULTURESCAPES, Sternberg Press

CULTURESCAPES
Schwarzwaldallee 200
Basel 4058
Switzerland
Tel. +41 (0) 61 263 35 35
info@culturescapes.ch
www.culturescapes.ch

Sternberg Press
71–75 Shelton Street
London WC2H 9JQ
www.sternberg-press.com

Distributed by The MIT Press, Art Data, and Les presses du réel

CULTURE SCAPES

Sternberg Press